MARIE-LOUISE
VON MOTESICZKY
1906–1996

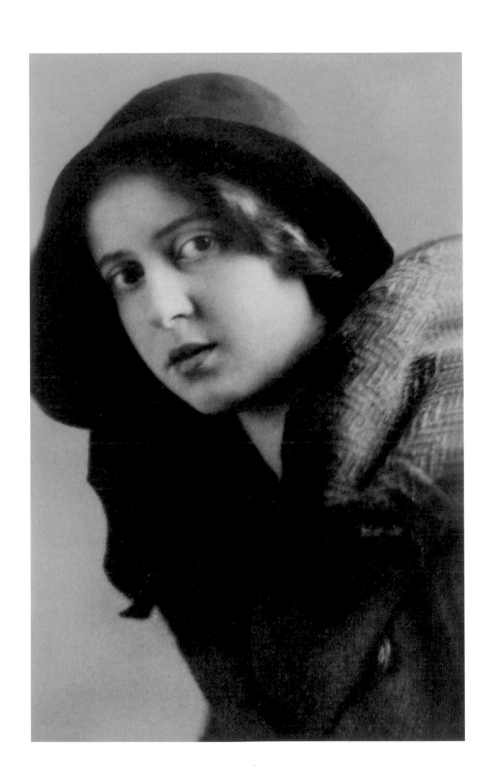

MARIE-LOUISE VON MOTESICZKY

1906–1996

THE PAINTER / DIE MALERIN

EDITED BY / HERAUSGEGEBEN VON
JEREMY ADLER
BIRGIT SANDER

WITH CONTRIBUTIONS BY / MIT BEITRÄGEN VON
JILL LLOYD
BIRGIT SANDER
INES SCHLENKER

PRESTEL
MUNICH · BERLIN · LONDON · NEW YORK

This book is published in conjunction with the exhibition Marie-Louise von Motesiczky, held at: /
Dieses Buch erscheint anlässlich der Ausstellung Marie-Louise von Motesiczky in der:
Tate Liverpool, 11 April 2006–13 August 2006
MUSEUM GIERSCH, Frankfurt am Main, 24 September 2006–28 January 2007
Wien Museum, Vienna, 15 February 2007–6 May 2007
Southampton City Art Gallery, Southampton, 28 September 2007–9 December 2007

Edited by / Herausgegeben von: Jeremy Adler and / und Birgit Sander

Front cover / Umschlagabbildung: Self-portrait with Straw Hat, 1937,
Marie-Louise von Motesiczky Charitable Trust, London
Back cover / Umschlagrückseite: Elias Canetti, 1960, Wien Museum
Frontispiece / Frontispiz: Marie-Louise von Motesiczky, Photograph, late 1920s /
Fotografie, späte 1920er Jahre, Marie-Louise von Motesiczky Charitable Trust, London

Prestel Verlag
Königinstrasse 9, D-80539 Munich
Tel. +49 (89) 38 17 09-0
Fax +49 (89) 38 17 09-35
www.prestel.de

Prestel Publishing Ltd.
4, Bloomsbury Place, London WC1A 2QA
Tel. +44 (020) 7323-5004
Fax +44 (020) 7636-8004

Prestel Publishing
900 Broadway, Suite 603, New York, NY 10003
Tel. +1 (212) 995-2720; Fax +1 (212) 995-2733

www.prestel.com

Library of Congress Control Number: 2006902802
British Library Cataloguing-in-Publication Data: a catalogue record for this book is available
from the British Library; Deutsche Bibliothek holds a record of this publication in the Deutsche
Nationalbibliografie; detailed bibliographical data can be found under: http://dnb.ddb.de

Prestel books are available worldwide. Please contact your nearest bookseller or one of the above
addresses for information concerning your local distributor.

Project Management / Projektleitung: Anja Besserer
Translations / Übersetzungen: Willfried Baatz, Sylvia Höfer, Timothy Jones,
Jennifer Taylor-Gaida for / für alpha & bet VERLAGSSERVICE
Copyediting / Lektorat: Nadia Lawrence, Willfried Baatz
Editorial direction / Projektabwicklung: alpha & bet VERLAGSSERVICE, Munich
Design / Gestaltung: WIGEL, Munich
Typesetting / Satz: Alfred Wigel, Munich
Origination / Lithografie: Reproline Genceller, Munich
Printing and Binding / Druck und Bindung: sellier druck GmbH, Freising

Printed in Germany on acid-free paper.

ISBN 3-7913-3693-2/978-3-7913-3693-0 (trade edition)
ISBN 3-935283-12-1 (catalogue edition, MUSEUM GIERSCH, Frankfurt a. M.)
ISBN 3-7913-6074-4/978-3-7913-6074-4 (catalogue edition, Wien Museum)
ISBN 3-7913-6075-2/978-3-7913-6075-1 (english edition)

MUSEUM
GIERSCH WIEN MUSEUM

Contents / Inhalt

Lenders / Leihgeber

We thank the following museums and institutions who have kindly loaned us works from their collections: / Wir danken folgenden Museen und Institutionen, die uns durch Leihgaben unterstützt haben:

Cambridge, Fitzwilliam Museum
Frankfurt a. M., Städelsches Kunstinstitut
Linz, Lentos Kunstmuseum
London, Arts Council
London, National Portrait Gallery
London, Tate Gallery
London, Marie-Louise von Motesiczky Charitable Trust
Manchester, Art Gallery
Oxford, St Anne's College
Wien, Österreichische Galerie Belvedere
Wien, Wien Museum

Wir danken folgende Privatpersonen:

Eva Adler, London
Georg Baldass, Wien
Jantien and Peter Black, Glasgow
Ursula Brentano, Blonay
Mirli and Daniele Grassi, Tervuren
Mirjam Kann, Amsterdam
Gaby Reydon-Nechansky, Zwolle
Ladislas Rice, London
Karin and Jan-Willem Salomonson, Bilthoven
Karin and Rüdiger Volhard, Frankfurt a. M.

We also thank all those persons who do not wish to be named. /
Weiter gilt unser Dank allen Personen, die nicht genannt werden wollen.

The artist herself gave her pictures the English titles that are used throughout this catalogue. Most of the German titles are also by Marie-Louise von Motesiczky herself, but as she did not give German titles to all her paintings, a number of them have been newly translated for the present catalogue.

Bei den englischen Bildtiteln handelt es sich um die Originaltitel der Werke von Marie-Louise von Motesiczky. Die deutschen Bildtitel stammen in der Mehrzahl von der Künstlerin selbst, lediglich einige von ihnen wurden für diesen Katalog ins Deutsche übersetzt.

My longing is to paint beautiful pictures,
to become happy in doing so, and
to make other people happy through them.
Marie-Louise von Motesiczky

Meine Sehnsucht ist es, schöne Bilder zu malen,
dadurch glücklich zu werden und
andere Menschen glücklich zu machen.
Marie-Louise von Motesiczky

Preface

The hot, bright rays of the sun,
The deep shadows of the past,
You pictured them in your art,
Captured for all eternity.
Henriette von Motesiczky

The life of Marie-Louise von Motesiczky spanned a troubled era and was shaped by its key moments, from the Viennese fin de siècle and the sunset days of the Austro-Hungarian Empire and the Great War to the Second World War and late twentieth century Britain. She was born in Vienna in 1906, fled her homeland in 1938, and found refuge in England in 1939, where she lived for almost fifty years until her death in 1996. The century's variegated history has left many a trace on her work as did the cities that she knew, cities that each has its own associations in the modern memory: Vienna, Berlin and Frankfurt, Amsterdam and Madrid, Paris and London. The present major retrospective enables her work to be seen in all its subtlety and variety, both as the product of these distinctive milieus and their often difficult circumstances, and as one woman's unique response to the twentieth century.

The exhibition builds on two retrospectives that the artist prepared herself, at the Goethe Institut in London (1985), and the Austrian Gallery in the Belvedere (1994). In displaying a representative selection of her paintings and drawings in chronological sequence, the present exhibition affirms both the consistency of her vision and the intuitive intelligence of her debate with previous art, ranging from the classical Dutch and Spanish Schools to French Impressionism and Vincent van Gogh as well as to the great painters she knew personally, Max Beckmann and Oskar Kokoschka. Having emigrated from her own glittering social and intellectual scene in Central Europe, in wartime and postwar London she lived at first in virtual isolation as an émigré, but remained lively and active, outgoing and intellectualy curious up until high old age. She was privileged throughout these years to continue her vocation, and on occasion to share a venue with some of the leading artists of her day, notably at Helen Lessore's Beaux Arts Gallery. As she looked after her aged mother who appears in so many of her finest works, she was sustained intellectually by her friendship with Elias Canetti; and, seemingly working aside from the mainstream, she remained faithful to the principles of figurative art, but keenly followed new developments. Moreover, she infused the northern light of her London studio with the colours experienced on her travels: thus her intimate, often domestic pictures reflected her journeys beyond Europe, to Cuba and to Mexico, to Israel, Egypt and India. The vitality and painterly expressiveness of her work assure this humane and gentle artist a significant place in the art of the twentieth century. Marie-Louise von Motesiczky's retrospectives in London and Vienna were greeted by critical acclaim, but her *œuvre* still awaits discovery by the public at large as well as by specialized art historians. It is our hope just such a discovery may be achieved by the present exhibition and by this, the accompanying catalogue.

In her later years, as a shy yet public figure, Marie-Louise von Motesiczky became increasingly concerned to preserve her art for the future. Overcoming her own distaste for paperwork, she produced a catalogue of all her paintings with her personal secretary, Barbara Price; and, with the help of her lawyer, John Evans at Farrers & Co., drew up the terms for the Marie-Louise von Motesiczky Charitable Trust to which she bequeathed her estate.

She selected the trustees to represent her different interests: the Chairman of the Trustees, Jeremy Adler, Senior Research Fellow and Professor of German at King's College, London, who shared her background, her friends and her thoughts; her cousin, Richard Karplus, unique familiar with her circumstances, counsellor and practical assistant in her later years; and the art historians Sean Rainbird, Curator at the Tate Gallery, London, and Director designate

Vorwort

Die heissen lichten Sonnenstrahlen
Die tiefen Schatten jener Zeit,
Du konntest auf ein Bild sie malen
Nun eingefangen für die Ewigkeit.
Henriette von Motesiczky

Marie-Louise von Motesiczkys Leben fiel in unruhige Zeit- und Lebensumstände, deren radikale Umbrüche sich prägend auf die Künstlerin auswirkten: 1906 in Wien geboren, erlebte sie die Endphase und den Untergang der k. u. k. Monarchie sowie den Ersten und Zweiten Weltkrieg, letzteren im Exil in Großbritannien, wo sie fast die gesamte Hälfte des 20. Jahrhunderts bis zu ihrem Tod 1996 lebte. Diese bewegte Biografie hat im Œuvre der Malerin ebenso deutliche Spuren hinterlassen wie die bedeutenden Orte, an denen sie lebte oder sie bereiste – Orte von ganz unterschiedlichem Charakter, die eigene Assoziationen wecken: Wien, Berlin und Frankfurt, Amsterdam und Madrid, Paris und London. Diese große Retrospektive zum 100. Geburtstag der Künstlerin ermöglicht es dem Betrachter, das Werk dieser einzigartigen Malerin in seiner ganzen Subtilität und Bandbreite zu erleben. Sie zeigt sowohl die Einflüsse der besonderen, oft schwierigen Zeit- und Lebensumstände auf ihr Werk als auch die singuläre Reaktion einer sensiblen Künstlerin auf ebendieses 20. Jahrhundert.

Die Ausstellung schließt an die bisherigen Retrospektivausstellungen im Goethe Institut in London 1985 und der Österreichischen Galerie in Wien 1994 an und zeichnet die künstlerische Entwicklung der Malerin anhand einer repräsentativen Werkauswahl an Gemälden und Zeichnungen nach. Sie belegt sowohl die Kohärenz ihrer Vision als auch die intuitive Intelligenz in der Auseinandersetzung mit bedeutenden Werken der Kunstgeschichte – von den Holländern und Spaniern des 17. und 18. Jahrhunderts über den französischen Impressionismus und Vincent van Gogh bis hin zu den großen Malern, die sie persönlich kannte, Max Beckmann und Oskar Kokoschka. Nachdem Marie-Louise von Motesiczky aus dem aristokratisch-großbürgerlichen Milieu ihrer Wiener Herkunft mit regen gesellschaftlichen und geistigen Kontakten herausgerissen worden war, lebte sie im London der Kriegs- und Nachkriegszeit als Emigrantin zunächst mehr oder weniger isoliert. Bis ins hohe Alter jedoch war sie weltoffen und ihr Horizont alles andere als eingegrenzt. Sie hatte das Privileg, ihre künstlerische Tätigkeit fortzusetzen und konnte gelegentlich gemeinsam mit einigen der angesehensten Künstler ihrer Zeit ausstellen, insbesondere in Helen Lessores Beaux Arts Gallery. Während sie ihre betagte Mutter pflegte, die in so vielen ihrer eindruckvollsten Werke zu sehen ist, war für sie die Freundschaft mit Elias Canetti eine intellektuelle Stütze. Sie blieb stets der figurativen Malerei verbunden und arbeitete scheinbar abseits der künstlerischen Hauptrichtungen, jedoch verfolgte sie das Kunstgeschehen überaus aufmerksam. In das nördliche Licht ihres Londoner Ateliers ließ sie all jene Farben einfließen, die sie auf ihren zahlreichen Reisen bis ins hohe Alter in sich aufgenommen hatte und die sie in zahlreiche außereuropäische Länder wie Kuba, Mexiko, nach Israel, Ägypten oder Indien führten. Die Vitalität und malerische Ausdruckskraft ihres Werkes sichern der stillen und sanften Malerin einen bedeutenden Platz innerhalb der Malerei des 20. Jahrhunderts. Die Retrospektiven in London und in Wien zeugten von überaus positiver Publikumsresonanz, doch ist das Werk der Marie-Louise von Motesiczky für ein breiteres Publikum wie auch für die Kunstgeschichte immer noch zu entdecken, was mit dieser Ausstellung und diesem Katalog nun erstmalig umfassender gelingen soll.

Die öffentlichkeitsscheue Malerin machte sich in ihren späteren Lebensjahren zunehmend Gedanken darüber, wie sie ihr Werk für die Zukunft bewahren könnte. Gemeinsam mit ihrer Privatsekretärin, Barbara Price, stellte sie einen Katalog ihrer Gemälde zusammen und erarbeitete mit Hilfe ihres Anwalts, John Evans bei der Firma Farrars & Co.,

of the Staatsgalerie, Stuttgart, David Scrase, now Assistant Director, Collections and Keeper, Paintings, Drawings and Prints, at the Fitzwilliam Museum, Cambrige, who have acted as the knowledgable advocates of her art ever since the Tate and then the Fitzwilliam first took an interest in it during her lifetime and acquired several important paintings. A fifth trustee sadly died before the Trust could begin its work, the late Michael Jaffé, distinguished scholar of Rubens, Jordaens and Van Dyck, and Syndic of the Fitzwilliam Museum, Cambridge. From the first, the Trust set its sights on a centenary exhibition as the most suitable occasion to celebrate the artist's achievement. To this end it funded a researcher, Ines Schlenker, via a post-doctoral fellowship at King's College, London, who was entrusted with the task of producing a *catalogue raisonné* and, more widely, of setting up a computerized database and an archive of Marie-Louise's papers; it further commissioned a biographer, Jill Lloyd, formerly of University College, London, to write a study of the artist's life. Both the *catalogue raisonné* and the biography are complete in draft, and it is hoped that they will appear shortly. An ambitious programme was also launched to record and conserve the artist's works: we are indebted to Rachel Barker and Sam Hodge who conducted the painting survey and undertook the conservation of Marie-Louise von Motesiczky's paintings; and to Rosie Freemantle for the equally conscientious conservation and mounting of her drawings. Mike Howden has conserved the original frames and made new ones, appropriate to the artist's style; and the photographer Matthew Hollow has recorded a major part of her *œuvre*. All of these have, we believe, ensured that the Trust's activities could achieve the world-class standards Marie-Louise's work requires. The plans for the exhibition, agreed jointly by the trustees, were conceived by Sean Rainbird and David Scrase, who are responsible for managing this project and conducted the negotiations with our partners, in which a core of common pictures was decided for each venue. The practical arrangements were initiated by Chloe Johnson, former Trust Secretary and Curator, and have been seen through to a successful conclusion with untiring attention to detail by Andrew Crosbie, the new Trust Secretary

die Rahmenbedingungen für die Einrichtung des Marie-Louise von Motesiczky Charitable Trust, dem sie ihren Nachlass und ihr Vermögen übertrug.

Die Treuhänder, die ihre Interessen vertreten sollten, bestimmte sie noch selbst: Der Vorsitzende des Kuratoriums, Jeremy Adler, Senior Research Fellow und Professor für Germanistik am King's College, London, der einen vergleichbaren geistigen Hintergrund wie die Künstlerin hat, zu ihrem Freundeskreis zählte und mit dem die Malerin einen intensiven geistigen Austausch pflegte; ihr Vetter, Richard Karplus, der mit ihren Lebensumständen bestens vertraut ist und ihr im Alter als Berater und praktischer Helfer zur Seite stand; die Kunsthistoriker Sean Rainbird, Kurator an der Tate Gallery, London, und designierter Direktor der Staatsgalerie Stuttgart, und David Scrase, Assistant Director, Collections and Keeper, Paintings, Drawings and Prints, am Fitzwilliam Museum in Cambridge, die sich beide als kenntnisreiche Sachwalter für ihre Kunst engagiert haben, zumal die Tate Gallery und später das Fitzwilliam Museum noch zu Lebzeiten der Malerin Interesse an ihren Werken bekundeten und mehrere bedeutende ihrer Gemälde erwarben. Ein fünfter Treuhänder verstarb leider, bevor der Trust seine Tätigkeit aufnehmen konnte; es war Michael Jaffé, ein herausragender Gelehrter und Kenner der Werke von Rubens, Jordaens und van Dyck sowie Syndikus des Fitzwilliam Museum in Cambridge. Von Anfang an war der Trust bestrebt, eine Ausstellung zum 100. Geburtstag der Künstlerin auszurichten, um ihre künstlerischen Leistungen zu diesem bedeutenden Anlass zu würdigen. Vor diesem Hintergrund vergab er ein Stipendium an die Wissenschaftlerin Ines Schlenker, um als Postdoctoral Fellow am King's College, London, einen systematischen Katalog der Werke Marie-Louise von Motesiczkys zu erstellen und darüber hinaus ein Archiv des schriftlichen Nachlasses der Künstlerin aufzubauen. Ferner beauftragte der Trust Jill Lloyd, vormals University College, London, eine biografische Studie über das Leben der Künstlerin zu erarbeiten. Sowohl der Catalogue raisonné als auch die Biografie sind im Entwurf fertiggestellt, und es ist zu hoffen, dass sie in Kürze erscheinen werden. Eine computergestützte Inventarisation der Werke erfolgte ebenso wie eine intensive konservatorische Betreuung. Der Trust ist Rachel Barker und Sam Hodge zu Dank verpflichtet, die den Zustand von Marie-Louise von Motesiczkys Gemälden prüften und notwendige Konservierungsmaßnahmen durchführten, ebenso wie Rosie Freemantle, die für die gewissenhafte Konservierung und Rahmung ihrer Zeichnungen sorgte. Mike Howden hat die originalen Rahmen restauriert beziehungsweise passend zum Stil der Künstlerin neue Rahmen angefertigt, während der Fotograf Matthew Hollow einen großen Teil ihres Œuvres fotografisch dokumentierte. Alle Beteiligten trugen dazu bei, dem hohen Standard gerecht zu werden, den Marie-Louise von Motesiczkys Werk verlangt. Die Pläne für diese große Schau wurden vom Kuratorium der Marie-Louise von Motesiczky Charitable Trust abgestimmt, mit Konzeption und Durchführung beauftragte man Sean Rainbird und David Scrase, die auch die Verhandlungen mit Partner-Museen und Leihgebern geführt haben. Die praktische Umsetzung wurde durch Chloe Johnson, der früheren Trust Secretary und Curator, und durch Andrew Crosbie, dem neuen Trust Secretary und Administrator, mit einem sicheren Blick für jedes Detail realisiert. Der Künstler George Lewis, der Marie-Louise über viele Jahre gekannt hat, stand uns jederzeit mit Rat und Tat zur Seite. Der Katalog wurde in gemeinsamer Arbeit von Jeremy Adler vom Marie-Louise von Motesiczky Charitable Trust und Birgit Sander vom MUSEUM GIERSCH in Frankfurt ediert. Der Trust und alle Ausstellungsorte sind vor allem Ines Schlenker zu großem Dank verpflichtet. Ihre Forschung zu Leben und Werk der Künstlerin bilden für die Ausstellung und den Katalog die wissenschaftliche Grundlage. Ihr persönliches Engagement hat sich als unschätzbar erwiesen und wesentlich zum Gelingen der Ausstellung beigetragen.

In der Wahl der vier Ausstellungsorte in England, Deutschland und Österreich spiegeln sich die Stationen von Marie-Louise von Motesiczkys Leben ebenso wider wie die kulturellen Schwerpunkte, die ihre Kunst maßgeblich prägten.

Die Tate Gallery in London unterstützte zu Lebzeiten Marie-Louises Werk über viele Jahre, und es ist daher nur recht und billig, dass die Ausstellung in der Tate Liverpool ihren Anfang nimmt. In der ersten Zeit ihres Umgangs mit der Tate vertrat dort Richard Calvacoressi, Kurator ihre Interessen. Die Tate hat drei wichtige Bilder der Künstlerin erworben und die

and Administrator. The artist George Lewis, who knew Marie-Louise for many years, has ever been on hand with advice and assistance. The catalogue was conceived on the basis of earlier proposals and jointly edited by Jeremy Adler at the Trust and Birgit Sander in Frankfurt. The Trustees and all exhibitors owe a particular debt to Ines Schlenker: her research into the artist's life and work underpins both the exhibition and the catalogue, whilst her personal engagement has proved invaluable in ensuring the exhibition's success.

The choice of four venues in England, Germany and Austria reflects the facts of Marie-Louise von Motesiczky's life as well as the cultural centres which nourished her art.

The Tate Gallery in London, as it then was, supported Marie-Louise's work for many years, and it is therefore entirely appropriate that the travelling exhibition should begin with a Tate venue. The Tate acquired three important paintings by the artist and has long looked kindly on the Trust's activities. During the artist's lifetime, Richard Calvocoressi took an active interest in her work. A memorial showing of Marie-Louise von Motesiczky's work was mounted at the Tate Gallery on the occasion of her death, which was curated by Sean Rainbird, and—a rare and significant gesture—the Tate also held a memorial for the artist in the Duffield Room in 1996, at which Sir Nicholas Serota acted as host, and which was addressed by Sir Ernst Gombrich. We especially wish to thank the following at Tate Liverpool for enabling the present exhibition: Simon Groom, Head of Exhibitions & Displays, Amy Dickson, Assistant Curator at Tate Modern (formerly at Tate Liverpool) who was instrumental in putting the show together for Tate Liverpool, ably assisted by Wendy Lothian, Exhibitions & Displays Co-ordinator, and Kyla McDonald, Assistant Curator. We also gratefully acknowledge that this exhibition is supported by the Austrian Cultural Forum London.

In Frankfurt am Main, MUSEUM GIERSCH is by no means presenting an artist unknown to its public, and yet the retrospective will prove a discovery. Every exhibition hitherto devoted to the Frankfurt pupils of Max Beckmann at MUSEUM GIERSCH—the last was in 2000/2001—have included individual works by Marie-Louise von Motesiczky, a strategy that has always met with considerable success. On every occasion her work stood out against that of her contemporaries in Beckmann's master class. Her very individualistic choice of motif, her artistic signature and her lively colours always attracted the public's attention. That made them keen to see more of this passionate painter and draughtsman, but there was no immediate opportunity; then, when MUSEUM GIERSCH was contacted by the Marie-Louise von Motesiczky Charitable Trust in summer 2004, as an established museum and research centre for the art and cultural history of the Rhein-Main region, it agreed with alacrity to the proposal to hold an exhibition of Marie-Louise von Motesiczky's life and work. The idea of mounting a travelling exhibition to celebrate the centenary of her birth which would be held in the major towns that formed her as an artist was a convincing one, and MUSEUM GIERSCH took on the task gladly, seeing it as a duty towards this notable émigré artist. Birgit Sander assumed the role of organizer for the exhibition in Frankfurt and researched the artist's fascinating Frankfurt years as well as Max Beckmann's artistic and cultural milieu and the artist's own traces in Frankfurt am Main. In her catalogue essay, she has analysed the similarities but also the differences between Marie-Louise and Max Beckmann in order to reveal Marie-Louise von Motesiczky's unique individual power. Dr. Sander deserves a very special word of thanks for this contribution, but especially for her passionate commitment to the exhibition as a whole and to the editing of the present catalogue, neither of which could have been realized without her. She has also curated a selection of drawings by Max Beckmann and other items that will accompany the exhibition which demonstrate Marie-Louise's links with Frankfurt, and MUSEUM GIERSCH is particularly proud that the show will take place in a part of town that has close personal associations with the artist. The secretarial work for the exhibition was conducted by Carina Matschke and Jeannette Falcke, Anja Damaschke was the Frankfurt restorer, and Antonio Amaral dos Santos provided the technical co-ordination. The financial support for both exhibition and catalogue were granted by Stiftung Giersch. The museum gratefully acknowledges the support of the donors, Senator Carlo Giersch and his wife, Mrs. Karin Giersch, as well as that of Stephan Rapp, Chairman of Stiftung Giersch.

Aktivitäten des Trust über lange Zeit mit Wohlwollen begleitet. Eine Gedenkausstellung wurde in der Tate in London anlässlich des Todes der Künstlerin 1996 von Sean Rainbird kuratiert und – eine seltene und bedeutsame Geste – die Tate hielt im selben Jahr im Duffield Room ein Memorial Meeting für die Künstlerin ab, bei der Sir Nicholas Serota als Gastgeber auftrat und Sir Ernst Gombrich einen Vortrag hielt. Wir möchten vor allem folgenden Mitarbeitern der Tate Liverpool dafür danken, dass sie die Ausstellung ermöglicht haben: Simon Groom, Leiter der Abteilung Exhibitions & Displays, sowie Amy Dickson, Assistant Curator an der Tate Modern (vormals Tate Liverpool), die geholfen hat, die Schau für die Tate Liverpool zusammenzustellen. Unser Dank gilt auch Wendy Lothian, Exhibitions & Displays Co-ordinator, und Kyla McDonald, Assistant Curator. Mit Dankbarkeit verweisen wir auch auf die Unterstützung, die unserer Ausstellung vom Austrian Cultural Forum, London, gewährt wurde.

Mit der Künstlerin Marie-Louise von Motesiczky stellt das MUSEUM GIERSCH in Frankfurt am Main keineswegs eine Unbekannte vor, und doch wird die Retrospektive für das hiesige Kunstpublikum eine Entdeckung sein. Alle bisherigen Ausstellungen, die sich mit den Frankfurter Schülern von Max Beckmann – zuletzt 2000/01 – auseinander setzten, berücksichtigten Motesiczkys künstlerisches Schaffen mit einzelnen ausgesuchten Werken, und dies immer mit sehr großem Erfolg. Denn stets überragte die leidenschaftliche Malerin und Zeichnerin die Schar ihrer einstigen Studienkollegen, indem sie mit ihrem eigenständigen Motivrepertoire, ihrer überzeugenden künstlerischen Handschrift und mit ihrem Sinn für ein frisches Kolorit die Aufmerksamkeit der Besucher auf sich ziehen konnte. Das machte zwar neugierig, doch ergab sich bisher noch keine Gelegenheit, das Œuvre der emigrierten Künstlerin in einer repräsentativen Schau wissenschaftlich aufgearbeitet in Frankfurt vorzustellen. Daher hat das MUSEUM GIERSCH als etabliertes Ausstellungshaus und als Forschungsstelle für die Kunst- und Kulturgeschichte der Region Rhein-Main die Anfrage des Motesiczky-Trusts im Sommer 2004 nach einer inhaltlichen und organisatorischen Beteiligung an einer Ausstellung zu Leben und Werk der Künstlerin ohne Umschweife bejaht. Das Konzept, anlässlich des 100. Geburtstages eine retrospektive Wanderausstellung durch die Städte ihrer wichtigsten und prägenden Lebensstationen zu veranstalten, musste überzeugen und gestaltete sich für das MUSEUM GIERSCH geradezu als Verpflichtung. Birgit Sander, stellvertretende Leiterin des Museums, die das Ausstellungsprojekt für den Frankfurter Ausstellungspartner betreut, recherchierte die spannenden 1920er Jahre in Frankfurt, das künstlerische und intellektuelle Umfeld von Max Beckmann und seiner Schule und folgte den Spuren, die Marie-Louise von Motesiczky in der Stadt am Main hinterlassen hat. Sie analysierte in ihrem Katalogbeitrag Gemeinsamkeiten, aber auch wesentliche Unterschiede im Schaffen Beckmanns und Motesiczkys, um deren eigene künstlerische Fähigkeiten zu würdigen. Für ihren sehr gelungenen und überzeugenden Aufsatzbeitrag wie für ihren enthusiastischen Einsatz, der ganz wesentlich zur Realisierung von Ausstellung und Katalog beitrug, ist ihr ganz herzlich zu danken.

Sie stellte auch eine Auswahl von Zeichnungen Max Beckmanns und anderen Objekten zusammen, die die Schau begleiten und Marie-Louises Verbindungen zu Frankfurt aufzeigen – einer Stadt, mit der die Künstlerin persönlich eng verbunden war. Die Koordination der Ausstellungsvorbereitung oblag Carina Matschke und Jeannette Falcke; die Restauratorin in Frankfurt war Anja Damaschke, während Antonio Amaral dos Santos für die technische Koordination verantwortlich zeichnete. Sowohl die Ausstellung selbst als auch der Katalog wurden von der Stiftung Giersch mitfinanziert. Das Museum dankt den großzügigen Unterstützern, Senator Carlo Giersch und seiner Frau, Karin Giersch, sowie Stephan Rapp, dem Vorsitzenden der Stiftung Giersch.

Das Wien Museum, ein Großstadtmuseum mit breitem kulturgeschichtlichem Spektrum, zu dem auch eine bemerkenswerte Kunstsammlung gehört, war an diesem Ausstellungsprojekt von Anfang an interessiert. Ich danke in diesem Zusammenhang Hubert Gaisbauer, der sich intensiv mit Marie-Louise von Motesiczky befasst und vor vielen Jahren ein ausführliches Radiogespräch für den Österreichischen Rundfunk mit der Künstlerin geführt hat. Er hatte aus London von einem damals noch vagen transnationalen Ausstellungsprojekt er-

The Wien Museum, which is a city museum with objects displaying a wide cultural focus, including a large collection of paintings, was interested in the present exhibition from the outset. In this connection, we are grateful to Hubert Gaisbauer who conducted an important radio interview with Marie Louise von Motesiczky herself many years ago and has continued to study and promote her work ever since. He first heard about the original plans for an international exhibition at an early stage, and when these plans became more concrete, it was his enthusiasm that led the Wien Museum to participate. Marie-Louise was closely connected to Vienna throughout her life—from her childhood and youth spent in the city to her relationship with the Viennese writer Elias Canetti and the important solo exhibitions she held in the Vienna Secession (1966) and in the Österreichische Galerie in the Belvedere (1994). The Wien Museum itself owns one of her pictures, a portrait of Elias Canetti, and the biographical context is an important factor for the Wien Museum, which will be showing a specially curated selection of documents and photographs relating to the artist's life. The Wien Museum is confident that this exhibition will inspire a new awareness of Marie-Louise von Motesiczky's work among the Austrian public, not least given the fact that the popularity of the Viennese Modernism of Klimt and Schiele—the Viennese stars on the loan list—remains strong, and that in Vienna itself the period after 1920 has attracted growing attention. The present exhibition should contribute towards this new perspective by opening up new vistas in Austrian art. It is not quite coincidental that the Wien Museum is also preparing an exhibition of "Vienna Kineticism" in the 1920s, a movement of almost exclusively women artists. In Vienna, the exhibition was curated by Dr Ursula Storch, whom the exhibitors wish to thank most warmly.

After the exhibition's tour from Liverpool to Frankfurt and Vienna, it seems appropriate that it returns to England, to be shown at Southampton City Art Gallery, where it is curated by Esta Mion-Jones, Exhibitions and Marketing Manager, whom we thank for her personal contribution to the show's success.

In conclusion we gratefully acknowledge the encouragement of Marie-Louise's family and friends who have supported the Marie-Louise von Motesiczky Charitable Trust since its inception. We extend our particular thanks to the individuals and institutions who have graciously made loans of items in their possession for the exhibition or who have supplied images for reproduction in the catalogue. For permission to print extracts from the unpublished letters of Elias Canetti to Marie-Louise von Motesiczky we thank Johanna Canetti. For permission to quote from an unpublished diary entry of Iris Murdoch, we thank John Bayley and Peter Conradi. Last but by no means least, we wish to thank the Prestel Verlag, Munich, for its commitment to this project and its invaluable work in the production of this catalogue.

Jeremy Adler
Chairman
Motesiczky Trust

Nicholas Serota
Director
Tate Gallery

Christoph Grunenberg
Director
Tate Liverpool

Manfred Großkinsky
Director
MUSEUM GIERSCH

Wolfgang Kos
Director
Wien Museum

Tim Craven
Director
Southampton City Art Gallery

fahren. Sein Enthusiasmus führte zu unserem Einstieg in das immer konkreter werdende Vorhaben. Marie-Louise von Motesiczkys Leben war vielfach mit Wien verknüpft – Kindheit, Jugend, Beziehung zu Elias Canetti, wichtige Personalausstellungen gab es in der Secession (1966) und in der Österreichischen Galerie Belvedere (1994). Der biografische Kontext ist für uns deshalb sehr bedeutend, weshalb bei der Wiener Ausstellungsstation die Lebensdokumentation und die Darstellung des gesellschaftlichen Umfelds besonders herausgearbeitet wird. Das Wien Museum verfügt in seiner Sammlung über eines von Marie-Louise von Motesiczkys Bildern, das Porträt Elias Canettis, und der biografische Kontext ist ein wichtiger Faktor für das Wien Museum, das eine eigens zusammengestellte Auswahl von Dokumenten und Fotografien über das Leben der Künstlerin präsentieren wird.

Das Wien Museum ist sicher, dass es gelingen wird, beim österreichischen Kunstpublikum die faszinierende Künstlerin Marie-Louise von Motesiczky stärker ins Bewusstsein zu rücken. Dafür spricht, dass die internationale Popularität der frühen Wiener Moderne um Klimt und Schiele – die Stars der Verleihliste des Wien Museums! – zwar nicht abebbt, dass aber Wien betreffend zunehmend auch die Zeit nach 1920 in den Fokus rückt. Diese Ausstellung soll ein Beitrag dazu sein, sie hat also auch einen »kunststrategischen« Aspekt. Nicht ganz zufällig wird zeitparallel im Wien Museum eine Ausstellung über die international zu wenig bekannte Avantgarde-Bewegung des »Wiener Kinetismus« der frühen 1920er Jahre vorbereitet. Dieser war fast ausschließlich von Künstlerinnen getragen. Kuratorisch betreut wird die Ausstellung Marie-Louise von Motesiczky seitens des Wien Museums von Ursula Storch, der nachdrücklich hierfür zu danken ist.

Es erscheint nur konsequent, dass die Ausstellung nach den Stationen Liverpool, Frankfurt und Wien nach England zurückkehrt und schließlich in der Southampton City Art Gallery zu sehen sein wird. Dort wird sie von Esta Mion-Jones, Exhibitions and Marketing Manager, betreut, der wir für ihren persönlichen Beitrag zum Erfolg der Schau unseren Dank aussprechen möchten.

Abschließend danken wir den Mitgliedern der Familie Marie-Louises und ihren Freunden, die den Marie-Louise von Motesiczky Charitable Trust von Anfang an unterstützt haben, ganz herzlich für ihre fortdauernde Ermunterung. Unser ganz besonderer Dank gilt all jenen Personen und Institutionen, die freundlicherweise bereit waren, in ihrem Besitz befindliche Objekte für die Ausstellung auszuleihen oder Bildvorlagen für die Reproduktion im Katalog zur Verfügung zu stellen. Für die Erlaubnis, aus den ungedruckten Briefen Elias Canettis an Marie-Louise von Motesiczky zu zitieren, danken wir Frau Johanna Canetti. Für die Erlaubnis, unveröffentliche Tagebuchaufzeichnungen von Iris Murdoch zu zitieren, danken wir John Bayley und Peter Conradi. Abschließend danken wir dem Prestel Verlag für die engagierte und effektive Zusammenarbeit an diesem Katalogprojekt.

Jeremy Adler
Vorsitzender
Motesiczky Trust

Nicholas Serota
Direktor
Tate Gallery

Christoph Grunenberg
Direktor
Tate Liverpool

Manfred Großkinsky
Leiter
MUSEUM GIERSCH

Wolfgang Kos
Direktor
Wien Museum

Tim Craven
Direktor
Southampton City Art Gallery

Ines Schlenker

Marie-Louise von Motesiczky:
An Outstanding Artist in Troubled Times

Marie-Louise von Motesiczky was an artist whose life spanned almost the entire 20th century. Her works were produced over a period of seven decades and range from the first small oil painting, *Small Roulette* (Fig. 2), painted in 1924, when she was only 17 years old, to *Still-life, Vase of Flowers* (Fig. 3), which she was still working on in 1996 shortly before her death in her ninetieth year. Her *œuvre* includes over 300 paintings and several hundred drawings. She filled some hundred sketchbooks with studies and ideas. For a long time, however, Marie-Louise did not receive the attention she deserves, notwithstanding a considerable number of exhibitions. This was mainly owing to the radical political changes brought about by National Socialism. The political developments in Central Europe destroyed her highly promising career before she had reached full maturity. In addition, all her life she found it hard to expose herself to the public gaze and even had difficulty parting from her pictures. She always wanted to produce new and better works, and not to spend her time and energy in achieving a fame that might prove ephemeral. For many years, therefore, her painting was able to mature out of the public eye and away from the critical debate surrounding modern art. She always held on to her independence and refused to follow any fashions. Marie-Louise von Motesiczky was herself aware that working in relative independence from the art scene and trusting to one's own artistic judgement can be of advantage, and she proved this fact with her fascinating body of work, which she produced in several different European countries, often under difficult circumstances.

Marie-Louise stemmed from the Jewish aristocracy that flourished in Vienna towards the close of the Habsburg monarchy. She came from a large extended family of bankers and academics that included many outstanding representatives of social and intellectual life in the Austrian capital and which enjoyed close contact with painters, poets and musicians. Her mother, Henriette, fell in love as a child with the poet Hugo von Hofmannsthal; her father, Edmund, made music with Johannes Brahms. The family also played a notable role in the history of psychoanalysis, with Marie-Louise's grandmother, Anna von Lieben, being one of Sigmund Freud's first patients.

Marie-Louise received a good artistic training, at first at various art schools in Vienna, then in The Hague, Frankfurt, Paris and Berlin. The painter Max Beckmann, whose master class in Frankfurt she entered in 1927, became a formative influence. In the years of intensive work that followed, she discovered her own artistic style and also took part in her first exhibition. But her well-founded hopes of growing recognition were dashed by the invasion of Austria by the National Socialists. Marie-Louise and her mother—her father had died while she was still a child—fled their homeland precipitately and went into exile, first in Holland, then, from 1939, in England, where Marie-Louise was to live for more than 50 years. Despite having some important solo exhibitions and taking part in several group exhibitions, she was often noticed only indirectly, in the shadow of great men: she was seen as a pupil of Beckmann, a friend of the painter Oskar Kokoschka, the lover of the author Elias Canetti. It was not until the last years of her life that her work received the attention that it deserves in its own right, when, in 1985, the London Goethe Institut organised a solo exhibition that was a great success. Critics showered her with praise, the well-known English critic, Marina Vaizey, calling the almost 80-year-old artist "a dazzling talent".[1] Then, at the end of her long life, her reputation was established once and for all when, in 1994, the Österreichische Galerie in the Belvedere put on a retrospective of her works. Marie-Louise von Motesiczky was accepted into the canon of great Austrian artists of the 20th century.

The present comprehensive retrospective to mark the centenary of her birth, which is to be shown in Liverpool, Frankfurt, Vienna and Southampton, provides the first opportunity

Ines Schlenker

Marie-Louise von Motesiczky: Eine überlegene Malerin in unruhiger Zeit

Marie-Louise von Motesiczky war eine Künstlerin, deren Leben fast das gesamte 20. Jahrhundert umspannte: Ihr Werk entstand über einen Zeitraum von sieben Jahrzehnten und reicht vom ersten Ölbild *Kleines Roulette* (Abb. 2) aus dem Jahre 1924, gemalt, als sie 17 Jahre alt war, bis zu *Stilleben, Blumenvase* (Abb. 3), an dem sie noch kurz vor ihrem Tod 1996 im 90. Lebensjahr arbeitete. Ihr Œuvre umfasst über 300 Gemälde und mehrere hundert Zeichnungen. Sie füllte um die hundert Skizzenbücher mit Studien und Ideen. Lange Zeit jedoch erhielt die Künstlerin, trotz einer sehr beachtlichen Anzahl von Ausstellungen, nicht die Aufmerksamkeit, die ihr gebührt. Dies ist hauptsächlich auf die politischen Umwälzungen durch den Nationalsozialismus zurückzuführen. Die politische Entwicklung in Mitteleuropa zerstörte ihre beginnende, viel versprechende Karriere, noch ehe Motesiczky zur vollen Reife gelangt war. Auch fiel es ihr zeitlebens schwer, sich der Öffentlichkeit zu stellen oder sich gar von ihren Bildern zu trennen. Sie wollte immer neue und bessere Werke schaffen und nicht ihre Zeit und Energie auf das Erringen eines vielleicht flüchtigen Ruhms verschwenden. Viele Jahre lang konnte ihre Malerei daher abseits von Kritik und Öffentlichkeit reifen. Sie bewahrte stets ihre Unabhängigkeit, ließ sich von keiner Mode einnehmen. Dass ein von der Kunstszene relativ unabhängiges Arbeiten nicht immer schlecht, das Vertrauen auf das eigene künstlerische Urteil auch von Vorteil sein kann, hat Marie-Louise von Motesiczky selbst erkannt und mit ihrem faszinierenden, in mehreren Ländern Europas und oft unter schwierigen Umständen geschaffenen Gesamtwerk bewiesen.

Motesiczky entstammte der Wiener jüdischen Aristokratie der ausgehenden Habsburger Monarchie. Sie kam aus einer reichen und weit verzweigten Familie von Bankiers und Wissenschaftlern, zu der viele herausragende Vertreter des gesellschaftlichen und geistigen Lebens der österreichischen Hauptstadt zählten und die enge Kontakte zu Malern, Dichtern

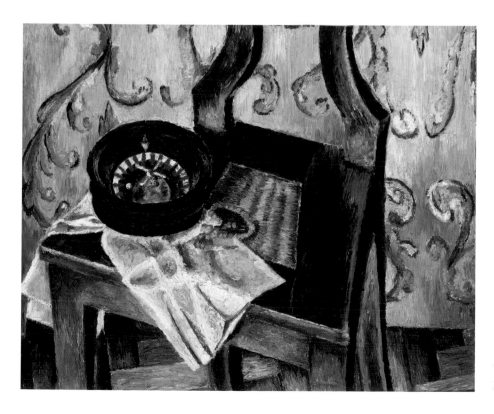

2 *Small Roulette / Kleines Roulette*, 1924,
Oil on canvas / Öl auf Leinwand,
398 × 503 mm, Marie-Louise von Motesiczky
Charitable Trust, London

to see the artist's entire *œuvre* in all its entrancing beauty, undistorted by the preconceptions formerly attached to it. In her works—mainly still-lifes, self-portraits and portraits painted in an ever-changing and later increasingly lyrical Expressionistic style—Marie-Louise went her own way. The paintings bear witness to various aspects of her life and confirm the central role that family and friends played for her, and, in the process, they evoke a picture of her century. Her still-lifes, full of gentle radiance and poetry, make up a large group of works that run through her entire creative life. Expressing peace and charm, but also loneliness and love, they often show the artist's domestic surroundings and give personal objects a prominent status; many of these, like the toy roulette wheel depicted in her first picture, *Small Roulette*, have survived the turbulence of the years and are today preserved in her estate. For her later still-lifes, Marie-Louise liked to use flowers from her garden, arranging them in colourful bouquets.

Above all, Marie-Louise von Motesiczky was a master of the portrait. She was possessed of an insatiable curiosity about her fellow human beings and blessed with a gift of keen observation, and this helped to make her many portraits some of her most striking works. She was prepared to hold up a mirror to herself and others without reservations and to explore her models with sensitivity and understanding, but also with acute clarity. She depicts their

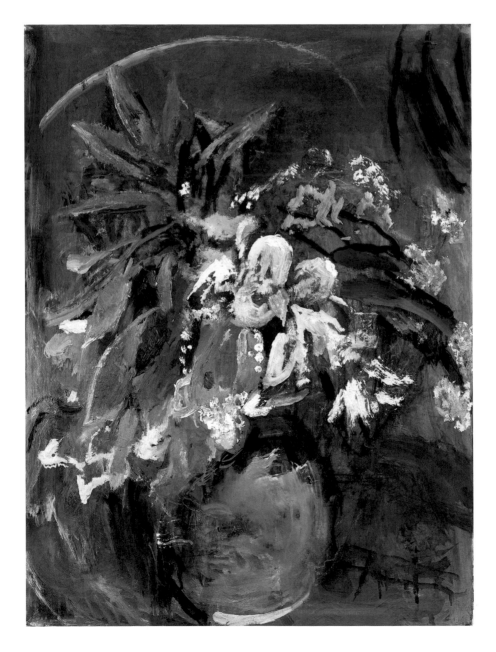

3 *Still-life, Vase of Flowers / Stilleben, Blumen-vase*, 1996, Oil on canvas / Öl auf Leinwand, 610 × 457 mm, Marie-Louise von Motesiczky Charitable Trust, London

und Musikern unterhielt. Ihre Mutter Henriette verliebte sich als Kind in den Dichter Hugo von Hofmannsthal. Ihr Vater Edmund musizierte mit Johannes Brahms. Die Familie nimmt nicht zuletzt auch einen bemerkenswerten Platz in der Geschichte der Psychoanalyse ein, war Marie-Louises Großmutter Anna von Lieben doch eine der ersten Patientinnen Sigmund Freuds.

Motesiczky erhielt eine gute künstlerische Ausbildung, zunächst an Kunstschulen in Wien, dann in Den Haag, Frankfurt am Main, Paris und Berlin. Einen prägenden Einfluss übte der Maler Max Beckmann aus, in dessen Frankfurter Meisterklasse sie 1927 eintrat. Die folgenden arbeitsintensiven Jahre ließen Motesiczky ihren eigenen künstlerischen Stil finden und zogen auch eine erste Ausstellungsbeteiligung nach sich. Die begründete Hoffnung auf wachsende Anerkennung wurde jedoch Opfer des Einmarsches der Nationalsozialisten in Österreich. Motesiczky und ihre Mutter – der Vater war in ihrer Kindheit gestorben – verließen fluchtartig ihre Heimat und begaben sich ins Exil, zunächst in Holland, ab 1939 dann in England. Hier lebte Motesiczky über 50 Jahre. Trotz einiger Einzelausstellungen und Ausstellungsbeteiligungen nahm man sie oft nur indirekt, im Schatten großer Männer stehend, wahr. Man sah sie als Schülerin Beckmanns, als Bekannte des Malers Oskar Kokoschka, als Geliebte des Schriftstellers Elias Canetti. Erst in ihren letzten Lebensjahren wurde ihr Werk als eigenständige Leistung angemessen gewürdigt: 1985 veranstaltete das Londoner Goethe Institut eine Einzelausstellung, die ein grandioser Erfolg wurde. Die Kritiker überschlugen sich mit Lob. Die bekannte englische Kritikerin Marina Vaizey nannte die fast achtzigjährige Künstlerin »ein überwältigendes Talent«.[1] Am Ende ihres langen Lebens war Motesiczkys Ruf endgültig gefestigt, als in ihrer Heimatstadt die Österreichische Galerie im Belvedere ihr 1994 eine Retrospektive ausrichtete. Nun nahm man Motesiczky in den Kanon großer österreichischer Künstler des 20. Jahrhunderts auf. Die umfassende Retrospektive anlässlich ihres 100. Geburtstags, die in Liverpool, Frankfurt, Wien und Southampton gezeigt wird, bietet erstmals die Gelegenheit, Motesiczkys Gesamtwerk unverstellt von früheren Zuschreibungen in seiner berückenden Schönheit wiederzuentdecken.

In ihrem gewissermaßen autobiografischen Œuvre, das hauptsächlich aus Stillleben, Selbstporträts und Porträts in einem sich stets wandelnden und später zunehmend lyrisch gebrochenen Expressionismus besteht, geht Motesiczky eigene Wege. Die Gemälde legen Zeugnis von verschiedenen Aspekten ihres Lebens ab, bestätigen die zentrale Rolle, die Familie und Freunde für sie spielten, und entwerfen dabei ein Bild ihres Jahrhunderts. Eine große, ihre ganze Schaffenszeit durchziehende Werkgruppe bilden die Stillleben, die von sanftem Glanz und Poesie erfüllt sind. Sie atmen Ruhe und Charme, aber auch Einsamkeit und Liebe. Sie zeigen Motesiczkys häusliche Umgebung und weisen persönlichen Gegenständen eine herausgehobene Bedeutung zu, von denen sich viele – wie zum Beispiel das Spielzeugroulette, das in ihrem ersten Bild, *Kleines Roulette*, abgebildet ist – im Nachlass der Künstlerin über die Jahre und Wirrungen der Zeit erhalten haben. Für die späteren Stillleben verwendete Motesiczky gern Blumen aus ihrem Garten und arrangierte sie in farbenfrohen Sträußen.

Sie war vor allem eine Meisterin des Porträts. Ausgestattet mit unersättlicher Neugier für ihre Mitmenschen und gesegnet mit einer scharfen Beobachtungsgabe, fertigte Motesiczky eine beträchtliche Anzahl von Porträts, die zu ihren eindrucksvollsten Arbeiten gehören. Ohne Vorbehalte war sie bereit, sich und anderen den Spiegel vorzuhalten. Einfühlsam und verständnisvoll, doch zugleich klar und scharf erkundet Motesiczky ihr Modell, dessen wahren Charakter sie ehrlich, niemals idealisierend darstellt. So haben Kritiker ihre Porträts selbst mit jenen Rembrandts verglichen, denen sie in Ernsthaftigkeit[2] in nichts nachstünden. Elias Canetti drückte seine Bewunderung so aus: »Du musst wissen, ..., dass Du ... die gesegnete Gabe hast, Menschen zu bewahren, wie sie wirklich sind. Dafür liebe ich Dich und darum brauche ich Dich, Du gibst mir etwas, was ich nicht habe und ohne das ich nicht leben könnte.«[3] Im festen Glauben an ihr künstlerisches Talent prophezeite er: »Du wirst der grosse deutsche Porträtist werden«[4].

In keinem anderen Corpus ihres Werks kommt sie der Erfüllung dieser Prophezeiung näher als in den bewegenden Porträts ihrer Mutter. Die rückhaltlosen, aber doch würdevollen Darstellungen eines alternden, später fast hilflosen Menschen zählen zu den hervorragenden

characters honestly, without any idealisation. Critics have even compared her portraits with those of Rembrandt, claiming that they equalled his in serious intent.[2] Elias Canetti expressed his admiration as follows: "You must know … that you have … the gift of preserving people the way they really are. That is why I love you and that is why I need you, you give me something I do not have and which I cannot live without."[3] Firmly convinced of her artistic talent, he predicted: "You will become the great German portraitist."[4]

There are no works in which Marie-Louise comes closer to fulfilling this prophecy than in the moving portraits of her mother. These unsparing yet dignified depictions of an ageing and later almost helpless woman are among the most outstanding examples of European portraiture of the 20th century. Elias Canetti boldly maintained that the portraits of her mother were "your greatest, most original work, … for whose sake your painting will always endure".[5] Ernst Gombrich even compared these paintings with those of Albrecht Dürer, who portrayed his mother with similar honesty.[6] Marie-Louise herself was too modest to accept such high praise.

The great self-portraits are also among the pinnacles of her work. In these "perfect pictures",[7] Marie-Louise courageously confronts her own reality. With great intensity, she examines her own personality, her appearance, her age, her profession, her friendships and her fate. In her struggle for artistic self-knowledge, she creates arresting self-portraits that capture both her momentary emotional state and her circumstances at the time. The self-portraits are records of self-observation that form a chronicle of her life.

There is one aspect above all that should not be forgotten in any judgement of Marie-Louise von Motesiczky's life work: the sheer joy and enthusiasm that the paintings cause viewers to feel. They seem to touch the nerve of the viewer and to carve themselves upon the memory, as numerous letters to the artist attest. A knowledgeable admirer expressed his esteem as follows: "Unlike so many 20th-century paintings, they do lift the spirit!"[8] Such praise makes it seem as though Marie-Louise's wish had been fulfilled: "My longing is to paint beautiful pictures … to become happy in doing this and to make other people happy through them."[9]

Translated from German by Timothy Jones

1 Marina Vaizey, "The revelation of a dazzling talent", in: *Sunday Times*, November 24, 1985.
2 Eric Newton, "The Eye-Witness Painter", in: *Sunday Times*, October 8, 1944.
3 Canetti in an undated letter to Marie-Louise [1954], archive of the Marie-Louise von Motesiczky Charitable Trust, London.
4 Canetti to Marie-Louise, October 1, 1967, archive of the Marie-Louise von Motesiczky Charitable Trust, London.
5 Canetti to Marie-Louise, December 23, 1975, archive of the Marie-Louise von Motesiczky Charitable Trust, London.
6 Ernst H. Gombrich, "Marie-Louise von Motesiczky" in: *Marie-Louise von Motesiczky. Paintings Vienna 1925– London 1985*, exh. cat., Goethe Institut, London, 1985, p. 7.
7 Franz Tassié, "Secession. Ausstellung Marie-Louise von Motesiczky. Schatten des Zwiespalts", in: *Express*, May 13, 1966.
8 Philip Vann to Marie-Louise, August 27, 1986, archive of the Marie-Louise von Motesiczky Charitable Trust, London.
9 Marie-Louise as quoted in Josef Paul Hodin, "The Poetic Realism of Marie Louise Motesiczky" in: *The Painter & Sculptor*, vol. 4, no. 3, winter 1961/62, p. 19.

Beispielen der Porträtkunst Europas im 20. Jahrhundert. Elias Canetti behauptete kühn, dass die Serie der Mutterbilder »Dein grösstes, eigentlichstes Werk ist, ... um derentwillen Deine Malerei immer bestehen bleiben wird«.[5] Ernst Gombrich verglich die Bilder gar mit denen Albrecht Dürers, der seine Mutter mit ähnlicher Ehrlichkeit darstellte.[6] Sie selbst war zu bescheiden, so hohes Lob zu akzeptieren.

Die großen Selbstbildnisse gehören ebenfalls zu den Höhepunkten von Motesiczkys Werk. In diesen »vollkommene[n] Bilder[n]«[7] stellt sich Motesiczky mutig ihrer eigenen Realität. Sie untersucht eindringlich ihre Persönlichkeit, ihr Aussehen, ihr Alter, ihren Beruf, ihre Freundschaften und ihr Schicksal. Im Kampf um die malerische Selbsterkenntnis ringt sie sich beeindruckende Darstellungen ab, die ihren jeweiligen Gemütszustand und die Lebensumstände, in denen sie sich befindet, einfangen. Als Zeugnisse der Selbstbeoachtung bilden die Selbstporträts eine Chronik ihres Lebens.

Bei der Beurteilung von Motesiczkys Lebenswerk darf vor allem ein Aspekt nicht vergessen werden: die schiere Freude und Begeisterung, die die Gemälde bei den Betrachtern hervorrufen. Sie scheinen den Nerv der Ausstellungsbesucher zu treffen und sich in ihr Gedächtnis einzugraben, wie zahlreiche Briefe an die Künstlerin beweisen. Ein kenntnisreicher Bewunderer drückte seine Wertschätzung folgendermaßen aus: »Anders als so viele Bilder des 20. Jahrhunderts heben sie die Stimmung!«[8] Angesichts solchen Lobs scheint es, als hätte sich Motesiczkys Wunsch erfüllt: »Ich sehne mich danach, schöne Bilder zu malen ... dadurch glücklich zu werden und mit ihnen andere Leute glücklich zu machen.«[9]

1 Marina Vaizey, »The revelation of a dazzling talent«, in: *Sunday Times*, 24.11.1985.
2 Eric Newton, »The Eye-Witness Painter«, in: *Sunday Times*, 8.10.1944.
3 Canetti in einem undatierten Brief an Motesiczky [1954]: Archiv des Marie-Louise von Motesiczky Charitable Trust, London.
4 Canetti am 1.10.1967 an Motesiczky, Archiv des Marie-Louise von Motesiczky Charitable Trust, London.
5 Canetti am 23.12.1975 an Motesiczky, Archiv des Marie-Louise von Motesiczky Charitable Trust, London.
6 Ernst H. Gombrich, »Marie-Louise von Motesiczky«, in: *Marie-Louise von Motesiczky. Paintings Vienna 1925– London 1985*, Ausst.-Kat. London, Goethe Institut 1985, S. 7.
7 Franz Tassié, »Secession. Ausstellung Marie-Louise von Motesiczky. Schatten des Zwiespalts«, in: *Express*, 13.5.1966.
8 »Unlike so many twentieth century paintings, they do lift the spirit!«: Philip Vann am 27.8.1986 an Motesiczky, Archiv des Marie-Louise von Motesiczky Charitable Trust, London.
9 »My longing is to paint beautiful pictures ... to become happy in doing this and to make other people happy through them.« Motesiczky, zit. nach: Josef Paul Hodin »The Poetic Realism of Marie Louise Motesiczky«, in: *The Painter & Sculptor*, Vol. 4, No. 3, Winter 1961/62, S. 19.

Jill Lloyd

The Vienna Years:
Family Background and First Paintings

The Background[1]

Vienna in 1900 was the glittering capital of the Austro-Hungarian Empire. Although high society was stiff with tradition, a brilliant avant-garde emerged in architecture and the fine arts as well as in philosophy and literature, music and opera. Culturally, this made the city into one of the most exciting in Europe. The Vienna Secession, founded in 1897, added its own style to the art nouveau movement that was sweeping Europe. Literature was equally innovative: Hofmannsthal's poetry and dramas raised Viennese writing to new heights and the cynical plays of Arthur Schnitzler were all the rage. The Opera performed the controversial music of Richard Strauss and in the intellectual sphere Sigmund Freud was developing his revolutionary theories of psychoanalysis. Marie-Louise von Motesiczky was born into this creative hothouse and had links to many of these figures, including Freud, Hofmannsthal and Schnitzler.

As the second child of Henriette von Lieben (1882–1978) (Fig. 5) and Edmund Motesiczky von Kesseleökeö (1886–1909) (Fig. 6), through her mother she was descended from one of the most prominent Viennese families and was related *inter alia* to the equally glamorous Todescos, Brentanos, Auspitzes and Scheys. The family home until 1939 was a spacious apartment in Vienna's fashionable Brahmsplatz (Fig. 4). When Edmund died suddenly in 1909, Henriette and her two young children were drawn more closely into the aristocratic sphere of the Lieben family, whose home was a rendezvous for artists, musicians and scholars. Yet although we think of modern Vienna in terms of the arts, science was no less important, and here likewise Marie-Louise was well connected: her great-grandfather, Adolf Lieben (1836–1914),[2] was the father of organic chemistry in Austria and founder of the celebrated Lieben Prize for chemistry; and her uncle, Robert von Lieben (1878–1913), invented the Lieben condensor, which was used in the first telephones and helped to inaugurate the electronic age.[3]

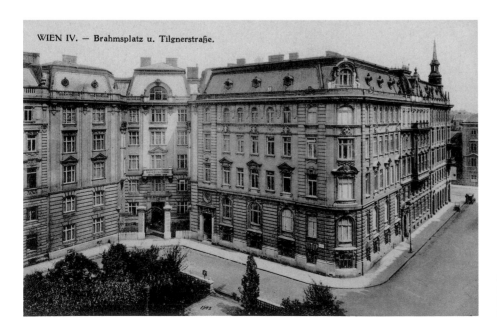

WIEN IV. — Brahmsplatz u. Tilgnerstraße.

4 View of Brahmsplatz 7, Vienna / Blick auf den Brahmsplatz 7 im IV. Wiener Bezirk, Postcard / Postkarte, 1912, Marie-Louise von Motesiczky Charitable Trust, London

Jill Lloyd

Die Wiener Jahre:
Familiärer Hintergrund und frühe Werke

Herkunft und Umfeld[1]

Um 1900 war Wien die glanzvolle Hauptstadt von Österreich-Ungarn. Obwohl die gesell-
schaftliche Elite in der Tradition erstarrt war, brach sich in der Architektur und in den schönen
Künsten ebenso wie in der Philosophie und der Literatur, in der Musik und der Oper eine
geniale Avantgarde Bahn. Aus diesem Grund war die Stadt in kultureller Hinsicht eine der auf-
regendsten in ganz Europa. Die 1897 gegründete Wiener Secession ließ ihren eigenen Stil in die
Jugendstil-Bewegung (»Art Nouveau«) einfließen, die wie eine Welle ganz Europa erfasste.
Die Literatur war ebenso innovativ: Hugo von Hofmannsthal führte mit seiner Dichtung
und seinen Dramen die Wiener Literatur zu neuen Höhen, und Arthur Schnitzlers zynische
Theaterstücke waren der letzte Schrei. In der Oper wurde die umstrittene Musik von Richard
Strauss aufgeführt, und in der intellektuellen Sphäre entwickelte Sigmund Freud seine revo-
lutionären Theorien der Psychoanalyse. In dieses kreative Treibhaus wurde Marie-Louise
von Motesiczky hineingeboren, die mit vielen dieser Persönlichkeiten, einschließlich Freud,
Hofmannsthal und Schnitzler, später in Verbindung stehen sollte.

Als zweites Kind von Henriette von Lieben (1882–1978) (Abb. 5) und Edmund Motesiczky von
Kesseleökeö (1866–1909) (Abb. 6) entstammte sie mütterlicherseits einer der prominentesten
Wiener Familien und war unter anderen mit den ebenso illustren Familien Todesco, Brentano,
Auspitze und Schey verwandt. Die Familie bewohnte bis 1939 eine geräumige Wohnung in
Wiens damals schickster Wohngegend, am Brahmsplatz (Abb. 4). Als 1909 ihr Vater plötzlich
starb, wurde ihre Mutter mit den beiden kleinen Kindern noch fester in den aristokratischen
Kreis der Familie Lieben eingebunden, deren Haus einen Treffpunkt bildender Künstler,
Musiker und Gelehrter bildete. Doch obwohl wir die Wiener Moderne vorrangig immer mit
einer Blüte der Künste in Verbindung bringen, war die Wissenschaft, wie jüngst wieder
hervorgehoben wurde, nicht weniger bedeutsam, und auch hier befand sich Marie-Louise
in einem einflussreichen Beziehungsgeflecht: Ihr Urgroßvater, Adolf Lieben (1836–1914)[2],
Nestor der organischen Chemie in Österreich, rief den berühmten Lieben-Preis für Chemie
ins Leben, und ihr Onkel Robert von Lieben (1878–1913) erfand die Liebensche Verstärker-
röhre, die in den ersten Telefonen verwendet wurde und als eine der Voraussetzungen für
das elektronische Zeitalter gilt.[3]

Die Ermordung des österreichischen Erzherzogs Franz Ferdinand in Sarajewo im Jahr 1914
löste den Ersten Weltkrieg aus, der dieser künstlerischen und geistigen Blüte Wiens ihr Ende
bereitete. Nicht zuletzt wurde dadurch auch das Leben von Marie-Louises Familie endgültig
in andere Bahnen gelenkt. Nach dem Krieg förderte ihre Mutter ihre Begabungen, und sie
wurde bald mit den Meisterwerken im Wiener Kunsthistorischen Museum von niemand
geringerem als dem späteren Direktor Ludwig Baldass selbst vertraut gemacht. Dann, im
Sommer 1920, besuchte der 36 Jahre alte deutsche Maler Max Beckmann das Haus der Familie
in Hinterbrühl. Mit ihm kam eine Aura aufregender Bohème in die Sommerfrische – eine
Erfahrung, die die damals 13-jährige Marie-Louise niemals vergaß. Später sollte sie sich daran
erinnern, wie sie, nach einem Abend in einem Dorfwirtshaus mit ihrem neuen Begleiter
durch die Getreidefelder spazierte und bis zur Morgendämmerung aufblieb. Das leicht zu
begeisternde Mädchen wurde angeregt, ihre künstlerischen Studien mit frischem Eifer wei-
terzubetreiben, und beschloss, eine engagierte, professionelle Künstlerin zu werden.

Während ihres langen Lebens malte Marie-Louise von Motesiczky nur ein einziges, selt-
sam enigmatisches Bild von ihrer berühmten Familie. Es handelt sich um *Stilleben mit*

5 Henriette von Motesiczky, Photograph /
Fotografie, early 1900s / um 1900, Marie-Louise
von Motesiczky Charitable Trust, London

6 Edmund von Motesiczky with his cello /
Edmund von Motesiczky mit seinem Cello,
Photograph, early 1900s / Fotografie, um 1900,
Marie-Louise von Motesiczky Charitable Trust,
London

The assassination of the Austrian archduke Franz Ferdinand at Sarajevo in 1914 precipitated the First World War and to some extent destroyed Vienna's artistic and cultural efflorescence. Not least, it altered forever the life of Marie-Louise's family. After the war, her mother encouraged her gifts, and she was soon introduced to the masterpieces at Vienna's Kunsthistorisches Museum by no less a person than the curator himself. Then, in the summer of 1920, the 36-year-old German painter Max Beckmann visited the family home in Hinterbrühl. He introduced a heady, bohemian atmosphere into the holiday routine, an experience the 13-year-old Marie-Louise never forgot. She later recalled how, after an evening at a local inn, she and her new friend walked through the cornfields and stayed up until dawn. The impressionable young lady was inspired to pursue her artistic studies with renewed vigour and determined to become a dedicated, professional artist.

During her long life, Marie-Louise von Motesiczky made just one, strangely enigmatic picture of her famous family. This is in *Still-life with Photo* (cat. no. 21), painted in Vienna in 1930 when that whole culture was about to disintegrate. The picture shows a gold-framed photograph of her mother's family, the Todesco clan, balanced precariously on top of a brightly coloured china jardinière above a three-legged wooden stool. Lined up stiffly in front of the photographer's lens, her relatives appear in the formal fashions of the mid-19th century. The patriarch at the centre, almost certainly Marie-Louise's great-grandfather, Baron Eduard von Todesco, is flanked by two formidable ladies, who are seated in front of a row of insubstantial, even ghostly men. The precarious stance indicates the fragility of the world into which the artist was born.

Like some others of Marie-Louise's later paintings, this group portrait was based on a real photograph. It shows the family at the height of its power. Yet throughout Marie-Louise's adult life, not least the period when this picture was painted, a shadow fell across this prosperity, beginning with the death of Marie-Louise's father and continuing with the First World War; and like so many, the family was struck again in the 1920s when the immense fortune of the Todescos was shaken by the financial crash that shattered the world markets. With the "Anschluss" in 1938, when the Nazis marched into Vienna, the sorry process was completed, for now the family, as indeed the whole Jewish people, was hit by its worst crisis. Those who were lucky or far-sighted enough to escape found themselves flung to the four corners of the world. The Todescos, the von Liebens, the von Scheys, the Ephrussis, the Gomperzes—all the various branches of Marie-Louise's family who made up the cultured, liberal Jewish aristocracy in turn-of-the-century Vienna—either perished in Nazi concentration camps or were stripped of their wealth and forced to pick up the threads of their lives elsewhere.

The Todescos: The Rise of a Viennese Family

Marie-Louise's family on her mother's side, the Todescos, had made their fortune in the first half of the 19th century. Hermann Todesco, father of Eduard and Moritz, was born in Hungary in 1791. His beginnings in the Jewish ghetto were modest, but by 1830 he was successful enough to set up a flax-spinning factory in the little village of Marienthal. The business prospered, allowing its owner to establish himself in Vienna, and he extended his fortune by investing in the southern railways. When he died in 1844, he left behind an estate of some twelve million guilders and a reputation for good works. Marienthal was a model company town. Hermann also pledged large sums of money to a synagogue, to his native town to establish schools, and to a charitable hospital near Vienna.[4] These were typical of the good works performed by wealthy Jews that were conveniently forgotten a century later. Hermann's sons, Eduard and Moritz continued the expansion and were elevated to the nobility. Marie-Louise was consequently a third-generation aristocrat, and her noble descent affected her behaviour at many crucial junctures.

The modern visitor to Vienna will know at least by sight the family's landmark building: the famous Todesco Palace (Fig. 7). This imposing five-storey house opposite the Opera was built in the Medici style between 1861 and 1864 by the notable Ringstrasse architects, Theophil

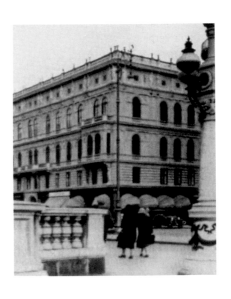

7 Palais Todesco, Vienna / Wien, Photograph / Fotografie, 1930s / 1930er Jahre

Photographie (Kat. Nr. 21), das 1930 in Wien entstand, als diese ganze Kultur kurz vor ihrem Zerfall stand. Das Bild zeigt ein goldgerahmtes Foto von der Familie ihrer Mutter, der Todesco-Sippe. Die Fotografie balanciert gefährlich auf dem Rand einer fröhlich bunten Porzellan-Jardinière, die ihrerseits auf einem dreibeinigen Holzhocker steht. Steif aufgereiht vor der Linse des Fotografen erscheinen ihre Verwandten in der Gesellschaftskleidung, die Mitte des 19. Jahrhunderts Mode war. Der Patriarch in der Mitte, mit großer Wahrscheinlichkeit Marie-Louises Urgroßvater Baron Eduard von Todesco, wird von zwei imposanten Damen flankiert, die vor einer Reihe schmächtiger, ja gespenstisch wirkender Männer sitzen. Die prekäre Position weist auf die Fragilität jener Welt hin, in die die Künstlerin hineingeboren wurde.

Es begann mit dem Tod ihres Vaters und setzte sich mit dem Ersten Weltkrieg fort, und wie so viele andere Familien erlitt ihre in den 1920er Jahren erneut einen Schicksalsschlag, als das riesige Vermögen der Todescos durch den Börsenkrach, der die Weltmärkte erschütterte, in Mitleidenschaft gezogen wurde. Mit dem »Anschluss« Österreichs im Jahr 1938, als die Nazis in Wien einmarschierten, fanden die traurigen Entwicklungen ihren Höhepunkt, denn jetzt war die Familie von den Judenverfolgungen und von der Vernichtung des jüdischen Volkes durch die Nazis mitbetroffen. Diejenigen, die genug Glück oder Weitblick besaßen und entkamen, fanden sich in alle Ecken der Welt verstreut wieder. Die Todescos, die von Liebens, die von Scheys, die Ephrussis, die Gomperz – all die verschiedenen Zweige von Marie-Louises Familie, aus denen sich die gebildete, liberale jüdische Aristokratie Wiens um die Jahrhundertwende zusammengesetzt hatte – kamen entweder in den Konzentrationslagern der Nazis um oder wurden ihres Reichtums beraubt und gezwungen, anderswo einen Neuanfang zu wagen.

Die Todescos: Der Aufstieg einer Wiener Familie

Die Todescos – Marie-Louises Familie mütterlicherseits – waren in der ersten Hälfte des 19. Jahrhunderts zu Reichtum gelangt. Hermann Todesco, der Vater von Eduard und Moritz, wurde 1791 in Ungarn geboren. Seine Anfänge im jüdischen Ghetto waren bescheiden, aber schon 1830 hatte er genug Erfolg, um in dem kleinen Dorf Marienthal eine Flachsspinnerei zu gründen. Seine Geschäfte blühten und ermöglichten es seinem Besitzer, sich in Wien niederzulassen. Als er überdies noch in den Bau der Südbahn investierte, wuchs sein Reichtum weiter. Bei seinem Tod 1844 hinterließ er ein Vermögen von etwa zwölf Millionen Gulden und eine hohe Reputation als Wohltäter. Marienthal hatte er zu einer vorbildlichen Arbeiterkolonie ausgebaut. Hermann übertrug große Geldbeträge einer Synagoge, seiner Heimatstadt zum Bau von Schulen sowie einem Armenkrankenhaus in der Nähe Wiens.[4] Diese guten Werke waren typisch für die Wohltätigkeit begüterter Juden, die ein Jahrhundert später so gut wie vergessen war. Hermanns Söhne, Eduard und Moritz, setzten die Expansion der Geschäfte fort und wurden in den Adelsstand erhoben. Marie-Louise ist somit als Aristokratin der dritten Generation anzusehen, und tatsächlich beeinflusste ihre vornehme Abstammung ihr Verhalten in vielen entscheidenden Momenten ihres Lebens.

Der heutige Besucher Wiens wird vermutlich vom Ansehen das Wahrzeichen der Bautätigkeit der Familie kennen – das berühmte Palais Todesco (Abb. 7). Dieses eindrucksvolle fünfstöckige Gebäude gegenüber der Oper wurde zwischen 1861 und 1864 von den bedeutenden Ringstraßen-Architekten Theophil Hansen und Ludwig Förster im Medici-Stil errichtet und von dem Maler Carl Heinrich Rahl mit klassischen Fresken ausgestattet. Marie-Louises Onkel Ernst von Lieben, der ältere Bruder ihrer Mutter, erinnerte sich später an seine verlorene Welt: »Am Abend versammelten wir Kinder uns hinter diesen Spiegeltüren, um den großen Bällen zuzusehen, die meine Großeltern berühmt gemacht hatten. Als kleiner Bub kauerte ich hier und beobachtete Brahms und Liszt und die bedeutenden Politiker jener Tage sowie die großen Dichter und Maler. Mir schien, die ganze Welt käme in unser Haus.«[5] Die Todescos besaßen auch ein Sommerhaus in Hinterbrühl, 20 Kilometer südlich von Wien. Außer der Villa selbst mit ihren ungefähr 18 Zimmern umfasste das Anwesen mehrere Morgen landschaftlich gestalteter Gärten und Wald. Auf diesem Landgut, das Marie-

Hansen and Ludwig Förster, and decorated with classical frescoes by the artist, Carl Heinrich Rahl. Marie-Louise's uncle—her mother Henriette's elder brother—Ernst von Lieben, recalled its lost world: "We children used to gather in the evenings behind these mirrored doors to watch the great balls that made my grandparents famous. Crouched here as a small boy, I watched Brahms and Liszt and the great politicians of the day, and the great poets and painters. It seemed to me that the whole world came to our house."[5] The Todescos also maintained a country estate at Hinterbrühl, 20 kilometres to the south of Vienna, comprising a villa with some 18 large rooms, built on several acres of landscaped gardens and woodland. Henriette inherited the estate, and it was here that Marie-Louise and her brother Karl passed their happiest years.

In the most important relationship of her life, her long love affair and friendship with the writer Elias Canetti, Marie-Louise's talent played an important role, but her nobility caused him problems. Morbidly sensitive to any supposed slight from her relatives, in his memoirs, "The Tongue Set Free", he reserved a stinging insult for the Todescos. Comparing his own proud Sephardic Jewish roots, by implication, to Marie-Louise's, he recalled: "With a naive arrogance, the Sephardim looked down on other Jews; a word always charged with scorn was 'Todesco', meaning a German or Ashkenazi Jew. It would have been unthinkable to marry a 'Todesca', a Jewish woman of that background. (...) I wasn't even six years old when my grandfather warned me against such a misalliance in the future."[6] Throughout his relationship with Marie-Louise, Canetti stuck to his grandfather's advice; whilst for her part, Marie-Louise never renounced her pride in her family heritage.

Marie-Louise's grandfather, Eduard Todesco, raised his social and cultural standing in 1845 when he married Sophie Gomperz, the daughter of a distinguished family of scholars and businessmen who had been living in Vienna and Brno since the early 18th century. They can be traced back to their origins in Emmerich am Rhein and to Nymwegen in the Netherlands around 1600. Benedikt, who was responsible for the Dutch branch of the family firm, was also known for his efforts to protect persecuted Jewish communities throughout the world and played a key role in the emancipation of the Jews in Austria when he persuaded Empress Maria Theresia not to expel them from Prague. In the reign of her son, Joseph II, the Jews were granted freedom to practise their religion openly, and under Emperor Franz Joseph, who came to the throne in 1848, a small number of prominent families, like the Todescos, were elevated to the nobility.[7]

Although the Jewish presence in Vienna grew rapidly until 1890 and then stabilised, the Jews still made up only twelve per cent of the population. However, there was strong anti-semitic sentiment among the people, and before the First World War Vienna was the only capital to have an elected anti-semitic government. The tiny proportion of aristocratic Jewish families to whom Marie-Louise's ancestors belonged, tended to rise above this general tide by integrating into high society and often assimilating culturally.[8] In one of her mother's memoirs, Henriette von Motesiczky recalls that the only time she visited the synagogue was to attend the wedding of Bertha Breuer, daughter of the famous Viennese doctor and early supporter of Freud, Josef Breuer. On this occasion, Henriette's mother had to explain to her that the strange foreign language being spoken in the ceremony was Hebrew.[9]

Despite their secularisation, the great Jewish families tended to make dynastic marriages within the faith. Their attitude was proud and protective. In his memoirs, Sophie Todesco's brother, the great classical philologist and philosopher Theodor Gomperz, complained that conversion was a betrayal of the family's history.[10] Gomperz was the editor of the German edition of John Stuart Mill's collected works, and when he was looking for a translator for the twelfth volume of Mill's writings, he came across a young man whose introduction to the family was to have far-reaching consequences. The prospective translator was the young Sigmund Freud, who was introduced to Gomperz by another relative, the philosopher Franz Brentano. Freud was inspired by Brentano's lectures and also acknowledged the role that Gomperz had played in prompting his interest in the dream life of "primitive" peoples. Among Gomperz's many books is one whose title clearly foreshadows Freud: "The Interpretation of Dreams and Magic" (1866).

Louises Mutter Henriette später erbte, verbrachte sie mit ihrem Bruder Karl ihre glücklichsten Jahre.

In der wichtigsten Beziehung ihres Lebens, ihrer lange währenden Liebesaffäre und Freundschaft mit dem Schriftsteller Elias Canetti, spielte Marie-Louises Talent als Malerin eine wichtige Rolle; ihre adlige Herkunft bereitete Canetti jedoch offenkundig Probleme. Da Canetti auf jede vermeintliche Beleidigung durch ihre Verwandten krankhaft empfindlich reagierte, richtete er in seinen Erinnerungen, »Die gerettete Zunge«, eine scharfe Spitze gegen die Todescos. Indem er seine eigenen stolzen sephardisch-jüdischen Wurzeln indirekt mit denen Marie-Louises verglich, erinnerte er sich: »Mit naiver Überheblichkeit sah man auf andere Juden herab, ein Wort, das immer wieder mit Verachtung geladen war, lautete ›Todesco‹, es bedeutete einen deutschen oder aschkenasischen Juden. Es wäre undenkbar gewesen, eine ›Todesca‹ zu heiraten [...] Ich war keine sechs Jahre alt, als mich mein Großvater vor einer solchen Mesalliance in der Zukunft warnte.«[6] Im Laufe seiner Beziehung zu Marie-Louise hielt sich Canetti an den Rat seines Großvaters, während Marie-Louise ihrerseits niemals auf den Stolz verzichtete, mit dem sie ihr Familienerbe wahrte.

Marie-Louises Großvater, Eduard Todesco, vermehrte sein gesellschaftliches und kulturelles Prestige dadurch, dass er 1845 Sophie Gomperz heiratete, die Tochter einer bedeutenden Familie von Wissenschaftlern und Geschäftsleuten, die seit dem frühen 18. Jahrhundert in Wien und Brünn ansässig war. Ihre Ursprünge lassen sich in die Zeit um 1600 nach Emmerich am Rhein und Nimwegen in den Niederlanden zurückverfolgen. Benedikt Gomperz, der für den holländischen Zweig des Familienunternehmens verantwortlich zeichnete, hatte Bekanntheit für seine Bemühungen erlangt, verfolgte jüdische Gemeinden in der ganzen Welt zu schützen, und er spielte bei der Emanzipierung der Juden in Österreich insofern eine Schlüsselrolle, als er Kaiserin Maria Theresia überredete, die Juden nicht aus Prag zu vertreiben. Während der Herrschaft ihres Sohnes, Joseph II., wurde den Juden die Freiheit gewährt, ihre Religion offen auszuüben, und unter Kaiser Franz Joseph, der 1848 den Thron bestieg, wurden einige wenige prominente Familien, wie die Todescos, in den Adelsstand erhoben.[7]

Obwohl der jüdische Bevölkerungsanteil in Wien bis 1890 rasch anwuchs und sich dann stabilisierte, machten die Juden immer noch lediglich zwölf Prozent der Einwohnerzahl aus. Nach wie vor gab es in der Bevölkerung starke antisemitische Strömungen. Vor dem Ersten Weltkrieg war Wien die einzige Hauptstadt mit einer gewählten antisemitischen Gemeindeverwaltung. Der winzige Anteil aristokratischer jüdischer Familien neigte indes dazu, sich über die allgemeine Entwicklung hinwegzusetzen, sich in die Oberschicht zu integrieren und oft auch kulturell zu assimilieren.[8] In ihrem Erinnerungsbuch entsinnt sich Henriette von Motesiczky, dass sie nur ein einziges Mal eine Synagoge besuchte, und zwar anlässlich der Hochzeit von Bertha Breuer, der Tochter des berühmten Wiener Arztes und frühen Förderers Sigmund Freuds, Josef Breuer. Bei dieser Gelegenheit hatte ihr ihre eigene Mutter erklären müssen, dass die seltsame Sprache, die bei der Zeremonie gesprochen wurde, Hebräisch sei.[9]

Trotz ihrer Säkularisierung neigten die bedeutenden jüdischen Familien dazu, dynastische Ehen innerhalb ihrer eigenen Glaubensgemeinschaft zu schließen. Aus dieser Haltung spricht Stolz und Fürsorglichkeit. In seinen Memoiren klagte Sophie Todescos Bruder, der große Altphilologe und Philosoph Theodor Gomperz, dass eine Konversion ein Verrat an der Geschichte der eigenen Familie sei.[10] Gomperz, der als Herausgeber der deutschen Version von John Stuart Mills' gesammelten Werken einen Übersetzer für den zwölften Band der Werkausgabe suchte, stieß dabei auf einen jungen Mann, dessen Einführung in die Familie weit reichende Folgen haben sollte. Der ins Auge gefasste Übersetzer war nämlich der junge Sigmund Freud, der ihm von einem anderen Verwandten, dem Philosophen Franz Brentano, vorgestellt worden war. Freud wurde von Brentanos Vorlesungen inspiriert, und Gomperz leistete auch einen Beitrag dazu, sein Interesse am Traumleben »primitiver« Völker zu wecken. Unter Gomperz' vielen Büchern befindet sich eines aus dem Jahr 1866, dessen Titel »Traumdeutung und Zauberei« bereits eindeutig auf Freud verweist.

Sophie und ihre Schwester Josephine erlangten als Gastgeberinnen zweier der berühmtesten Wiener Salons in der Mitte des 19. Jahrhunderts Berühmtheit. Neben den legendären

Sophie and Josephine became known as hostesses of two of the most famous salons in mid-19th-century Vienna. Alongside the legendary coffee houses, such salons were at the centre of liberal cultural and intellectual life in 19th-century middle Europe, and were also an instrument of social integration. These two hostesses, Sophie and Josephine, are almost certainly the two women flanking Eduard Todesco in Marie-Louise's group portrait of her ancestors in the *Still-life with Photograph* (cat. no. 21). Their salons—at the Villa Wertheimstein in Döbling and the Todesco Palace—attracted the most distinguished and influential men from the world of politics and commerce as well as the most brilliant scientists, artists and musicians of the day. Johann Strauss, king of the Viennese waltz, met his first wife, the singer Jetty Treffz, at a party in the Todesco Palace. Sophie's papers include letters from Johannes Brahms, Franz Liszt, Johann Strauß, Franz von Lenbach, Hans Makart, Moritz von Schwind and Henrik Ibsen.[11] The family villa in Hinterbrühl provided the scene of similar dazzling events. In a letter of 1857, Sophie's brother Theodor complained about the constant throng of visitors: "As one turns around," he wrote, "one encounters—not other people, but calibans, centaurs, monsters, who speak French and quote Victor Hugo when one would like to talk peacefully or even to sleep."[12]

In the years following Sophie Gomperz's marriage to Eduard Todesco, four children were born in quick succession. The second daughter, Anna (Fig. 8), born in 1847, was Marie-Louise's grandmother. Together with her brothers and sisters, Anna thus spent her childhood years in one of the most fashionable houses in town. In later years, she passed into history as the mysterious "Frau Cäcilie M." in Freud and Breuer's "Studies on Hysteria." She spent her childhood at Hinterbrühl and was by all accounts a talented artist and poet; but her elder sister Fanny, considered the prettiest girl in Vienna, outshone her in more obvious ways. Fanny was hotly pursued for her hand until in 1864, at the age of 17, she married Baron Henry de Worms, an event commemorated in a poem by no less a figure than the great Austrian dramatist, Franz Grillparzer. This was the occasion chosen to inaugurate the newly built Todesco Palace. Until the age of 16, Anna showed no signs of her subsequent illness; in the years following Fanny's marriage, however, she would often take to her bed, writing about her sufferings in a series of poignant poems.[13] It would seem from these that Anna was blighted by an unfulfilled youthful passion, and that she feared her parents would attempt to marry her off, like Fanny, to a noble but unloved suitor.

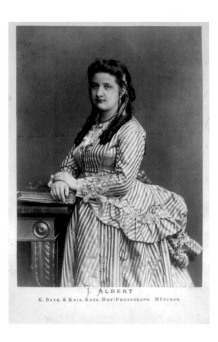

8 Anna von Lieben, Photograph / Fotografie, c. 1870 / um 1870, Marie-Louise von Motesiczky Charitable Trust, London

Freud's First Patient: Marie-Louise's Grandmother

In 1870, Anna Freiin von Todesco married Leopold von Leiben. He was director of his own family bank, president of the stock exchange and vice-governor of the Austro-Hungarian bank. Both her grandparents showed signs of the artistic talent that would blossom in Marie-Louise: Anna was a talented portraitist, and Leopold loved to paint landscapes. He possessed an outstanding collection of Flemish tapestries and Japanese jades and ivories. Their apartment in the Todesco Palace was hung with paintings by Breughel and Crivelli, Rudolf von Alt, Franz Lenbach and Arnold Böcklin. In the summer months, they moved to the Villa Todesco in Hinterbrühl (Fig. 9) and also spent time hunting at their estate in Hungary, establishing a pattern also adopted by Marie-Louise's parents. Their first child, Ilse, was born in 1873, and three more children followed, the youngest, Marie-Louise's mother Henriette, being born in 1882. A few years later, in 1888, the family moved to a new home, a large first-floor apartment in a splendid house just off the Ringstrasse, at Oppolzergasse, 6. Situated above the famous Landtmann café and adjacent to the Burgtheater, the residence had an enviable position. It was while the family lived here that Anna's links with Sigmund Freud began.

Freud, who had recently set up his private practice as a specialist in nervous diseases in Maria Theresienstrasse, just five minutes' walk from the von Lieben home, was well acquainted with Franz Brentano; but it was probably either the family doctor Josef Breuer, or the gynaecologist Rudolf Chrobak who put him in touch with Anna. By 1888, he had taken

Kaffeehäusern standen solche Salons im Mittelpunkt des liberalen kulturellen und intellektuellen Lebens im Mitteleuropa des 19. Jahrhunderts und dienten auch als Instrumente gesellschaftlicher Integration. Bei diesen beiden Gastgeberinnen, Sophie und Josephine, dürfte es sich vermutlich um die beiden Frauen handeln, die auf der bereits erwähnten Fotografie auf dem Stillleben Marie-Louises (Kat. Nr. 21) links und rechts von Eduard Todesco zu sehen sind. Ihre Salons – in der Villa Wertheimstein in Döbling und im Palais Todesco – zogen die bedeutendsten und einflussreichsten Persönlichkeiten aus Politik und Wirtschaft ebenso an wie die brillantesten Wissenschaftler, bildenden Künstler und Musiker der Zeit. So lernte Johann Strauß, der König des Wiener Walzers, seine erste Frau, die Sängerin Jetty Treffz, auf einem Fest im Palais Todesco kennen. Zu den von Sophie aufbewahrten Dokumenten gehören u. a. Briefe von Johannes Brahms, Franz Liszt, Johann Strauß, Franz von Lenbach, Hans Makart, Moritz von Schwind und Henrik Ibsen.[11] Im Landhaus der Familie in Hinterbrühl fanden ähnlich glanzvolle Ereignisse statt. In einem Brief aus dem Jahr 1857 klagte Sophies Bruder Theodor über den ständigen Besucherstrom: »Man braucht sich nur umzudrehen, und schon begegnet man – nicht anderen Menschen, sondern Kalibanen, Zentauren, Monstern, die französisch sprechen und Victor Hugo zitieren, wenn man sich gern in Ruhe unterhalten oder einfach nur schlafen gehen möchte.«[12]

In den Jahren nach Sophie Gomperz' Heirat mit Eduard Todesco kamen in rascher Folge vier Kinder zur Welt. Die zweite Tochter, die 1847 geborene Anna (Abb. 8), war Marie-Louises Großmutter. Zusammen mit ihren Brüdern und Schwestern verbrachte Anna also ihre Kinderjahre in einem der elegantesten Häuser der Stadt. In späteren Jahren sollte sie als die geheimnisvolle »Frau Cäcilie M.« in die Geschichte eingehen. Unter diesem Namen erscheint sie in Freuds und Breuers »Studien über die Hysterie« (1895). Sie verbrachte ihre Kindheit in Hinterbrühl und war, nach allem, was man weiß, eine talentierte Künstlerin und Dichterin, wurde aber von ihrer älteren Schwester Fanny, die als schönstes Mädchen von Wien galt, augenfällig überstrahlt. Um Fannys Hand wurde heftig geworben, bis sie 1864, im Alter von 17 Jahren, Baron Henry de Worms heiratete – ein Ereignis, an das kein Geringerer als der große österreichische Dichter Franz Grillparzer in einem Gedicht erinnerte. Die Hochzeit war auch der Anlass, um das neu erbaute Palais Todesco einzuweihen. Bis zum Alter von 16 Jahren zeigte Anna keine Anzeichen ihrer späteren Krankheit. Dann, in den Jahren nach Fannys Hochzeit, blieb sie immer länger im Bett und schrieb eine Reihe ergreifender Gedichte über ihre Leiden.[13] Diese Gedichte legen den Gedanken nahe, dass Annas Leiden einer unerfüllten jugendlichen Leidenschaft geschuldet waren und dass ihre Eltern versuchen würden, sie, wie ihre Schwester Fanny, mit einem vornehmen, aber ungeliebten Mann zu verheiraten.

Freuds erste Patientin: Marie-Louises Großmutter

1870 heiratete Anna Freiin von Todesco Leopold von Lieben, Direktor seiner familieneigenen Privatbank. Er war Präsident der Wertpapierbörse und Vizegouverneur der Österreichisch-Ungarischen Bank. Bei beiden Großeltern waren die Keime jenes künstlerischen Talents angelegt, das in Marie-Louise aufblühen sollte: Anna galt als begabte Porträtistin, während Leopold mit Vorliebe Landschaften malte. Er besaß eine außergewöhnliche Sammlung flämischer Wandteppiche und japanischer Jade- und Elfenbeinschnitzereien. Zur Ausstattung ihrer Wohnung im Palais Todesco gehörten Gemälde von Brueghel und Crivelli, Rudolf von Alt, Franz Lenbach und Arnold Böcklin. In den Sommermonaten zog das Paar in die Villa Todesco in Hinterbrühl (Abb. 9) und verbrachte während der Jagdsaison auch einige Zeit auf ihrem Gut in Ungarn. Der Gewohnheit saisonbedingter Wohnortwechsel sollten später auch Marie-Louises Eltern nachgehen. Anna und Leopolds erstes Kind, Ilse, wurde 1873 geboren, und in rascher Folge kamen drei weitere Kinder zur Welt. Das jüngste, Marie-Louises Mutter Henriette, wurde 1882 geboren. Ein paar Jahre später, 1888, zog die Familie in die große Beletage eines prächtigen Hauses, gleich um die Ecke der Ringstraße, in der Oppolzergasse 6. Oberhalb des berühmten Café Landtmann gelegen und an das Burgtheater angrenzend,

over her treatment.[14] In their description of the woman they call "Cäcilie M.", Freud and Breuer describe Anna as "a woman of quite exceptional, especially artistic talents, whose highly developed sense of form expresses itself in perfectly formed poems."[15] They explain that Anna was haunted by traumas from the past, and "the only way of relieving her was to give her an opportunity of talking off under hypnosis the particular reminiscence which was tormenting her at the moment". From the family's point of view there was a darker side to Freud's visits, only hinted at in his work. Anna was addicted to morphine, and Freud supervised her daily injections.[16] Watching these daily events, the children regarded Freud with suspicion, believing that the man with the black beard who visited their mother was a magician who was doing their mother more harm than good.[17] The family terminated the treatment in 1893. It is clear, however, that Anna von Lieben played a key role in the development of Freud's theory of psychoanalysis. Descriptions of her in later life remark on her continued aura of girlish innocence, a quality which can also be see in Marie-Louise. The Viennese poet Ferdinand von Saar visited her in 1894, reporting: "She speaks with more difficulty than before and tires easily; the effect of all the poisons which she takes is devastating. But her characteristic spirit, free and humorous, has remained faithful to her."[18]

Although Anna von Lieben died six years before Marie-Louise was born, she remained a powerful family legend. Both her gifts and her eccentricity were inherited by Henriette and passed down to Marie-Louise herself as part of a rich yet troubled heritage. For Marie-Louise's mother Henriette, Anna von Lieben symbolised a crack in the surface of things, a fissure that grew deeper with time. As an old lady in exile in London, she meditated on this lost world in a poem about Marie-Louise's haunting painting, *Still-life with Photo* (cat. no. 21).

> You can judge what the painting means to me:
> It captures the high spirits of youth.
> Carefree living, laughter and a few tears
> When that tennis ball flew past.
> A scrap of colourful chintz could still draw it together
> Into a world that perhaps betrayed us."[19]

Henriette von Lieben. Marie-Louise's Early Years

A particularly striking cultural link in Henriette's early years was with the poet Hugo von Hofmannsthal who was introduced to the family circle by their cousin Felix Oppenheimer,

hatte der neue Wohnsitz die ideale Lage. Zu jener Zeit, als die Familie hier residierte, setzte auch Annas Verbindung zu Sigmund Freud ein.

Freud, der kurz zuvor seine Privatpraxis als Spezialist für Nervenkrankheiten in der Maria-Theresien-Straße, unweit dem Haus der von Liebens, eröffnet hatte, war ein guter Bekannter Franz Brentanos. Den Kontakt zu Anna aber stellte wahrscheinlich der Hausarzt der Familie, Josef Breuer, oder aber der Gynäkologe Rudolf Chrobak her. Jedenfalls hatte Freud im Jahr 1888 bereits die Behandlung von Anna übernommen.[14] Sigmund Freud als auch Josef Breuer äußerten sich sehr lobend über Anna: »eine Person von ganz ungewöhnlicher, insbesondere künstlerische Begabung, deren hochentwickelter Sinn für Form sich in vollendet schönen Gedichten kundgab.«[15] In den Notizen über die Frau, die sie »Cäcilie M.« nennen, erläutern Freud und Breuer ferner, dass Anna von Traumata aus der Vergangenheit verfolgt werde, und »die einzige Möglichkeit, sie davon zu befreien«, darin bestünde, »ihr eine Gelegenheit zu geben, sich unter Hypnose die besondere Erinnerung, die sie im Augenblick quälte, von der Seele zu reden«. Aus Sicht der Familie gab es im Zusammenhang mit Freuds Visiten eine noch dunklere Seite, die in seiner Arbeit nur angedeutet wird. Anna war nämlich morphiumsüchtig, und Freud überwachte ihre täglichen Injektionen.[16] Die Kinder, die Tag für Tag Zeugen dieser Vorgänge waren, betrachteten Freud mit Argwohn und glaubten, er würde ihrer Mutter mehr schaden als helfen. Sie hielten den Mann mit dem schwarzen Bart, der ihre Mutter besuchte, für einen Magier.[17] Die Familie beendete die Behandlung im Jahr 1893. Doch es steht fest, dass Anna von Lieben bei der Entwicklung von Freuds Theorie der Psychoanalyse eine entscheidende Rolle spielte. Aus Beschreibungen, die sie in ihren reiferen Jahren schildern, geht hervor, dass sie noch immer eine Aura mädchenhafter Unschuld ausstrahlte – ein Charakteristikum, das auch Marie-Louise später auszeichnen sollte. Der Wiener Dichter Ferdinand von Saar besuchte Anna 1894 und berichtete: »Sie spricht mit größerer Mühe als zuvor und ermüdet leicht; die Wirkung all der Gifte, die sie zu sich nimmt, ist verheerend. Doch ihr charakteristischer Geist, frei und witzig, ist ihr treu geblieben.«[18]

Obwohl Anna von Lieben zehn Jahre vor Marie-Louises Geburt starb, blieb sie eine nachhaltig wirkende Familienlegende. Sowohl ihre Begabungen als auch ihre Exzentrik vererbte sie ihrer Tochter Henriette und ihrer Enkelin Marie-Louise als Teil eines reichen, wenn auch unsteten Erbes. Nach Meinung von Marie-Louises Mutter symbolisierte Anna von Lieben einen Riss auf der Oberfläche der Dinge, eine Spalte, die mit der Zeit immer tiefer klaffte. Als alte Dame meditierte Henriette im Londoner Exil über diese verlorene Welt in einem Gedicht über Marie-Louises Bild *Stilleben mit Photographie* (Kat. Nr. 21):

Was mir das Bild ist, kannst Du ermessen
Es liegt darin der Jugend Übermuth.
Sorgloses Leben, Lachen und ein Weinen
Wenn jener Tennisball vorüberflog.
Ein Stückchen bunten Gins konnt's noch vereinen
Zu einer Welt die uns vielleicht betrog.«[19]

Henriette von Lieben. Marie-Louises frühe Jahre

Ein besonders bemerkenswerter Kontakt in Henriettes Kindheit stellte der mit dem Dichter Hugo von Hofmannsthal dar, der von ihrem Vetter Felix Oppenheimer, Hofmannsthals Klassenkamerad am Akademischen Gymnasium, in den Kreis ihrer Familie eingeführt wurde. Der junge Dichter schloss sogleich eine innige Freundschaft mit Henriettes Brüdern, Robert und Ernst von Lieben. Die jungen Leute verband eine gemeinsame Liebe für das Theater und für philosophische Diskussionen. Hofmannsthal nahm an den Vergnügungen der Familie teil und begeisterte sich auch für deren »tableaux vivants«, bei denen sich die jungen Leute und ihre Freunde kostümierten und als Figuren berühmter Bilder posierten. Ein Familienfoto aus dem Jahr 1893 zeigt Hofmannsthal, wie er, neben Ilse und Valla, zusammen mit Cousins aus

Hofmannsthal's classmate at the Academic Gymnasium. The poet soon established a firm friendship with Robert and Ernst von Lieben. The young men shared a love of the theatre and philosophical discussions. Hofmannsthal joined in the family entertainments, including their craze for *tableaux vivants* where the youngsters and their friends dressed up and posed as the characters in famous paintings. A family photograph of 1893 shows Hofmannsthal posing alongside Ilse and Valla, together with cousins from the Ephrussi and von Schey branches of the family, for a picture of an elaborate wedding procession. At Aunt Jella Oppenheimer's home, one of these events was turned into a famous society ball, where all the beautiful young women of the day, including Ilse and Valla, took their place alongside their handsome cousins to mime paintings by Moritz von Schwind and Hans Makart. The whole event was punctuated by recitals of Hofmannsthal's verse.[20]

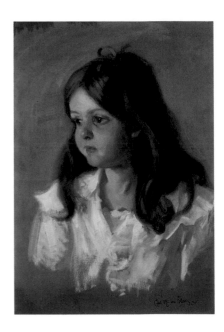

10 Carl Theodor von Blaatz, *Marie-Louise von Motesiczky*, 1911, Oil on board / Öl auf Holz, 560 × 377 mm, Marie-Louise von Motesiczky Charitable Trust, London

The young poet visited the Lieben family at Hinterbrühl during the late summer of 1893, and it was here that Marie-Louise's mother, Henriette, aged eleven, met him for the first time and immediately fell in love. To some extent he encouraged her infatuation, although it is clear that he never considered her as anything more than a child. On their first meeting, Hofmannsthal accompanied her on her daily visit to the stables after tea, or "Jause", to give sugar to the horses. His poem, set in the palm house at Döbling, about a child with large, knowing eyes, may well refer to this event.[21] In the coming months, Henriette saw him fleetingly in Vienna. She also decided to compose a birthday letter to him, which was despatched by a faithful servant, and to Henriette's delight she received a long reply by return, which initiated a short correspondence, providing Henriette with a few precious letters from Hofmannsthal that made her feel she was marked out from the common run of things. Indeed, she began to write her own remarkably vivid poems under his influence, published in a small portfolio in 1903, and she left behind her a collection of poems, stories and memoirs that testify to a not inconsiderable literary talent.[22]

Henriette was just 27 when she became a widow. Although she was devastated by Edmund's sudden death, her naturally buoyant and self-centred temperament helped her to recover, but the loss had a profound effect on Marie-Louise, who repeatedly sought out father-figures in later life in strong men such as Beckmann and Canetti. In a sense, Henriette's early widowhood gave her the licence to live her life according to her own laws, and to some extent this held for her daughter, too. Growing up in an atmosphere where there were few firm rules (Fig. 10 and 11), Marie-Louise and her brother Karl must have found it difficult to find their bearings. Henriette was a loving mother and hated to be separated from her daughter, even for a short time, but she was an indulgent and lazy parent. In addition, Marie-Louise received unconditional love from a woman she called her "second mother", Marie Hauptmann, her wet-nurse, who stayed with them for the rest of her life, following them into exile in England.[23]

Henriette and the children continued to live life on a grand scale, although the castle at Vázsony was sold (Henriette bought her first motor car with her share of the proceeds). In the winter months, the children lived with their mother and nannies in Vienna, and in the spring they joined their extended family at Hinterbrühl. Ilse would arrive from Holland with her four children during the summer months; Marie-Louise was particularly close to two of these cousins, Kees and Sophie, who eventually married Franz and Ida Brentano's son, Gio. The Karplus boys lived in Vienna and were constant companions; and there were also more distant cousins from the Ephrussi, Rothschild and von Schey branches with whom the Motesiczky children played.[24]

Above all, Marie-Louise's closest friend was her brother, Karl. As the two children grew up they confided their secrets to one another and kept up a regular correspondence when they were apart. But the relationship was nevertheless strained by the necessity each felt to play the role of missing parent for the other. Karl had a sensitive, troubled personality that was sometimes overstrained by his intellectual ambitions. Marie-Louise recalled a typical encounter: "Karl wanted to know everything, and I always listened to his doubts, and he insisted that no one could comfort him as I could ... Hegel was a source of great concern—to get *through* it. In late summer in Hinterbrühl ... 'I can't get through it and I must

dem Ephrussi- und Schey-Zweig der Familie, für ein Bild einer Hochzeitsprozession posiert. Im Hause von Tante Jella Oppenheimer wurde eine solche Unterhaltung bei einem berühmten Ball veranstaltet, auf dem all die schönen jungen Damen, darunter auch Ilse und Valla, die älteren Schwestern von Henriette, ihren Platz neben ihren hübschen Vettern einnahmen, um Bilder von Moritz von Schwind und Hans Makart nachzustellen. Zwischen den einzelnen »Bildern« las der junge Hofmannsthal aus seinen Gedichten.[20]

Im Spätsommer 1893 besuchte der junge Dichter die Familie von Lieben in Hinterbrühl. Hier begegnete Marie-Louises Mutter Henriette Hofmannsthal zum ersten Mal und fing sofort Feuer. In einem gewissen Maße förderte er die Schwärmerei der gerade 11-Jährigen, obwohl er zweifellos in ihr niemals etwas anderes als ein Kind sah. Während ihres ersten Treffens begleitete Hofmannsthal sie nach der »Jause« bei ihrem täglichen Rundgang durch die Ställe, wo sie den Pferden Zucker gab. Ein Gedicht Hofmannsthals, das im Döblinger Palmenhaus spielt und in dem ein Kind mit großen, wissenden Augen vorkommt, könnte auf dieses Ereignis anspielen.[21] In den darauf folgenden Monaten sah Henriette Hofmannsthal in Wien nur selten und beschloss, einen Geburtstagsbrief für ihn zu verfassen, der von einer getreuen Hausangestellten abgeschickt wurde. Zu Henriettes Freude erhielt sie eine lange Antwort, mit der ein kurzer Austausch von Briefen begann. Er bescherte Henriette einige kostbare Briefe von Hofmannsthal, die ihr das Gefühl gaben, aus dem Alltäglichen herausgehoben zu sein. Tatsächlich fing sie an, unter seinem Einfluss ihre eigenen bemerkenswert lebhaften Gedichte zu verfassen, die 1903 in einem kleinen Band veröffentlicht wurden. Am Ende ihres Lebens hinterließ sie eine Sammlung von Gedichten, Geschichten und Erinnerungen, die von einem nicht unbeträchtlichen literarischen Talent zeugen.[22]

Mit nur 27 Jahren war Marie-Louises Mutter Henriette bereits Witwe. Obwohl der plötzliche Tod ihres Mannes, der im Alter von nur 43 Jahren an einer Darmverschlingung verstarb, sie sehr mitnahm, half ihr ihr von Natur aus lebhaftes und ichbezogenes Wesen, bald über diesen Verlust hinwegzukommen, während der Tod des Vaters Marie-Louise schwer belastete. Vielleicht suchte sie deshalb in ihrem späteren Leben wiederholt in starken Männern wie Beckmann und Canetti auch eine Art Vaterfigur. In gewisser Weise gab die frühe Witwenschaft Henriette die Freiheit, ihr Leben nach ihren eigenen Gesetzen zu regeln, und dies galt bis zu einem gewissen Grad auch für ihre Tochter. Marie-Louise und ihr Bruder Karl wuchsen in einer Atmosphäre mit nur wenigen festen Regeln auf (Abb. 10 und 11). Sie müssen deshalb mitunter Schwierigkeiten gehabt haben, sich außerhalb der Familie zurechtzufinden. Als liebevolle und nachgiebige Mutter trennte sich Henriette höchst ungern von ihrer Tochter, und sei es auch nur für kurze Zeit. Zugleich war Marie-Louise auch das Objekt der bedingungslosen Liebe einer Frau, die sie ihre »zweite Mutter« nannte – Marie Hauptmann, ihre Amme, die für den Rest ihres Lebens bei ihnen bleiben und sie ins Exil nach England begleiten sollte.[23]

Henriette und die Kinder setzten ihr Leben im großen Stil fort, obwohl das Schloss in Vázsony verkauft wurde – aus ihrem Anteil des Erlöses erstand Henriette ihr erstes Auto. In den Wintermonaten lebten die Kinder mit ihrer Mutter und den Kindermädchen in Wien, und im Frühling zogen sie zur Familie nach Hinterbrühl. Während der Sommermonate kam auch Ilse, eine Schwester ihrer Mutter, mit ihren vier Kindern aus Holland dorthin. Zwei dieser Cousins, Kees und Sophie, stand Marie-Louise besonders nahe; Sophie sollte später Franz und Ida von Brentanos Sohn Gio heiraten. Die Jungen aus der Familie Karplus lebten in Wien und waren ständig mit den Motesiczky-Kindern zusammen. Zudem gab es auch noch entferntere Vettern und Cousinen aus den Zweigen der Ephrussi, Rothschild und von Schey, mit denen sie spielten.[24]

Doch Marie-Louises bester Freund war ihr Bruder Karl. Während die beiden Kinder aufwuchsen, vertrauten sie einander ihre Geheimnisse an und unterhielten, waren sie einmal voneinander getrennt, eine regelmäßige Korrespondenz. Dennoch wurde ihre Beziehung durch den von beiden Geschwistern verspürten Drang belastet, füreinander die Rolle des fehlenden Elternteils zu übernehmen. Karl hatte einen empfindsamen, rastlosen Charakter, der manchmal von seinen intellektuellen Ambitionen überfordert wurde. So erinnerte sich Marie-Louise an eine typische Situation: »Er wollte alles begreifen und seine Zweifel habe

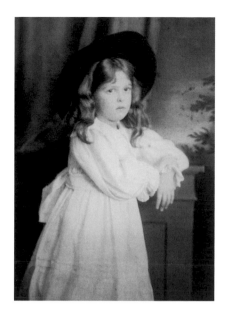

11 Marie-Louise as a child, Photograph, early 1910s / Marie-Louise als Kind, Fotografie, um 1910, Marie-Louise von Motesiczky Charitable Trust, London

understand it,' (Karl said). 'And I simply can't get through it.' And once it was late at night and I said to him: 'You know, I really think that philosophy is sometimes the result of all the stupid little things we think about at night, which don't lead to anything at all.' And then he said: 'Oh, now I feel better! Oh, now I feel better! You understand so well.' And I was happy that I had calmed him down."[25] Marie-Louise later portrayed her brother characteristically engrossed in reading "Das Kapital" by Karl Marx (cat. no. 14). The siblings supported each other through several crises.[26] In later life, Marie-Louise never entirely got over the feeling that when it came to Karl's moment of greatest need, in Auschwitz in 1943, she was not there for him. Her guilt and sadness about the loss of her brother overshadowed the second half of her life.

When war broke out in August 1914, the Motesiczkys were sheltered from its worst effects. Not many of Henriette's friends were called up to fight, and the family fortune was not adversely affected. Nevertheless, like all Austrians, Henriette was aware that her world would never be the same: "In 1916, Emperor Franz Joseph died," she wrote, "and with him, an entire age. There was to be no more Imperial music, no more Imperial policemen mounted on horseback."[27] One result of the war was that the new laws to alleviate housing shortages obliged Henriette to take lodgers. A series of colourful characters passed through her apartment in the Brahmsplatz, surrounding the Motesiczkys with talented young foreigners who were temporarily studying in Vienna. A handsome American architecture student, Paul Döring, who lived in the house as a lodger, became one of Marie-Louise's first lovers, and Arthur Schnitzler was a frequent visitor during the tenancy of one of his women friends.

Marie-Louise's education during these years was, to say the least, patchy. She briefly attended the local girls' lyceum between 1917 and 1919, but left when she was just 13 ("a mistake", she later acknowledged).[28] She did not enjoy schoolwork and frequently missed school, being more interested in the world at large. Although Henriette indulged her whims, she put her foot down when Marie-Louise suggested working in the local factory at Hinterbrühl. However, she shared her daughter's interest in the visual arts, and it was probably for this reason that she fostered her talent. Pauly Wagner, daughter of the influential modern architect, Otto Wagner, was engaged as a part-time governess, and, as luck would have it, she married the future director of the Kunsthistorisches Museum in Vienna, Ludwig Baldass, and Marie-Louise frequently visited the great museum and attended informal lectures by its director. The fabulous collection of Dutch still-lifes and Spanish, Italian and Flemish portraits made a lasting impact on Marie-Louise. Echoes from the museum's collection reverberate in her paintings throughout the 1920s and 1930s. Her own charming painting, *Tea-time* (1933, cat. no. 25), for example, where a small blond girl in a silver-pink bodice reaches for a tray of fruit on the tea table, refers to the child's head and table of fruit in Gerard ter Borch's *Woman Peeling Apples* (c. 1661). Marie-Louise was drawn above all to Dutch painting, perhaps because its realism and unpretentious humanism meant more to her than the exalted themes in Italian art. The symbols of worldly vanity in the Dutch flower paintings and still-lifes that hung in the Kunsthistorisches Museum touched a special nerve. Many years later, during her years of English exile, she returned to these themes, painting symbolic still-lifes where clocks, flowers and burning candles symbolise the inevitable march of time. Her poignant portraits of Henriette as an old woman also hark back to her earliest experiences of great art in the Kunsthistorisches Museum: Rembrandt's portraits of the aged *Apostle Paul* (1633) or *The Prophetess Hannah* (1639) provided her with examples of some of the most moving renditions of old age.

In August 1919, she had her first opportunity to visit Holland, when she travelled with her mother and Karl to visit Tante Ilse and the Leembruggen cousins. They spent three weeks visiting Amsterdam, Delft and The Hague. Marie-Louise loved every minute and felt deeply attracted to Dutch life. In the Rijksmuseum in Amsterdam she saw "the most beautiful Rembrandts", and she felt inspired "to certainly draw a Dutch landscape in my diary when I get home." [29] By this time, she was attending drawing lessons in the private studio of a Viennese artist, Hans Kohn.

ich immer angehört und er hat gemeint, daß niemand ihn so beruhigen kann wie ich ... Hegel war eine große Sorge. Da durchzukommen. Im Spätsommer in der Hinterbrühl ... ›Ich komme nicht durch und ich muß es begreifen. Und ich komme nicht durch.‹ Und einmal war es spät in der Nacht und da habe ich ihm gesagt: ›Weißt Du, ich glaube halt, daß die Philosophie manchmal auch letzten Endes das ist, was die dummen, kleinen Sachen sind, die man sich in der Nacht ausdenkt und die zu gar nichts führen.‹ Und da sagt er: ›Ach, jetzt ist mir leichter! Ach, jetzt ist mir leichter! Du verstehst so gut.‹ Und ich war glücklich, daß ich ihn zur Ruhe gebracht habe.«[25] Jahre später malte Marie-Louise ihren Bruder, bezeichnenderweise in die Lektüre von Karl Marx' »Das Kapital« (Kat. Nr. 14) vertieft. Die Geschwister halfen einander durch mehrere Krisen.[26] In ihrem späteren Leben konnte es Marie-Louise niemals ganz verwinden, dass sie in dem Augenblick, als Karl sie am meisten gebraucht hätte, nämlich 1943 in Auschwitz, nicht bei ihm war. Ihre Gefühle von Schuld und Trauer über den Verlust ihres Bruders überschattete die gesamte zweite Hälfte ihres Lebens.

Als im August 1914 der Krieg ausbrach, blieben die Motesiczkys von den schlimmsten Folgen verschont. Nur wenige von Henriettes Freunden wurden zum Kriegsdienst eingezogen, und es gab keine negativen Auswirkungen auf das Vermögen der Familie. Trotzdem war sich Henriette, wie viele Österreicher, bewusst, dass ihre Welt nie mehr so sein würde wie zuvor: »1916 starb der Kaiser Franz Joseph und mit ihm eine ganze Zeit. Keine Burgmusik gab es mehr, keine berittenen Burggendarmen.«[27] Als Kriegsfolge zwangen neue Gesetze zur Linderung der Wohnungsnot Henriette, Untermieter aufzunehmen. Eine Reihe schillernder Persönlichkeiten zog nun durch ihre Wohnung am Brahmsplatz. Die Motesiczkys sahen sich unter anderem von talentierten jungen Ausländern umgeben, die zeitweilig in Wien studierten. Ein gut aussehender amerikanischer Student, Paul Döring, der im Haus zur Untermiete wohnte, wurde einer von Marie-Louises ersten Liebhabern, und Arthur Schnitzler war ein häufiger Gast des Hauses, als eine seiner Freundinnen bei Henriette zur Miete wohnte.

Marie-Louises schulische Bildung dieser Jahre war eher unzulänglich. Sie besuchte lediglich für kurze Zeit, zwischen 1917 und 1919, das Öffentliche Mädchenlyzeum, ging dann aber mit nur 13 Jahren von der Schule ab (»ein Fehler«, wie sie später einräumte).[28] Die Schularbeiten machten ihr keinen Spaß, und sie schwänzte oft den Unterricht. Ihr Interesse richtete sich vielmehr auf die Welt draußen. Obwohl Henriette den Launen der Tochter oft nachgab, sprach sie ein Machtwort, als Marie-Louise meinte, in der Fabrik in Hinterbrühl arbeiten zu wollen. Aber sie teilte das Interesse ihrer Tochter für die bildenden Künste und förderte daher auch ihr Talent. Pauly Wagner, die Tochter des einflussreichen Architekten Otto Wagner, wurde als Teilzeit-Gouvernante engagiert. Sie sollte den späteren Direktor des Kunsthistorischen Museums in Wien, Ludwig Baldass, heiraten, und so lauschte Marie-Louise bei ihren häufigen Besuchen im Museum oft Baldass' zwanglosen Vorträgen. Die fantastische Sammlung niederländischer Stillleben und spanischer, italienischer und flämischer Porträts hinterließen einen bleibenden Eindruck bei Marie-Louise. Reminiszenzen an alte Meister finden sich in all ihren Bildern, die in den 1920er und 1930er Jahren entstanden. Ihr eigenes reizendes Bildnis, *Jause* (1933, Kat. Nr. 25), etwa, auf dem ein kleines blondes Mädchen in einem silber-rosa Mieder nach einem Tablett mit Früchten auf dem Teetisch greift, enthält eine Anspielung auf den Kopf des Kindes und den früchtebeladenen Tisch in Gerard ter Borchs *Apfelschälerin* (um 1661). Marie-Louise fühlte sich vor allem von der holländischen Malerei angezogen, vielleicht, weil für sie der Realismus und die unaufdringliche Menschlichkeit inspirierender waren als die überschwänglichen Themen der italienischen Kunst. Die Symbole weltlicher Eitelkeit in den holländischen Blumenbildern und Stillleben zu entdecken, trafen bei ihr einen besonderen Nerv. Viele Jahre später, während ihrer Jahre im englischen Exil, kehrte sie zu diesen Themen zurück, als sie symbolische Stillleben malte, auf denen Uhren, Blumen und brennende Kerzen den unabänderlichen Lauf der Zeit symbolisieren. In ihren ergreifenden Porträts von Henriette als alter Frau finden sich auch Anklänge an ihre frühesten Erfahrungen mit den bedeutenden Kunstwerken des Kunsthistorischen Museums: Rembrandts Bildnisse des betagten *Apostel Paulus* (1633) oder *Die Prophetin Hannah* (1639) dienten ihr als Leitbilder für ihre eigenen besonders bewegenden Interpretationen des Alters.

Marie-Louise was aware that she was living through an exciting time in avant-garde Vienna but she was also influenced by the conservative tastes of her family. In later life she spoke with hostility about Karl Kraus (who had founded his famous satirical journal, *Die Fackel*, in 1899), because she considered him anti-semitic; while the old vagabond poet, Peter Altenburg, she said, had scrounged off some members of her family.[30] Although Karl "dragged" Marie-Louise to the latest lectures on literature and art, and took her, for example, to Stravinsky's first concerts, she was never entirely convinced by the more radical avant-garde and remained suspicious of "intellectual", abstract art throughout her life.

From her early childhood, Marie-Louise had grown up with the traditional art collections of her uncle, Richard von Lieben, and her grandfather, Leopold. These helped to shape her tastes and preferences, but she also admired the art nouveau work of Gustav Klimt and the vital Expressionism of Egon Schiele and Oskar Kokoschka, whose works she collected in postcard illustrations. Her most exciting encounter with modern art, however, came when her mother made her a gift of a catalogue of prints by the German artist Max Beckmann, a friend of their cousin, Irma Simon, née von Schey, who had married the editor of the "Frankfurter Zeitung," Heinrich Simon. Since 1915, Beckmann had lived and worked in Frankfurt, recording his images of the war. His graphic cycles—*Faces* (1918) and *Hell* (1919)— were far from reassuring, and in later life Marie-Louise recalled the impact that his raw, un-compromising art made on her family circle: "Among all my mother's acquaintances, admirers of Hofmannsthal, I hardly knew anyone who wasn't shocked by Beckmann's early graphic art, and there certainly wasn't anybody who didn't find his paintings horribly ugly."[31]

Birth of the Artist: The Meeting with Beckmann

In the summer of 1920, Irma Simon brought Beckmann to Vienna. One fine evening they made a surprise visit to Hinterbrühl, and the arrival of the famous German artist had an enormous impact (Fig. 12). "A winged creature from Mars", Marie-Louise recalled, "could not have made a greater impression on me. On top of this, the fact that I should be chosen as the only one among all the people I knew, to recognise that his pictures were beautiful rather than ugly, and that the man from Mars was a good rather than an evil spirit—all this was very strange, even stranger than the events Alice in Wonderland experienced when she fell into the deep hole."[32] Max Beckmann introduced a heady atmosphere of freedom into the family's holiday routine. At first sight she found him somewhat forbidding, but when they all sat down to supper in the garden, he devised an impromptu playlet to amuse her, transform-ing a wisp of hay into a drunken dancer by dipping it in a small pool of spilt white wine. By the end of the evening, they were friends for life. She was aware that something magical had happened, providing a fitting climax to her childhood years and a marvellous new beginning. "It was", Marie-Louise later recalled, "the first time in my life that I stayed awake until dawn."[33] The works on paper which Beckmann gave to the painter over the years—sometimes with a dedication—reveal the depth of their friendship (Fig. 12, 13, 16, 22–24, 35).

Marie-Louise's earliest paintings resonate with the experiences of Hinterbrühl. Her first great landscape, *Street in Hinterbrühl* (cat. no. 2), portrays a local street, and the early *Summer Landscape* (Fig. 14) likewise depicts a scene from Hinterbrühl. Although the vertical structure may recall Beckmann, the free brush-strokes and idyllic mood in this hay-making episode hark back to earlier masters, imbuing the summer landscape with a mood of painterly nostalgia. If neither of these canvases yet betrays exactly how Marie-Louise will develop as an artist in later life, they already show the birth of a remarkable talent. Her earliest portraits are also devoted to local themes. What may be her first oil painting, *Hanni, Hinterbrühl* (Fig. 15), takes a girl from the village near the family estate as its subject. The fact that this picture has also been referred to as *Arbeiterin / Junge Farbige (Worker / Young Negro)* suggests that she may have worked in the local "Bördelfabrik", a factory producing shoe-laces.[34] Seated on a chair directly before a wall patterned with green-beige wallpaper, the young girl, with her long thin neck projecting from a bony chest and her large black eyes gazing unguardedly

Im August 1919 hatte sie zum ersten Mal Gelegenheit, nach Holland zu reisen, und besuchte mit ihrer Mutter und ihrem Bruder Karl ihre Tante Ilse und die Leembruggen-Cousins. Sie verbrachten drei Wochen zwischen Amsterdam, Delft und Den Haag. Marie-Louise genoss jede Minute und war von der holländischen Lebensart fasziniert. Im Rijksmuseum von Amsterdam sah sie »die schönsten Rembrandts« und fühlte sich angeregt, »ganz bestimmt eine holländische Landschaft in mein Tagebuch zu zeichnen, wenn ich wieder daheim bin«.[29] Nach ihrer Rückkehr nahm sie Zeichenunterricht im privaten Atelier des Wiener Künstlers Hans Kohn.

Marie-Louise war sich durchaus darüber im Klaren, dass sie in dem von der Avantgarde geprägten Wien eine spannende Zeit durchlebte. Aber sie war auch von dem konservativen Geschmack ihrer Familie geprägt. In ihrem späteren Leben sprach sie mit großer Distanz und sogar Ablehnung von Karl Kraus (der seine berühmte satirische Zeitschrift »Die Fackel« 1899 gegründet hatte), weil sie ihn für einen Antisemiten hielt, während sich der alte Kaffeehauspoet Peter Altenberg, wie sie sagte, bei einigen Mitgliedern ihrer Familie als Schnorrer gezeigt hatte.[30] Obwohl ihr Bruder sie zu den neuesten Vorträgen über Literatur und Kunst »schleppte« und sie zum Beispiel in Igor Strawinskis erste Konzerte mitnahm, war sie niemals ganz von der radikalen Avantgarde überzeugt und blieb zeitlebens der »intellektuellen« abstrakten Kunst gegenüber misstrauisch.

Seit ihrer frühen Kindheit war Marie-Louise mit den Kunstsammlungen ihres Onkels Richard und ihres Großvaters Leopold aufgewachsen. Diese trugen unter anderem dazu bei, ihren Geschmack und ihre Vorlieben zu prägen. Doch sie bewunderte auch Gustav Klimts Jugendstilkunst und den vitalen Expressionismus von Egon Schiele und Oskar Kokoschka, deren Werke sie in Form gedruckter Postkarten sammelte. Ihre aufregendste Begegnung mit der modernen Kunst fand allerdings statt, als ihre Mutter ihr einen Katalog mit grafischen Arbeiten des deutschen Künstlers Max Beckmann schenkte, eines Freundes ihrer Cousine, Irma Simon, geborene von Schey, die mit dem Herausgeber und Verleger der »Frankfurter Zeitung«, Heinrich Simon, verheiratet war. Der seit 1915 in Frankfurt ansässige Beckmann hatte hier seine Kriegserfahrungen künstlerisch umgesetzt. Seine grafischen Zyklen – *Gesichter* (1918) und *Die Hölle* (1919) – waren alles andere als beruhigend, und Marie-Louise sollte sich später an den Eindruck erinnern, den seine rohe, kompromisslose Kunst im Kreis ihrer Familie machte: »Unter all den Bekannten meiner Mutter, Verehrern von Hofmannsthal, hätte ich wohl kaum jemanden gefunden, der nicht vor der frühen Graphik Beckmanns erschrocken wäre und niemanden, der seine Bilder nicht ganz einfach furchtbar häßlich gefunden hätte.«[31]

Geburt einer Künstlerin: Die Begegnung mit Max Beckmann

Im Sommer 1920 brachte Irma Simon Beckmann nach Wien. An einem schönen Abend machten sie einen Überraschungsbesuch in Hinterbrühl, und das Eintreffen des berühmten deutschen Künstlers hinterließ einen tiefen Eindruck (Abb. 12). »Ein geflügeltes Wesen vom Mars hätte auf mich keinen größeren Eindruck machen können, und daß ich dazu ausersehen sein sollte, als Einzige unter all den Menschen, die ich kannte, zu erkennen, daß seine Bilder schön und nicht häßlich waren und der Mann vom Mars ein guter und kein böser Geist, das war sehr sonderbar, noch sonderbarer als das, was Alice im Wunderland erlebte, als sie in das tiefe Loch fiel.«[32] Max Beckmann brachte eine aufregende Atmosphäre von Freiheit in den Alltag ihrer Familien-Sommerfrische. Auf den ersten Blick fand sie ihn etwas düster, doch als sie sich alle im Garten zum Abendessen setzten, dachte er sich zu ihrem Vergnügen ein Stegreifspielchen aus: Er tauchte ein Büschel Heu in eine kleine Lache verschütteten Weißweins und verwandelte es in einen betrunkenen Tänzer. Als der Abend zu Ende ging, waren sie Freunde fürs Leben. Marie-Louise war sich bewusst, dass etwas Magisches geschehen war, etwas, was einen passenden Schlussakkord unter ihre Kinderjahre setzte und einen wunderbaren Neuanfang markierte. »Das war die erste durchwachte Nacht meines Lebens«, erinnerte sich Marie-Louise später.[33] Die grafischen Arbeiten, die Max

at the viewer, appears vulnerable and ill at ease. Apart from the formal debt to Beckmann, one also senses the impact of van Gogh, an artist whom Marie-Louise discovered on her first visit to Holland and whom she passionately admired. Both his art and his ethical views had a powerful effect on her development, also providing a source of comfort to her during the long years of exile.

The tension in these early works between her will to forge her own style and the impact of Beckmann becomes apparent again in one of her most successful self-portraits, *At the Dressmaker's* (1930, cat. no. 20), which is both a homage to Beckmann and a declaration of independence. The painting, which shows the artist confronting herself in the mirror during a fitting for a new white dress, closely resembles Beckmann's *Clarkroom (The Fitting)*, painted two years earlier;[35] but whereas he shows a coquettish model, her self-portrait is characterised by an austere beauty, heightened by the frankness and directness of her gaze and the tentative gesture of her raised arm. Behind her shoulder hangs the hand mirror that appears in many of her self-portraits, not so much a testament to the young woman's beauty as a symbol of introspection and of vanity in the original sense of the word, marking her awareness of passing time. Looking back, Marie-Louise recognised this painting as one of her most important works: "When I painted *At the Dressmaker's*," she wrote, "I wasn't thinking about myself but only about how to paint a beautiful painting. However, I now realise that unconsciously I was offering the viewer a picture of everything I represented at 26 years old."[36]

Consolidation in a Time of Danger: The 1930s

Marie-Louise looked back on the 1930s as a period of quiet reflection, "working for herself in Vienna and in Hinterbrühl, without troubling about exhibitions, hardly giving outward success a thought".[37] In fact, it was a restless, difficult period, although in retrospect it seemed like a hiatus before Europe was hit by the political storm that drove her and her mother into exile, alongside countless other Jewish refugees. Despite the blow to the family fortune resulting from the collapse of the Lieben bank in the mid-1920s, the decade from 1924 to 1933 was both fruitful for Marie-Louise and relatively stable in political terms.

Meditating more generally on the years leading up to the war, Stephan Zweig remarked on the hectic pace of life and the impulse that seized a whole generation to travel restlessly from place to place. "Never did people travel as much as in those years," he recalled. "Was it the impatience of the young to absorb quickly what they had missed ... Or was it, perhaps, some dark premonition that one had to escape in time before the barriers closed down anew?"[38] Marie-Louise was caught up in this frenzy, moving between Vienna, Berlin, Paris, the South of France, Spain and Holland in the early 1930s, and making her first trip across the Atlantic to visit the USA in 1934. Soon after leaving Beckmann's master class in Frankfurt in 1928 (Fig. 16), she undertook a journey to Spain and was fascinated by the bullfights that she witnessed there, writing home excitedly to Henriette about one she saw in El Puerto de Santa Maria, north of Cadiz,[39] and commemorating these events in *Bullfight* (1928, cat. no. 12). She painted the scene back at home in Hinterbrühl, probably the first of her paintings to be influenced by photography. It shows the scene from a distorted perspective, almost as if viewed through a convex lens.[40] In Madrid, it is likely that Marie-Louise visited the great collections of Spanish old master paintings at the Museo del Prado; the tonal palette she adopts in several paintings, including *Spanish Girl* (Fig. 17) of 1928 (also painted at home in Hinterbrühl, using a costume that she had brought back from Spain), and the striking new depth to her realism, bear witness to the impact that Goya, Velázquez and Zurbarán made on the young artist.

Marie-Louise used the same tonal colour scheme in several paintings of nudes that she made in Vienna around this time. This was a new subject for her, and the most successful painting is entitled *The Balcony* (1929, cat. no. 18), which is in fact a self-portrait of the artist, sunbathing in the nude on a pink chaise-longue. The scene takes place in the Villa Todesco

13 Max Beckmann, *Beach / Strand*, 1922, Etching / Radierung, 212 × 342 mm, Marie-Louise von Motesiczky Charitable Trust, London

14 *Summer Landscape / Sommerlandschaft*, 1926, Oil on canvas / Öl auf Leinwand, 950 × 286 mm, Marie-Louise von Motesiczky Charitable Trust, London

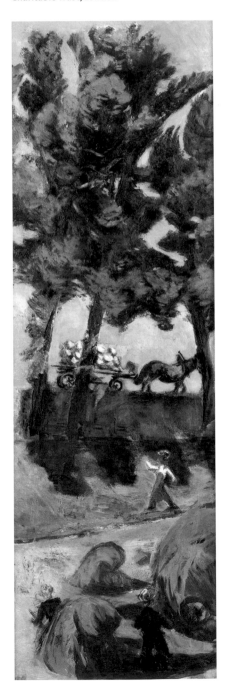

Beckmann im Laufe ihrer langen Freundschaft – oft mit Widmung – der Malerin verehrte, bezeigen die Tiefe ihrer Freundschaft (Abb. 12, 13, 16, 22–24, 35).

Marie-Louises früheste Gemälde sind vom Widerhall ihrer Erlebnisse in Hinterbrühl geprägt. Ihr erstes Landschaftsbild, *Straße in Hinterbrühl* (Kat. Nr. 2), zeigt eine Dorfstraße, und das frühe *Sommerlandschaft* (Abb. 14) hält ebenfalls eine Szene aus Hinterbrühl fest. Obwohl das extreme Hochformat und der vertikale Aufbau an Beckmann erinnern, gehen die freien Pinselstriche und die idyllische Stimmung dieser Heumahd-Darstellung auf ältere Meister zurück, die die Sommerlandschaft mit einer Atmosphäre malerischer Wehmut erfüllen. Wenn auch noch keines dieser Gemälde genau verrät, in welche Richtung sich Marie-Louise als Künstlerin entwickeln würde, zeigen sie doch die Anfänge eines beachtlichen Talents. Ihre ersten Porträts sind ebenfalls lokalen Themen gewidmet. Ein sehr frühes Ölgemälde, *Hanni, Hinterbrühl* (Abb. 15), stellt ein Mädchen aus dem Dorf beim Anwesen ihrer Familie dar. Die Tatsache, dass dieses Bild auch den Titel *Arbeiterin /Junge Farbige* trägt, legt nahe, dass das Modell vielleicht in der örtlichen Bördelfabrik gearbeitet hat, in der Schnürsenkel hergestellt wurden.[34] Auf einem Stuhl direkt vor einer Wand sitzend, die mit grün-beiger Tapete beklebt ist, wirkt das junge Mädchen mit ihrem langen dünnen Hals, der aus einer knochigen Brust herausragt, und ihren großen schwarzen Augen, die den Betrachter direkt anstarren, verletzlich und scheint sich unbehaglich zu fühlen. Abgesehen von dem formalen Einfluss Beckmanns spürt man auch das Vorbild Vincent van Goghs, eines Künstlers, dessen Malerei Marie-Louise bei ihrem ersten Holland-Aufenthalt entdeckt hatte und den sie leidenschaftlich bewunderte. Sowohl seine Kunst als auch sein Ethos hatten eine starke Wirkung auf ihre Entwicklung und stellten auch während ihrer langen Jahre des Exils eine Quelle des Trostes dar.

Die Spannung zwischen dem Willen, ihren eigenen Stil herauszubilden, und dem Einfluss Beckmanns wird auch in einem anderen frühen Werk deutlich, dem sehr gelungenen Selbstbildniss, *Bei der Schneiderin* aus dem Jahr 1930 (Kat. Nr. 20), das sowohl eine Hommage an Beckmann als auch eine Unabhängigkeitserklärung ist. Das Gemälde, das die Künstlerin vor dem Spiegel während der Anprobe eines neuen weißen Kleides zeigt, erinnert stark an Beckmanns zwei Jahre zuvor entstandenes Bild *Garderobe (Die Anprobe)*.[35] Doch während er ein kokettes Modell zeigt, ist Marie-Louises Selbstporträt durch eine strenge Schönheit gekennzeichnet, die hervorgehoben wird durch die Offenheit und Direktheit ihres Blicks und die zaghafte Geste des erhobenen Arms. Hinter ihrer Schulter hängt der allgegenwärtige Spiegel, nicht so sehr als Beweis für die Schönheit der jungen Frau, denn als Symbol der Selbstbetrachtung und der Eitelkeit im ursprünglichen Sinn des Wortes. Er verdeutlicht, dass ihr die Vergänglichkeit durchaus bewusst ist. Im Rückblick erkannte Marie-Louise in diesem Bild eines ihrer bedeutendsten Werke: »Als ich *At the Dressmaker's* malte«, schrieb sie, »dachte ich nicht an mich selbst, sondern nur daran, wie ein schönes Bild zu malen sei. Doch jetzt ist mir klar, daß ich dem Betrachter unbewußt ein Bild all dessen anbot, was ich repräsentierte, als ich sechsundzwanzig Jahre alt war.«[36]

Konsolidierung in einer Zeit der Gefahr: die 1930er Jahre

Rückblickend begriff sie die 1930er Jahre als eine Zeit der stillen Einkehr: »Später arbeitete sie ruhig für sich in Wien und in der Hinterbrühl, ohne sich um Ausstellungen zu bemühen, auf äußeren Erfolg kaum bedacht ...«[37] In Wirklichkeit handelte es sich um eine unruhige, schwierige Periode, obwohl sie im Rückblick wie eine Ruhe vor dem politischen Sturm wirkte, der über Europa hinwegfegte und Marie-Louise und ihre Mutter ins Exil trieb – wie unzählige andere jüdische Flüchtlinge auch. Trotz des Verlustes, den der Zusammenbruch der Lieben-Bank in der Mitte der 1920er Jahre für das Vermögen der Familie bedeutet hatte, war die Dekade von 1924 bis 1933 für Marie-Louise persönlich sehr fruchtbar und in politischer Hinsicht einigermaßen stabil.

In seinen Reflexionen über die Jahre vor der Machtergreifung der Nazis und dem Ausbruch des Zweiten Weltkriegs beschrieb Stefan Zweig die Hektik des Lebens und den Drang,

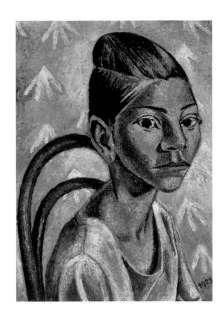

15 *Hanni, Hinterbrühl*, 1925, Oil on canvas / Öl auf Leinwand, 412 × 294 mm, Marie-Louise von Motesiczky Charitable Trust, London

in Hinterbrühl, where Marie-Louise continued to spend the summer months. As she later explained: "My room and a guest room opened out to the balcony. I pushed the settee and a large heavy standing mirror from the guest room out onto the sunny balcony, so that I could be my own model. It was the end of June, beginning of July, my favourite season."[41] Because she could not paint herself while lying down, she studied the various parts of her body in the mirror and then assembled them into a composite nude. The result is a sensuously elongated, slightly doll-like body, in a twisted position that is echoed by the folds of a bright yellow scarf flung casually over the settee. As in many of Marie-Louise's later paintings, an unspoken narrative hangs in the air: the balustrade of the balcony is decorated with a heart-shaped motif, and somewhere in the villa's extensive park an unseen figure is flying a white kite that bobs cheerfully into view behind the reclining nude. The self-portrait is not so much about Marie-Louise's appearance as about her romantic dreams and fantasies on a warm summer's day.

The central role that Marie-Louise's family played in her life gave rise to several portraits in the mid-1930s, notably her first portraits of Henriette and Karl. In *Henriette von Motesiczky, Portrait Number One* (1929, cat. no. 17)—the painting that begins the sequence devoted to the artist's mother that was to reach its climax some 50 years later (cat. no. 57–59, 66, 74–78)—Henriette is shown lying in bed, resting her head on her arm. Marie-Louise concentrates on her mother's head, contrasting her rosy cheeks and general healthy glow with the sad facial expression and doleful eyes. Slightly later she returned to the same theme in *Siesta* (1933, cat. no. 22), a pastel drawing showing Henriette taking her afternoon nap—a ritual she always indulged in, insisting that Marie-Louise do the same in the periods they spent together. Whereas the mood of the first painting (rendered in a subdued range of pink, grey and beige tones) is somewhat austere, *Siesta* celebrates Henriette's sensual abandonment to idleness. Lying on her stomach with her nightdress ridden up to reveal her amply rounded belly and upper arm, Henriette looks towards the viewer with a child-like, wide-eyed gaze. Henriette's plump figure appears in another guise in *Hunting* (1936, cat. no. 24). This time she is shown crouching in a boat among the reeds, aiming her shotgun at ducks, two of which are flying off in the background. In Marie-Louise's affectionate depiction of her mother as a huntress (her blue dress straining at the seams with the effort of aiming her gun), she is transformed into a resolute figure, later described by one critic as "a monstrous Amazon".[42]

Along with an unidentified still-life, *The Balcony* was the only painting that Marie-Louise showed publicly in Vienna in the 1930s, on the occasion of the Hagenbund exhibition in April 1933. The Hagenbund exhibiting society is thought of as a somewhat middle-of-the-road organisation, mediating between the conservative artists who exhibited annually in the Künstlerhaus and the revolutionary Viennese Secession, where Klimt and Schiele were exhibited alongside the great figures of French Modernism. In fact, the Vienna Secession became increasingly conservative in the 1920s and 1930s: many members of its leadership sympathised with the rise of fascism, and after 1930 only non-Jewish members of the Association of Austrian artists were admitted to the Secession.[43] The Hagenbund, on the other hand, became a showcase in the 1920s for the daringly modern Expressionist tendencies that the general public in Vienna still failed to understand. Most of the Hagenbund artists—like Marie-Louise—worked in a figurative style, concentrating on the traditional genres of portraiture, still-life painting and landscape.

This was the promising development that the rise of Nazism, the "Anschluss" and Marie-Louise's subsequent exile in Holland and England brought to an abrupt end. Henceforth, she was condemned to work for many years without the support of a benign artistic environment. Instead, she had to come to terms with the hardships of life in exile and a new artistic environment. When the world of Vienna reappeared in her work, it was no longer the actual Vienna of her childhood and youth, but a world transmuted by memory, a Vienna whose objects she treasured in her home in Hampstead and which so often appear in her mature still-lifes. Thus, for example, throughout her life she kept a miniature portrait of Anna von Lieben by an unknown artist, showing her as a pretty girl with long brown plaits and an

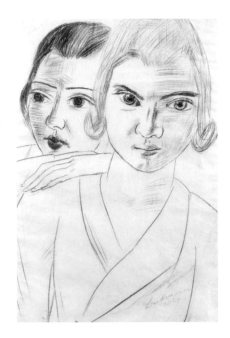

16 Max Beckmann, *Marie-Louise von Motesiczky und Mathilde Kaulbach*, 1924, Lithographic chalk on transfer paper / Lithokreide auf Umdruckpapier, 465 × 315 mm, Marie-Louise von Motesiczky Charitable Trust, London

rastlos von Ort zu Ort zu reisen, der eine ganze Generation erfasst hatte, wie folgt: »Niemals ist ein Volk so viel gereist wie in jenen Jahren. War es die Ungeduld der Jungen, nur schnell das nachzuholen, was sie versäumt hatten … Oder war es vielleicht irgendeine dunkle Vorahnung, daß man rechtzeitig entkommen müsse, bevor sich die Schranken erneut schließen würden?«[38] Auch Marie-Louise war von diesem Fieber gepackt und bewegte sich in den frühen 1930er Jahren zwischen Wien, Berlin, Paris, Südfrankreich, Spanien und Holland. 1934 unternahm sie ihre erste Reise über den Atlantik und besuchte die Vereinigten Staaten. Kurz nachdem sie 1928 Beckmanns Meisterklasse in Frankfurt verlassen hatte (Abb. 16), reiste sie nach Spanien. Marie-Louise war fasziniert von den Stierkämpfen, denen sie beiwohnte, und berichtete Henriette in einem Brief aufgeregt über einen Stierkampf, den sie in El Puerto de Santa María, nördlich von Cádiz, erlebt hatte.[39] Marie-Louise hielt diese Ereignisse in dem Gemälde *Stierkampf* aus dem Jahr 1928 (Kat. Nr. 12) fest, das nach ihrer Rückkehr von der Reise im Atelier in Hinterbrühl entstand. Vermutlich handelt es sich um eines ihrer ersten Bilder, das durch die Fotografie beeinflusst ist. Es zeigt die Szene aus einer verzerrten Perspektive, fast so, als würde sie sie durch eine konvexe Linse betrachten.[40] In Madrid besuchte Marie-Louise wahrscheinlich die großen Altmeistersammlungen im Museo del Prado. Die Farbpalette in mehreren Bildern, einschließlich *Spanisches Mädchen* aus dem Jahr 1928 (Abb. 17), das ebenfalls in Hinterbrühl unter Verwendung eines aus Spanien mitgebrachten Kostüms entstand, und die auffallende neue Tiefe ihres Realismus zeugen von dem Eindruck, den Goya, Velázquez und Zurbarán bei der jungen Künstlerin hinterlassen hatten.

Derselben Farbpalette bediente sich Marie-Louise bei verschiedenen Aktbildern, die sie um diese Zeit in Wien malte. Dies war für sie ein neues Genre, und das gelungenste dieser Bilder mit dem Titel *Akt auf dem Balkon* aus dem Jahr 1929 (Kat. Nr. 18) ist eigentlich ein Selbstbildnis der Künstlerin, die, nackt auf einer rosafarbenen Chaiselongue liegend, ein Sonnenbad nimmt. Schauplatz der Szene ist die Villa Todesco in Hinterbrühl, wo Marie-Louise nach wie vor die Sommermonate verbrachte. Später erklärte sie dazu: »Mein Zimmer und ein Gästezimmer öffneten sich zum Balkon. Ich schob das Canapée und einen großen, schweren Spiegel vom Gästezimmer hinaus auf den sonnigen Balkon, so dass ich mein eigenes Modell sein konnte. Es war Ende Juni, Anfang Juli, meine Lieblingsjahreszeit.«[41] Da sie keine Aktdarstellung von sich selbst anfertigen konnte, während sie dalag, studierte sie die verschiedenen Teile ihres Körpers im Spiegel und setzte sie dann zu einem einzigen Akt zusammen. Das Ergebnis ist ein sinnlich ausgestreckter, etwas puppenhaft wirkender Körper in einer verdrehten Position, die von den Falten eines leuchtend gelben, über das Sofa geworfenen Tuchs nachgezeichnet wird. Wie in vielen von Marie-Louises späteren Gemälden schwingen auch hier wieder subtile narrative Elemente mit: Die Balustrade des Balkons ist mit einem herzförmigen Muster verziert, und irgendwo in dem weitläufigen Park der Villa lässt eine unsichtbare Gestalt einen weißen Drachen steigen, der hinter der liegenden Nackten fröhlich ins Blickfeld schwebt. Das Selbstbildnis hat weniger Marie-Louises äußere Erscheinung im Fokus als vielmehr ihre romantischen Träume und Fantasien an einem warmen Sommertag.

Die zentrale Rolle, die Marie-Louises Familie in ihrem Leben spielte, führte in der Mitte der 1930er Jahre zu mehreren Porträts, insbesondere zu den ersten Bildnissen von Henriette und Karl. In *Henriette von Motesiczky, Porträt Nr. 1* (1929, Kat. Nr. 17) – das Bild, mit dem die Reihe der ihrer Mutter gewidmeten Porträts beginnt, die dann ungefähr 50 Jahre später mit den Bildnissen der alten Frau ihren Höhepunkt erreichen sollte (Kat. Nr. 57–59, 66, 74–78), ist Henriette im Bett liegend dargestellt, den Kopf auf den Arm gestützt. Marie-Louise konzentrierte sich auf den Kopf ihrer Mutter und kontrastierte ihre rosigen Wangen und ihre gesunde Ausstrahlung mit dem leidenden Gesichtsausdruck und den traurigen Augen. Etwas später kehrte sie zu demselben Motiv in *Siesta* (1933, Kat. Nr. 22) zurück, einer Pastellzeichnung, die Henriette bei ihrem Nachmittagsschlaf zeigt – einem Ritual, dem sie immer frönte. Während die Stimmung des ersten Bildes (in gedämpften Farben einer Skala von Rosa über Grau bis Beige) noch etwas strenger ist, feiert Siesta Henriettes sinnliche Hingabe an den Müßiggang: Auf dem Bauch liegend – das nach oben gerutschte Nachthemd legt ihren recht gerundeten Bauch und den Oberarm frei –, blickt Henriette den Betrachter mit den

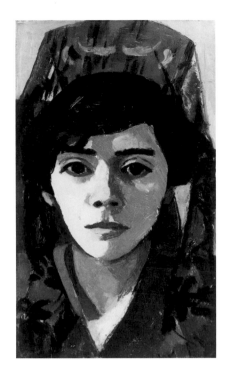

17 *Spanish Girl / Spanisches Mädchen*, 1928,
Oil on canvas / Öl auf Leinwand, 440 × 260 mm,
Private collection / Privatsammlung,
Switzerland / Schweiz

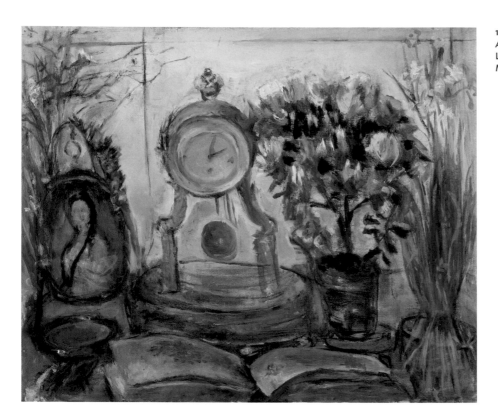

18 *Still-life with Azalea and Clock / Stilleben mit Azalee und Uhr*, 1974, Oil on canvas / Öl auf Leinwand, 508 × 610 mm, Marie-Louise von Motesiczky Charitable Trust, London

open, intelligent face. In a painting from the mid-1970s, Marie-Louise placed this miniature into a still-life, alongside a gold clock with a pendulum, an open book, and two pots of spring flowers (Fig. 18). The azalea and the narcissi—captured by Marie-Louise in all the freshness and beauty of their spring bloom—are destined to fade, as the clock marks the irrevocable passage of time. But Anna, who symbolises art and poetry, has retained her youth. The painting is a poignant reminder of our mortality, of the fragility and transience of beauty, themes that are always near the surface of Marie-Louise's work. It also expresses a sentiment that is equally fundamental to her achievement: the hope that in some mysterious way, art might conquer death.

aufgerissenen Augen eines Kindes an. Henriettes füllige Figur erscheint in *Auf der Jagd* (1936, Kat. Nr. 24) in einem völlig anderen Kontext. Dieses Mal sieht man sie in einem Boot im Schilfrohr kauern und mit ihrer Flinte auf die Enten zielen, die im Hintergrund davonfliegen. In Marie-Louises liebevoller Darstellung ihrer Mutter auf der Jagd ist sie in eine so energiegeladene Gestalt verwandelt, dass ein Kritiker sie später als »monströses Flintenweib« beschrieb.[42]

Außer einem nicht identifizierten Stillleben war *Akt auf dem Balkon* das einzige Bild, das Marie-Louise in den 1930er Jahren öffentlich in Wien zeigte, und zwar im Rahmen der Hagenbund-Ausstellung im April 1933. Die Hagenbund-Ausstellungsgesellschaft gilt als eher gemäßigte Organisation. Sie vermittelte zwischen den konservativen Künstlern, die jährlich im Künstlerhaus Schauen veranstalteten, und der revolutionären Wiener Secession, die neben Klimt und Schiele auch die großen Vertreter der französischen Moderne ausstellte. Tatsächlich wurde die Wiener Secession in den 1920er und 1930er Jahren immer konservativer. Viele Mitglieder an ihrer Spitze sympathisierten mit dem aufkommenden Faschismus, und nach 1930 wurden nur noch nichtjüdische Mitglieder des österreichischen Künstlerbundes in die Secession aufgenommen.[43] In den 1920er Jahren entwickelte sich der Hagenbund hingegen in ein Schaufenster für die kühnen expressionistischen Tendenzen, für die dem breiteren Wiener Publikum noch immer das Verständnis fehlte. Die meisten der Hagenbund-Künstler arbeiteten – wie Marie-Louise – im figurativen Stil und konzentrierten sich auf die traditionellen Genres der Porträt-, Stillleben- und Landschaftsmalerei.

So sah die viel versprechende Entwicklung der Künstlerin aus, als sie mit dem Aufstieg der Nazis, dem »Anschluss« Österreichs und Marie-Louises darauf folgendem Exil in Holland und England abrupt endete. Von da an war sie dazu verurteilt, viele Jahre ohne den Rückhalt eines wohlwollenden künstlerischen Umfelds zu arbeiten. Stattdessen musste sie mit den Entbehrungen eines Lebens im Exil und einer neuen künstlerischen Umgebung fertig werden. Als die Welt von Wien in ihren Werken wieder auftauchte, war es nicht mehr das Wien ihrer Kindheit und Jugend, sondern eine Welt, die durch die Erinnerung verändert war, ein Wien, dessen Überbleibsel sie in ihrem Haus in Hampstead bewahrte und die so oft in ihren Stillleben der reiferen Jahre erscheinen. So hob sie zum Beispiel zeitlebens ein von einem unbekannten Künstler gefertigtes Miniaturbildnis ihrer Großmutter Anna von Lieben auf, das diese als hübsches Mädchen mit langen braunen Zöpfen und einem offenen, intelligenten Gesicht zeigt. In einem Mitte der 1970er Jahre gemaltem Bild Marie-Louises findet sich diese Miniatur in einem Stillleben, neben einer goldenen Uhr mit einem Pendel, einem aufgeschlagenen Buch und zwei Töpfen mit Frühlingsblumen wieder (Abb. 18). Die Azalee und die Narzissen – von Marie-Louise in der ganzen Frische und Schönheit ihrer Frühlingsblüte eingefangen – sind ebenso dazu bestimmt zu verwelken, wie die Uhr das unwiderrufliche Vergehen der Zeit anzeigt. Anna von Lieben aber, die hier die Kunst und die Poesie symbolisiert, hat ihre Jugend bewahrt. Das Bild ist ein melancholisches Memento an unsere Sterblichkeit, an die Zerbrechlichkeit und Vergänglichkeit der Schönheit – Themen, die in Marie-Louises Werken stets unterschwellig präsent sind. Es drückt auch ein Gefühl aus, das ihrem Werk in gleicher Weise zugrunde liegt, nämlich die Hoffnung, dass die Kunst auf geheimnisvolle Weise den Tod besiegen könne.

Übersetzt aus dem Englischen von Sylvia Höfer

1 I wish to record my thanks to Andrew Crosbie for his editorial work on this essay and my debt to Ines Schlenker for kindly allowing me to use her unpublished *catalogue raisonné* of Marie-Louise von Motesiczky's paintings.

2 Werner Soukop, "Adolf Lieben—Nestor der organischen Chemie in Österreich. Über den Initiator des Lieben-Preises", in: *Die Liebens. 150 Jahre einer Wiener Familie*, exhib. cat., Jüdisches Museum, Vienna 2004, pp. 124–140.

3 Hans-Thomas Schmidt, "Unendliche Gedanken Denken. Robert von Lieben— ein großer Erfinder", in: *Die Liebens. 150 Jahre einer Wiener Familie*, exhib. cat., Jüdisches Museum, Vienna 2004, pp. 141–162.

4 John Kallir, "Tracing the Hermanns", unpublished manuscript. I wish to record my thanks to John Kallir for sharing with me his wide-ranging knowledge of family history.

5 Interview with Ernst von Lieben's grandson, Peter Verdamato, 2001.

6 Elias Canetti, *The Tongue Set Free. Remembrance of a European Childhood*, London 1988, p. 5.

7 Godehard Schwarz, *Villa Wertheimstein*, Vienna 1980, pp. 18–19. Hanns Jäger-Sunstennau, *Die geadelten Judenfamilien im vormärzlichen Wien*, phil. Diss., Vienna 1950.

8 Steven Beller, *Vienna and the Jews 1867–1938. A cultural history*, Cambridge 1980, p.188ff.

9 Unpublished manuscript in the archives of the Marie-Louise von Motesiczky Charitable Trust, London.

10 Theodor Gomperz, *Essays, Erinnerungen*, Stuttgart/Leipzig 1905, p. 197.

11 The correspondence has been donated to the Jewish Museum in Vienna.

12 Cited in: Rudolf Holzer, *Villa Wertesheim*, Vienna 1960, p. 80.

13 Anna von Lieben, *Gedichte: Ihren Freunden zur Errinerung*, Privately printed, K. u. K. Hofbuchdruckerei Carl Fromme, Vienna 1901.

14 In an interview with Kurt Eissler, Henriette von Motesiczky said that the family doctor Josef Breuer put Freud in touch with Anna, and this would seem the most likely explanation. In a published letter of October 24, 1887, Freud mentions to his wife's mother and sister that he had recently been asked by Chrobak to attend a joint consultation "at Frau L's". (cited by Peter J. Swales, "Freud, His Teacher and the Birth of Psycho-analysis", in: *Freud: Appraisals and Reappraisals*, ed. Paul E. Stepansky, New Jersey 1986, p. 26. One of Anna von Lieben's published poems is dedicated to Chrobak.

15 Josef Breuer and Sigmund Freud, *Studien über Hysterie*, Frankfurt am Main, 2003, p. 201.

16 In the interview with Kurt Eissler, Henriette von Motesiczky insisted that this was the most important aspect of his visits and the only true reason why her mother wished to see him. Freud refers to an episode when Breuer had refused to give Cäcilie M. "a drug she had asked for" in: *Studien über Hysterie*, ibid., p. 255.

17 Interview with Kurt Eissler, ibid.

18 Handschriftensammlung, 122.204, Vienna Stadtbibliothek, cited in: Swales, 1986 (Note 14), p. 57.

19 Unpublished poem by Henriette von Motesiczky included in the memorial album Marie-Louise made in 1982 of her mother's poems and drawings after her death in 1978, Archive of the Marie-Louise von Motesiczky Charitable Trust, London.

20 Several photographs of these "living pictures" can be found in the archives of the Marie-Louise von Motesiczky Charitable Trust, London. A letter from Hugo von Hofmannsthal to Richard Beer Hofmann, in: *Briefwechsel*, 1972, p. 203, describes the "tableaux vivants" at the Todesco palace. The Todesco, Gomperz and Wetheimstein families also inspired Hofmannsthal's notes for a Ringstrasse epic entitled "Andics", written in 1888, that remained unfinished at the time of his death. In these notes he described the families as "pleasure seekers in every sense" (Glücksucher auf allen Wegen").

21 Henriette von Motesiczky, "Erinnerungen" (Geschrieben für meine Tochter Marie-Louise und meine Cousine Fanny), unpublished manuscript in the archives of the Marie-Louise von Motesiczky Charitable Trust, London, dated October 1966, p. 7.

22 Henriette von Lieben, *Gedichte*, Druck und Verlag von F. Przibram, Vienna 1903.

23 Hubert Gaisbauer and Heinz Janisch (eds.), *Menschenbilder*, Vienna 1992, p. 172.

24 Diary in the archives of the Marie-Louise von Motesiczky Charitable Trust, London.

25 Gaisbauer 1986 (Note 23).

26 Karl studied law in Vienna (1924–1928), philosophy in Heidelberg (1928–1930) and theology in Marburg and Berlin (1930–1933) before following the communist and psychoanalyst Wilhelm Reich into exile in Oslo. During his time in Germany, Karl was active in the Socialist students' movement, giving speeches and writing for their journals. The portrait in the Marie-Louise von Motesiczky Charitable Trust, London, is dated 1928, the same period as Marie-Louise's memory of Karl's troubles with Hegel.

27 Henriette von Motesiczky, "Erinnerungen", ibid., p. 39.

28 Marie-Louise von Motesiczky, "About Myself", in: *Marie-Louise von Motesiczky. Paintings Vienna 1925–London 1985*, exh. cat., Goethe Institut, London 1985, p. 11.

29 Diary in the archives of the Marie-Louise von Motesiczky Charitable Trust, London.

30 Undated letter from Brian Fallon to the author, 2002. The Irish journalist Brian Fallon, who became a friend of Marie-Louise's in the 1980s, kindly recorded his memories of his conversations with the artist over a period of several years in this long letter, archives of the Marie-Louise von Motesiczky Charitable Trust, London.

31 Marie-Louise von Motesiczky, "Max Beckmann als Lehrer, Erinnerungen einer Schülerin des Malers", in: *Frankfurter Allgemeine Zeitung*, January 11, 1964.

32 Ibid.

33 Ibid.

34 Ines Schlenker, *Marie Louise von Motesickzy: Catalogue raisonné*, in preparation.

35 *Garderobe (Die Anprobe)*, 1928, oil on canvas, 81 × 60.5 cm, number 282 in: Erhard and Barbara Göpel, *Max Beckmann, Katalog der Gemälde*, 2 vols., Bern 1976.

36 Undated letter from Marie-Louise to Klaus Gallwitz, quoted in the *catalogue raisonné* of her paintings

37 Undated biographical notes in the archives of the Marie-Louise von Motesiczky Charitable Trust, London.

38 Stefan Zweig, *The World of Yesterday. An Autobiography*, London 1943, p. 248.

39 "In spite of the poor bulls and bullfighter it was very strange and exciting. Unfortunately most of the bulls looked more like cows than wild beasts and therefore had to be made brace in a very cruel way … the whole thing was something like a dangerous sex murder to a musical accompaniment. Nothing for weak nerves." Marie-Louise von Motesiczky to Henriette von Motesiczky, n. d. (1927) in the archive of the Marie-Louise von Motesiczky Charitable Trust, London.

40 Photographs that Marie-Louise took of the bullfight survive in the archives of the Marie-Louise von Motesiczky Charitable Trust, London, showing the same pronounced shadows that are evident in the painting, but seen from a more distant perspective.

41 Marie-Louise von Motesiczky to Ladislas Rice, April 10, 1989, collection Ladislas Rice.

42 Johann Muschik, "Auf Stippvisite in Wien. Secession. Marie-Louise Motesiczky zeigt Bilder aus 40 Schaffensjahren", in: *Neues aus Österreich*, May 22, 1966.

43 For a detailed history of the Vienna Secession, see *Secession, Permanence of an Idea*, exh. cat. Wiener Secession, Vienna 1997.

1 Herzlichen Dank an Andrew Crosbie, der diesen Aufsatz editiert hat, und vor allem an Ines Schlenker, die mir freundlicherweise ihren unveröffentlichten *Catalogue raisonné* zur Verfügung stellte.
2 Werner Soukop, »Adolf Lieben – Nestor der organischen Chemie in Österreich. Über den Initiator des Lieben-Preises«, in: *Die Liebens. 150 Jahre einer Wiener Familie*, Ausst.-Kat. Jüdisches Museum, Wien 2004, S. 124–140.
3 Hans-Thomas Schmidt: »Unendliche Gedanken denken. Robert von Lieben – ein großer Erfinder«, in: ebd. S. 141–162.
4 John Kallir, Tracing the Hermanns, unveröffentlichtes Manuskript. Die Autorin dankt John Kallir dafür, dass er sie von seinen weit reichenden Kenntnissen der Familiengeschichte profitieren ließ.
5 Interview mit seinem Enkel, Peter Verdamato, 2001.
6 Elias Canetti, *Die gerettete Zunge. Geschichte einer Jugend*, Frankfurt 1979, S. 9f.
7 Godehard Schwarz, *Villa Wertheimstein*, Wien 1980, S. 18–19; Hanns Jäger-Sunstenau, *Die geadelten Judenfamilien im vormärzlichen Wien*, phil. Diss., Wien 1950.
8 Steven Beller, *Vienna and the Jews 1867–1938*, a cultural history, Cambridge 1980, S. 188f.
9 Unveröffentlichtes Manuskript im Archiv des Marie-Louise von Motesiczky Charitable Trust, London.
10 Theodor Gomperz, *Essays. Erinnerungen*, Stuttgart/Leipzig 1905, S. 197.
11 Die Korrespondenz wurde dem Jüdischen Museum in Wien geschenkt.
12 Zitiert nach Rudolf Holzer, *Villa Wertheimstein*, Wien 1960, S. 80.
13 Anna von Lieben, *Gedichte, Ihren Freunden zur Erinnerung*, Privatdruck, K. u. k. Hofbuchdruckerei Carl Fromme, Wien 1901.
14 In einem Interview mit Kurt Eissler sagte Henriette von Motesiczky, dass der Hausarzt der Familie, Josef Breuer, die Verbindung zwischen Freud und Anna herstellte, und das scheint auch die plausibelste Erklärung zu sein. In einem Brief vom 24. Oktober 1887 erwähnt Freud gegenüber der Mutter und Schwester seiner Frau, dass er jüngst von Chrobak gefragt worden sei, ob er einer gemeinsamen Sitzung »bei Frau L.« beiwohnen möchte (zitiert nach Peter J. Swales »Freud, His Teacher and the Birth of Psychoanalysis«, in: Freud: Appraisals and Reappraisals, hrsg. von Paul E. Stepansky, New Jersey 1986, S. 26.) Eines von Anna von Liebens Gedichten ist Chrobak gewidmet.
15 Josef Breuer und Sigmund Freud, *Studien über Hysterie*, Frankfurt am Main, 2003, S. 201.
16 In dem Interview mit Kurt Eissler bestand Henriette von Motesiczky darauf, dass dies der wichtigste Aspekt seiner Besuche war und der einzig wahre Grund, warum ihre Mutter ihn überhaupt zu empfangen wünschte. Freud berichtet, dass Breuer sich einmal geweigert habe, Cäcilie M. »eine Droge zu verabreichen, nach der sie verlangt hatte«, in: *Studien über Hysterie*, ebd., S. 255.
17 Interview mit Kurt Eissler, ebd.
18 Handschriftensammlung, 122.204, Wiener Stadtbibliothek, zitiert in: Swales, 1986 (Anm. 14), S. 57.
19 Unveröffentlichtes Gedicht von Henriette von Motesiczky. Marie-Louise hatte es in das Gedenkalbum aufgenommen, das sie nach dem Tod der Mutter 1978 im Jahr 1982 aus deren Gedichten und Zeichnungen zusammenstellte. Archiv des Marie-Louise von Motesiczky Charitable Trust, London.
20 Mehrere Fotos dieser »Lebenden Bilder« finden sich im Archiv des Marie-Louise von Motesiczky Charitable Trust, London. Ein Brief Hugo von Hofmannsthals an Richard Beer Hofmann (*Briefwechsel*, 1972, S. 203) beschreibt das »tableau vivant« im Palais Todesco. Die Familien Todesco, Gomperz und Wertheimstein inspirierten Hofmannsthal 1888 zu Notizen über ein Ringstraßen-Epos mit dem Titel »Andics«, das jedoch unvollendet blieb. Hier nannte er die Familien »Glücksucher auf allen Wegen«.
21 Henriette von Motesiczky, »Erinnerungen« (Geschrieben für meine Tochter Marielouise und meine Cousine Fanny), unveröffentlichtes Manuskript im Archiv des Marie-Louise von Motesiczky Charitable Trust, London, datiert Oktober 1966, S. 7.
22 Henriette von Lieben, *Gedichte*, Druck und Verlag von F. Przibram, Wien 1903.
23 Hubert Gaisbauer und Heinz Janisch (Hrsg.), *Menschenbilder*, Wien 1992, S. 172.
24 Tagebuch im Archiv des Marie-Louise von Motesiczky Charitable Trust, London.
25 Gaisbauer (Anm. 23).
26 Karl studierte in Wien Jura (1924–1928), in Heidelberg Philosophie (1928–1930), in Marburg und Berlin Theologie (1930–1933), bevor er dem Kommunisten und Psychoanalytiker Wilhelm Reich ins Exil nach Oslo folgte. Während seiner Zeit in Deutschland war Karl in der sozialistischen Studentenbewegung aktiv und hielt Reden und schrieb Beiträge für ihre Zeitschriften. Das Porträt im Marie-Louise von Motesiczky Charitable Trust, London, ist von 1928 datiert, stammt also aus derselben Zeit wie Marie-Louises Erinnerung an Karls Probleme mit Hegel.
27 Henriette von Motesiczky, »Erinnerungen«, unveröffentlichtes Manuskript, Archiv des Marie-Louise von Motesiczky Charitable Trust, London, S. 39.
28 Marie-Louise von Motesiczky, »About Myself« in: *Marie-Louise von Motesiczky, Paintings, Vienna 1925–London 1985*, Ausst.-Kat., Goethe Institut, London 1985, S. 11.
29 Tagebuch im Archiv des Marie-Louise von Motesiczky Charitable Trust, London.
30 Undatierter Brief von Brian Fallon an die Autorin (2002). Der irische Journalist Brian Fallon, der sich in den 1980er Jahren mit Marie-Louise anfreundete, hielt in diesem langen Brief freundlicherweise seine Erinnerungen an seine Gespräche fest, die er im Laufe mehrerer Jahre mit der Künstlerin geführt hatte. Archiv des Marie-Louise von Motesiczky Charitable Trust, London.
31 Marie-Louise von Motesiczky, »Max Beckmann als Lehrer. Erinnerungen einer Schülerin des Malers«, in: *Frankfurter Allgemeine Zeitung*, 11. Januar 1964.
32 Ebd.
33 Ebd.
34 Ines Schlenker, *Marie-Louise von Motesiczky, Catalogue raisonné*, unveröffentlichtes Manuskript.
35 *Garderobe (Die Anprobe)*, 1928, Öl auf Leinwand, 81 × 60,5 cm, in: Erhard und Barbara Göpel, *Max Beckmann. Katalog der Gemälde*, 2 Bände, Bern 1976, Kat. Nr. 282.
36 Undatierter Brief Marie-Louises an Klaus Gallwitz, zitiert in: Ines Schlenker, *Catalogue raisonné*, ebd.
37 Undatierte biografische Hinweise im Archiv des Marie-Louise von Motesiczky Charitable Trust, London.
38 Stefan Zweig, *The World of Yesterday. An Autobiography*, London, 1943, S. 248.
39 »Es war trotz der schlechten Stiere u. Stierkämpfer doch sehr merkwürdig u. aufregend. – Leider hatten die Stiere mehr Ähnlichkeit mit Kühen als mit wilden Bestien u. mußten daher auf sehr grausame Art in Wut gebracht werden ... Das ganze hatte etwas von gefährlichem Lustmord mit Musikbegleitung. Nichts für zarte Nerven.«, Marie-Louise von Motesiczky an Henriette von Motesiczky, undatierter Brief (1927), im Archiv des Marie-Louise von Motesiczky Charitable Trust, London.
40 Fotos, die Marie-Louise von dem Stierkampf aufnahm, finden sich im Archiv des Marie-Louise von Motesiczky Charitable Trust, London. Darauf sieht man dieselben ausgeprägten Schatten, die auf dem Gemälde ins Auge fallen, jedoch aus größerer Distanz gesehen.
41 Marie-Louise von Motesiczky an Ladislas Rice, 10. April 1989 (Sammlung Ladislas Rice), Archiv des Marie-Louise von Motesiczky Charitable Trust, London.
42 Johann Muschik, »Auf Stippvisite in Wien. Secession. Marie-Louise Motesiczky zeigt Bilder aus 40 Schaffensjahren«, in: *Neues aus Österreich*, 22. Mai 1966, Archiv des Marie-Louise von Motesiczky Charitable Trust, London.
43 Zur detaillierten Geschichte der Wiener Secession siehe: *Secession, Permanence of an Idea*, Ausst.-Kat. Wiener Secession, Wien, 1997.

1 **Still-life with Coffee Pot (Stilleben mit Kaffeekanne)**

1925
Oil on canvas / Öl auf Leinwand
433 × 475 mm
Marie-Louise von Motesiczky Charitable Trust, London

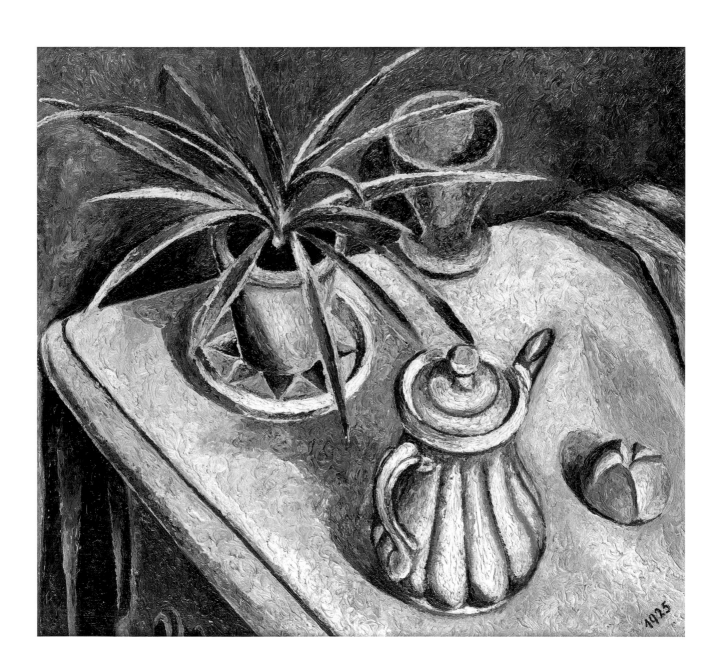

2 Street in Hinterbrühl (Straße, Hinterbrühl)

1925
Oil on canvas / Öl auf Leinwand
550 × 390 mm
Private collection / Privatbesitz

The artist's first landscape painting shows the street near the railway station in Hinterbrühl, a small village in the Vienna Woods south-west of the Austrian capital. In the 19th century, it became a popular holiday resort for wealthy Viennese families. Many grand villas were built there, including Villa Todesco, built by Moritz Todesco, an ancestor of the painter. In her childhood and youth, Marie-Louise regularly spent the summer here with her family. In her old age, she still remembered how intensely she had worked on this early painting, how she had counted the leaves on the trees and arranged the paints on her palette so that they did not become mixed.

Marie-Louise von Motesiczkys erstes Landschaftsbild zeigt die Dorfstraße im Bereich des Bahnhofs von Hinterbrühl, einem kleinen Ort im Wienerwald südwestlich der öster-reichischen Hauptstadt. Im 19. Jahrhundert wurde das Dorf zu einem beliebten Ferienort für wohlhabende Wiener Familien. Es entstanden viele herrschaftliche Villen, unter anderem auch die Villa Todesco, erbaut von Moritz Todesco, einem Vorfahren der Malerin. In ihrer Kindheit und Jugend verbrachte Motesiczky mit ihrer Familie dort regelmäßig den Sommer. Im Alter erinnerte sie sich noch, mit welcher Intensität sie an diesem frühen Bild gearbeitet hatte, wie sie die Blätter an den Bäumen zählte und die Farben auf die Palette häufte, damit sie sich nicht mischten.

3 View from the Window, Vienna (Blick aus dem Fenster, Wien)
1925
Oil on canvas / Öl auf Leinwand
625 × 310 mm
Tate Gallery, London, Inv. no. T 04849

Marie-Louise painted this view of Vienna in winter in her studio on Brahmsplatz, which was situated one floor above the family apartment. The dome of the Johann-Strauß Theatre, which the artist occasionally visited, can be seen rising above the jumble of snow-covered roofs, façades and courtyards.

Motesiczky malte diese Ansicht des winterlichen Wien in ihrem Atelier am Brahmsplatz, das ein Stockwerk über der Familienwohnung lag. Über dem Gewirr der verschneiten Dächer, Fassaden und Hinterhöfe erhebt sich die Kuppel des Johann-Strauß-Theaters, das in den 1920er Jahren für seine Operettenaufführungen berühmt war und das auch die Künstlerin gelegentlich besuchte.

4 Apache

1926
Oil on canvas / Öl auf Leinwand
461 × 270 mm
Marie-Louise von Motesiczky Charitable Trust, London

In the Paris of the 1920s, an "Apache" was a young man from the poorer suburbs who had no regular employment and lived from theft or prostitution. At the weekend, these "Apaches", who usually wore colourful scarves and slicked down their hair with hair cream, used to gather at fairgrounds or dances. Marie-Louise, who was studying at the Académie de la Grande Chaumière in Paris, is sure to have known the meaning of the word "Apache", but probably—as the horn buttons on the jacket suggest—took a model in her native Austria, making him more "exotic" by giving him almond-shaped eyes.

Im Paris der zwanziger Jahre verstand man unter »Apache« einen jungen Mann aus den ärmeren Vororten, der keiner geregelten Arbeit nachging und von Diebstahl oder Prostitution lebte. An den Wochenenden versammelten sich diese »Apachen«, die gewöhnlich ein buntes Halstuch trugen und ihr Haar mit Pomade glätteten, auf Rummelplätzen oder Tanzveranstaltungen. Motesiczky, die in Paris an der Académie de la Grande Chaumière studierte, kannte sicherlich die Bedeutung des Worts »Apache«, nahm sich aber wahrscheinlich – wie die Hirschhornknöpfe an der Jacke andeuten – ein Modell im heimatlichen Österreich, das sie durch die mandelförmigen Augen »exotisierte«.

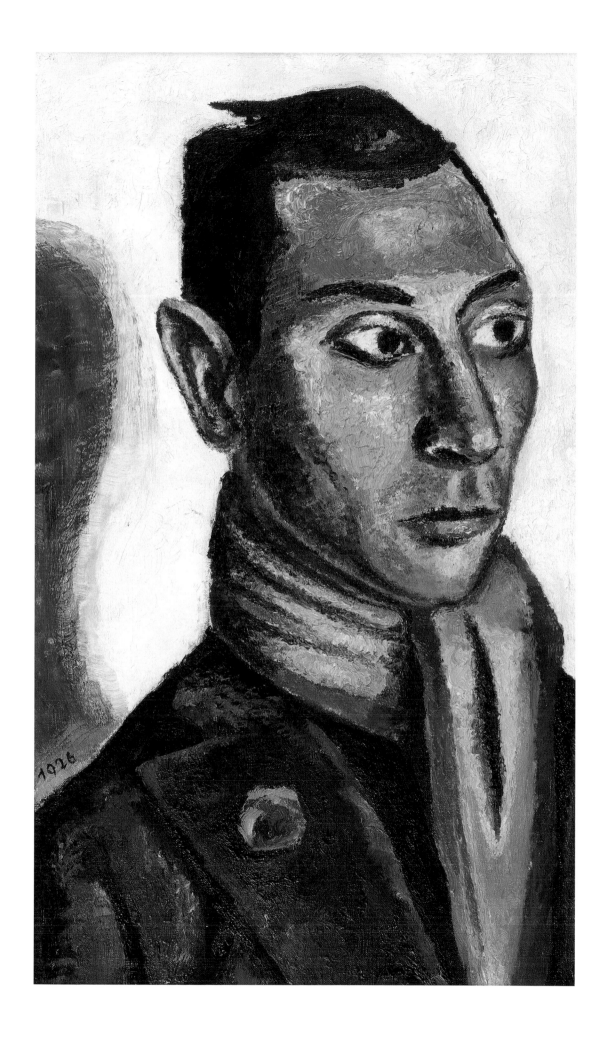

5 Self-portrait with Comb (Selbstporträt mit Kamm)

1926
Oil on canvas / Öl auf Leinwand
830 × 450 mm
Österreichische Galerie Belvedere, Vienna / Wien, Inv. no. 9094

This touching self-portrait of the 20-year-old artist shows the external features for which Marie-Louise was known among her friends and acquaintances: the big, questioning, some-what sad eyes, the piercing gaze, the long limbs—features that the painting especially emphasises. Beckmann provided the initial impetus for this portrait. While they were visit-ing the Louvre together, he praised El Greco's portrait *St Louis, King of France, with a Page*. Marie-Louise took this praise as a hint, imitating the style of the Spanish master in the pose and gracefully elongated hands of her picture. Beckmann's direct influence can also be clearly seen in the choice of colour and the unusual vertical format. Marie-Louise portrayed herself during the privacy of her morning toilette and not with the attributes of her profession, yet the comb and mirror call to mind brush and palette.

Dieses ergreifende Selbstbildnis der 20-Jährigen gibt die äußeren Charakteristika wieder, durch die Motesiczky in ihrem Bekanntenkreis auffiel: die großen, fragenden, etwas trauer-vollen Augen, der scharfe Blick, die langen Glieder – alles Eigenschaften, die das Bild ganz besonders betont. Max Beckmann gab zu diesem Porträt Anstöße. Bei einem gemeinsamen Besuch des Louvre lobte er El Grecos Porträt *Ludwig der Heilige, König von Frankreich, mit einem Pagen*. Motesiczky griff dieses Lob als Anregung auf und ahmte den Stil des spanischen Meisters in der Haltung und in den graziös verlängerten Händen nach. Beckmanns unmittel-barer Einfluss wird hingegen in der Wahl der Farben und des ungewöhnlichen Hochformats deutlich. Obwohl sich Motesiczky nicht mit den Attributen ihres Berufs umgab, sondern in einem privaten Moment bei der morgendlichen Toilette darstellt, lassen Kamm und Spiegel an Pinsel und Palette denken.

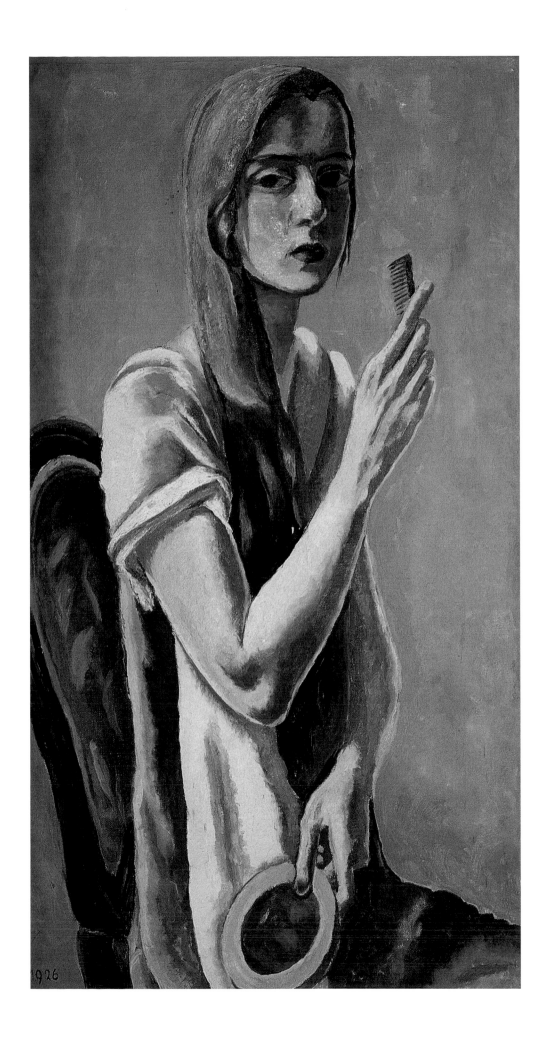

6 **Still-life with Tulips (Stilleben mit Tulpen)**
1926
Oil on canvas / Öl auf Leinwand
637×460 mm
Marie-Louise von Motesiczky Charitable Trust, London

The name printed on one of the books in the foreground in this still-life recalls the story of a friendship. "Laczi" was the artist's nickname for Baron Lajos Hatvany (1880–1961), also known as Ludwig Deutsch. Hatvany, who came from one of the most prominent families in Hungary, and was the owner of a sugar factory, but he was also a socialist, writer and patron of the arts, including Thomas Mann and Arthur Koestler amongst his friends. When Admiral Horthy came to power in 1920, Hatvany fled with his wife to Vienna and became involved in attempts to overthrow Horthy. It is likely that Marie-Louise met him in 1925, but the relationship ended when Hatvany decided to return to Hungary in 1927. In this still-life, the young painter expresses her admiration for the man through the reference to him as the author of one of the books depicted in the picture; this is probably Hatvany's study on Hungary's recent history, "Das verwundete Land" (The Wounded Country), published in 1921.

Das Stillleben erinnert durch den Namenszug auf einem der im Vordergrund verstreuten Bücher an die Geschichte einer Freundschaft. »Laczi« war Motesiczkys Spitzname für Baron Lajos Hatvany (1880–1961), auch bekannt als Ludwig Deutsch. Hatvany, Besitzer einer Zuckerfabrik, war Sozialist, Schriftsteller und Kunstmäzen. Er stammte aus einer der prominentesten Familien Ungarns und zählte Thomas Mann und Arthur Koestler zu seinen Freunden. Nachdem Admiral Horthy 1920 an die Macht gekommen war, floh Hatvany mit seiner Frau nach Wien und engagierte sich für den Sturz Horthys. Motesiczky lernte ihn vermutlich 1925 kennen, aber die Beziehung fand ihr Ende, als sich Hatvany 1927 entschloss, nach Ungarn zurückzukehren. In dem Stillleben drückt die junge Malerin ihre Bewunderung für den Mann durch den Hinweis auf ihn als den Autor eines der abgebildeten Bücher aus. Wahrscheinlich handelt es sich hier um Hatvanys 1921 veröffentlichte Untersuchung zu Ungarns jüngerer Geschichte »Das verwundete Land«.

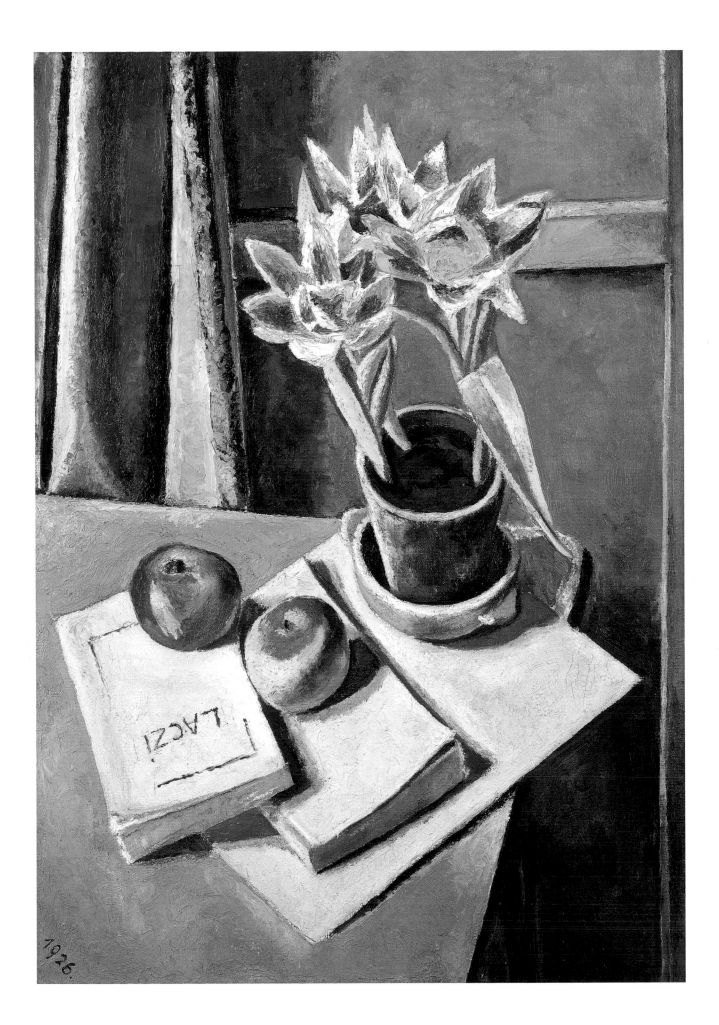

9 **Fräulein Engelhardt**
1926/27
Oil on canvas / Öl auf Leinwand
626 × 594 mm
Marie-Louise von Motesiczky Charitable Trust, London

After the early death of her husband in 1909, the artist's mother, Henriette von Motesiczky, took on a certain Fräulein Engelhardt as her companion. Fräulein Engelhardt was an elderly Viennese lady; the two women went on trips together and spent many hours in Vienna in one another's company. This portrait of the aged family friend is the first time the theme of ageing occurs in Marie-Louise's *œuvre*; she was to take it up again decades later in the great paintings of her mother.

Nach dem frühen Tod ihres Mannes im Jahr 1909 nahm sich die Mutter der Künstlerin, Henriette von Motesiczky, ein gewisses Fräulein Engelhardt zur Gesellschafterin. Es handelte sich um eine ältere Wiener Dame. Gemeinsam gingen die zwei Frauen auf Reisen und verbrachten in Wien viele Stunden miteinander. In dem Portrait der hochbetagten Familienfreundin begegnet man erstmals in Motesiczkys Œuvre dem Thema des Alters, das sie Jahrzehnte später in den großen Bildern ihrer Mutter wieder aufgreifen sollte.

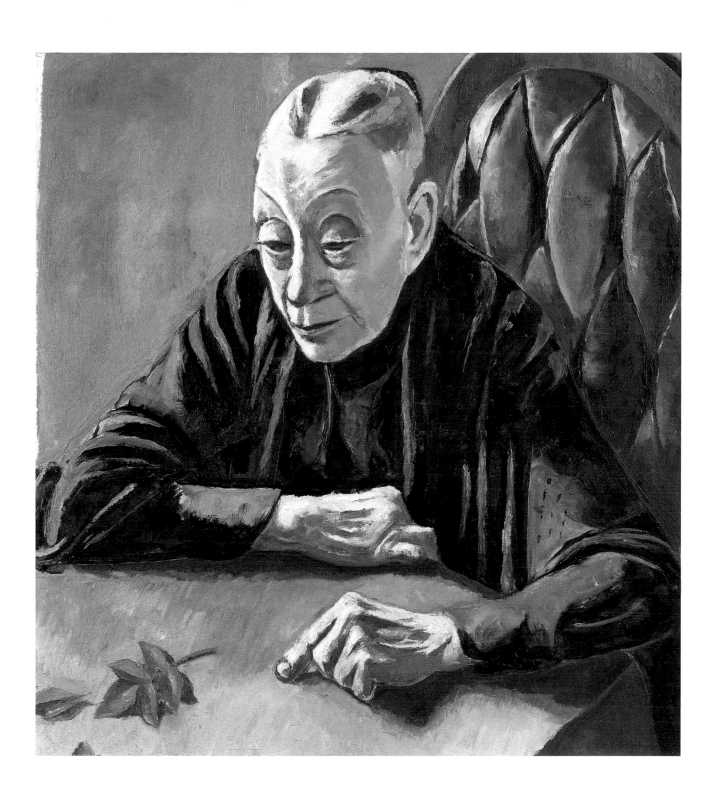

10 Kröpfelsteig, Hinterbrühl

1927
Oil on canvas / Öl auf Leinwand
614×572 mm
Marie-Louise von Motesiczky Charitable Trust, London

The Motesiczky family estate in Hinterbrühl was on the edge of the village, at Kröpfel-steig 42. The large property contained a tennis court, a greenhouse and stables, as well as the grand Villa Todesco with its 18 rooms. In this sun-drenched landscape, the painter shows the road that surrounds the estate and gently climbs on up the hill.

Das Anwesen der Familie Motesiczky in Hinterbrühl lag am Rand des Ortes, am Kröpfel-steig 42. Auf dem riesigen Grundstück befanden sich ein Tennisplatz, ein Schwimmbad, ein Glashaus und Stallungen sowie die herrschaftliche Villa Todesco mit 18 Räumen. In dieser sonnendurchfluteten Landschaft präsentiert die Malerin die Straße, die das Anwesen umgibt und sich sanft den Hügel hochzieht.

13 Dwarf (Zwerg, Hinterbrühl)

1928
Oil on canvas / Öl auf Leinwand
633 × 500 mm
Marie-Louise von Motesiczky Charitable Trust, London

The model for this daring half-length portrait was probably a road sweeper in Hinterbrühl. Like other paintings from these years, it documents Marie-Louise's interest in social themes and particularly in people on the fringes of society.

Das Modell für dieses kühne Brustbild war vermutlich ein kleinwüchsiger Straßenkehrer in Hinterbrühl. Zusammen mit anderen Gemälden jener Jahre dokumentiert es Motesiczkys Interesse an sozialen Themen und besonders an Randfiguren der Gesellschaft.

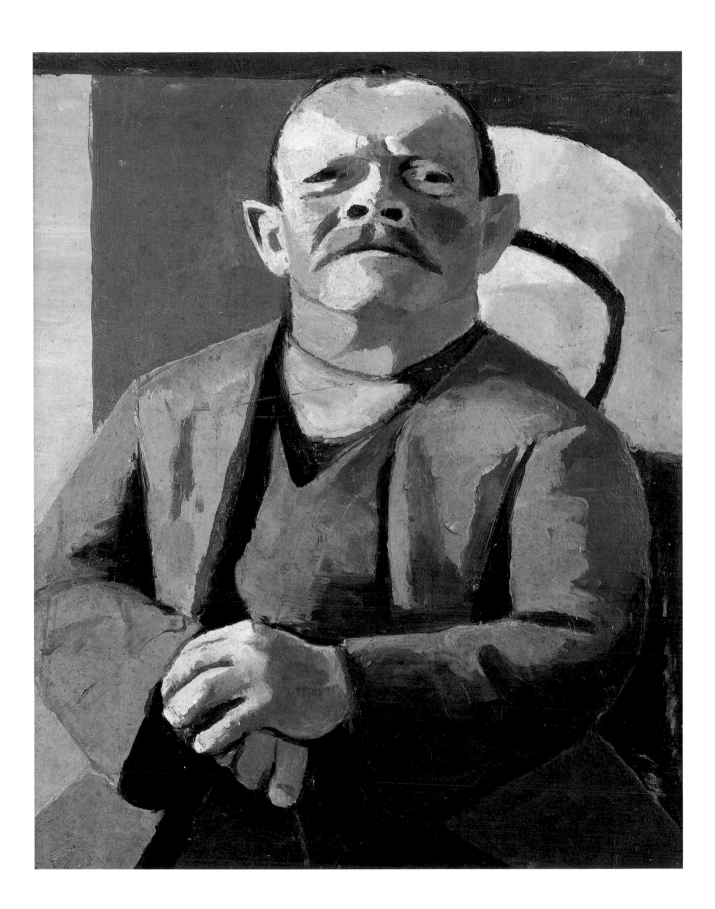

15 Still-life with Monkey on Garden Bench (Stilleben mit Affe)
1928
Oil on canvas / Öl auf Leinwand
362 × 490 mm
Private collection / Privatbesitz

For this still-life, which was painted at the family's summer residence in Hinterbrühl, Marie-Louise has placed a flower arrangement on a striped cushion next to a toy monkey upon a sunny garden bench. In the course of her career, the painter produced a large number of still-lifes, which were often inspired by flowers from her own garden. This small soft toy was only used once as a subject.

In diesem Stillleben, das auf dem Sommersitz der Familie in Hinterbrühl entstand, platziert Motesiczky auf einer sonnenbeschienenen, hölzernen Gartenbank ein Rosenarrangement auf einem gestreiften Kissen neben einem Spielzeugaffen. Die Malerin schuf im Laufe ihrer Karriere eine Fülle von Stillleben, die oft von Blumen aus ihrem eigenen Garten inspiriert waren. Das kleine Stofftier blieb ein einmalig verwendetes Objekt.

16 **Still-life with Scales (Stilleben mit Obst und Waage)**
1929
Oil on canvas / Öl auf Leinwand
444 × 313 mm
Marie-Louise von Motesiczky Charitable Trust, London

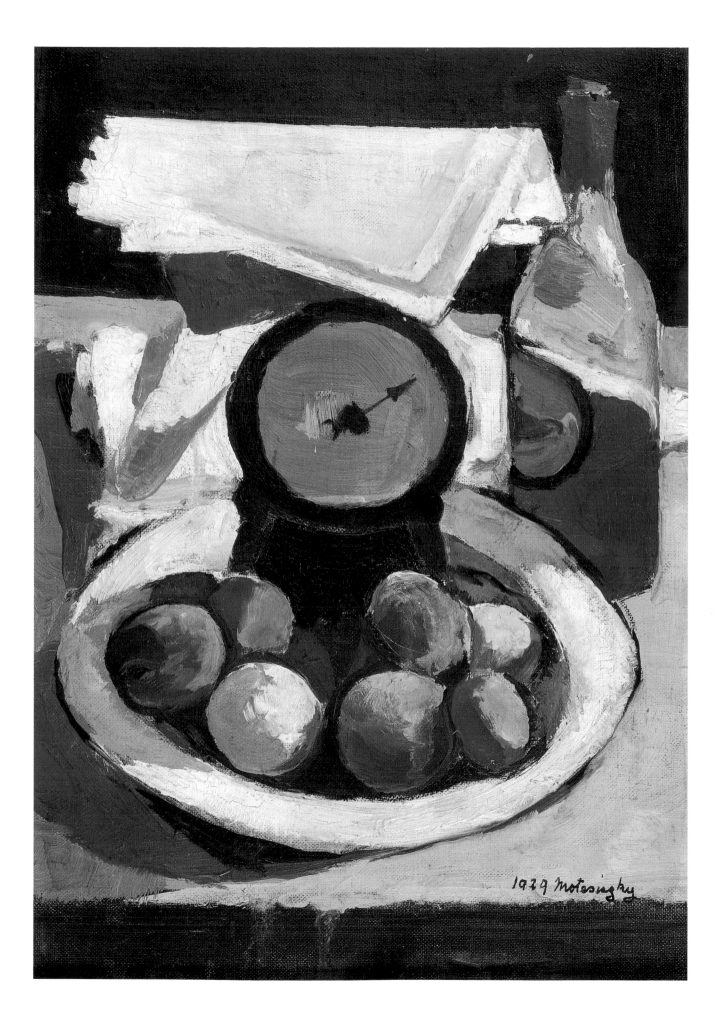

1929 Motesiczky

17 Henriette von Motesiczky—Portrait No. 1 (Henriette von Motesiczky – Porträt Nr. 1)
1929
Oil on canvas / Öl auf Leinwand
447 × 463 mm
Marie-Louise von Motesiczky Charitable Trust, London

In this, the first of a long series of portraits of her mother, the painter shows a robust middle-aged woman resting on her bed. This form of relaxation was not unusual for Henriette von Motesiczky, as friends of the house have often recounted (the drawing *Siesta* of the year 1933, cat. no. 22, also attests to this fact). Anna von Lieben, Henriette's mother, had also had the habit of withdrawing to her bed for long periods of time.

In diesem ersten aus einer langen Reihe von Porträts ihrer Mutter stellt die Malerin eine robuste Frau mittleren Alters dar, die sich auf ihrem Bett ausruht. Diese Art der Entspannung war für Henriette von Motesiczky nichts Ungewöhnliches, wie Freunde des Hauses immer wieder berichteten (davon zeugt auch die Zeichnung *Siesta* aus dem Jahr 1933, Kat. Nr. 22). Schon Anna von Lieben, Henriettes Mutter, hatte die Angewohnheit besessen, sich für längere Zeit ins Bett zurückzuziehen.

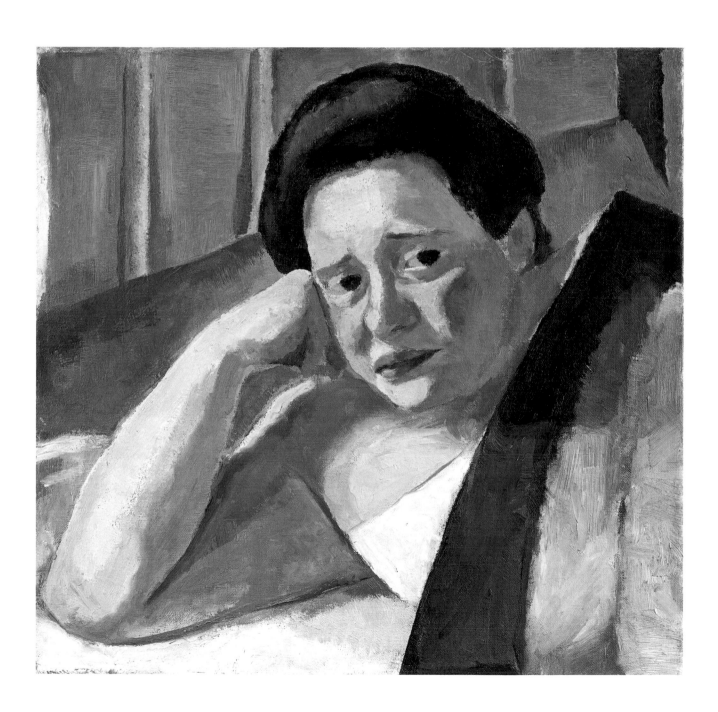

18 **The Balcony (Akt auf dem Balkon)**
1929
Oil on canvas / Öl auf Leinwand
480 × 600 mm
Private collection / Privatbesitz

The Balcony, along with an as yet unidentified still-life, was the first painting the artist exhibited publicly. It was shown in the "Frühjahrsausstellung des Hagenbundes" (Spring Exhibition of the Hagenbund) in Vienna in 1933. The neutral title disguises the fact that the young woman sunbathing on the sofa is actually a self-portrait. Marie-Louise painted this picture on the balcony in front of her rooms in the Villa Todesco in Hinterbrühl, from where she had a view of the garden, the woods and the surrounding hills. She overcame the difficulty of portraying herself naked in a recumbent position with the help of a large mirror, which allowed her to inspect the various parts of her body before painting them. The body that has been "assembled" in this way, with its extremely long and twisted legs, is almost doll-like.

Zusammen mit einem nicht identifizierten Stillleben war *Akt auf dem Balkon* das erste Gemälde, das Motesiczky 1933 in der »Frühjahrsausstellung des Hagenbundes« in Wien ausstellte. Der neutrale Titel ihres Bildes verschleiert die Tatsache, dass es sich bei der sonnenbadenden jungen Frau auf dem Sofa um ein Selbstporträt handelt. Motesiczky malte das Bild auf dem Balkon vor ihrem Zimmer in der Villa Todesco in Hinterbrühl, von dem aus sie den Garten, die Wälder und die Hügel der Umgebung überblickte. Der Schwierigkeit, sich selbst nackt in einer liegenden Position darzustellen, stellte sie sich mit Hilfe eines großen Spiegels, der es ihr ermöglichte, die einzelnen Körperteile nach einer visuellen Inspektion einzeln abzubilden. Der so zusammengesetzte Körper mit seinen extrem langen und verdrehten Beinen wirkt beinahe puppenhaft.

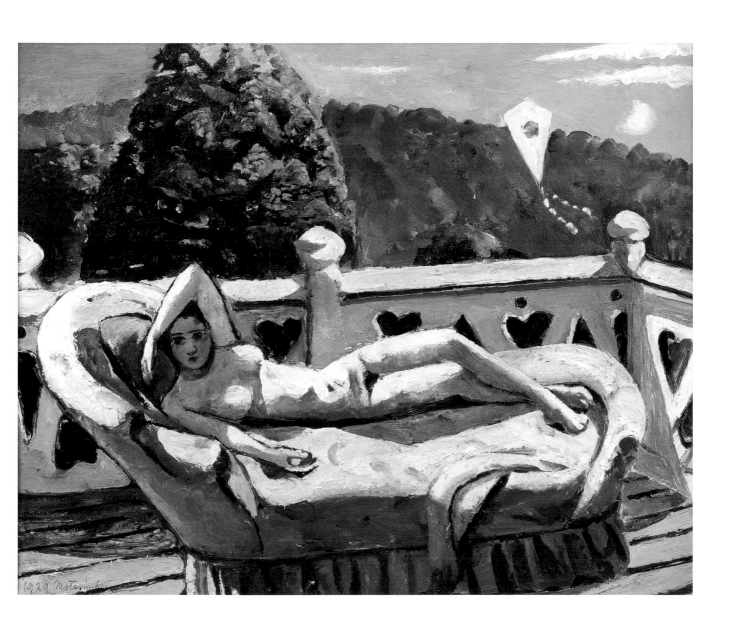

19 Self-portrait Playing Darts (Selbstporträt beim Pfeilwerfen)
late 1920s / späte 1920er Jahre
Pastel and charcoal on paper / Pastellkreide und Kohle auf Papier
612 × 466 mm
Private collection / Privatbesitz

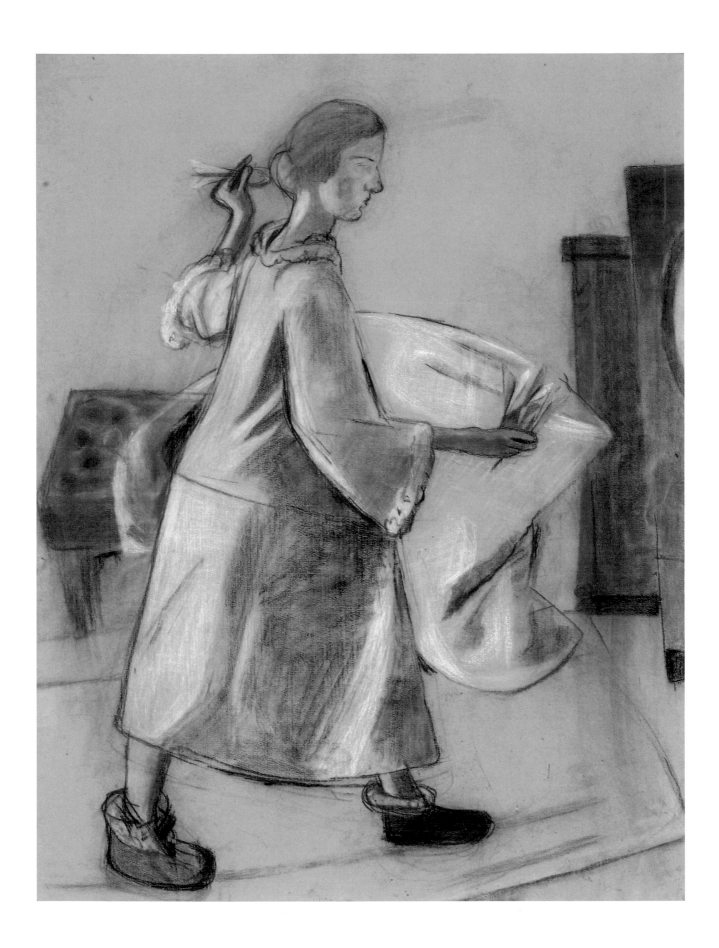

20 **At the Dressmaker's (Bei der Schneiderin)**
1930
Oil on canvas / Öl auf Leinwand
1150 × 610 mm
Fitzwilliam Museum, Cambridge, Inv. no. PD-55-1993

In this self-portrait, Marie-Louise depicts herself with the graceful self-confidence of youth. Yet the scene should not be misunderstood as an expression of female vanity, as the hand mirror, which shows no reflection, is hanging on the wall unused. Marie-Louise is looking at herself thoughtfully rather than admiringly. This picture has inspired other artists more than once. For example, it probably led Iris Murdoch to give the character Nina in the novel "Flight from the Enchanter" (1956) the profession of dressmaker. It also makes a short but anonymous appearance in Anita Brookner's novel "The Next Big Thing" (2003).

In diesem Selbstbildnis präsentiert sich Motesiczky mit anmutigem, jugendlichem Selbstvertrauen bei der Anprobe eines weißen Kleides im Salon ihrer Schneiderin. Doch darf diese Szene nicht als Ausdruck weiblicher Eitelkeit missverstanden werden, denn der Handspiegel, der kein Spiegelbild zeigt, hängt unbenutzt an der Wand. Motesiczky betrachtet sich selbst eher nachdenklich als bewundernd. Das Bild hat mehrfach andere Künstler angeregt. So inspirierte es wohl Iris Murdoch dazu, der Figur Nina in ihrem Roman »Flight from the Enchanter« (1956) den Beruf der Schneiderin zu geben. Außerdem feiert es einen kurzen, wenn auch anonymen Auftritt in Anita Brookners Roman »The Next Big Thing« (2003).

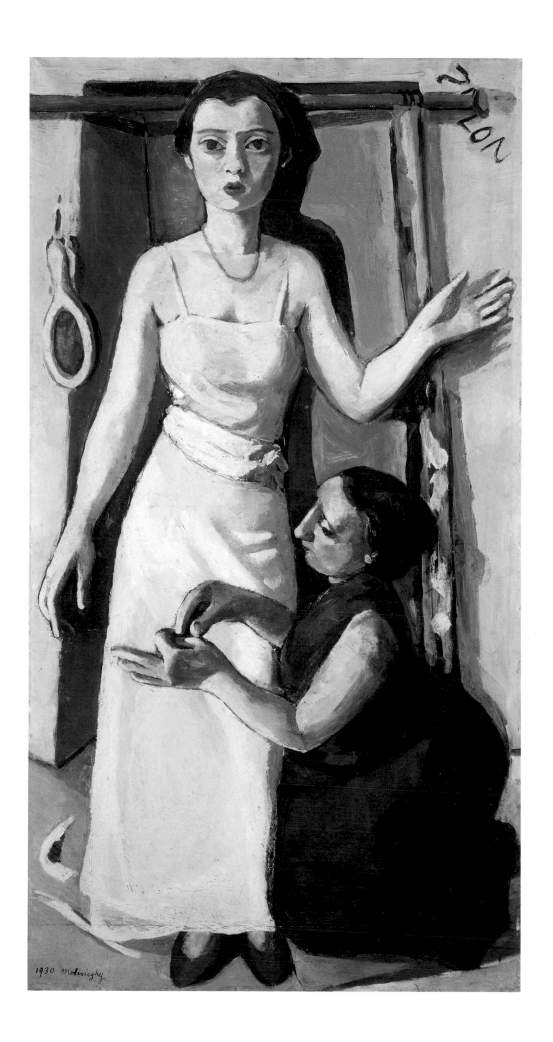

24 Hunting (Auf der Jagd)

1936
Pastel and charcoal on paper / Pastellkreide und Kohle auf Papier
459 × 568 mm
Marie-Louise von Motesiczky Charitable Trust, London

Henriette von Motesiczky, the painter's mother, was an enthusiastic huntress. She is to be seen in photographs (Fig. 54) posing proudly in front of shot stags. Members of the family recounted how, when staying at the villa in Hinterbrühl, Henriette used to like going out on the balcony in her nightgown with a gun early in the morning. When she came down to breakfast a little later, she would greet everyone cheerfully with the news that she had just shot a hare. The portrait shows the resolute huntress sitting in a boat amongst the reeds, aiming at ducks.

Henriette von Motesiczky, die Mutter der Malerin, war eine begeisterte Jägerin. Auf Fotos (Abb. 54) sieht man sie stolz vor erlegten Hirschen posieren. In Familienkreisen erzählt man sich, dass Henriette, wenn sie in der Villa in Hinterbrühl weilte, gern früh am Morgen im Nachthemd und mit einem Gewehr bewaffnet auf den Balkon hinausging. Wenn sie dann wenig später zum Frühstück herunterkam, begrüßte sie alle freudig mit der Nachricht, sie habe gerade einen Hasen geschossen. Das Portrait zeigt die resolute, massige Jägerin, wie sie, in einem Boot im Schilf sitzend, auf Enten anlegt.

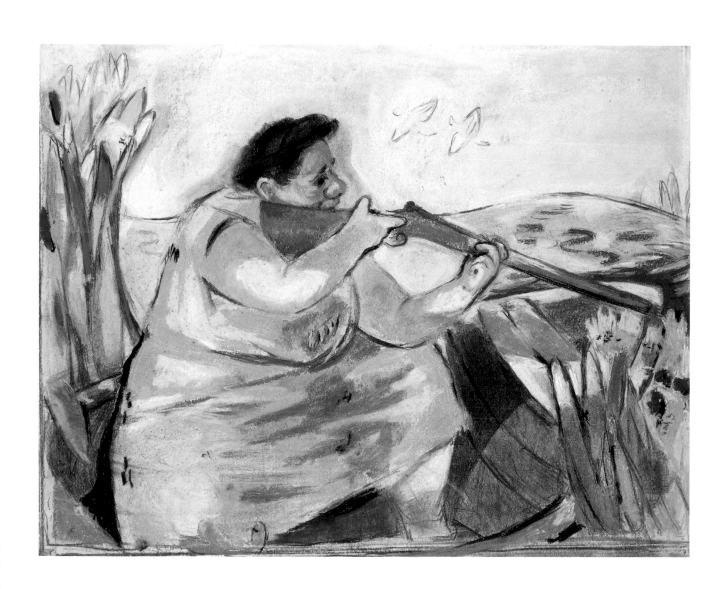

27 Hilda (Hilda, meine Milchschwester)

c. 1937 / ca. 1937
Oil on canvas / Öl auf Leinwand
345 × 283 mm
Marie-Louise von Motesiczky Charitable Trust, London

Hilda (Hilde) was the daughter of Marie Hauptmann (Fig. 64), Marie-Louise's Bohemian wet-nurse, who became a second mother to her and remained loyal to the family all her life. During her first position in Vienna, the young Marie Hauptmann became pregnant by the son of the house. Her illegitimate daughter, Hilda, who was probably born in 1906, was brought up by relatives. Marie found a new position with the Motesiczkys, but kept in contact with her daughter. Hilda and Marie-Louise were thus "milk sisters", both suckled by Marie as babies. The two girls also occasionally played with one another. As an adult, Hilda often lent her support to Karl von Motesiczky when he came into conflict with the Nazis during his fight for the family property. Hilda's fate remains unclear. She probably died during the Second World War, perhaps in the air raid on Dresden in February 1945.

Hilda (Hilde) war die Tochter Marie Hauptmanns (Abb. 64), Motesiczkys böhmischer Amme, die ihr zur zweiten Mutter wurde und der Familie ein Leben lang treu blieb. Während einer ersten Anstellung in Wien war die junge Marie Hauptmann vom Sohn des Hauses ge-schwängert worden, und ihre vermutlich 1906 unehelich geborene Tochter Hilda wuchs bei Verwandten auf. Marie Hauptmann fand eine neue Anstellung bei den Motesiczkys, hielt aber den Kontakt zu ihrer Tochter aufrecht. Hilda und Marie-Louise waren somit »Milch-schwestern«, die als Babys beide von Marie Hauptmann gesäugt worden waren. Die beiden Mädchen spielten auch gelegentlich miteinander. Die erwachsene Hilda setzte sich wieder-holt für Karl von Motesiczky ein, als dieser im Kampf um den Familienbesitz mit den Natio-nalsozialisten in Konflikt geriet. Hildas Schicksal bleibt ungeklärt. Sie starb vermutlich während des Zweiten Weltkriegs, vielleicht während des Bombenangriffs auf Dresden im Februar 1945.

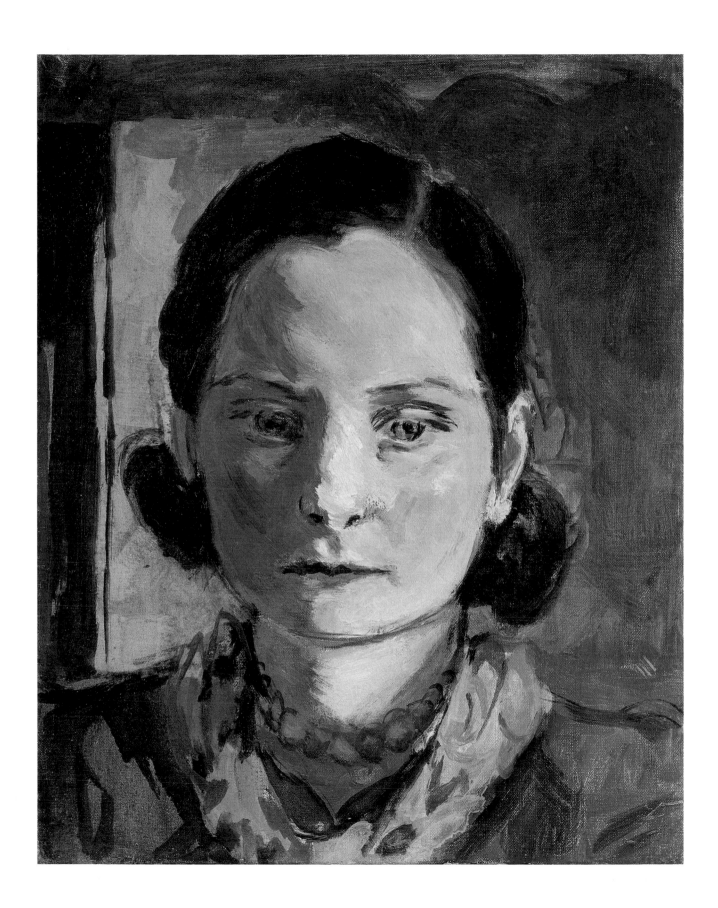

28 Frau Zischka

1938
Oil on canvas / Öl auf Leinwand
955 × 637 mm
Marie-Louise von Motesiczky Charitable Trust, London

Rosa Zischka, who probably worked in a bank in Vienna, became friendly with the Motesiczky family in the 1930s. The contact was resumed after the war, as the Motesiczkys regularly travelled to Vienna. For some years, Frau Zischka would seem to have lost something of her ample stature, but in 1956 Henriette von Motesiczky was able to report: "Frau Zischka ... looks nice and fat again, as in your picture."

Rosa Zischka, die vermutlich in einer Wiener Bank arbeitete, freundete sich wohl in den 1930er Jahren mit der Familie Motesiczky an. Der Kontakt wurde nach dem Krieg wieder aufgenommen, als die Motesiczkys regelmäßig nach Wien reisten. Frau Zischka scheint für einige Jahre ihre füllige Statur etwas eingebüßt zu haben. Henriette von Motesiczky konnte jedoch 1956 vermelden: »Frau Zischka ... schaut wieder gut u. dick aus, wie auf Deinem Bild.«

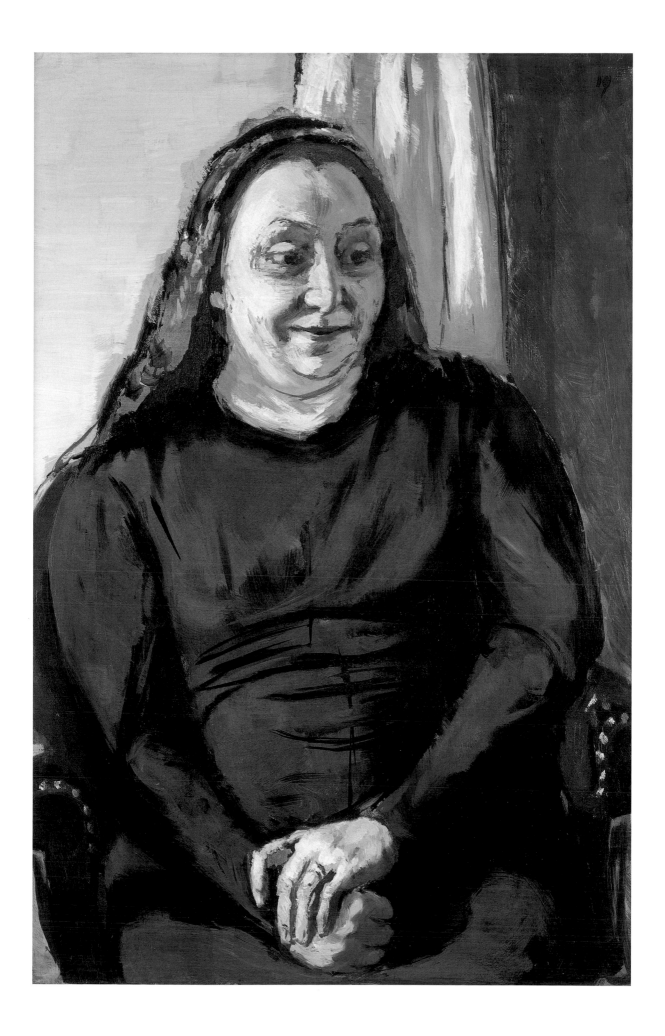

29 Self-portrait with Red Hat (Selbstporträt mit rotem Hut)
1938
Oil and charcoal on canvas / Öl und Kohle auf Leinwand
507 × 355 mm
Marie-Louise von Motesiczky Charitable Trust, London

This self-portrait is probably Marie-Louise 's best-known work. It has often been shown and discussed, and it appeared in most obituaries. It is emblematic of the style and her elegant appearance. However, for all its beauty, this painting is complicated, even enigmatic. It was painted at a time of political and personal change, possibly using a photograph as inspiration (see frontispiece). Shortly after the Nazis invaded Austria, Marie-Louise and her mother left their homeland and took refuge in Holland. The movement of the left hand can therefore be interpreted as a gesture of farewell to her native country. The mask-like, black profile at the right-hand edge of the picture may represent an unknown lover who remained behind.

Dieses Selbstporträt ist wahrscheinlich das bekannteste Werk Motesiczkys. Es wurde schon oft gezeigt, vielfach besprochen und auch in den meisten Nachrufen abgebildet. Geradezu als Markenzeichen fasst es ihren Stil und die Eleganz ihrer Erscheinung zusammen. Doch handelt es sich bei aller Schönheit um ein kompliziertes, auch hintergründiges Gemälde. Vielleicht unter Verwendung einer Fotografie (vgl. Frontispiz) schuf Motesiczky dieses Selbstbildnis in einer Zeit des politischen und persönlichen Umbruchs. Kurz nach dem Einmarsch der Nationalsozialisten in Österreich hatte sie Wien verlassen und Unterschlupf in Holland gefunden. So kann die Bewegung der linken Hand, die den Hut zurechtzurücken scheint, als Abschiedsgeste an ihre Heimat gedeutet werden. Das maskenartige, schwarze Profil am rechten Bildrand stellt einen unbekannten Liebhaber dar, der in der Heimat zurückblieb.

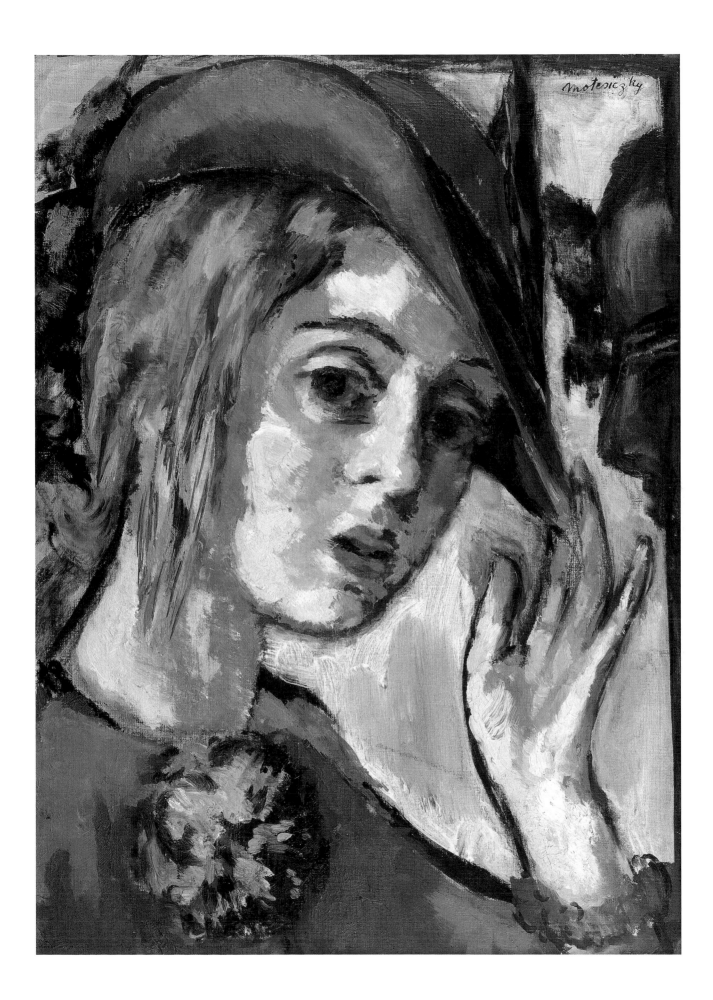

30 Still-life with Sheep (Stilleben mit Schafen)
1938
Oil on canvas / Öl auf Leinwand
400 × 805 mm
Tate Gallery, London, Inv. no. T 04850

Marie-Louise painted this picture in exile in Holland after fleeing from Austria in March 1938. So that she had something attractive to paint and dream about, while at the same time giving the impersonal hotel room a homely touch, she arranged different objects for a still-life. An ironing board served as a base—the most suitable surface available. Two Chinese enamelled cloisonné sheep from the 18th century dominate the arrangement. This were family heirlooms that mother and daughter had taken with them when they fled.

Dieses Bild schuf Motesiczky nach der Flucht aus Österreich im holländischen Exil im März 1938. Um etwas Schönes zu malen, dabei ein wenig zu träumen und das unpersönliche Hotel-zimmer familiär zu gestalten, stellte sie verschiedene Gegenstände für ein Stillleben zu-sammen. Als Unterlage diente ein Bügelbrett – die geeignetste Oberfläche. Es dominieren zwei emaillierte chinesische Cloisonné-Schafe aus dem 18. Jahrhundert, Familienerbstücke, die Mutter und Tochter Motesiczky mit auf die Flucht genommen hatten.

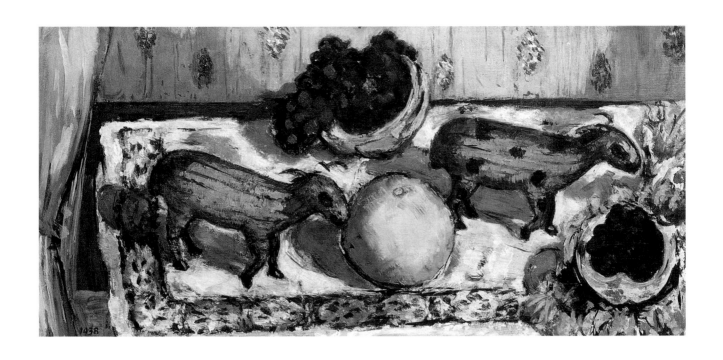

31 **Still-life with Cigarettes (Stilleben mit Zigaretten)**
1938/39
Oil on canvas / Öl auf Leinwand
425 × 335 mm
Private collection / Privatbesitz

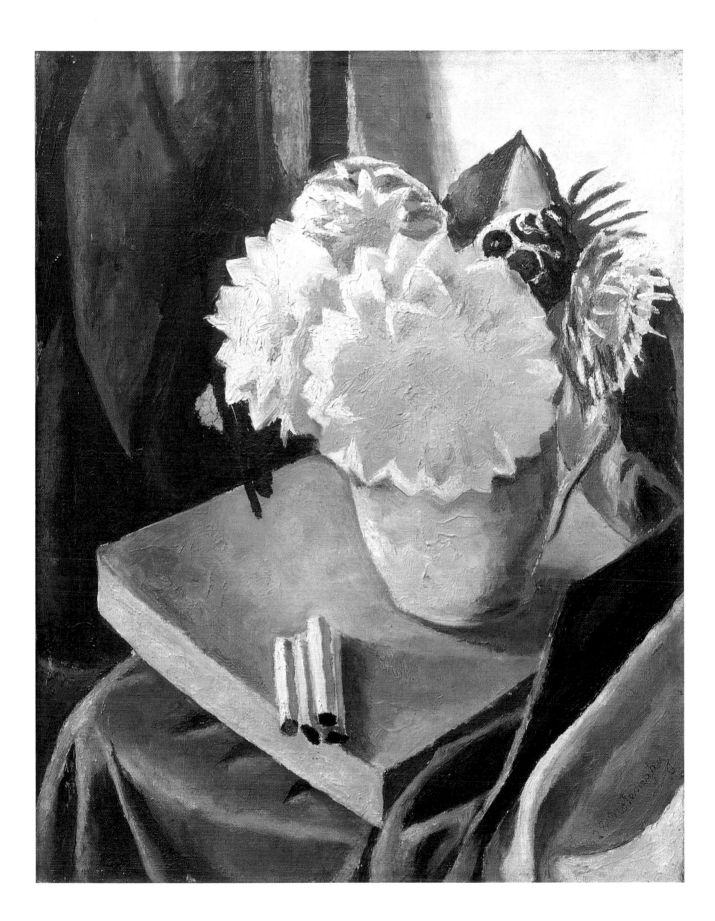

Birgit Sander

Marie-Louise von Motesiczky, Max Beckmann and Frankfurt

An ongoing dialogue with the art of Max Beckmann (1884–1950) accompanied the painter Marie-Louise von Motesiczky throughout the course of her life.[1] In the 1920s, she regarded this artist, who is today revered as one of the outstanding painters of the 20th century, as a shining example, and accordingly followed him as his student to Frankfurt. Even in her old age, he was still an influential role model for her: late in her career she drew inspiration while working at her studio in Hampstead from the catalogue of Beckmann paintings compiled by Erhard and Barbara Göpel and published in 1976.[2] But Marie-Louise always remained independent. With her choice of styles and motifs, she set her own personal accents, and had completely different aspirations for her work than Beckmann. She saw their relationship as a kind of personal affinity, and derived stimulus only from certain aspects of his work. Her orientation towards Beckmann was thus always coupled with a certain divergence and distance, as she was also influenced by completely different styles, including the Dutch painters of the 17th century, the work of Vincent Van Gogh, which she especially admired, and her fellow emigrant Oskar Kokoschka.

19 Max Beckmann, *Heinrich Simon*, 1922, Lithography / Lithographie, 520 × 309 mm

Encounter with the "Black Tightrope Artist"[3]

In 1920, the 14-year-old Marie-Louise von Motesiczky met Beckmann, then aged 36, for the first time. Her relative Irma Simon, wife of the editor-in-chief of the "Frankfurter Zeitung" newspaper, Heinrich Simon (Fig. 19), brought the painter home with her to the family's villa in Hinterbrühl near Vienna.[4] Beckmann had achieved success in Berlin before the First World War; then, after suffering a mental and physical collapse on the front, had settled in with friends in Frankfurt in 1915 and had come into contact with the Simons.[5] His war experiences had left him shattered, and as he struggled to comprehend the senselessness of human fate, his world view became radicalised. In the post-war years, he developed an expressive pictorial language of unusual formal power, taking as his theme the oddities and entanglements of modern human existence.

Marie-Louise von Motesiczky, with her interest in art, was overwhelmed by both Beckmann's charisma and his work: "A winged being from Mars could not have made a stronger impression on me, and the fact that I was also the chosen one who, alone among all the people I knew, could recognise that his pictures were beautiful and not ugly, and that the man from Mars was a good and not a bad spirit, this was very strange, even stranger than what Alice in Wonderland experienced when she fell down the rabbit hole."[6] At first, she knew only the artist's graphic works (Fig. 12, 13, 35). Then, on her first visit to Frankfurt in spring 1924 (Fig. 20), she saw the oil paintings in Beckmann's studio on Schweizer Strasse, as well as at the Simons' home and in Peter Zingler's gallery, and perhaps also at the Frankfurt Kunstverein, and was inspired to try her hand at oil painting. Beckmann's repeated encouragement— she had sent him photos of her pictures,[7] which he praised—reinforced her resolve to take up painting as a serious profession. Thanks to the approval and support of her mother, she was able to do so without fearing the financial consequences. She took art lessons in The Hague, Frankfurt, Vienna, Paris and Berlin, but Beckmann was always of special significance to her, as his moral stance was so congenial to her own nature. After having made his acquaintance, she visited him again in Frankfurt in 1926 and 1927 and attended his painting class at the Frankfurt Academy of Applied Arts during the 1927/28 semester.

It was at the Motesiczky's home in Vienna that Beckmann met the 20-year-old Mathilde Kaulbach in spring 1924, the daughter of the Munich painter Friedrich August von Kaulbach

Birgit Sander

Marie-Louise von Motesiczky, Max Beckmann und Frankfurt

Zeit ihres künstlerischen Lebens begleitete die Malerin Marie-Louise von Motesiczky der Dialog mit Max Beckmann (1884–1950).[1] In den 1920er Jahren sah sie ihn, der als einer der herausragenden Maler des 20. Jahrhunderts gilt, als leuchtendes Vorbild und folgte ihm als Schülerin nach Frankfurt. Noch im Alter wirkte sein Beispiel auf sie: So ließ sie sich in ihrem Atelier in Hampstead von dem von Erhard und Barbara Göpel herausgegebenen Werkkatalog der Beckmann-Gemälde inspirieren, der 1976 erschien.[2] Doch blieb sie immer unabhängig. In Stil- und Motivwahl setzte sie stets persönliche Akzente und vertrat in ihrer Malerei einen deutlich anderen Anspruch als Beckmann. Sie verstand ihre Beziehung als eine Art Wahlverwandschaft und nahm lediglich bestimmte Anregungen von ihm auf. So ging mit ihrer Orientierung an Beckmann auch immer Abweichung und Distanz einher, zumal sie Anregungen auch von ganz anderen Malern übernahm, etwa von niederländischen Malern des 17. Jahrhunderts, dem von ihr besonders geschätzten Vincent van Gogh oder aber ihrem Freund in der Emigration, Oskar Kokoschka.

Begegnung mit dem »Schwarzen Seiltänzer«[3]

1920 traf die 14-jährige Marie-Louise von Motesiczky erstmalig den damals 36-jährigen Beckmann. Ihre Verwandte Irma Simon, Ehefrau des Redaktionsleiters der Frankfurter Zeitung, Heinrich Simon (Abb. 19), brachte den Maler mit in die Villa der Familie in Hinterbrühl bei Wien.[4] Beckmann hatte vor dem Ersten Weltkrieg in Berlin Erfolge verzeichnet, sich dann nach einem psychischen und physischen Zusammenbruch an der Front 1915 bei Freunden in Frankfurt niedergelassen und dort auch Kontakte zu Simons geknüpft.[5] Die Kriegserfahrung hatte ihn erschüttert und seine mit dem Widersinn menschlichen Schicksals hadernde Weltanschauung radikalisiert. In den Nachkriegsjahren entwickelte er eine expressive Bildsprache von außergewöhnlicher Formkraft, die von den Absonderlichkeiten und Verstrickungen moderner menschlicher Existenz berichtete.

Die kunstinteressierte Marie-Louise zeigte sich von der Ausstrahlung wie vom Werk Beckmanns überwältigt: »Ein geflügeltes Wesen vom Mars hätte auf mich keinen größeren Eindruck machen können, und dass ich dazu ausersehen sein sollte, als Einzige unter all den Menschen, die ich kannte, zu erkennen, dass seine Bilder schön und nicht hässlich waren und der Mann vom Mars ein guter und kein böser Geist, das war sehr sonderbar, noch sonderbarer als das, was Alice im Wunderland erlebte, als sie in das tiefe Loch fiel.«[6] Zunächst kannte sie nur grafische Arbeiten des Künstlers (Abb. 12, 13, 35). Bei ihrem ersten Besuch in Frankfurt im Frühjahr 1924 (Abb. 20) sah sie dann auch Ölbilder in Beckmanns Atelier in der Schweizer Straße, im Hause Simon sowie in Peter Zinglers Kabinett und vielleicht auch im Frankfurter Kunstverein. Nun wollte auch sie sich der Ölmalerei zuwenden. Beckmanns wiederholte Ermutigungen – so schickte sie ihm auch Fotos ihrer Bilder[7], die er lobte – bestärkten sie darin, die Malerei als ernsthafte Profession anzugehen, was sie Dank der verständnisvollen Unterstützung ihrer Mutter ohne finanziellen Druck tun konnte. Sie nahm Kunstunterricht in Den Haag, Frankfurt, Wien, Paris und Berlin, aber Beckmann besaß für sie immer eine besondere Bedeutung, zumal die ethische Haltung des Künstlers ihrem eigenen Wesen entsprach. Nach der ersten Bekanntschaft suchte sie ihn 1926 und 1927 in Frankfurt auf und besuchte dessen Malklasse an der Frankfurter Kunstgewerbeschule im Semester 1927/28.

Im Hause Motesiczky in Wien lernte Beckmann im Frühjahr 1924 auch die damals 20-jährige Mathilde von Kaulbach, Tochter des Münchner Malers Friedrich August von Kaulbach

20 Max Beckmann, *Marie-Louise von Motesiczky*, 1924, Pencil on paper / Bleistift auf Papier, 482 × 320 mm, Karin und Rüdiger Volhard collection / Sammlung Karin und Rüdiger Volhard

(1850–1920). She was a friend of Marie-Louise, who was two years younger (Fig. 55). Beckmann sent the attractive young women joint letters[8] and portrayed them in a sensitive sketch (Fig. 16). When he and "Quappi"—a nickname bestowed by Marie-Louise's mother, Henriette—fell in love and married in 1925, Marie-Louise naturally felt a certain disappointment: in the rivalry for Beckmann's favour, her girlfriend had triumphed. Beckmann depicted a tense moment in the relationship between the two women in an oil painting of 1928 (Fig. 21): Quappi, standing, presents her friend, sitting in front of her, with a doll whose hands have been torn off. Quappi's friendly expression is countered here by distanced reserve on the part of Marie-Louise.

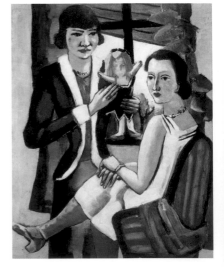

On the whole, however, the altered situation did not cloud relations between the three friends. Marie-Louise was soon back in Frankfurt at the side of the newly-wed artist, who had been appointed to a teaching position there. When in 1933 he lost his post because of the Nazi seizure of power, moving first to Berlin and then in 1938 to Amsterdam, they still maintained close contact. During Marie-Louise's short stay in Holland in 1938, the three met up once again. Marie-Louise and her mother persuaded a relative living in Holland at the time, Ilse Leembruggen, to buy some of Beckmann's works, which helped the artist in is financial straits.[9] On the right wing of the triptych *Actors* of 1941/42, Beckmann integrated portraits of Quappi and Marie-Louise, lending elements of his life at the moment to the picture, as he often did in his figurative scenes.[10] After the end of the war, in 1945, Marie-Louise sent her revered teacher painting utensils. In 1947 they saw each other again in Amsterdam, after which they regularly exchanged letters, even after Beckmann's move to the USA that same year. Three sketches dedicated to Marie-Louise made during Beckmann's Amsterdam period and found in her estate testify to his friendship and esteem for her (Figs. 22–24). Beckmann sent his friend some encouraging words from St. Louis on January 15, 1949: "Damn it, Pizchen, you really have talent; paint a few good pictures and the world will be beautiful again—for a time—and please stay in touch."[11] When Beckmann died of a heart attack in New York on December 27, 1950, Quappi notified her friend the very same day.[12]

The two would remain close friends. For example, on April 29, 1952, Quappi wrote to Marie-Louise from New York, congratulating her on a successful exhibition in Amsterdam: "Max would have been delighted at your successes; I know it, because he believed in you and your work and it would have really done him good."[13]

With Beckmann as her role model, the young Marie-Louise von Motesiczky had chosen an artist who, independent of both the avant-garde and traditionalists, stubbornly and with unflagging resolve pursued an ethically oriented art bound to reality and its figurative representation. He devoted his attention to traditional pictorial genres and took up modern stylistic tendencies in an effort to overcome the "isms" of the modern period. Beckmann, like Marie-Louise, wanted to break out of the modern movement's narrow obsession with issues of form, seeking instead to tackle the great themes of the world and of life, to create the kind of painting that would probe the questions of human existence. He thus wrote in 1918: "this is the only thing that can justify our actually quite superfluous and self-absorbed existences: That we give people an image of their destiny; and one can only do so if one loves them."[14] Both painters always aimed for sensual presence. Beckmann articulated his striving as follows: "My form of expression just happens to be painting. Burdened—or blessed—with a terribly vital sensuality, I have to see wisdom with my *eyes*. I emphasise my eyes in particular, because nothing would be more ridiculous and irrelevant than a cerebrally painted world view without the dreadful clamouring of the senses for every form of beauty and ugliness the visible world has to offer."[15] Marie-Louise had selected as her role model a painter whose art was more than just a way of taking a critical stance on society and the times, but which nevertheless reflected autobiographical and contemporary currents. Subjectivity formed the point of departure for the paintings of both artists, meaning neither egocentricity nor the cult of the self, but rather individual experience in general. Beckmann's theoretical notions were shot through by the idea of an art that should resist the absurdity of the world; as a moral authority, the artist would come to terms with man's existential fears and would raise human consciousness by means of what he called

21 Max Beckmann, *Two Ladies at the Window / Zwei Damen am Fenster*, 1928, Oil on canvas / Öl auf Leinwand, 1090 × 850 mm, Saarland-Museum Saarbrücken

22 Max Beckmann: *Beach scene / Strandszene*, 1938, Pencil on paper / Bleistift auf Papier, 177 × 217 mm, Marie-Louise von Motesiczky Charitable Trust, London (signed bottom right / bez. u. r.: Meinem lieben Pizchen Motesiczky zum 24. Okt. 38 Amsterdam von Beckmann)

(1850–1920) kennen. Sie war mit der zwei Jahre jüngeren Marie-Louise befreundet (Abb. 55). Beckmann sandte den attraktiven jungen Frauen gemeinsame Briefe[8] und porträtierte sie in einer sensiblen Bildniszeichnung (Abb. 16). Als sich zwischen ihm und Quappi – dieser Spitzname stammte von Marie-Louises Mutter Henriette – eine engere Beziehung entwickelte und beide 1925 heirateten, bedeutete dies für Motesiczky eine gewisse Enttäuschung. Die Freundin trug in der Rivalität um Beckmanns Gunst den Sieg davon. Ein spannungsvolles Moment im Verhältnis der Frauen deutete Beckmann 1928 in einem Ölgemälde an (Abb. 21): Die stehende Quappi präsentiert der vor ihr sitzenden Freundin eine Puppe, der die Hände abgerissen sind. Dem Sympathie bekundenden Gesichtsausdruck Quappis steht die distanzierte Verschlossenheit Marie-Louises gegenüber.

Insgesamt jedoch trübte die veränderte Situation das Verhältnis zwischen den drei Freunden nicht. Motesiczky suchte alsbald die Nähe des in Frankfurt frisch verheirateten und in ein Lehramt berufenen Künstlers. Als er 1933 diese Stelle durch die Nazis verlor und zunächst nach Berlin und 1938 nach Amsterdam ging, blieb der Kontakt weiterhin eng. Auch während Motesiczkys kurzem Aufenthalt in Holland im Jahr 1938 kam es zum Wiedersehen. Marie-Louise und ihre Mutter überzeugten ihre damals in Holland lebende Verwandte Ilse Leembruggen, Werke Beckmanns zu kaufen, was dem Künstler in schwieriger Lage half.[9] Auf dem rechten Flügel des Triptychons *Schauspieler* von 1941/42 integrierte er Porträts von Quappi und Marie-Louise, wodurch er – wie häufig in seinem Werk – figurativen Szenen aktuelle biografische Züge verlieh.[10] Nach Kriegsende 1945 übersandte Motesiczky ihrem verehrten Freund Malutensilien. 1947 kam es erstmals in Amsterdam zum Wiedersehen, dem ein kontinuierlicher Briefkontakt auch nach Beckmanns Übersiedlung in die USA im gleichen Jahr folgte. Drei Motesiczky gewidmete Zeichnungen in ihrem Nachlass aus Beckmanns Amsterdamer Zeit bekunden seine Freundschaft und Wertschätzung (Abb. 22–24). Der Freundin schrieb er am 15. Januar 1949 ermutigend aus St. Louis: »Verflucht noch mal Pizchen, Sie haben doch wirklich ein schönes Talent, malen sie ein paar gute Bilder und die Welt wird wieder schön – für eine Zeit und lassen sie weiter von sich hören.«[11] Als Beckmann am 27. Dezember 1950 in New York an einem Herzanfall starb, übermittelte Quappi ihrer Freundin noch am gleichen Tag die Nachricht.[12] Der Kontakt blieb weiterhin eng. Später z. B. gratulierte sie Marie-Louise, als diese 1952 erfolgreich in Amsterdam ausstellte, am 29. April 1952 aus New York: »Max hätte sich auch gefreut über Deine Erfolge, das weiß ich, denn er glaubte an Dich und Deine Arbeit und es hätte ihm merklich wohlgetan.«[13]

23 Max Beckmann, *Couple on a Bicycle / Paar auf dem Fahrrad*, 1945, Pen and ink on paper / Feder und Tusche auf Papier, 237 × 297 mm, Marie-Louise von Motesiczky Charitable Trust, London

24 Max Beckmann, *Man with Candle / Mann mit Kerze*, 1947, Pen and ink on paper / Feder und Tusche auf Papier, 240 × 163 mm (signed bottom right / bez. r. u.: für Pizchen souvenir Amsterdam 18. August 47 von Beckmann), Marie-Louise von Motesiczky Charitable Trust, London

Mit Beckmann als Vorbild hatte die junge Motesiczky die Entscheidung für einen Künstler getroffen, der unabhängig von den Avantgardisten wie auch von den Traditionalisten eigensinnig und mit nicht nachlassender Eindringlichkeit eine ethisch orientierte, an Realität und Figur gebundene Kunst verfolgte. Er wandte sich traditionellen Bildgattungen zu und nahm moderne Stiltendenzen auf, um die »Ismen« der Moderne zu überwinden. Beckmann wie Marie-Louise wollten die Verengung der Moderne auf Formprobleme aufbrechen, suchten Welthaltigkeit und teilnehmende Auseinandersetzung der Malerei mit Fragen menschlicher Existenz. So schrieb Beckmann 1918: »Das ist das einzige, was unsere eigentlich recht überflüssige und selbstsüchtige Existenz motivieren kann. Daß wir den Menschen ein Bild ihres Schicksals geben, und das kann man nur, wenn man sie liebt.«[14] Beide Künstler zielten stets auf sinnliche Präsenz. Beckmann formulierte dies für sich wie folgt: »Meine Ausdrucksform ist nun einmal aber die Malerei. Belastet – oder begnadet – mit einer furchtbaren vitalen Sinnlichkeit muß ich die Weisheit mit den *Augen* suchen. Ich betone besonders Augen, denn nichts wäre lächerlicher und belangloser wie eine zerebrale gemalte Weltanschauung ohne den schrecklichen Furor der Sinne für jede Form von Schönheit und Häßlichkeit des Sichtbaren.«[15] Motesiczky nahm sich einen Künstler zum Leitbild, dessen Kunst sich nicht in gesellschafts- und zeitkritischer Stellungnahme erschöpfte, wohl aber echohaft Autobiografisches und Zeitgeschichtliches verarbeitete. Dabei bildete für beide das Subjektive den Ausgangspunkt der Malerei, die weder Egozentrik noch Ich-Kult bedeutete, sondern individuelle Erfahrung ins Generelle einband. Wie ein Generalbass durchzog Beckmanns theoretische Überlegungen die Vorstellung von einer sich dem Widersinn der Welt entgegenstellenden Kunst, die als ethische Instanz existentielle Bewältigung und

others. She thus came into contact with the circles that shaped Frankfurt's intellectual and cultural life.[21] When she then returned to Frankfurt almost two and a half years later, in autumn 1926, this time living in the West End with the Hirsch family at Oberlindau, 51 (Fig. 26), Beckmann had already been teaching a painting class at the city's Academy of Applied Arts for about a year.[22] We know that she took part in a performance of the comedy "Der verwechselte Bräutigam" (The Mistaken Bridegroom) at the Frankfurter Hof hotel on April 7, 1927, with her brother Karl (Fig. 27, 56).[23] The theologian and sinologist Richard Wilhelm had translated the piece from the Chinese, and the actors were figures from Marie-Louise's Frankfurt circle: Irma Simon; Marie Swarzenski, wife of the Städel director; Käthe von Porada, a devotee of Beckmann and a friend of her mother from the Vienna days; as well as Fritz Wichert. After a summer sojourn in Vienna, in September 1927 Beckmann encouraged her to take part in his class officially, which she did from the beginning of 1928.[24]

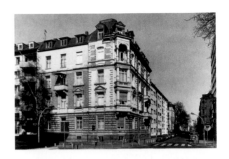

Marie-Louise soon made friends with her classmates, most of them men. Close friendships developed with Karl Tratt (1900–1937) and Theo Garve (1902–1987) (Fig. 28, 57) with whom she corresponded for the rest of her life. Although Tratt, whom she regarded as a talented painter, had fallen in love with her, she did not return his affections and instead their bond evolved into a platonic friendship.[25] Letters from Christoph Bernoulli of Basel, who tried his hand as both a journalist and actor, indicate that these two also enjoyed a close personal connection. It was during her Frankfurt days as well that she encountered the graphic artist and painter Siegfried Sebba (1897–1975), who was originally from Tilsit and worked in Berlin and Frankfurt. Sebba, who had found a patron in Simon, also stood under the influence of Beckmann for a time (Fig. 29, 58).[26] He and Marie-Louise were at one point very close.

After a caesura due to the war and her emigration to England, Marie-Louise resumed her ties with Frankfurt, particularly as, through her cousin Gretel Karplus, she was related by marriage to the Frankfurt School philosopher Theodor W. Adorno. They were close friends, going on holiday together in Sils Maria in the early 1960s and paying each other occasional visits. Adorno gave the painter some of his books, signing them with an affectionate dedication. (Fig. 66). In 1968 she accepted a commission to paint a portrait of the journalist, art critic and co-publisher of the "Frankfurter Allgemeine Zeitung" newspaper, Benno Reifenberg, and did preparatory studies in Kronberg and Frankfurt (cat. no. 70).[27] In 1980 she had 14 works on display at the exhibition "Max Beckmanns Frankfurter Schüler 1925–1933" at the Carmelite convent. On this occasion she met up with some of her former Frankfurt classmates (Fig. 71).[28] Press reports of the exhibition were enthusiastic; a passionate Beckmann admirer and collector, Lilly von Schnitzler, accorded the painter a special status among Beckmann's students.[29] Marie-Louise herself actively followed and supported the growing interest in Beckmann on the part of art historians in the decades after the war, and at an advanced age she visited the exhibition "Max Beckmann Gemälde 1905–1950" at the Städelsche Kunstinstitut in 1990 (Fig. 74).[30] Her works were also shown for a second time together with those of Beckmann after her death in an exhibition sponsored by the Frankfurt Sparkasse bank: "Aus der Meisterklasse Max Beckmanns. Karl Tratt, Friedrich Wilhelm Meyer und ihre Kommilitonen".[31]

26 During her stays in Frankfurt in 1926 and 1927, Marie-Louise lived at the corner Oberlindau 51, Photograph, c. 1990 / Im Eckhaus Oberlindau 51 wohnte Marie-Louise von Motesiczky bei ihren Aufenthalten in Frankfurt 1926 und 1927, Fotografie, ca. 1990, Institut für Stadtgeschichte, Frankfurt am Main

27 Marie-Louise von Motesiczky and her cousin Irma Simon at the play "Der verwechselte Bräutigam" (The Mistaken Bridegroom), April 1927, Frankfurt am Main, Photograph / Marie-Louise von Motesiczky und ihre Cousine Irma Simon in dem Theaterstück »Der verwechselte Bräutigam« im April 1927 in Frankfurt am Main, Fotografie, Marie-Louise von Motesiczky Charitable Trust, London

Beckmann as teacher, Beckmann as father figure

A text Marie-Louise published in 1964, "Max Beckmann als Lehrer" (Max Beckmann as Teacher), proves revealing not only with regard to her teacher but also to the author herself, who otherwise wrote little about her own painting. Beckmann's fascinating personality and the overwhelming power of his work had a strong impact on his students. Marie-Louise compared studying under him with learning a language: "Just as a child learns the languages with which one names the things of this world, we learned to call the world by names that were part of Beckmann's language."[32] She recounts his conviction "that he could tell his students and explain to them only what he himself considered right—but what a student needed to pursue, his own path, was something he had to find out for himself".[33] With this

Marie-Louise von Motesiczky, Max Beckmann and Frankfurt

wesentlich mitprägten.[21] Als sie sich dann fast 2½ Jahre später, ab Herbst 1926, erneut in Frankfurt aufhielt und im Westend bei einer Familie Hirsch, Oberlindau 51 (Abb. 26), wohnte, leitete Beckmann seit dem Vorjahr seine Malklasse an der Städtischen Kunstgewerbeschule.[22] Am 7. April 1927 nahm sie gemeinsam mit ihrem Bruder Karl an einer Aufführung des Lustspiels »Der verwechselte Bräutigam« im Hotel Frankfurter Hof teil, das der Theologe und Sinologe Richard Wilhelm aus dem Chinesischen übersetzt hatte (Abb. 27, 56).[23] Als Mitspielende finden sich mit Irma Simon, Marie Swarzenski, Ehefrau des Städel-Direktors Swarzenski, Käthe von Porada, Verehrerin Beckmanns und eine Freundin ihrer Mutter aus Wiener Tagen, sowie Fritz Wichert bekannte Namen ihres Frankfurter Umfelds. Nach einem Sommeraufenthalt in Wien ermutigte Beckmann sie im September 1927 zum offiziellen Lehrbesuch in seiner Klasse, den sie mit Beginn des Jahres 1928 wahrnahm.[24]

Die Kontakte der Wienerin zu ihren meist männlichen Kommilitonen entwickelten sich freundschaftlich. Mit Karl Tratt (1900–1937) und Theo Garve (1902–1987) (Abb. 28, 57) verband sie eine enge Freundschaft, die sich nach ihrem Weggang aus Frankfurt zeitlebens in Form von brieflichen Kontakten fortsetzte. Der von ihr als talentiert geschätzte Tratt war in heftiger Zuneigung zu seiner Mitstudentin entbrannt, die sie nicht erwiderte, aber die Beziehung mündete in gegenseitiger freundschaftlicher Verbundenheit.[25] Briefe des Baselers Christoph Bernoulli, der sich als Journalist und Schauspieler versuchte, lassen auf eine enge persönliche Verbindung schließen. In ihre Frankfurter Zeit fällt auch die Begegnung Motesiczkys mit dem aus Tilsit stammenden, in Berlin und Frankfurt tätigen Grafiker und Maler Siegfried Sebba (1897–1975), der – von Simon gefördert – zeitweilig ebenfalls unter dem Einfluss Beckmanns stand (Abb. 29, 58).[26] Mit ihm verband sie eine zeitweilig sehr enge Beziehung.

Nach der Zäsur durch Krieg und Emigration hielt Motesiczky ihre Verbindungen nach Frankfurt, zumal sie durch ihre Cousine Gretel Karplus mit dem Philosophen der Frankfurter Schule, Theodor W. Adorno, verschwägert war: Man unterhielt eine herzliche Freundschaft, verbrachte in Sils Maria in den frühen 1960er Jahren gemeinsame Ferien und besuchte sich ab und zu. Adorno schenkte der Malerin auch manche seiner Werke mit einer herzlichen Widmung (Abb. 66). 1968 nahm sie dann den Auftrag für ein Porträt des Publizisten, Kunstkritikers und Mitherausgebers der »Frankfurter Allgemeinen Zeitung«, Benno Reifenberg, an und hielt sich für Porträtstudien in Kronberg und Frankfurt auf (Kat. Nr. 70).[27] 1980 war sie mit 14 Werken auf der Ausstellung »Max Beckmanns Frankfurter Schüler 1925–1933« im Karmeliterkloster vertreten. Bei diesem Anlass traf sie mit ehemaligen Kommilitonen und Kommilitoninnen zusammen (Abb. 71).[28] Die Ausstellung erfuhr eine positive Presseresonanz. Lilly von Schnitzler, eine glühende Beckmann-Verehrerin und Sammlerin, räumte ihr einen besonderen Status unter den Beckmann-Schülern ein.[29] Die verstärkte kunsthistorische Beschäftigung mit Beckmann in den Nachkriegsjahrzehnten unterstützte und verfolgte sie aufmerksam und besuchte schließlich 1990 im hohen Alter auch die Ausstellung »Max Beckmann. Gemälde 1905–1950« im Städelschen Kunstinstitut (Abb. 74).[30] Nach ihrem Tode sollten 2000/01 ein zweites Mal Werke von ihr in der Ausstellung der Frankfurter Sparkasse »Aus der Meisterklasse Max Beckmanns. Karl Tratt, Friedrich Wilhelm Meyer und ihre Kommilitonen« vertreten sein.[31]

Beckmann als Lehrer, Beckmann als Vater

Der 1964 veröffentliche Text Motesiczkys »Max Beckmann als Lehrer« erweist sich nicht nur im Hinblick auf ihren Lehrer, sondern auch auf sie selbst, die sich wenig über ihre eigene Malerei äußerte, als aufschlussreich. Beckmanns faszinierende Persönlichkeit und die überwältigende Kraft seines Werks strahlten stark auf die Schüler aus. Motesizcky verglich denn auch das Studium bei ihm mit dem Erlernen einer Sprache: »Wie ein Kind die Sprachen erlernt, die die Dinge der Welt bei ihrem Namen nennt, so lernten wir die Welt in Namen nennen, die Beckmanns Sprache waren«.[32] Sie berichtete von seiner Überzeugung, »daß er seinen Schülern nur das sagen und erklären könne, was er von sich aus für richtig hielt – was aber ein Schüler für seinen eigenen Weg nötig habe, müsse er selbst finden«.[33] Mit diesem

28 Marie-Louise von Motesiczky and Theo Garve on the bank of the Main River, c. 1927/28, Photograph / Marie-Louise von Motesiczky und Theo Garve am Mainufer, Fotografie, ca. 1927/28, Marie-Louise von Motesiczky Charitable Trust, London

29 Siegfried Sebba, Self-portrait / *Selbstbildnis*, 1929, Oil on canvas / Öl auf Leinwand, 1150 × 430 mm, Private collection / Privatsammlung, Tel Aviv

modern model of art and creativity, Beckmann pursued the idea predominant since the Romantic era, that art could not be taught according to a fixed canon of rules but that, by teaching the fundamentals of the craft and providing personal suggestions, the teacher could nurture the unfolding of each student's own artistic power. He was not interested in claiming his own art as an absolute or in using his classes as a tool for disseminating his own style. From his later teaching activities in the USA we know that he did not want to "raise a herd of little Beckmanns".[34] Consistently committed to fostering self-knowledge, his learning methods were instead founded on his own belief in individualism, which always demanded independence and self-reliance. This attitude had a lasting effect on the young Marie-Louise, who single-mindedly pursued her own path.

At the same time, when looking back, she emphasised that for her "identification, a process of transforming oneself into one's model—whether present or past—is the best form of learning".[35] She saw identification as the basis for individuation. This recalls the theories of Sigmund Freud, the Viennese founder of psychoanalysis.[36] According to Freud, a human being's path to finding himself led through identification and appropriation; a person developed his own identity by first identifying with others. Marie-Louise von Motesiczky felt a strong affinity with Beckmann, who was a teacher and—perhaps because she had lost her own father at an early age—a father figure with whom she believed she shared a kindred spirit.[37] However, with her quest for "self-transformation", she diverged from the belief in the artist as a creative force emerging whole without any pre-conditions. Developed from the philosophy of transformation evolved by Marie-Louise's friend Elias Canetti, her idea of "self-transformation" meant achieving an individual position in the world. She therefore viewed her artistic development neither as emancipation nor critical distancing, but rather as a process of self-realisation.

Marie-Louise von Motesiczky knew what a towering aspiration Beckmann had connected with his painting in his determination to interpret the world. From her commentary on his work, however, it is evident that she never tried to penetrate more deeply into his philosophical or religious reflections. She did not believe one could comprehend his work through intellectual analysis alone. Her access to his work was intuitive, an identification that went beyond intellect and the senses, and which arose directly from the reality of the pictures themselves. She believed in the pictures as if "in an oracle".[38] Writing about Beckmann's world view, she paraphrased him as follows: "The belief in God, which we have lost, must be transferred to human beings themselves. Man must become God. A person who prays to God is really saying: I must help myself. What Beckmann demanded was the most intense form of self-experience; this also meant taking the greatest degree of responsibility for oneself. He did not perceive the history of creation as progress, but rather as an unwinding. The gods had perhaps concealed the meaning of the world at the beginning, in order that man, who was once God himself, could gradually lift the veil. But who am I to repeat things today that I probably did not really understand even at the time ... It all sounds fearfully grand, and perhaps it is more important to portray for young painters what kind of person he was in his daily life."[39] The reserve, even shyness, Marie-Louise shows with regard to philosophical reflection, was combined with a tendency to focus on what was graphically clear and straightforward, which is also apparent as an essential property of her painting.

In the Shadow of the Master—Interpretations and Appraisals

Art critics and historians have attributed various degrees of importance to Marie-Louise von Motesiczky's relationship with Beckmann. The criticism of her work as derivative and therefore weak can be disregarded as this is an undifferentiated blanket judgement.[40] Sensitive analyses by Ludwig Baldass in 1955,[41] Josef Paul Hodin in 1961/62,[42] Hilde Spiel in 1966 and 1986,[43] Benno Reifenberg in 1966,[44] Ernst Gombrich in 1985,[45] David Cohen in 1994,[46] Sabine Plakolm-Forsthuber[47] or Jill Lloyd in 2004,[48] on the other hand, have noted echoes of Beckmann in her colouration and painting technique, in the plasticity of her figures and objects, as well

modernen Kunst- und Kreativitätsmodell folgte Beckmann der seit der Romantik herrschenden Vorstellung, dass Kunst nicht nach einem festgelegten Regelkanon lehrbar sei, wohl aber die Vermittlung handwerklicher Grundlagen und individuelle Anregungen durch den Lehrer die Entfaltung selbständiger künstlerischer Potenz fördere. Ihm ging es keinesfalls darum, sich absolut zu setzen oder gar seine Klasse als Instrumentarium zur Verbreitung seines Stils zu benutzen. Aus seiner späteren Lehrtätigkeit in den USA wissen wir, dass er nicht »eine Herde kleiner Beckmanns heranziehen« wollte.[34] Seine konsequent auf Selbsterkenntnis angelegte Lehrmethode gründete vielmehr in seinem Individualismus, der stets Selbständigkeit, ja Selbstverantwortung einforderte. Diese Einstellung prägte nachhaltig auch die junge Motesiczky, die unbeirrbar ihre eigenen Wege gehen sollte.

Zugleich betonte sie rückblickend, dass für sie »Identifizierung, ein Sichverwandeln in das Vorbild – sei es eines der Gegenwart oder der Vergangenheit – die beste Form der Lehre ist.«[35] Identifikation verstand sie als Grundlage der Individuation. Dies erinnert an Thesen Sigmund Freuds, dem Wiener Begründer der Psychoanalyse.[36] Nach seiner Auffassung verlief der Weg des Menschen zu sich selbst über Identifikation und Aneignung, werde der Mensch zu dem, was er ist, erst aufgrund identifikatorischer Beziehungen. In Beckmann sah Motesiczky einen Wahlverwandten, eine ihr wesensnahe Lehrer- und – zumal sie ihren eigenen Vater in jungen Jahren verloren hatte – eine Vaterfigur.[37] Mit ihrer Forderung des »Sichverwandelns« wich sie von der Auffassung eines voraussetzungslos aus sich heraus schaffenden Künstlertums ab. Der Prozess des »Sichverwandelns«, den sie sich aus der Verwandlungslehre ihres Freundes Elias Canetti entwickelte, bedeutete für sie eine individuelle Positionierung. Sie begriff daher ihre Entwicklung weder als Emanzipation noch als kritische Distanzierung, sondern vielmehr als Verselbständigung.

Marie-Louise von Motesiczky besaß eine Vorstellung von dem großen Anspruch auf Weltdeutung, den Beckmann mit seiner Malerei verband. Aus ihrer Rückschau wird jedoch auch ersichtlich, dass sie nie in seine philosophischen oder religiösen Überlegungen tiefer einzudringen bestrebt war oder gar glaubte, dass seinem Werk mit analysierendem Intellekt allein beizukommen war. Ihr Zugang zu seinem Schaffen war intuitiv, ein über Intellekt und Sinne hinausgehendes Erkennen, das unmittelbar von der Wirklichkeit der Bilder selbst ausging, an die sie wie »an ein Orakel« glaubte.[38] Auf seine Weltanschauung eingehend, paraphrasierte sie: »Der Glaube an Gott, den wir verloren haben, muß in den Menschen selbst verlegt werden. Der Mensch muß Gott werden. Ein Mensch, der zu Gott betet, sagt in Wahrheit: hilf Dir selbst. Seine Forderung war die intensivste Form des Sichselbsterlebens; eben das war auch die größte Selbstverantwortung. Die Geschichte der Schöpfung empfand er nicht als Entwicklung, sondern als Abwicklung. Die Götter hätten vielleicht den Sinn der Welt zu Anbeginn verschleiert, damit der Mensch, der schon einmal Gott war, sie sich allmählich wieder entschleiere. Aber wer bin ich, daß ich die Dinge, die ich damals wohl kaum alle richtig verstanden habe, heute wiederholen dürfte ... Das klingt alles furchtbar großartig, und vielleicht wäre es viel wichtiger, ich könnte jungen Malern schildern, was für ein Mensch er war im täglichen Leben.«[39] Die Zurückhaltung, ja geradezu Scheu Motesiczkys vor philosophischer Reflexion verband sich mit einer Neigung zu Anschaulichem und Unverblümtem, was auch als Wesenszug ihrer Malerei wiederkehren wird.

Im Schatten des Meisters – Interpretationen und Wertungen

Die Kunstkritik und Kunstgeschichte werteten das Verhältnis Motesiczkys zu Beckmann unterschiedlich. Die Kritik, die ihr Werk als unselbständig und deshalb schwach einstufte, kann man aufgrund ihrer undifferenzierten Wertung vernachlässigen.[40] Einfühlsame Analysen von Ludwig Baldass 1955[41], Josef Paul Hodin 1961/62[42], Hilde Spiel 1966 und 1986[43], Benno Reifenberg 1966[44], Ernst Gombrich 1985[45], David Cohen 1994[46], Sabine Plakolm-Forsthuber[47] oder Jill Lloyd 2004[48] haben Beckmann-Anregungen in ihrer Farbgebung und Malweise, in der Plastizität von Figuren und Dingen sowie in der Raumauffassung festgestellt. Baldass erinnerte vor allem das Allegorische an ihren Lehrer. Gombrich sah die Verbindung

Self-Portraits

Self-portraits play a special role in Marie-Louise's work—as in that of Beckmann. As occasions for self-questioning, self-affirmation and self-discovery, they form a thread running through her entire *œuvre*. Beckmann's belief in the self as the only indestructible reality was unshakeable: "Becoming a 'self' is always the urge of all 'inessential souls' (wesenlose Seelen).—I search for this 'self' in my life—and in my painting."[58] Although Marie-Louise basically shared this viewpoint, her choice of motifs was evidently also determined by more pragmatic considerations. Hence her tongue-in-cheek acknowledgement that she herself was the most obvious model, since she—like her mother—was always available.[59] Unlike Beckmann, she never assumed different roles in her portraits or dressed up in costumes. Her portraits are more direct, more immediate, more concrete than those of Beckmann, and yet not without a subtle tension. Her earliest self-portrait—painted at the age of 20 (cat. no. 5)—unmistakeably betrays the mark of her teacher in the coolness of the pictorial standpoint and the sharpness of the drawing. The high, narrow format, the attenuated bodily proportions, the flatness of the pictorial space, with selected sections strongly modelled by the use of contrasts, and the slightly pastel colouration, all have their parallels in the work of Beckmann (Fig. 31). Inspired by the older painter's formal language, she uses it here in her own individual way to depict herself in a confident erect posture, although somewhat awkward in her movements as she prepares to go out. Mirror and comb allude to the fragility of her beauty. The motif of the mirror resonates with its traditional symbolism as a sign of knowledge as well as of vanity, lending the portrait an expression of early self-reflection.

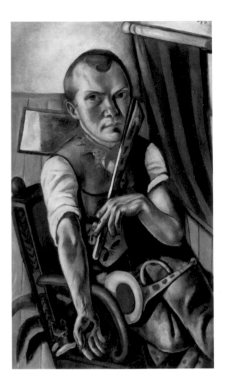

Ladylike elegance and a reserved penchant for fashionable extravagance characterise all of Marie-Louise's self-portraits (cat. no. 20, 26, 29, 42, 53, 89). However, she never parades her own beauty in a narcissistic, showy manner or depicts herself in a self-absorbed attitude of jaded sophistication. In a self-portrait with sensuous appeal, her bust-length *Self-portrait in Black* of 1959 (cat. no. 53), it seems as if Beckmann's fresh colours and softer painting style in the second half of the 1920s, with its more colour-intensive underpainting and the energetic use of black, had found a late reflection in her work. The pose brings to mind his famous *Self-portrait in Evening Dress* of 1927, which he painted in what was by his standards a particularly happy phase of his life (Fig. 32). In comparison with the defiant nonchalance and worldly elegance characterising Beckmann's grandiose self-portrait, designed to mesmerise the viewer, her own posture with her head tilted slightly downward seems pensive. The portrait of herself at 53 exudes feminine grace; her expression is dreamy, sensitive and vulnerable. The smooth finish of the early self-portrait has made way here for a new style. The paint is soft-textured, with pasty, wide brushstrokes emphasising the painting process. While using a technique involving coloured underpainting inspired by Beckmann, she nonetheless sets completely different accents. By alternating impasto with transparent veils of colour, along with the use of black, Beckmann had underlined the impression of the unreal, the hermetic and the enigmatic in his painting. Marie-Louise by contrast never applied these kinds of impenetrable layers of colour, and used black neither as local colour nor as contour. Her painting technique thus seems much more transparent and relaxed—a tendency that increased in later years.

In her last self-portrait, which shows her at age 87, an elegant hat covers her thinning hair and lightly applied makeup hides the paleness of her aged skin (cat. no. 89). With the open, tersely executed painting technique typical of her later work, the portrait seems to want to reaffirm a self that is in the process of physically disintegrating. The alertness of her gaze out of her large, round eyes is undiminished, testifying to the old woman's still-lively participation in life. Her self-portraits manifest a mixture of liveliness, melancholy and a spark of self-mockery—an attitude that fundamentally differentiates them from the inner tension and composure, from the earnest, auratic severity and form-accentuating style of Beckmann's late self-portraits (Fig. 33).

Selbstbildnisse

Im Werk der Motesiczky kommt den Selbstbildnissen – ähnlich wie bei Beckmann – ein besonderer Rang zu, denn als Orte der Selbstbefragung, Selbstbestätigung und Selbstfindung durchziehen sie das Gesamtwerk. Für Beckmann war der Glaube an das Ich als der einzigen unzerstörbaren Wirklichkeit unerschütterlich: »Ein ›Selbst‹ zu werden ist immer der Drang aller noch wesenlosen Seelen. – Dieses ›Selbst‹ suche ich im Leben – und in meiner Malerei.«[58] Mochte Motesiczky ihm grundsätzlich in dieser Auffassung folgen, so bestimmte ihre Motivwahl offenkundig auch ein pragmatischer Zug. So bekannte sie augenzwinkernd, dass sie sich selbst das naheliegendste Modell sei, weil sie – ähnlich wie ihre Mutter – stets verfügbar sei.[59] Anders als Beckmann schlüpfte sie nie in Rollen oder Kostümierungen. Ihre Bildnisse sind direkter, unmittelbarer, konkreter als die Beckmanns und doch nicht ohne hintergründige Spannung. Ihr frühestes Selbstbildnis – entstanden im Alter von 20 Jahren (Kat. Nr. 5) – verrät in der Kühle der Bildauffassung und der Schärfe der Zeichnung unverkennbar das Vorbild des Lehrers. Das schmale Hochformat, die überlängten Körperproportionen, die flächige Bildanlage bei partiell stark herausgearbeiteten Modellierungen und die leicht pastellig wirkende Farbigkeit haben Parallelen zu Werken Beckmanns (Abb. 31). Die von ihm inspirierte Formensprache nutzt die junge Malerin individuell zu einer Selbstdarstellung, in der sie sich als selbstbewusst aufrecht, zugleich auch ein wenig ungelenk bei der Toilette präsentiert. Spiegel und Kamm verweisen auf ihre fragile Schönheit. Im Motiv des Spiegels schwingt das Wissen um seine traditionelle Symbolik als Zeichen der Erkenntnis wie der Eitelkeit mit, was dem Bildnis einen Ausdruck früher Selbstreflexion vermittelt.

Damenhafte Eleganz und eine dezente Neigung zu modischer Extravaganz kennzeichnen Motesiczkys Selbstbildnisse insgesamt (Kat. Nr. 20, 26, 29, 42, 53, 89), ohne dass die Künstlerin auf narzistisch-aufdringliche Weise die eigene Schönheit bespiegelte oder sich in den Selbstbildnissen gar ein Ausdruck selbstbezogener mondäner Attitüde fände. Bei einem Selbstbildnis von sinnlicher Ausstrahlung wie ihrem halbfigurigen *Selbstporträt in Schwarz* von 1959 (Kat. Nr. 53) scheint es so, als hätte Beckmanns farbfrischere und weichere Malweise der zweiten Hälfte der 1920er Jahre mit farbintensiven Untermalungen und dem kräftigen Einsatz von Schwarz einen späten Reflex in ihrem Werk gefunden. In der Pose kommt dem Betrachter Beckmanns berühmtes *Selbstbildnis im Smoking* von 1927 in den Sinn, das er in einer für ihn besonders glücklichen Lebensphase schuf (Abb. 32). Gegenüber der herausfordernden Lässigkeit und weltmännischen Eleganz, die Beckmanns grandiose, auf bannenden Effekt ausgelegte Selbstdarstellung auszeichnet, wirkt Motesiczkys Haltung mit leicht geneigtem Kopf nachdenklich. Das Porträt der nunmehr 53-jährigen Frau strahlt weibliche Sanftmut aus, sie gibt sich versonnen, sensibel und verletzbar. Die malerische Glätte des frühen Selbstbildnisses ist gewichen. Die Farbe ist stofflich weich und malerisch aufgefasst. Pastose, breit hingestrichene Pinselzüge betonen das Prozesshafte der Malerei. Mit der von Beckmann inspirierten Technik farbiger Untermalungen setzte sie deutlich andere Akzente: Mit dem Wechsel von Pastosität und Transparenz des Farbauftrags und der Farbe Schwarz hatte Beckmann den Eindruck des Irrealen, Hermetischen und Tiefgründigen in seiner Malerei betont. Motesiczky setzte nie ähnlich undurchdringliche Farbschichtungen und räumte der Farbe Schwarz weder als Lokalfarbe noch als Kontur nie diese Präsenz ein. Ihre Malweise wirkt daher durchsichtiger und gelöster – eine Tendenz, die in den folgenden Jahren noch weiter zunahm.

In ihrem letzten Selbstbildnis, das sie mit 87 Jahren zeigt, kaschiert ein eleganter Hut ihr schütter gewordenes Haar und ein zartes Make-up die Blässe der gealterten Haut (Kat. Nr. 89). Mit der für ihr Spätwerk charakteristischen offenen, lakonisch vorgetragenen Malweise wirkt es, als würde ihr im physischen Verschwinden begriffenes Ich sich seiner selbst nochmals vergewissern. Ein unvermindert wacher Blick aus ihren großen, runden Augen zeugt von teilnahmsvoller Lebendigkeit der alten Dame. In ihrem Selbstporträt mischen sich Munterkeit, Melancholie und auch ein Funke von Selbstironie – eine Haltung, die sich von der inneren Anspannung und Sammlung, von der Ernsthaftigkeit, auratischen Strenge und

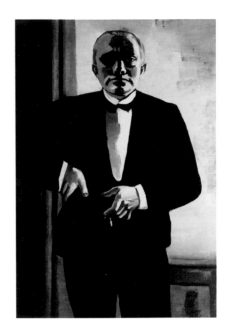

32 Max Beckmann, *Self-portrait in Evening Dress / Selbstbildnis im Smoking*, 1927, Oil on canvas / Öl auf Leinwand, 1410 × 960 mm, Busch-Reisinger Museum, Harvard University, Cambridge, MA

Portraits

In her portraits, Marie-Louise likewise took up impulses from Beckmann, but once again developed them in her own individual way. Her distanced portrait style of the 1920s, in which she plays the role of an objective observer, at times displaying a painstaking precision when dissecting her subject, as in *Workman, Paris* (cat. no. 8), *Fräulein Engelhardt* (cat. no. 9) or *Portrait of a Russian Student* (cat. no. 11), changed with time. She escaped the danger of anxious fixation on details and an overmeticulous verism. Her brushstrokes became increasingly generous, her colours fresher. Details were combined in lively phrases, while modelling became more plastic. She avoided decorative embellishments that distracted from the subject, and instead, like Beckmann, made do with adumbrated background elements, such as a chair or fragments of a curtain. At times, she focused on her subjects so closely that their faces fill the entire picture plane (Fig. 17).

These modifications lent her portraits added urgency and vitality, as demonstrated for example by *Dwarf* (1928, cat. no. 13), the earliest portrait of her mother, *Henriette von Motesiczky* (1929, cat. no. 17), *Hilda* (1937, cat. no. 27), *Frau Zischka* (1938, cat. no. 28) or *Frau Seidler* (1940, Fig. 43). By contrast with Beckmann, her concept of portraiture tended more towards physiognomic differentiation and reserved touches of liveliness created by the hint of a smile, an open mouth, wide-open eyes or eyebrows drawn gently together. One never finds in her portraits the mask-like severity and frozen facial expressions that characterise Beckmann's representations and make his subjects seem so bereft of individuality (Fig. 34). Beckmann saw his sitters with alarming acuity as alienated from all outer reality as well as from themselves. The forlornness of their gazes and their monumental aloofness signifies man's inward-looking nature, with the self segregated from the world around it.

Motesiczky's approach to portraiture assumed this stance as her springboard and yet took off in another direction. With the loosening up of her painting technique, coupled with a tendency to apply colour in thinner layers in the 1950s, clarity and directness entered her portraits. She became increasingly interested in her subject's inner experience, in exploring the reality behind the outer appearance. Portraits such as *Conversation in the Library* (1950, cat. no. 43), *Iris Murdoch* (1962, cat. no. 61) or *Benno Reifenberg* (1967, cat. no. 70) thus diverge from Beckmann's portrait style. The double-portrait of the intellectual masters Franz Baermann Steiner and Elias Canetti dispenses with the kind of authoritative reserve that would underscore the prestige of her sitters; instead, the figures' facial expressions and gestures give the impression that they are engaged in a lively, carefree intellectual exchange. The portrait of Iris Murdoch, which shows her apparently lost in thought, brings out the writer's inner countenance, while the translucent, open portrait of Reifenberg expresses the journalist's finely honed sensibilities and intellectual vitality.

A high point in her late portraiture is formed by the depictions of her mother (cat. no. 17, 54, 57–59, 66, 74–78). Coming to terms here with age and transience, she sounded one of painting's major themes with a privacy and intimacy that would have been unthinkable for Beckmann. And yet Marie-Louise was here once again pursuing in her own individual fashion Beckmann's credo of "giving people an image of their destiny".[60] With their expression of affection and compassion, her portraits also fulfil Beckmann's demand for empathy as the most important prerequisite for creating art.[61] The portrait series of her mother in her later years is realistic and yet discreet, never striving for a shock effect. With open brushstrokes, which lose themselves in the colours of the background, she succeeds in a masterly depiction of the evanescence of physical presence with advancing age. The liveliness and dignity of the personality are concentrated in the face and eyes, which reflect her mother's vitality in earlier years. With its touching but never sentimental, sometimes even humorous touches, this portrait series documents the artist's very considerable talent and humanity.

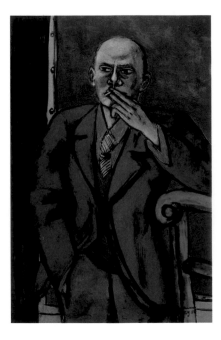

33 Max Beckmann, *Self-portrait / Selbstbildnis*, 1950, Oil on canvas / Öl auf Leinwand, 1395 × 915 mm, The Saint Louis Art Museum, St. Louis, Bequest of Morton D. May

formakzentuierenden Malweise der späten Selbstbildnisse Beckmanns fundamental unterscheidet (Abb. 33).

Porträts

In ihrem Porträtschaffen nahm Motesiczky ebenso Impulse von Beckmann auf, entwickelte aber auch hier ihre eigene Richtung. Ihr distanzierter, eher sachlich beobachtender Porträtstil der 1920er Jahre von bisweilen sezierend-minutiöser Genauigkeit, wie er in den Bildern *Arbeiter, Paris* (Kat. Nr. 8), *Fräulein Engelhardt* (Kat. Nr. 9) oder *Porträt eines russischen Studenten* (Kat. Nr. 11) zu sehen ist, wandelte sich mit der Zeit. Sie entging der Gefahr ängstlicher Detailfixiertheit und einem allzu akribischen Verismus. Ihre Pinselführung tendierte immer mehr zu Großzügigkeit, die Farbigkeit zu mehr Frische. Details wurden in schwunghaften Setzungen verbunden, Modellierungen großzügig angelegt. Sie vermied ausschmückendes, von der Personenerfassung ablenkendes Beiwerk, sondern beließ es wie Beckmann bei Motivandeutungen wie Stuhl- oder Vorhangfragmenten. Gelegentlich holte sie die Porträtierten so nah heran, dass ihre Physiognomien bildfüllend das Format einnehmen (Abb. 17).

Ihre Porträtmalerei gewann so an Eindringlichkeit und Vitalität, wie die Beispiele *Zwerg, Hinterbrühl,* 1928 (Kat. Nr. 13), das früheste Porträt ihrer Mutter *Henriette von Motesiczky – Porträt Nr. 1,* 1929 (Kat. Nr. 17), *Hilda, meine Milchschwester,* 1937 (Kat. Nr. 27), *Frau Zischka,* 1938 (Kat. Nr. 28) oder *Frau Seidler,* 1940 (Abb. Nr. 43) beweisen. Anders als Beckmann tendierte sie stärker zu physiognomischer Differenzierung und zu zurückhaltend mimischer Verlebendigung durch ein angedeutetes Lächeln, einen geöffneten Mund, weit geöffnete Augen oder sanft zusammengezogene Brauen. In ihren Bildnissen findet sich nie die maskenhafte Strenge und starre Mimik, die für das Porträtschaffen Beckmanns charakteristisch sind und seine Bildnisse entindividualisiert wirken lassen (Abb. 34). Er sah den Menschen mit erschreckender Schärfe von aller äußeren Wirklichkeit und von sich selbst entfremdet. Die Verlorenheit des Blicks und die denkmalhafte Distanziertheit der von ihm Porträtierten signalisieren ein von der Umwelt abgesondertes Bei-Sich-Sein des Menschen.

Motesiczkys Porträtauffassung knüpfte zwar daran an, wies aber doch in andere Richtung. Mit der Lockerung ihrer Malweise, die mit einem dünneren Farbauftrag in den 1950er Jahren einherging, traten Klarheit und Unmittelbarkeit in den Porträts zurück. Es ging ihr immer mehr um inneres Erleben, um Erkundung von Realität hinter der Realität. Porträts wie *Gespräch in der Bibliothek,* 1950 (Kat. Nr. 43), *Iris Murdoch,* 1964 (Kat. Nr. 61) oder *Benno Reifenberg,* 1968 (Kat. Nr. 70) unterscheiden sich damit fundamental von Beckmanns Porträtauffassung. Das Doppelporträt der Geistesgrößen Franz Baermann Steiner und Elias Canetti entbehrt offiziell-repräsentativer Distanziertheit, gibt sich in Mimik und Gestik als lebendig-unbekümmerte Schilderung intellektuellen Austauschs. Das Porträt der abwesend wirkenden Iris Murdoch kehrt das innere Gesicht der Schriftstellerin hervor, das transluzid-offene Porträt Reifenbergs die Sensibilität und geistige Vitalität des Publizisten.

Einen Höhepunkt ihres späten Porträtschaffens stellen die Bildnisse ihrer Mutter dar (Kat. Nr. 17, 54, 57–59, 66, 74–78). In der Auseinandersetzung mit Alter und Vergänglichkeit schlug sie ein großes Thema der Malerei an, wie es für Beckmann in dieser Privatheit und Intimität undenkbar gewesen wäre. Dabei folgte Motesiczky hier auf ihre ganz eigene Art nochmals Beckmanns Credo »dem Menschen ein Bild seines Schicksals zu geben«.[60] Mit ihrem Ausdruck von Zuneigung und Mitempfinden erfüllen sie zudem seine Forderung nach Empathie, die er als wichtigste Voraussetzung künstlerischen Schaffens ansah.[61] Die Porträtreihe ihrer Mutter ist wahrhaftig und zugleich diskret, sucht nie den schockierenden Effekt. Mit offenen Pinselsetzungen, die sich in den Farben des Hintergrunds verlieren, gelingt ihr eine meisterhafte Schilderung des Entweichens physischer Präsenz. Lebendigkeit und Würde der Person sind auf Gesicht und Augen konzentriert und spiegeln die Vitalität der Mutter, die diese in früheren Jahren auszeichnete. In ihren anrührenden, doch nie sentimentalen, ja bisweilen sogar humorvollen Zügen stellt diese Porträtfolge ein Dokument malerischen Könnens und menschlicher Größe dar.

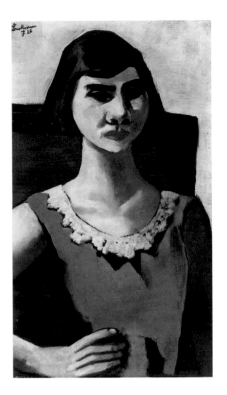

34 Max Beckmann, *Portrait of Quappi in blue / Bildnis Quappi in Blau,* 1926, Oil on canvas / Öl auf Leinwand, 605 × 355 mm, Bayerische Staatsgemäldesammlungen – Sammlung Moderne Kunst in der Pinakothek der Moderne, Munich / München

Figurative Painting

In her figurative painting, she neither echoes typical Beckmann themes, such as the theatre, acrobats and vaudeville shows (Fig. 35), nor imitates his trenchant depictions of the jaded bourgeoisie. An iconography of human brutality and horrors was alien to her. Nor did her painting revolve around mythical or literary subjects, as did above all Beckmann's hermetic late work of the 1930s and 40s, with its allusions to Christianity, Gnosticism, Kabbala and other themes. However, when in London she turned her attention to fantasy subjects, converting the realities of dreams and imagination into painted images, Beckmann's example may once again have shown her the way. In particular in his later years, Beckmann only found things worth painting that came together for him in a vision. Where acute observation and visionary experience penetrated Marie-Louise's work, however, she sought more than he did for direct connections to the reality of her own life.[62] But it was never a matter for her of seismographically depicting brief moments in life; she, too, aimed at symbolic expression, not at reproduction. The varying narrative approach taken by the two artists can be seen when contrasting Beckmann's triptych *Departure* of 1931/32 (Fig. 36) with her painting *The Travellers* of 1939 (cat. no. 32). On the side panels of his painting, Beckmann executed an iconography of terror in his scenes of martyrdom. The darkness, claustrophobia and brutality of the wings contrast with the serenity and radiant light of the central scene. In the bright noonday sun, mysterious figures drift along in a rowing boat on the blue sea—two men and a woman with a newborn baby in her arms—heading towards an unknown future. According to Beckmann, the child stands for freedom. The woman looks Madonna-like or antique, the man on the right with the crown is both monarch and fisherman, while the figure wearing a helmet on the left can be interpreted as Joseph, Charon or even as a self-portrait.[63] The visionary pictorial compression of different levels of time and reality cannot be interpreted. It had its roots in the experience of Nazi terror that, at a personal level, resulted in the artist's being driven from his teaching position. But its aspirations go far beyond a purely symbolic representation of historical and biographical events.

Marie-Louise's painting *The Travellers* shows four scantily clad fugitives in a small boat adrift on the high seas. The housekeeper, Marie Hauptmann, is depicted at the left, looking into a large mirror and smiling, while the artist's mother, Henriette, is at the centre of the scene, hugging a big salami. Another relative, perhaps the painter's uncle or brother, as well as the artist herself, cower fearfully in the boat. The painting was done during the early days of exile in London in a hotel room in which the family was waiting for their belongings to arrive. The painter later commented, "The picture 'The Travellers' represents the mood we, my mother and I and many other emigrants, were in at that time; people didn't know where they would end up, they applied for visas for Japan or America, had favourite objects with them, which they held onto for dear life. Sometimes it was like a ship of fools."[64] In contrast with Beckmann, her pictorial concept is based much more clearly on her concrete experiences and is—thanks to the artist's hints as to the identity of the subjects—to a certain extent interpretable in terms of her biography. At the same time, her work represents more than just a family-related document; it also records a specific moment in history. In this painting, she attempted to come to terms with her impressions of her flight from her homeland, which in her eyes could take on ridiculous, strange and even absurd qualities. She here alludes to traditional motifs such as the ship of fools, Noah's Ark and the Flood. In the humility of her aspirations, her work diverges strongly from the solemn and sacred echoes that Beckmann aimed to evoke with the choice of the triptych as a quasi-religious form. Characteristically, Marie-Louise never chose this format for one of her works.

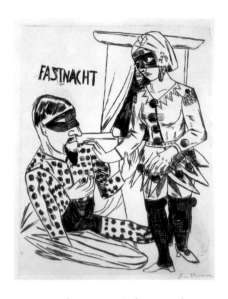

35 Max Beckmann, *Carnival / Karneval*, 1922, Etching / Radierung, 325 × 246 mm, Marie-Louise von Motesiczky Charitable Trust, London

Still-lifes

Still-life painting figured prominently in Marie-Louise's work throughout her career. The beauty and magic of reality captivated her, as it also did Max Beckmann, into frequently

Figurative Szenen

36 Max Beckmann, *Departure / Abfahrt*, 1932–1935, Oil on canvas (Triptych) / Öl auf Leinwand (Triptychon), 2155 × 115 mm/ 2155 × 995 mm, The Museum of Modern Art, New York

In ihrer figurativen Malerei spielten weder Beckmanns Theater-, Akrobaten- oder Varieté-thematik (Abb. 35) noch seine bissigen Schilderungen mondäner Bürgerlichkeit eine Rolle. Eine Ikonographie menschlicher Brutalität und des Schreckens war ihr fremd. Ihre Malerei kreiste weder um Mystisches noch um Literarisches, wie sie vor allem Beckmanns hermetisches Spätwerk der 1930er und 1940er Jahren mit Anspielungen auf Christentum, Gnosis, Kabbala und andere Stoffe bestimmt hatte. Als sie in London auch phantastische Stoffe, Wirklichkeiten von Traum und Imagination in Malerei umsetzte, mag vielleicht abermals Beckmanns Vorbild ihr den Weg gewiesen haben. Besonders dem späten Beckmann war im Grunde nur das malenswert, was sich bei ihm zur Vision verdichtete. Aber dort, wo sich in ihrem Schaffen Beobachtung und visionäres Erleben durchdrangen, suchte sie mehr als er die unmittelbare Anbindung an ihre eigene Lebensrealität.[62] Nie jedoch ging es ihr darum, seismographisch die momentanen Lebensumstände zu schildern. Auch sie zielte auf symbolische Gestaltung, nicht auf Reproduktion. Der unterschiedliche narrative Ansatz soll an der Gegenüberstellung von Beckmanns Triptychon *Abfahrt*, 1932/35 (Abb. 36) und ihrem Gemälde *Die Reisenden*, 1939 (Kat. Nr. 32) verdeutlicht werden. Beckmann führte auf den Seitentafeln eine Ikonographie des Terrors in märtyrerartigen Szenen vor: Dunkelheit, Beengtheit und Brutalität der Flügelszenen kontrastieren mit der Ruhe und Leuchtkraft des Mittelbildes. Im hellen Mittagslicht treiben in einer Barke auf dem blauen Meer rätsel-hafte Gestalten – zwei Männer und eine Frau mit einem Neugeborenen in den Armen – einer unbekannten Zukunft entgegen, wobei das Kind nach Beckmanns eigener Aussage für Freiheit steht. Die Frau mutet madonnenhaft wie antikisierend an, der rechte Mann mit Krone ist Herrscher und Fischer zugleich, während die linke behelmte Gestalt als Joseph, Charon oder gar als Selbstporträt des Malers gedeutet wurde.[63] Die visionär verdichtete Bildlichkeit verschiedener Zeit- und Realitätsebenen ist nicht dechiffrierbar. Sie hat den Naziterror mit der Vertreibung des Künstlers aus dem Lehramt als Erlebnisgrundlage, ihr Anspruch geht jedoch weit über eine rein symbolische Darstellung von zeitgeschichtlich-biografischem Hintergrund hinaus.

Motesiczkys Gemälde *Die Reisenden* zeigt vier dürftig bekleidete Flüchtende in einem kleinen Boot in einer Situation des Hin-und-Hergetriebenseins auf offenem Meer. Dargestellt sind die Haushälterin Marie Hauptmann links im Bild, die lächelnd in den großen Spiegel blickt, während Motesiczkys Mutter Henriette in der Bildmitte eine große Salami umklam-mert. Ein weiterer Verwandter, vielleicht der Onkel oder der Bruder, sowie die Künstlerin selbst kauern ängstlich im Boot. Das Gemälde entstand zu Beginn der Londoner Exilzeit in einem Hotelzimmer, in dem die Familie die Ankunft ihrer Habseligkeiten abwartete. Die Malerin kommentierte es später wie folgt: »Das Bild ›The Travellers‹ stellt die Stimmung dar, in der wir, meine Mutter, ich und viele andere Emigranten waren; man wußte nicht, wohin die Reise ging, man suchte um Visa nach Japan oder Amerika an, hatte Lieblingsgegen-stände mit sich, an denen man festhielt. Bisweilen glich es einem Narrenschiff.«[64] Anders als bei Beckmann geht die Bildidee Motesiczkys weit eher in Erlebtem auf und ist – durch die Hinweise der Künstlerin zur Identität der Dargestellten – bis zu einem gewissen Grad biografisch dechiffrierbar. Zugleich ist dieses Werk mehr als nur ein familienbezogenes, sondern ein zeitgeschichtliches Dokument: In ihm verarbeitete sie Eindrücke der Flucht-situation, die Züge des Lächerlichen, Befremdlichen, ja des Absurden annehmen konnte, und knüpfte motivisch an tradierte Vorstellungen wie Narrenschiff, Arche Noah oder Sint-flut an. Vom weihevoll-sakralen Ausdruck, der sich bei Beckmann auch in der Wahl des Triptychons als altehrwürdiger Pathosformel ausdrückt, unterscheidet sich ihre Darstel-lung in der Bescheidenheit des Anspruchs. Kennzeichnenderweise sollte Motesiczky daher auch nie dieses Format für eines ihrer Werke wählen.

37 Max Beckmann, *Large Still-life with Musical Instruments / Großes Stilleben mit Musikinstrumenten*, 1926, Oil on canvas / Öl auf Leinwand, 850 × 1950 mm, Städtische Galerie im Städelschen Kunstinstitut, Frankfurt am Main

painting lifeless objects. Her still-lifes are shaped by personal references and the traditional canon of the genre—she translates reality into art without any formal gimmickry, arranging objects into a symbolic narrative of her life. This approach seldom led to motifs similar to those of Beckmann. Her images transpose the genre into the modern style like Beckmann, she also departs from the conventional and replaces the baroque custom of standard symbolism by messages tied to her own biography. The still-lifes also diverge in purely formal terms from 19th-century realism and its new painterly reality by virtue of the meaning they contain, harnessing the productive tension between outward and inward reality in painting to breathe life into inert and only apparently trivial objects.

With their perspectival breaks, alternation between flatness and depth, their artificiality and cropped appearance, her earliest still-lifes (cat. no. 1, 6, 7) drew unmistakeably from Beckmann's works of the 1920s (Fig. 37). Like these, her pictures do not suggest any illusionistic pictorial world, but instead irritate through the charged juxtaposition of two-dimensional planes and spatial depth, which is used here as a means sensually to elevate the pictures' expressiveness. Simple objects such as potted plants, fruit, candles or flowers on top of distorted chairs and tables cling to the picture plane and with their plasticity unfold an enigmatic inner life. There is often a notable rhythm created by the interweaving of vantage points from head-on and from below. The elaborate juxtapositions and the powerful colouration intensify the pictures' vitality and sensual presence. This artificiality always confronts the viewer with the combinatory process involved in representing reality. By choosing to depict painting utensils in some of her still-lifes (cat. no. 73), Marie-Louise von Motesiczky also explicitly refers to painting itself, to the fiction of art as painted reality.

Biographical references in her still-lifes lend them a narrative note. For example, the word "Laczi" found in *Still-life with Tulips* of 1926 (cat. no. 6) refers to her friend, the Hungarian writer Baron Lajos Hatvany.[65] In *Still-life with Photo* (1930, cat. no. 21), she integrated an early photograph of her ancestors. For *Still-life with Sheep* (1938, cat. no. 30), she selected two Chinese cloisonné sheep, cherished family mementos that she took with her when she fled Austria.[66] In the still-life *Apples from Hinterbrühl* (1955, cat. no. 51), she "portrayed" the apples from her family's estate in Hinterbrühl, which later became the property of the SOS Children's Villages. The concepts of memory and preservation run like a leitmotif through her painting, without, however, invoking a mood of sentimentality.

In the still-lifes from her London days, Marie-Louise placed less and less importance on the dynamic staging of space, on fixing her objects with sharp contours and powerful modelling. Her still-lifes from this period have the effect of force fields made up of vital brushstrokes and colourful surfaces. This change in style evinces both parallels with and differences from

Stillleben

Die Stilllebenmalerei beschäftigte Motesiczky ihr ganzes Schaffen hindurch. Die Schönheit und Magie der Realität fesselte sie wie Max Beckmann an die Darstellung lebloser Gegenstände. Biografisch-persönliche Bezüge zu der Bildwelt der Stillleben mit durchaus traditionellen Motiven, Umsetzung von Realität ohne dekorative Gefälligkeit und ohne formalistische Spielerei auf kunstvoll-arrangierte und symbolhaft-narrative Weise – diese Grundkoordinaten bestimmten ihre Stillleben. Motivische Überschneidungen mit Beckmann ergaben sich von diesem Ansatz her eher selten. Ihre Bilder überführen die Gattung in die Moderne, denn wie auch er setzte sie sich von herkömmlichen Formen der Stilllebenmalerei ab: Von der barocken Tradition mit objektiv-verbindlichem Symbolgehalt unterscheiden sich ihre Stillleben durch ihren individualistischen Anspruch, indem sie mit ihrer Biografie verbundene Botschaften enthalten. Vom Realismus des 19. Jahrhunderts und seiner neuen malerischen Wirklichkeit in rein formaler Hinsicht grenzen sie sich durch ihren Bedeutungsgehalt ab und nutzen die produktive Spannung von äußerer und innerer Realität in der Malerei zur Verlebendigung unbelebter, nur scheinbar belangloser Gegenstände.

Mit den perspektivischen Brechungen, dem Wechsel von Fläche und Raum, mit ihrer Künstlichkeit und Ausschnitthaftigkeit knüpften die frühesten Stillleben (Kat. Nr. 1, 6, 7) unverkennbar an Arbeiten Beckmanns aus den 1920er Jahren an (Abb. 37). Auch Motesiczkys Bilder suggerieren keine illusionistische Bildwelt, sondern irritieren durch das spannungsvolle Miteinander von Fläche und Raum, das zu gesteigertem sinnlichem Ausdruck genutzt wird: Schlichte Gegenstände wie Topfpflanzen, Früchte, Kerzen oder Blumen auf flächig verzerrten Stühlen und Tischen entfalten in ihrer Plastizität ein rätselhaftes Eigenleben im Rhythmus der Verschränkungen von Auf- und Untersicht. Das ausladende Gegeneinander und die kräftige Farbigkeit intensivieren ihre Vitalität und sinnliche Präsenz. Diese Künstlichkeit konfrontiert den Betrachter immer mit dem kombinatorischen Verfahren der Wirklichkeitsschilderung. Mit der Darstellung von Malutensilien in einigen ihrer Stillleben (Kat. Nr. 73) verweist die Künstlerin auch motivisch auf die Malerei selbst, auf die Fiktion in der Kunst als malerischer Realität.

Biografische Bezüge verleihen ihren Stillleben eine narrative Komponente. So bezieht sich der Schriftzug »Laczi« auf dem *Stilleben mit Tulpen*, 1926 (Kat. Nr. 6) auf ihren Freund, den ungarischen Baron und Schriftsteller Lajos Hatvany.[65] In *Stilleben mit Photographie*, 1930 (Kat. Nr. 21) integrierte sie eine frühe Fotografie ihrer Vorfahren. In *Stilleben mit Schafen* 1938 (Kat. Nr. 30) wählte sie mit zwei chinesischen Schafen aus Email cloisonné vertraute familiäre Gegenstände, die sie mit auf die Flucht genommen hatte.[66] In dem Stillleben *Die letzten Äpfel aus der Hinterbrühl*, 1955 (Kat. Nr. 51) »porträtierte« sie Äpfel vom Anwesen der Familie in Hinterbrühl, das in den Besitz der SOS-Kinderdörfer überging. Erinnern und Bewahren zieht sich leitmotivisch durch ihre Malerei, ohne dass in ihr ein sentimentaler Zug dominieren würde.

Bei den Stillleben der Londoner Zeit legte Motesiczky immer weniger Wert auf dynamische Rauminszenierung, konturierende Fixierung und kraftvolle Modellierung. Ihre Stillleben wirken wie Kraftfelder vitaler Pinselschwünge und farbiger Flächen. Dieser Stilwandel weist Parallelen und Differenzen zu Beckmann auf. Sein spätes *Großes Stilleben/Interieur (blau)* 1949 (Abb. 38) wirkt mit seiner ungenau erfassten, abgeflachten Gegenständlichkeit wie auf einer Vordergrundbühne zusammengepresst. Der Eindruck zeichnerischer Schärfe und glatter Virtuosität ist zurückgenommen, die offene Faktur unbestimmt, zögernd, ja bisweilen nachlässig. Farbintensive Übermalungen und Korrekturen zeugen vom Malprozess als unaufhörlichem Ringen, an dessen Ziel für Beckmann immer die mächtige, konstruierte Form stand. Demgegenüber wirkt die späte Malweise Motesiczkys lässiger und leichter, weniger angespannt, ohne jemals in seichte Dekorativität zu verfallen.

38 Max Beckmann, *Large Still-life interior (blue) / Großes Stilleben / Interieur (blau)*, 1949, Oil on canvas / Öl auf Leinwand, 1425 × 890 mm, The Saint Louis Art Museum, St. Louis, Bequest of Morton D. May

Beckmann. His late *Large Still-life interior (blue)* from 1949 (Fig. 38) with its imprecisely captured, flattened objectivity, seems like a compressed stage foreground. The impression of sharp drawing and smooth virtuosity is less apparent; the open arrangement is indeterminate, hesitant, even indifferent at times. Overpainting in intense colours and corrections testify to the painting process as an incessant wrestling with form, which for Beckmann always comes across as both powerful and constructed. In contrast with this, Marie-Louise's late technique manifested a more relaxed, lighter touch, with less tension, but never succumbing to shallow decorativeness.

Landscapes

Landscape paintings are poorly represented in Marie-Louise von Motesiczky's work, but do accompany her sporadically throughout her career. Her landscapes referred to the places she lived in and her travel experiences; she was not concerned with evoking romantic moods or impressionistic, atmospheric nature scenes. Neither was the expression of intense oneness with nature her intention. Her landscapes—like Beckmann's—evoke both moments of alienation from and closeness to nature. In the mixture of naturalness and artificiality, they constitute a creative view of the relationship of modern human beings to their natural habitat—a relationship that was no longer naive and unselfconscious. The early scene *Kröpfelsteig, Hinterbrühl* (1927, cat. no. 10) was clearly inspired by Beckmann (Fig. 39). And yet she picturesquely captured the nature motif—seeming somehow distanced in its unreal tranquillity—in a finely differentiated light, based on her actual experience of the scene. By means of this lively lighting and the excerpt from her immediate experience, she preserved the impression of naturalness and spontaneity more strongly than did Beckmann in his disconcerting and unrealistically lighted panoramas.

39 Max Beckmann, *Lake scene with Poplars / Seelandschaft mit Pappeln*, 1924, Oil on canvas / Öl auf Leinwand, 600 × 605 mm, Kunsthalle Bielefeld

The artificiality of her early landscapes is substantially underscored by the vertical format she borrowed from Beckmann (Fig. 40). Sweeping, panoramic landscapes are only found in her work from the 1940s onwards. The choice of vertical format focuses the gaze on a narrow extract, which lends the image a powerful intensity. Drawing on Beckmann's compositional patterns, cropped foreground motifs, such as window panels and ledges, additionally narrow the view. The pictorial organisation is based on a flat, nested compositional arrangement, broken up by plastically modelled motifs. Foreground and background objects share the same pictorial presence, creating an unreal spatial tension. Using these means, she succeeds in pictures such as *Bullfight* (1929, cat. no. 12) to depict the tense atmosphere in the close quarters of a bullfighting arena under the glaring southern sun. Inspired by a trip to Spain, the work was completed later in the artist's studio with the help of a postcard. Motesiczky's landscapes were often based on memory, with the help of postcards and photos as prompts and sources of inspiration—a procedure that Beckmann is also know to have followed.[67]

Trueness to the reality of the motif and transformation of this reality—these are premises that the artist realised in her own individual way, especially in her London days. Some garden scenes in which forceful dark contours preserve a comparatively tight pictorial architecture still distantly recall the formal severity of earlier times (cat. no. 36). Other views of her garden in which form and colour are slurred (cat. no. 79, Fig. 50) give an impression of immediacy, naturalness and naiveté in her approach to nature. Such spontaneity and unselfconsciousness has no parallels in Beckmann's work.

The Female Gaze?—Role Models

Finally, one may ask whether Motesiczky's painting might be classified as more personal and more emotional, less intellectual and universally applicable than that of Beckmann. This conclusion would correspond with the attitude towards female creativity espoused by some of her contemporaries, such as art critic Hans Hildebrandt in his 1928 book "Die Frau

Landschaften

Landschaftsbilder haben zahlenmäßig im Werk Motesiczkys weniger Bedeutung, begleiteten die Malerin aber doch über ihr gesamtes Schaffen. Ihre Landschaftsschilderungen bezogen sich auf die Orte, an denen sie lebte, und auf Reiseerlebnisse. Es ging ihr weder um romantische Stimmungen noch um impressionistisch-atmosphärische Natureindrücke. Auch die expressive Umsetzung gesteigerter Natureinfühlung war nie ihre Absicht. In ihren Landschaften drücken sich – wie in denen Beckmanns – Momente der Naturentfremdung wie der Naturnähe aus. In der Mischung aus Natürlichkeit und Künstlichkeit sind sie gestalteter Blick eines nicht mehr unbefangenen Verhältnisses des modernen Menschen zum Lebensraum Natur. Die frühe Ansicht *Kröpfelsteig, Hinterbrühl*, 1927 (Kat. Nr. 10) ist deutlich von Beckmann inspiriert (Abb. 39). Dabei erfasste Motesiczky das in seiner unwirklichen Ruhe distanziert wirkende, malerisch großzügig geschilderte Naturmotiv doch mit einer differenzierten, vom konkreten Seherlebnis ausgehenden Lichtführung. Sie wahrte durch diese lebendige Lichtsituation und die ausschnitthafte Unmittelbarkeit stärker den Eindruck von Natürlichkeit und Spontaneität als Beckmann in dessen befremdlichen, irreal beleuchteten Überblickslandschaften.

Die Künstlichkeit ihrer frühen Landschaften wird erheblich durch das von Beckmann bekannte Hochformat mitbestimmt (Abb. 40). Überblicksartige, weite Panoramalandschaften finden sich in ihrem Werk erst seit den 1940er Jahren. Das Hochformat fokussiert den Blick auf einen schmalen, zu spannungsvoller Intensität gesteigerten Ausschnitt. Nach dem Kompositionsmuster Beckmanns engen zusätzlich angeschnittene Vordergrundmotive wie Fensterkreuze, -bänke usw. den Blick ein. Die Bildorganisation geht von einem flächig-verschachtelten Kompositionsgefüge aus, das von plastisch modellierten Motiven durchbrochen wird. Vorder- wie Hintergrundmotive sind von gleicher Bildpräsenz, so dass ein irrealer Spannungsraum entsteht. Mit diesen Mitteln gelingt ihr etwa in dem Gemälde *Stierkampf*, 1928 (Kat. Nr. 12) die effektvolle Schilderung der angespannten Atmosphäre im Kessel einer Stierkampfarena bei gleißendem, südlichem Sonnenlicht. Das Werk, das sich auf eine Spanienreise der Künstlerin bezieht, entstand nach einer Ansichtskarte im Atelier. Ihre Landschaftsmalerei speiste sich oft aus Anschauung und Bildgedächtnis, aus Ansichtskarten und Fotos als Inspirationsquellen – ein Vorgehen, das auch von Beckmann bekannt ist.[67]

Treue zur Motivwirklichkeit und Veränderung dieser Wirklichkeit – diese Prämissen setzte Motesiczky besonders in ihrer Londoner Zeit individuell um. Einige Gartenansichten, in denen durch kräftig dunkle Konturierungen eine vergleichsweise straffe Bildarchitektur gewahrt bleibt, erinnern allenfalls entfernt an die Formstrenge früherer Zeiten (Kat. Nr. 36). Andere gänzlich form- und farbverschleifende Ansichten ihres Gartens (Kat. Nr. 79, Abb. 50) vermitteln einen Eindruck von Unmittelbarkeit, Natürlichkeit und Naivität im malerischen Zugriff auf die Natur, der sich in dieser Spontaneität und Unbefangenheit vom Werk Beckmanns gänzlich unterscheidet.

Der weibliche Blick? – Rollenbilder

Abschließend stellt sich die Frage, ob die Malerei der Motesiczky gegenüber der Beckmanns als persönlicher, gefühlsbetonter, als weniger intellektuell und allgemein gültig einzustufen ist. Dies entspräche einer zeitgenössischen Auffassung von weiblicher Kreativität, wie sie der Kunstkritiker Hans Hildebrandt 1928 in seinem damals als grundlegend angesehenen Buch »Die Frau als Künstlerin« vertrat.[68] Emotionalität und Empathie zeichnet die Malerei Beckmanns ebenso wie die seiner Schülerin aus, jeweils freilich auf individuelle Weise. In beider Kunst verdichten sich persönliches Erleben und visionäre Schau. Im Gegensatz zu ihrem Lehrer war die Malerei Marie-Louise von Motesiczkys jedoch im Anspruch weniger auf Weltanschaulichkeit ausgerichtet. Das von Beckmann mit messianischem Kampfesgeist vorgetragene Credo »Kunst als Erlösung« vertrat sie nie, wohl aber erfüllte sie der Glaube an eine sinnstiftende Kunst Zeit ihres Lebens. Dieser dürfte ihr schon in frühester

40 Max Beckmann, *Wendelsweg*, 1928, Oil on canvas / Öl auf Leinwand, 705 × 440 mm, Kunsthalle Kiel

als Künstlerin" (The Woman as Artist), regarded at the time as a definitive treatment of the subject.[68] Emotionality and empathy characterise Beckmann's painting just as they do that of his student, however, although admittedly in a different way. In the art of both, personal experience and visionary display are consolidated. Unlike the work of her teacher, however, the painting of Marie-Louise von Motesiczky aimed less at expressing a world view: Beckmann's credo of "art as salvation", put forward with a messianic fighting spirit, was something she herself never aspired to, although throughout her life she maintained her faith in an art that could endow life with meaning. This was something that was probably instilled in her from her earliest youth through the Viennese modern movement, which extolled an autonomous art as the sole authority for making sense of existence.[69] It is true that Beckmann distanced himself from the optimistic faith in this kind of uniformly conceived cultural movement—particularly after his experiences in the First World War, during the Nazi regime and during his exile. But he clung ambitiously to the idea of art as having the power to change the world and to alter consciousness, as a route for gaining knowledge of and getting beyond the self. For Beckmann, the purpose of art was "knowledge and not entertainment—transfiguration or play".[70]

Marie-Louise von Motesiczky was prepared to grant him and his creative potency the power of pathos and the ability to interpret the world. For herself, on the other hand, she consistently and humbly stated that it was her longing to "paint beautiful pictures ... to become happy in doing this and to make other people happy through them".[71] This aim also indicates that she saw her art as something devoted to the good of humanity. Her failure to put forward more grandiose claims was surely attributable in part to generational and gender-specific conditioning. The fact that she belonged at the very outset of her career to a generation of painters moulded by the experiences of persecution and exile was surely responsible for her reluctance to share completely the drive for progress and the dissolution of boundaries characterising the modern movement. Her stance also had something to do with her role as a woman and with her biography. Through her origins in the aristocracy of the 19th century and in a male-dominated intellectual and artistic world, she was rooted so strongly in female role models that reserve and modesty were second nature to her. In the 1920s, as women were taking up a more strident position on the arts' scene, she confidently stepped out of the traditionally passive woman's role of model or muse and actively embarked on a course as painter. She embodied the image of a modern young woman who pursues her goals independently and with determination. Her emigration formed the decisive caesura in her life: wrested from her home environment, when she and her mother were forced largely to fend for themselves, she took on responsibility for the family and for her ageing parent, fulfilling the classic role of the caring woman—a duty she took on without bitterness. In this phase of her life, which also included her relationship with Elias Canetti in which she took on the role of a mistress waiting for her married lover to leave his wife, she once again demonstrated the highest degree of artistic power in her portrait series of her mother. Marie-Louise Motesiczky was an outstanding student of Max Beckmann who consistently pursued her own artistic path.

Translated from German by Jennifer Taylor-Gaida

Jugend durch die Wiener Moderne vermittelt worden sein, die eine autonome Kunst als allein sinngebende Instanz pries.[69] Beckmann distanzierte sich zwar – zumal nach den Erfahrungen des Ersten Weltkriegs, nach Nazidiktatur und Exil – gegenüber dem Optimismus einer einheitlich zu stiftenden Kulturbewegung. Er hielt aber ambitioniert an der Vorstellung einer welt- und bewusstseinsverändernden Macht der Kunst als Möglichkeit zur Selbsterkenntnis und -überwindung fest. Für ihn diente »Kunst der Erkenntnis nicht der Unterhaltung – der Verklärung oder dem Spiel.«[70]

Ihm und seiner gestalterischen Potenz mochte die Motesiczky Pathos und Weltdeutung zugestehen. Für sich hingegen trug sie konsequent bescheiden vor, dass es ihre Sehnsucht sei, »schöne Bilder zu malen, dadurch glücklich zu werden und andere glücklich zu machen.«[71] Damit aber sah auch sie ihre Kunst als etwas dem Menschen Verpflichtetes an. Bei ihrer Rücknahme von Bedeutungsansprüchen schwangen generations- wie geschlechtsbedingte Gründe mit. So war es ihrer Zugehörigkeit zu einer gleich am Beginn der Laufbahn durch Verfolgung und Exil geprägten Malergeneration geschuldet, dass sie das Entgrenzungs- und Fortschrittspathos der Moderne nicht mehr ungebrochen teilte. Ihre Haltung jedoch hing auch mit ihrer Rolle als Frau wie mit ihrer Biografie zusammen. So war sie durch ihre Herkunft aus dem Großbürgertum des 19. Jahrhunderts und einer männlich dominierten Geistes- und Kunstwelt noch sehr in einem weiblichem Rollenverhalten verwurzelt, das Zurückgenommenheit und Bescheidenheit als selbstverständlich ansah. In den 1920er Jahren, als die Frauen dem Kunstbetrieb vehementer begegneten, trat sie aus der traditionell passiven Frauenrolle als Modell oder als Muse selbstbewusst hervor und beschritt aktiv ihren Weg als Malerin. Sie entsprach dem Bild der modernen, jungen Frau, die unabhängig und selbstbestimmt ihr Ziel verfolgte. In ihrem Leben vollzog sich mit der Emigration die entscheidende Zäsur: Herausgerissen aus dem heimatlichen Milieu, auf sich und ihre Mutter weitgehend allein gestellt, übernahm sie mit der familiären Verantwortung und der Pflege ihrer alternden Mutter die klassische Rolle der fürsorglichen Frau – eine Aufgabe, die sie ohne Bitterkeit annahm. In dieser Lebensphase, in der ihr mit der Beziehung zu Elias Canetti auch noch die Rolle der auf den verheirateten Mann wartenden Geliebten zukam, bewies sie mit der Serie von Bildnissen ihrer Mutter nochmals höchste künstlerische Kraft.

1 "I was so impressed by Beckmann's personality that one might almost say it lasted my whole life." Marie-Louise in an interview with Gudrun Boch, Radio Bremen, 1994. Transcription in the archive of the Marie-Louise Motesiczky Charitable Trust, London. I would like to thank Ines Schlenker, Marie-Louise von Motesiczky Charitable Trust, London, for her friendly advice and generous assistance with my research.

2 Paint drops and other signs of wear on her copy show that she used it occasionally in her studio.

3 Beckmann referred to himself in these words in 1926/27 as author of the text "Die soziale Stellung des Künstlers". *Max Beckmann, Die Realität der Träume in den Bildern. Schriften und Gespräche 1911 bis 1950*, ed. and with epilogue by Rudolf Pillep, Munich 1990, p. 35.

4 Jill Lloyd, "Marie-Louise von Motesiczky—Eine Malerin der Erinnerung", in: *Die Liebens. 150 Jahre Geschichte einer Wiener Familie*, ed. E. Fuks, G. Kohlbauer, Vienna 2004, p. 209ff.

5 On Beckmann and Frankfurt see: *Max Beckmann. Frankfurt 1915–1933*, exh. cat. Städtische Galerie im Städelschen Kunstinstitut, Frankfurt am Main, 1984; Klaus Gallwitz (ed.), *Max Beckmann in Frankfurt*, Frankfurt am Main, 1984.

6 Marie-Louise Motesiczky, "Max Beckmann als Lehrer. Erinnerungen einer Schülerin des Malers", in: *Frankfurter Allgemeine Zeitung*, January 11, 1964.

7 "Thank you for the photos, they're wonderful! Keep up the good work. There is obviously a great deal of hard work behind them. Just keep at it." Beckmann to Marie-Louise on February 12, 1926. Klaus Gallwitz/Uwe M. Schneede/Stephan von Wiese (eds.) with collaboration by Barbara Golz, *Max Beckmann, Briefe*, Vol. II: 1925–1937, Munich, Zurich, 1994, p. 31.

8 Klaus Gallwitz/Uwe M. Schneede/Stephan von Wiese (eds.) with collaboration by Barbara Golz, *Max Beckmann, Briefe*, Vol. I: 1899–1925, Munich, Zurich, 1993, p. 261ff.

9 Mathilde Q. Beckmann, *Mein Leben mit Max Beckmann*, 2nd ed., Munich, 1985, p. 29.

10 Erhard and Barbara Göpel, *Max Beckmann, Katalog der Gemälde*, vol. 1, Bern, 1976, cat. no. 604.

11 Klaus Gallwitz/Uwe M. Schneede/Stephan von Wiese (eds.) with collaboration by Barbara Golz, *Max Beckmann, Briefe*, Vol. III: 1937–1950, Munich, Zurich, 1994, p. 237ff.

12 Quappi's letters in the archive of the Marie-Louise von Motesiczky Charitable Trust, London, attest to her close bond with Marie-Louise and her mother.

13 Quappi on April 20, 1952 to Marie-Louise. Archive of the Marie-Louise von Motesiczky Charitable Trust, London.

14 Max Beckmann 1918, quoted in Beckmann 1990 (Note 3), p. 22.

15 Beckmann 1939, quoted in ibid., p. 50.

16 Beckmann 1918, quoted in ibid., p. 22.

17 On the reception of Beckmann's work, see: Olaf Peters, *Vom schwarzen Seiltänzer. Max Beckmann zwischen Weimarer Republik und Exil*, Berlin, 2005, p. 59ff.

18 Marie-Louise on May 16, 1963 to Erhard Göpel. Göpel Estate in the Bavarian State Library in Munich, shelf mark Ana 415. I would like to express my thanks to Barbara Göpel, Munich, and Sigrid von Moisy and Nino Nodia of the Bavarian State Library in Munich.

19 Letters to her in the archive of the Marie-Louise von Motesiczky Charitable Trust, London, from March and April 1924, give her address as "Untermainkai 3, c/o Mr Hans Lothar". On the Lothar family see: Göpel, 1976 (Note 10), cat. no. 355.

20 Renate Berger, *Malerinnen auf dem Weg ins 20. Jahrhundert. Kunstgeschichte als Sozialgeschichte*, Cologne, 1982, p. 186ff.

21 Christoph Bernoulli, "Die Herrenrunde beim Chefredakteur Simon der Frankfurter Zeitung", see: Gallwitz, 1984 (Note 5), pp. 26–28. On Simon see: Wolfgang Schivelbusch, *Intellektuellendämmerung. Zur Lage der Frankfurter Intelligenz in den zwanziger Jahren*, Frankfurt am Main 1982, pp. 42–61.

22 Correspondence in the archive of the Marie-Louise von Motesiczky Charitable Trust, London, from October and November 1926 and January 1927 is addressed to "Oberlindau 51, c/o Mrs Hermann Hirsch".

23 The net proceeds from the play, which was performed in original costumes, went to the China Institute in Frankfurt, founded by Wilhelm in 1925. I would like to thank Bernhard Wirth, University Library Johann Christian Senckenberg, Frankfurt am Main, for his assistance, and especially Ursula Ballin, Vienna, who is working on a biography of Robert Wilhelm.

24 "I reserved some seats for you with Wichert for after Christmas 'just in case'." Beckmann at the end of September 1927 to Motesiczky. See: *Max Beckmann, Briefe*, Vol. II (Note 7), p. 100. From a letter Beckmann wrote to his wife on March 24, 1928 (ibid., p. 110) it is evident that Henriette Motesiczky was also staying in Frankfurt at the time. On the Academy of Applied Arts, see the recent work by *Willi Baumeister—Die Frankfurter Jahre 1928–1933*, exh. cat. Museum Giersch, Frankfurt am Main, 2005.

25 Hans-Jürgen Fittkau, "Leben und Werk des Frankfurter Beckmann-Schülers Karl Tratt (1900–1937)", in: *Archiv für Frankfurts Geschichte und Kunst 69*, published on behalf of the Gesellschaft für Frankfurter Geschichte e. V. in co-operation with the Institut für Stadtgeschichte, Frankfurt am Main 2003, pp. 159–176. See also: Tratt's letters in the archive of the Marie-Louise von Motesiczky Charitable Trust, London.

26 Karlheinz Gabler, *Siegfried Shalom Sebba. Maler und Werkmann mit Œuvre-Verzeichnis der Druckgrafik*, Kassel 1981.

27 Information kindly provided by Ines Schlenker.

28 *Max Beckmanns Frankfurter Schüler 1925–1933*, exh. cat. Karmeliterkloster, Frankfurt am Main 1980. I would like to thank Gerda Garve, Hamburg, and Ursula Seitz-Gray, Frankfurt am Main for their kind assistance.

29 "... admittedly, you and Theo Garve are the leading figures, the only ones whom Max Beckmann would recognise." Lilly von Schnitzler on December 15, 1980 to Motesiczky. Archive of the Marie-Louise von Motesiczky Charitable Trust, London.

30 Her friendly relations with Klaus Gallwitz, at the time director of the Städelsche Kunstinstitut, also attest to her close ties in Frankfurt. See also her correspondence with Gallwitz at the Institut für Stadtgeschichte, Frankfurt am Main. I would like to thank Klaus Gallwitz, Karlsruhe, for his kind assistance.

31 *Aus der Meisterklasse Max Beckmanns. Karl Tratt, Friedrich Wilhelm Meyer und ihre Kommilitonen*, ed. Hans-Jürgen Fittkau, exh. cat. 1822-Stiftung der Frankfurter Sparkasse 2000/01, p. 58ff.

32 Marie-Louise in 1964 (Note 6).

33 Ibid.

34 Beckmann, quoted in Walter Barker, "Lehren als Erweiterung der Kunst. Max Beckmanns pädagogische Tätigkeit", in: *Max Beckmann Retrospektive*, exh. cat. Bayerische Staatsgemäldesammlungen Munich, Haus der Kunst, Nationalgalerie Berlin, 1984, p. 176.

35 Marie-Louise 1964 (Note 6).

36 On Freud's theories see Isabelle Graw, *Die bessere Hälfte, Künstlerinnen des 20. und 21. Jahrhunderts*, Cologne, 2003, p. 26.

37 Marie-Louise in an undated letter to Sophie Brentano, archive of the Marie-Louise von Motesiczky Charitable Trust, London. Friendly assistance was provided by Ines Schlenker.

38 Marie-Louise 1964 (Note 6).

39 Ibid.

40 According to a critique by Kristian Sotriffer, "Im Schatten des Meisters", in: *Die Presse*, May 23, 1966.

41 Ludwig Baldass, "Die Malerin Marie-Louise Motesiczky", in: *Die Kunst und das schöne Heim*, 55, 1955, p. 218ff.

42 Josef Paul Hodin, "The Poetic Realism of Marie Louise Motesiczky", in: *The Painter & Sculptor*, vol. 4, no. 3, London, 1961/62, pp. 19–23.

43 Hilde Spiel, "Die Malerin Marie-Louise Motesiczky. Eine Ausstellung in der Wiener Secession", in: *Frankfurter Allgemeine Zeitung*, May 19, 1966; and Hilde Spiel, "Unbeirrt auf ihrem eigenen Weg", in: *Frankfurter Allgemeine Zeitung*, January 2, 1986.

44 Benno Reifenberg, "Marie-Louise von Motesiczky", in: *Marie-Louise Motesiczky*, exh. cat. Wiener Secession, 1996, w/o page no.

45 Ernst H. Gombrich, "Marie-Louise von Motesiczky" in: *Marie-Louise von Motesiczky. Paintings Vienna 1925–London 1985*, exh. cat. Goethe Institut, London, 1985, p. 6ff.

46 David Cohen, "Marie-Louise von Motesiczky", in: *Modern Painters*, 1994, vol. 7, no. 2, summer, pp. 93–95.

47 Sabine Plakolm-Forsthuber, *Künstlerinnen in Österreich 1897–1938*, Vienna, 1994, pp. 165–169, 193ff.

48 Lloyd 2004 (Note 4), pp. 205–225.

49 Cohen 1994 (Note 46), p. 93.

50 From the Beckmann literature one could cite Friedhelm W. Fischer, *Max Beckmann—Symbol und Weltbild. Grundriss zu einer Deutung des Gesamtwerks*, diss., Munich, 1972; Hans Belting, *Max Beckmann. Die Tradition als Problem in der Kunst der Moderne*, exh. cat., Munich/Berlin, 1984 (Note 34); Ortrud Westheider, *Die Farbe Schwarz in der Malerei Max Beckmanns*, Berlin, 1995; *Max Beckmann und Paris*, exh. cat. Kunsthaus Zürich, St. Louis Art Museum, Cologne, 1998; *Max Beckmann. Landschaft als Fremde*, exh. cat. Hamburger Kunsthalle, Kunsthalle Bielefeld, Kunstforum Wien, Stuttgart, 1998; Christian Lenz, *Max Beckmann und die Alten Meister. "Eine ganz nette Reihe von Freunden"*, Bönnigheim 2000; *Max Beckmann*, exh. cat. Centre George Pompidou Paris, Tate Modern London, MoMA QNS, New York, 2003; Peters 2005 (Note 17).

51 Rainer Zimmermann, *Expressiver Realismus. Malerei der verschollenen Generation*, Munich 1994.

52 "It is a woman who speaks. She speaks quietly but no less insistently." Günter Busch, *Some comments on the art of Marie-Louise von Motesiczky*, exh. cat., London, 1985 (Note 45), p. 9.

53 "Yet, from the beginning, Motesiczky's paintings had a softer, somewhat more feminine, touch." Ines Schlenker, introduction to *catalogue raisonné*. Unpublished manuscript, n.p.

54 On feminist art history and the critique of her work, see: Graw, 2005 (Note 36). On Marie-Louise, see: Plakolm-Forsthuber, 1994 (Note 47), p. 206.

55 Ingrid von der Dollen, "Marie-Louise von Motesiczky. Malerei des Expressiven Realismus", series XIX, *Weltkunst*, issue 15/16, August 15, 1997, p. 1594ff.; Ingrid von der Dollen, *Malerinnen im 20. Jahrhundert—Bildkunst der "verschollenen Generation"—Geburtsjahrgänge 1890–1910*, Munich 2000, pp. 69, 199, 122, 132, 158, 165, 187, 196ff, 233–238.

56 Eva Michel, *Marie-Louise von Motesiczky 1906–1996. Eine österreichische Schülerin von Max Beckmann*, University of Vienna, master's thesis, 2003.

57 "Die Revision der Postmoderne/Post-Modernism revisited", eds. Ingeborg Flagge/Romana Schneider, exh. cat. Deutsches Architekturmuseum Frankfurt am Main, 2004/05, Hamburg, 2004.

58 Beckmann 1918, quoted in Beckmann 1990 (Note 3), p. 22.

59 Marie-Louise von Motesiczky, quoted in Plakolm-Forsthuber 1994 (Note 47), p. 168.

60 See Note 14.

61 "He believed, and he said as much, that art could only emerge through the greatest love of things." Motesiczky 1964 (Note 6).

62 See the article by Ines Schlenker in this book.

63 *Das MoMA in Berlin, Meisterwerke aus dem Museum of Modern Art, New York*, exh. cat. Staatliche Museen zu Berlin, Neue Nationalgalerie, 2004, p. 315.

64 Letter from Marie-Louise to Kurt Wettengl on February 3, 1990, Historisches Museum Frankfurt am Main, archive of the Historisches Museum, Frankfurt am Main. I would like to thank Kurt Wettengl, Museum am Ostwall Dortmund, for his kind assistance, as well as Ursula Kern, Historisches Museum Frankfurt am Main; Plakolm-Forsthuber 1994 (Note 47), p. 193ff.

65 According to information provided by Ines Schlenker.

66 *Tate Gallery. Illustrated Catalogue of Acquisitions*, London 1996, p. 502ff.

67 Nina Peter, "Déjà vu. Die Bildquellen der Landschaften von Max Beckmann", in: exhib. cat. Hamburg/Bielefeld/Wien 1998 (Note 50), pp. 45–56.

68 Hans Hildebrandt, *Die Frau als Künstlerin*, Berlin 1928.

69 Walter Fähnders, *Avantgarde und Moderne 1890–1933*, Stuttgart/Weimar, 1998, pp. 80–120.

70 Beckmann 1938 quoted in Beckmann 1990 (Note 3) p. 50.

71 Marie-Louise von Motesiczky quoted in Hodin 1961/62 (Note 42), p. 19.

1 »Ich war so beeindruckt von der Persönlichkeit von Beckmann, dass es, fast könnt man sagen, das ganze Leben gedauert hat.« Motesiczky in einem Interview mit Gudrun Boch, Radio Bremen 1994. Transkription im Archiv des Marie-Louise Motesiczky Charitable Trust, London. Für die freundlichen Hinweise und großzügige Unterstützung bei der Recherche danke ich Ines Schlenker, Marie-Louise von Motesiczky Charitable Trust, London.

2 Farbkleckse und andere Gebrauchsspuren ihres Exemplars zeigen, dass sie es immer wieder in ihrem Atelier zur Hand nahm.

3 So bezeichnet sich Beckmann 1926/27 selbst als Autor des Textes »Die soziale Stellung des Künstlers«. *Max Beckmann, Die Realität der Träume in den Bildern. Schriften und Gespräche 1911 bis 1950*, hrsg. und mit einem Nachwort versehen von Rudolf Pillep, München 1990, S. 35.

4 Jill Lloyd, »Marie-Louise von Motesiczky – Eine Malerin der Erinnerung«, in: *Die Liebens. 150 Jahre Geschichte einer Wiener Familie*, Ausst.-Kat. Jüdisches Museum Wien 2004, S. 209f.

5 Zu Beckmann und Frankfurt: *Max Beckmann. Frankfurt 1915–1933*, Ausst.-Kat. Städtische Galerie im Städelschen Kunstinstitut Frankfurt am Main 1984; Klaus Gallwitz (Hrsg.), *Max Beckmann in Frankfurt*, Frankfurt am Main 1984.

6 Marie-Louise Motesiczky, »Max Beckmann als Lehrer. Erinnerungen einer Schülerin des Malers«, in: *Frankfurter Allgemeine Zeitung*, 11.1.1964.

7 »Danke für die Photos, alle Achtung! Nur so weiter. Es steckt viel ernsthafte Arbeit darin. Nur jetzt Stange Halten.« Beckmann am 12.2.1926 an Motesiczky. Klaus Gallwitz/Uwe M.Schneede/Stephan von Wiese, (Hrsg.) unter Mitarbeit von Barbara Golz, *Max Beckmann, Briefe*, Bd. II: 1925–1937, München/Zürich 1994, S. 31.

8 Klaus Gallwitz/Uwe M.Schneede/Stephan von Wiese (Hrsg.) unter Mitarbeit von Barbara Golz, *Max Beckmann. Briefe*, Bd. I: 1899–1925, München/Zürich 1993, S. 261ff.

9 Mathilde Q. Beckmann, *Mein Leben mit Max Beckmann*, 2. Aufl., München 1985, S. 29.

10 Erhard und Barbara Göpel, *Max Beckmann, Katalog der Gemälde*, Bd. 1, Bern 1976, Kat. Nr. 604.

11 Klaus Gallwitz/Uwe M.Schneede/Stephan von Wiese (Hrsg.) unter Mitarbeit von Barbara Golz, *Max Beckmann. Briefe*, Bd. III: 1937–1950, München/Zürich 1994, S. 237f.

12 Die Briefe Quappis im Archiv des Marie-Louise von Motesiczky Charitable Trust, London, zeugen von ihrer Verbundenheit mit Motesiczky und deren Mutter.

13 Quappi am 20.4.1952 an Marie-Louise. Archiv des Marie-Louise von Motesiczky Charitable Trust, London

14 Max Beckmann 1918, zit. nach: Beckmann, 1990 (Anm. 3), S. 22.

15 Beckmann 1939, zit. nach: ebd., S. 50.

16 Beckmann 1918, zit. nach: ebd., S. 22.

17 Zur Rezeption Beckmanns: Olaf Peters, *Vom schwarzen Seiltänzer. Max Beckmann zwischen Weimarer Republik und Exil*, Berlin 2005, S. 59ff.

18 Motesiczky am 16.5.1963 an Erhard Göpel. Nachlass Göpel in der Bayerischen Staatsbibliothek München, Signatur: Ana 415. Für die freundliche Unterstützung danke ich Barbara Göpel, München, sowie Sigrid von Moisy und Nino Nodia, Bayerische Staatsbibliothek München.

19 Die Korrespondenz an sie im Archiv des Marie-Louise von Motesiczky Charitable Trust, London, verzeichnet für März und April 1924 die Adresse: »Untermainkai 3, bei Herrn Hans Lothar«. Zur Familie Lothar vgl. Göpel, 1976 (Anm. 10), Kat. Nr. 355.

20 Renate Berger, *Malerinnen auf dem Weg ins 20. Jahrhundert. Kunstgeschichte als Sozialgeschichte*, Köln 1982, S. 186ff.

21 Christoph Bernoulli, »Die Herrenrunde beim Chefredakteur Simon der Frankfurter Zeitung«, in: Gallwitz, 1984 (Anm. 5), S. 26–28. Zu Simon vgl. Wolfgang Schivelbusch, *Intellektuellendämmerung. Zur Lage der Frankfurter Intelligenz in den zwanziger Jahren*, Frankfurt am Main 1982, S. 42–61.

22 An die Adresse »Oberlindau 51 bei Frau Hermann Hirsch« findet sich Korrespondenz im Archiv des Marie-Louise von Motesiczky Charitable Trust, London, von Oktober, November 1926 und Januar 1927.

23 Der Reinerlös des im Originalkostümen aufgeführten Lustspiels kam dem von Wilhelm 1925 gegründeten China-Institut in Frankfurt zugute. Für Hinweise danke ich Bernhard Wirth, Universitätsbibliothek Johann Christian Senckenberg, Frankfurt am Main, und vor allem Ursula Ballin, Wien, die eine Biografie über Robert Wilhelm erarbeitet.

24 »Ich habe übrigens schon bei Wichert für ›alle Fälle‹ für nach Weihnachten Plätzchen für sie belegt.« Beckmann Ende September 1927 an Motesiczky, in: *Beckmann-Briefe*, Bd. II (Anm. 7), S. 100. Aus einem Beckmann-Brief vom 24.3.1928 an seine Frau (ebd. S. 110) geht hervor, dass sich zu diesem Zeitpunkt auch Henriette Motesiczky in Frankfurt aufhielt. Zur Kunstgewerbeschule jüngst: *Willi Baumeister – Die Frankfurter Jahre 1928–1933*, Ausst.-Kat., Museum Giersch, Frankfurt a. M. 2005.

25 Hans-Jürgen Fittkau, »Leben und Werk des Frankfurter Beckmann-Schülers Karl Tratt (1900–1937)«, in: *Archiv für Frankfurts Geschichte und Kunst 69*, hrsg. im Auftrag der Gesellschaft für Frankfurter Geschichte e.V. in Verbindung mit dem Institut für Stadtgeschichte, Frankfurt am Main 2003, S.159–176; vgl. auch die Briefe Tratts im Archiv des Marie-Louise von Motesiczky Charitable Trust, London.

26 Karlheinz Gabler, *Siegfried Shalom Sebba. Maler und Werkmann mit Œuvre-Verzeichnis der Druckgrafik*, Kassel 1981.

27 Freundlicher Hinweis von Ines Schlenker.

28 »Max Beckmanns Frankfurter Schüler 1925–1933«, Ausst.-Kat. Karmeliterkloster, Frankfurt am Main 1980. Für die freundlichen Hinweise danke ich Gerda Garve, Hamburg, und Ursula Seitz-Gray, Frankfurt am Main.

29 »… zuzugeben, daß Sie und Theo Garve auch die Spitzenfiguren sind. Die einzigen, die Max Beckmann erkennen würde.« Lilly von Schnitzler am 15.12.1980 an Motesiczky. Archiv des Marie-Louise von Motesiczky Charitable Trust, London.

30 Auch ihre freundschaftlichen Kontakte zu Klaus Gallwitz, seinerzeit Direktor des Städelschen Kunstinstituts, zeigen ihre Verbundenheit mit Frankfurt. Vgl. ihre Korrespondenz mit Gallwitz im Institut für Stadtgeschichte, Frankfurt am Main. Für freundliche Hinweise danke ich Klaus Gallwitz, Karlsruhe, sowie Silvia Stenger im Institut für Stadtgeschichte, Frankfurt am Main.

31 *Aus der Meisterklasse Max Beckmanns. Karl Tratt, Friedrich Wilhelm Meyer und ihre Kommilitonen*, bearb. v. Hans-Jürgen Fittkau, Ausst.-Kat. 1822-Stiftung der Frankfurter Sparkasse 2000/01, S. 58ff.

32 Motesiczky 1964 (Anm. 6).

33 Ebd.

34 Beckmann, zit. nach Walter Barker, »Lehren als Erweiterung der Kunst. Max Beckmanns pädagogische Tätigkeit«, in: *Max Beckmann Retrospektive*, Ausst.-Kat. Bayerische Staatsgemäldesammlungen München, Haus der Kunst und Nationalgalerie Berlin 1984, S. 176.

35 Motesiczky 1964 (Anm. 6).

36 Zur Theorie Freuds: Isabelle Graw, *Die bessere Hälfte, Künstlerinnen des 20. und 21. Jahrhunderts*, Köln 2003, S. 26.

37 Motesiczky in einem undatierten Brief an Sophie Brentano, Archiv des Marie-Louise von Motesiczky Charitable Trust, London; freundlicher Hinweis von Ines Schlenker.

38 Motesiczky 1964 (Anm. 6).

39 Ebd.

40 So die Kritik von Kristian Sotriffer, »Im Schatten des Meisters«, in: *Die Presse*, 23.5.1966.

41 Ludwig Baldass, »Die Malerin Marie-Louise Motesiczky«, in: *Die Kunst und das schöne Heim*, 55, 1955, S. 218f.

42 Josef Paul Hodin, »The Poetic Realism of Marie Louise Motesiczky«, in: *The Painter & Sculptor*, vol. 4, no. 3, London 1961/62, S. 19–23.

43 Hilde Spiel, »Die Malerin Marie-Louise Motesiczky. Eine Ausstellung in der Wiener Secession«, in: *Frankfurter Allgemeine Zeitung*, 19.5.1966; dies., »Unbeirrt auf ihrem eigenen Weg«, in: *Frankfurter Allgemeine Zeitung*, 2.1.1986.

44 Benno Reifenberg, »Marie-Louise von Motesiczky«, in: *Marie-Louise Motesiczky*, Ausst.-Kat. Wiener Secession 1996, o. S.

45 Ernst H.Gombrich, »Marie-Louise von Motesiczky«, in: *Marie-Louise von Motesiczky. Paintings Vienna 1925–London 1985*, Ausst.-Kat. Goethe Institut London 1985, S. 6f.

46 David Cohen, »Marie-Louise von Motesiczky«, in: *Modern Painters*, 1994, vol. 7, no. 2, summer, S. 93–95.

47 Sabine Plakolm-Forsthuber, *Künstlerinnen in Österreich 1897–1938*, Wien 1994, S. 165–169, 193f.

48 Lloyd 2004 (Anm. 4), S. 205–225.

49 Cohen 1994 (Anm. 46), S. 93.

50 Aus der Beckmann-Literatur seien genannt: Friedhelm W. Fischer, *Max Beckmann – Symbol und Weltbild. Grundriss zu einer Deutung des Gesamtwerks*, Diss., München 1972; Hans Belting, *Max Beckmann. Die Tradition als Problem in der Kunst der Moderne*, München 1984; Ausst.-Kat. München/Berlin 1984 (Anm. 34); Ortrud Westheider, *Die Farbe Schwarz in der Malerei Max Beckmanns*, Berlin 1995; *Max Beckmann und Paris*, Ausst.-Kat. Kunsthaus Zürich/Saint Louis Art Museum, Köln 1998; *Max Beckmann. Landschaft als Fremde*, Ausst.-Kat. Hamburger Kunsthalle/Kunsthalle Bielefeld/Kunstforum Wien, Stuttgart 1998; Christian Lenz, *Max Beckmann und die Alten Meister. »Eine ganz nette Reihe von Freunden«*, Bönningheim 2000; Max Beckmann, Ausst.-Kat. Centre George Pompidou Paris/Tate Modern London/MoMA QNS, New York 2003; Peters 2005 (Anm. 17).

51 Rainer Zimmermann, *Expressiver Realismus. Malerei der verschollenen Generation*, München 1994.

52 »It is a woman who speaks. She speaks quietly but no less insistently«. Günter Busch, *Some comments on the art of Marie-Louise von Motesiczky*, in: Ausst.-Kat. London 1985 (Anm. 45), S. 9.

53 »Yet, from the beginning, Motesiczky´s paintings had a softer, somewhat more feminine, touch.«,Ines Schlenker, in: Einleitung zum Catalogue raisonné, unveröffentliches Manuskript, o. S.

54 Zur feministischen Kunstgeschichte und der Kritik an ihr jüngst: Graw, 2005 (Anm. 36); zu Motesiczky Plakolm-Forsthuber, 1994 (Anm. 47), S. 206.

55 Ingrid von der Dollen, »Marie-Louise von Motesiczky. Malerei des Expressiven Realismus«, Folge XIX, in: *Weltkunst*, H. 15/16 vom 15.8.1997, S. 1594f.; dies., *Malerinnen im 20. Jahrhundert – Bildkunst der »verschollenen Generation« – Geburtsjahrgänge 1890–1910*, München 2000, S. 69, 199, 122, 132, 158, 165, 187, 196f, 233–238.

56 Eva Michel, *Marie-Louise von Motesiczky 1906–1996. Eine österreichische Schülerin von Max Beckmann*, Universität Wien, Diplomarbeit 2003.

57 *Die Revision der Postmoderne/Post-Modernism revisited*, hrsg. von/ed. by Ingeborg Flagge/Romana Schneider, Ausst.-Kat., Deutsches Architekturmuseum Frankfurt am Main 2004/05, Hamburg 2004.

58 Beckmann 1918, zit. nach: Beckmann 1990 (Anm. 3), S. 22.

59 Motesiczky, zit. nach: Plakolm-Forsthuber 1994 (Anm. 47), S. 168.

60 Vgl. Anm. 14.

61 »Er glaubte, er sagte es auch, dass nur durch die größte Liebe zu den Dingen Kunst entstehen kann.« Motesiczky 1964 (Anm. 6).

62 Siehe den Beitrag von Ines Schlenker in diesem Band.

63 *Das MoMA in Berlin. Meisterwerke aus dem Museum of Modern Art, New York*, Ausst.-Kat. Staatliche Museen zu Berlin, Neue Nationalgalerie 2004, S. 315.

64 Motesiczky am 3.2.1990 an Kurt Wettengl, Historisches Museum Frankfurt am Main, Archiv des Historischen Museums, Frankfurt am Main. Für die freundlichen Hinweise danke ich Kurt Wettengl, Museum am Ostwall, Dortmund, und Ursula Kern, Historisches Museum Frankfurt am Main; Plakolm-Forsthuber 1994 (Anm. 47), S. 193f.

65 Freundlicher Hinweis von Ines Schlenker.

66 *Tate Gallery. Illustrated Catalogue of Acquisitions*, London 1996, S. 502f.

67 Nina Peter, »Déjà vu. Die Bildquellen der Landschaften von Max Beckmann«, in: Ausst.-Kat. Hamburg/Bielefeld/Wien 1998 (Anm. 50), S. 45–56.

68 Hans Hildebrandt, *Die Frau als Künstlerin*, Berlin 1928.

69 Walter Fähnders, *Avantgarde und Moderne 1890–1933*, Stuttgart/Weimar 1998, S. 80–120.

70 Beckmann 1938, zit. nach: Beckmann, 1990 (Anm. 3), S. 50.

71 »My longing is to paint beautiful pictures … to become happy in doing this and to make other people happy through them.« Motesiczky zit. nach: Hodin 1961/62 (Anm. 42), S. 19.

32 The Travellers (Die Reisenden)

1940
Oil on canvas / Öl auf Leinwand
667×753 mm
Marie-Louise von Motesiczky Charitable Trust, London

The Travellers was painted shortly after the Motesiczkys arrived in England and recalls their Channel crossing. A small boat drifts helplessly on the stormy seas. It has neither sail nor rudder. There is no land in sight. In the boat, four passengers are cowering, barely clad, if at all. They have only a few belongings with them, a mirror and a large sausage. Critics have identified the travellers as members of the Motesiczky household (from left): the wet-nurse Marie Hauptmann, Henriette von Motesiczky, Karl von Motesiczky (or Ernst von Lieben, the painter's uncle) and Marie-Louise herself. However, the meaning of the painting is more general, as the passengers represent all the refugees forced into exile by the Nazis. Marie-Louise herself compared the inadequate vessel—its freight of passengers marked by uncertainty and desperate cheerfulness—with a "Ship of Fools".

Das Bild entstand kurz nach der Ankunft der Motesiczkys in England und ruft die Über-querung des Ärmelkanals in Erinnerung. Ein kleines Boot treibt hilflos auf der stürmischen See. Es hat weder Segel noch Ruder. Land ist nicht in Sicht. Vier nicht oder nur spärlich be-kleidete Passagiere kauern im Boot. Sie führen nur wenige Habseligkeiten, einen Spiegel und eine große Wurst, mit sich. Kritiker identifizierten die Reisenden immer wieder als Mitglieder des Motesiczky-Haushalts (von links): die Amme Marie Hauptmann, Henriette von Motesiczky, Karl von Motesiczky (oder Ernst von Lieben, der Onkel der Malerin) und Marie-Louise von Motesiczky selbst. Letztendlich stehen die Passagiere jedoch stellvertretend für alle Flüchtenden, die von den Nazis ins Exil gezwungen wurden. Motesiczky selbst ver-glich das unzulängliche Boot mit seiner von Ungewissheit und verzweifelter Fröhlichkeit gezeichneten Fracht mit einem »Narrenschiff«.

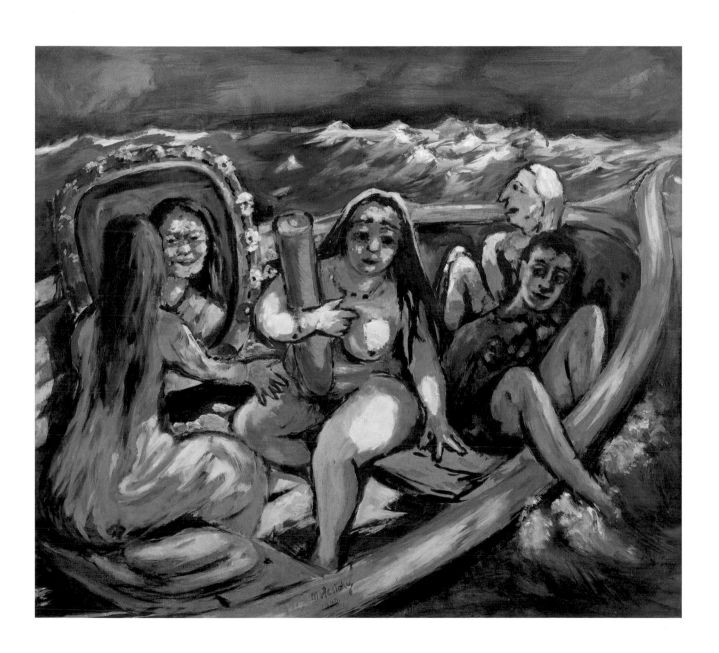

33 Girl by the Fire (Marie am Feuer)

1941
Oil on canvas / Öl auf Leinwand
510 × 762 mm
Marie-Louise von Motesiczky Charitable Trust, London

This picture shows Marie Hauptmann (Fig. 64), the daughter of a Bohemian shoemaker, who spent most of her life in the service of the Motesiczky family. At first, she was employed as wet-nurse to Marie-Louise, but in the course of time she became her "second mother" and followed the painter and her mother, Henriette von Motesiczky, into exile in England in 1939. Here Marie died in 1956 at the age of 69. Marie-Louise's picture shows Marie burning garden refuse in the garden of the house in Amersham, where she and the Motesiczkys found refuge from the air raids on London.

Das Bild zeigt Marie Hauptmann (Abb. 64), die Tochter eines böhmischen Schuhmachers, die den Großteil ihres Lebens im Dienst der Familie Motesiczky stand. Zunächst als Amme für die kleine Marie-Louise eingestellt, wurde sie im Laufe der Zeit zur »zweiten Mutter« und folgte der Malerin und ihrer Mutter 1939 ins englische Exil, wo sie 1954 im Alter von 69 Jahren starb. Motesiczkys Bild zeigt Marie beim Verbrennen von Gartenabfällen im Garten des Hauses in Amersham, in dem sie mit den Motesiczkys Zuflucht vor den Bombenangriffen auf London fand.

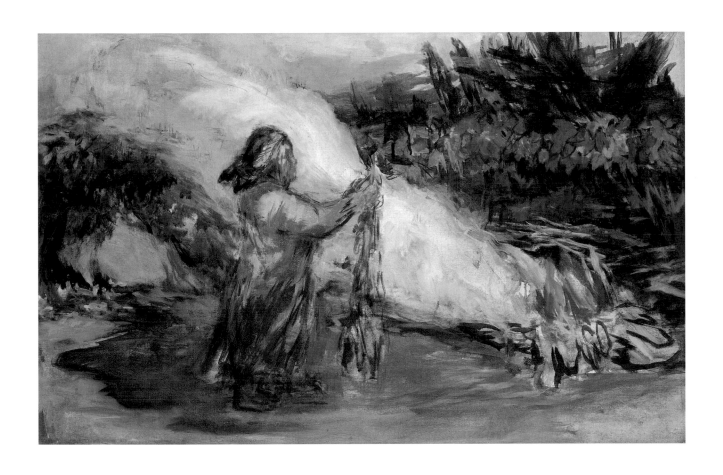

34 Old Woman, Amersham (Alte Frau, Amersham)

1942
Oil on canvas / Öl auf Leinwand
913 × 712 mm
Marie-Louise von Motesiczky Charitable Trust, London

The sitter for this portrait was a neighbour of the Motesiczkys in Amersham near London. Her name is unknown, but she was said to have been over 100 years old. Although she no longer has any teeth, she seems to have stood up well to the years. In her hands she is holding a sheet, a symbol of longevity. It is probably to be seen as a shroud, an object that was common in paintings of the 17th-century Dutch painting so admired by Marie-Louise, where it is used, as a symbol of the will to survive in the face of death.

Eine Nachbarin der Motesiczkys in Amersham bei London saß für dieses Porträt Modell. Ihr Name ist nicht bekannt, sie soll aber 100 Jahre alt gewesen sein. Obwohl nicht mehr im Besitz ihrer Zähne, scheint sie dem Alter die Stirn geboten zu haben. Wie zum Beweis ihrer Langlebigkeit hält sie ein Laken in den Händen, das wohl als Leichentuch zu verstehen ist; eine Requisite, die in der von Motesiczky bewunderten holländischen Malerei des 17. Jahrhunderts als Symbol für den Überlebenswillen im Angesicht des Todes weit verbreitet war.

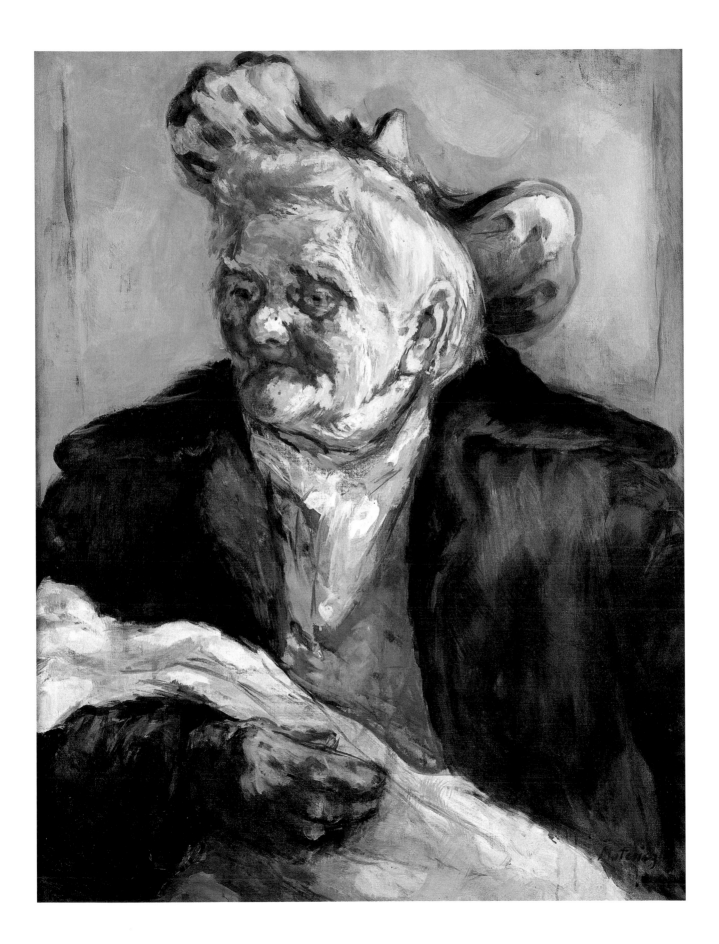

35 Self-portrait in Green (Selbstporträt in Grün)
1942
Oil on canvas / Öl auf Leinwand
406 × 304 mm
Private collection / Privatbesitz

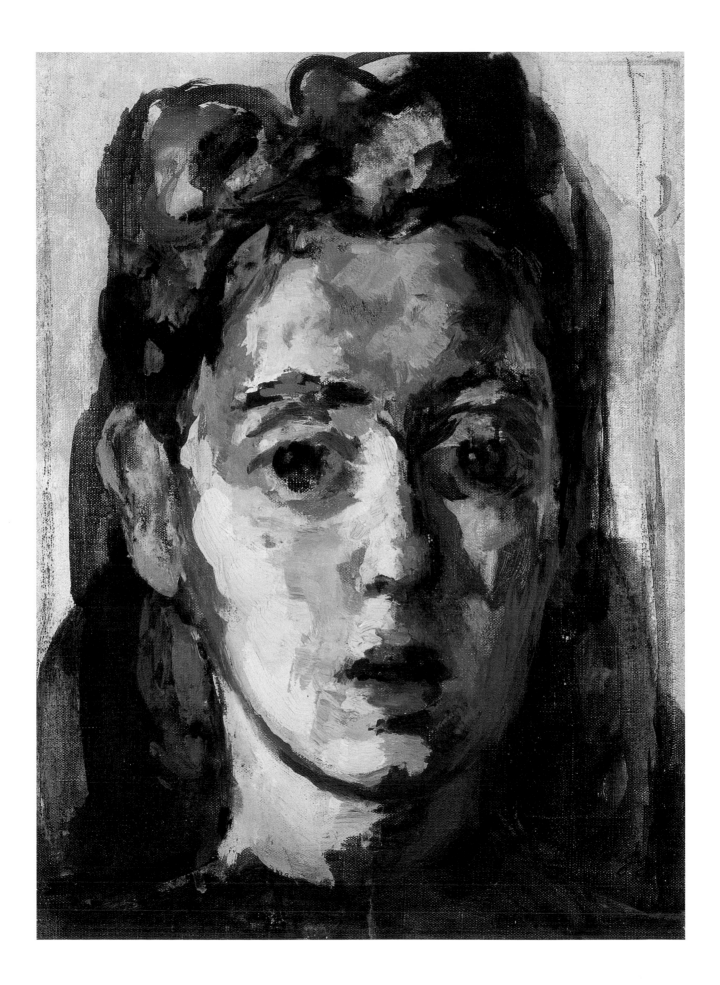

36 Morning in the Garden (Morgen im Garten)

1943
Oil on canvas / Öl auf Leinwand
636 × 766 mm
Marie-Louise von Motesiczky Charitable Trust, London

The painting, with its deceptively simple title, depicts a dreamlike encounter whose enigmatic quality was praised by one critic as an example of "Expressionist Surrealism". The scene is set in the Motesiczkys' garden in Amersham. The people playing ball can be identified as the painter and her mother. Their dog enthusiastically tries to join in their game.

Trotz des scheinbar einfachen Titels stellt Motesiczky in diesem Bild eine traumartige Begegnung dar, deren enigmatische Qualität ein Kritiker als »expressionistischen Surrealismus« pries. Die Szene spielt im Garten der Motesiczkys in Amersham. Die Ballspieler lassen sich als die Malerin und ihre Mutter identifizieren. Ihr Hund versucht freudig am Spiel teilzunehmen.

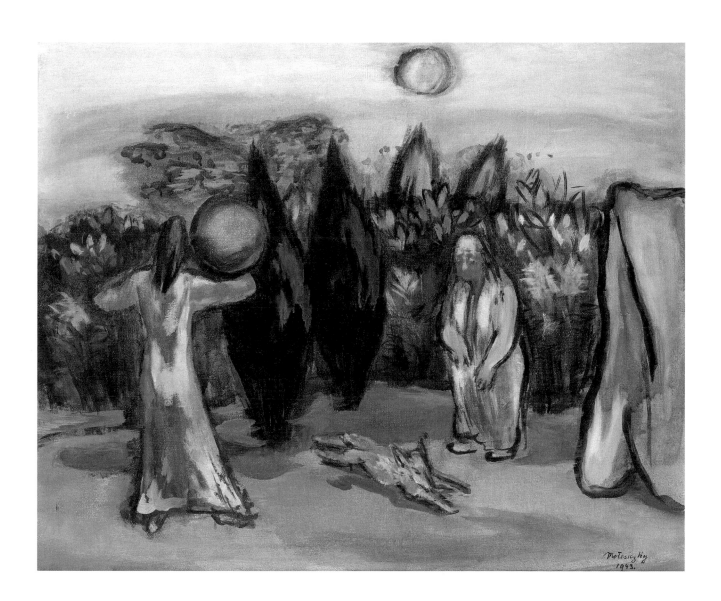

37 Three Heads (Drei Köpfe)
1944
Oil on canvas / Öl auf Leinwand
417 × 615 mm
Marie-Louise von Motesiczky Charitable Trust, London

This portrait shows three women in a bus, the "Green Line Bus", which runs between London and Amersham. This is suggested by the unusual arrangement of the portraitees and the green seats. Sitting between two fellow passengers, also wearing headscarves, Marie-Louise portrays herself as a housewife. The other women have been identified as her mother and her aunt. In its anonymity, the wartime scene is filled with an atmosphere of despondency.

Dieses Porträt zeigt drei Frauen in einem Omnibus, dem so genannten »Green Line Bus«, der zwischen London und Amersham verkehrte. Hierauf deuten die ungewöhnliche räumliche Anordnung der Porträtierten und die grünen Sitze hin. Zwischen zwei ebenfalls Kopftuch tragenden Mitreisenden sitzend, die auch als Motesiczkys Mutter und Tante interpetiert wurden, präsentiert sich Motesiczky als Hausfrau, die ihren täglichen Besorgungen nachgeht. In ihrer Anonymität ist die Szene von einer Atmosphäre der Niedergeschlagenheit erfüllt.

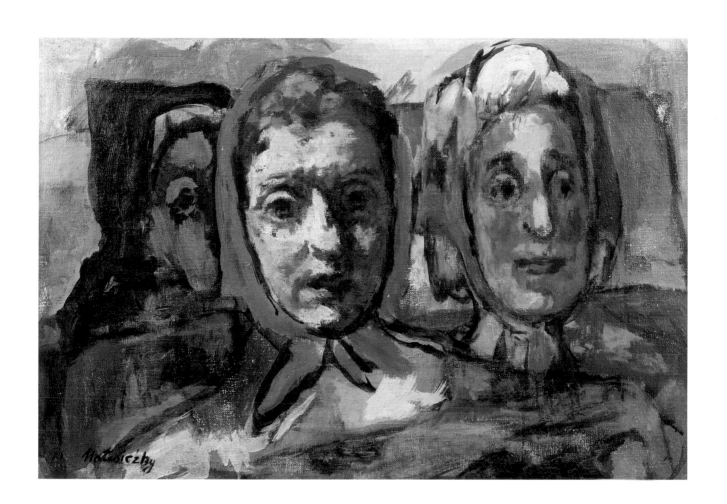

38 Snow Drift with Gate (Schneelandschaft)

early 1940s / frühe 1940er Jahre
Oil on canvas / Öl auf Leinwand
410 × 512 mm
Marie-Louise von Motesiczky Charitable Trust, London

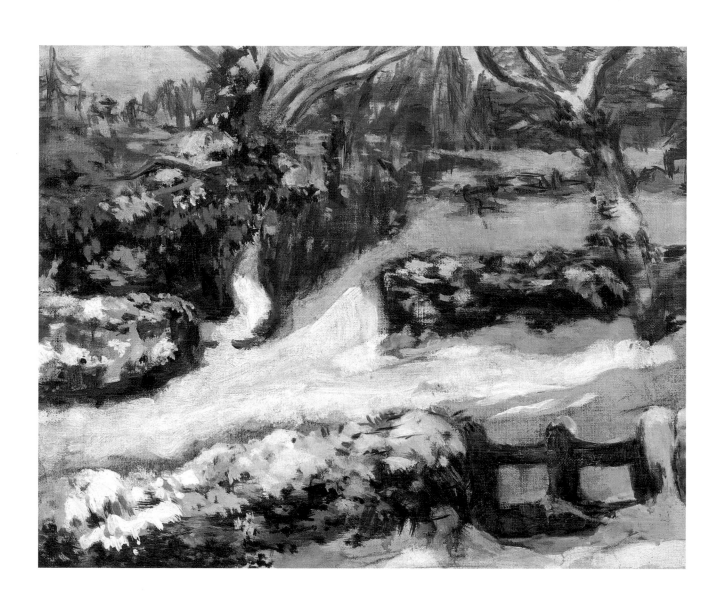

39 In the Garden (Familienbild)

1948
Oil and charcoal on canvas / Öl und Kohle auf Leinwand
867 × 1120 mm
Marie-Louise von Motesiczky Charitable Trust, London

This group portrait brings together Marie-Louise (right), her aunt Ilse Leembruggen (middle), who came to visit the Motesiczkys in Amersham after the war, and the author Elias Canetti (left), who had been a friend of the painter since the early 1940s and also lived in Amersham during the war. While Marie-Louise tackles the plants with a pair of garden shears, the aunt devotes herself to her drawing. Canetti, standing near the garden fence, looks as if he has come by for a short visit. Behind Ilse Leembruggen's back, however, a silent drama is being played out in looks. This may express Marie-Louise's upset over her aunt, who was displaying the first, as yet undiagnosed symptoms of Alzheimer's disease or a deeper conflict between Marie-Louise and Canetti. While the English title *In the Garden* seems innocent, the German title, *Familienbild*, implies that the writer was one of the family. Canetti's grim expression and forbidding attitude show clearly that this appropriation did not much please him.

Dieses Gruppenbild vereint Motesiczky (rechts), ihre Tante Ilse Leembruggen (Mitte), die nach dem Krieg zu den Motesiczkys nach Amersham zu Besuch kam, und den Schriftsteller Elias Canetti (links), der seit den frühen 1940er Jahren mit der Malerin befreundet war und während des Krieges ebenfalls in Amersham wohnte. Während Motesiczky mit einer Gartenschere den Pflanzen zu Leibe rückt, widmet sich ihre Tante dem Zeichnen. Canetti, am Gartenzaun stehend, scheint auf einen kurzen Besuch vorbeigekommen zu sein. Hinter dem Rücken Ilse Leembruggens spielt sich jedoch in den Gesten und Blicken ein stummes Drama ab. Es mag Motesiczkys Ungehaltenheit über ihre Tante, bei der sich erste, noch nicht diagnostizierte Anzeichen von Alzheimer zeigten, oder aber einen tieferen Konflikt zwischen Motesiczky und Canetti zum Ausdruck bringen. Während der englische Titel *In the Garden* unschuldig anmutet, impliziert der deutsche Titel *Familienbild* die Zugehörigkeit des Schriftstellers zur Familie. Canettis finsterer Gesichtsausdruck und seine abweisende Haltung zeigen deutlich, wie wenig ihm eine solche Vereinnahmung gefiel.

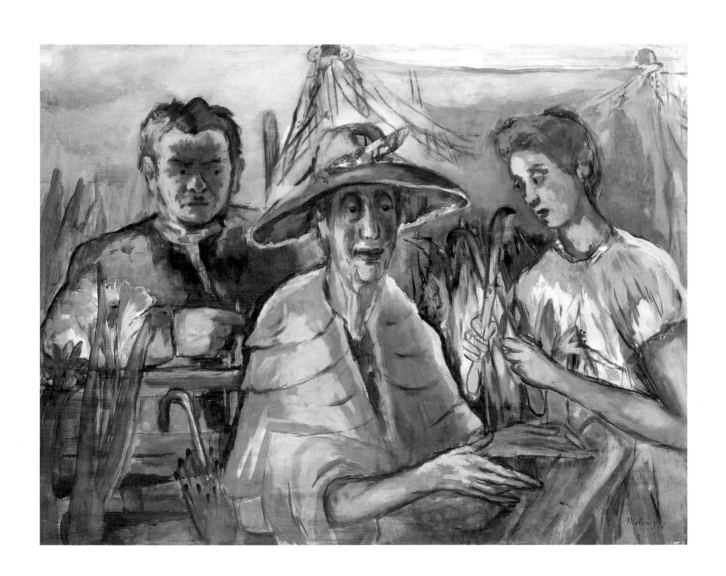

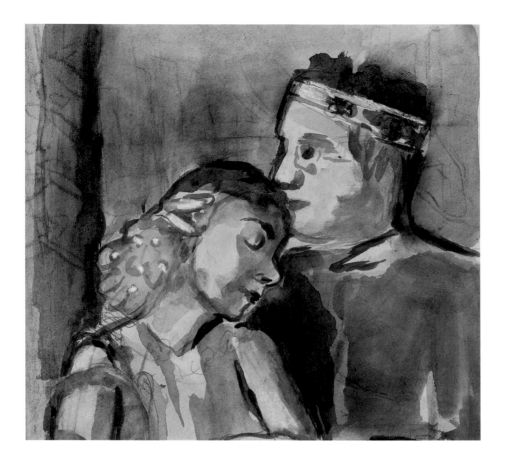

40 **Study for After the Ball (Studie zu »Nach dem Ball«)**

c. 1949 / ca. 1949
Graphite, watercolour and pastel on paper / Graphitstift, Aquarell und Pastellkreide auf Papier
250 × 350 mm
Marie-Louise von Motesiczky Charitable Trust, London

41 **After the Ball (Nach dem Ball)**

1949
Oil on canvas / Öl auf Leinwand
763 × 509 mm
Marie-Louise von Motesiczky Charitable Trust, London

This picture was painted in memory of Marie-Louise's brother, Karl von Motesiczky. When his mother and sister fled to Holland in 1938, Karl was not willing to leave Vienna. Instead, he joined the resistance and helped Jewish friends to escape the Nazis. In 1942 he was arrested and deported to Auschwitz, where he died in 1943. Marie-Louise's touching farewell portrait shows her brother with his Norwegian girlfriend. They have returned home, tired out after a masked ball, both still in their costumes. Karl seems to have dressed up as King David; he embraces his girlfriend protectively in a fleeting moment of happiness.

Das Bild entstand im Gedenken an Motesiczkys Bruder, Karl von Motesiczky. Als seine Mutter und Schwester 1938 nach Holland flohen, war Karl nicht bereit, Wien zu verlassen. Er ging in den Widerstand und half jüdischen Freunden, den Nazis zu entkommen. Im Jahr 1942 wurde er verhaftet und nach Auschwitz deportiert. Hier starb er im Jahr 1943. Ihr bewegendes Abschiedsbild zeigt den Bruder mit seiner norwegischen Freundin. Ermüdet zurückgekehrt von einem Maskenball, sind beide noch im Kostüm. Karl scheint sich als König David verkleidet zu haben. Er umarmt seine Freundin beschützend in einem Moment des Glücks, das nicht lange währt.

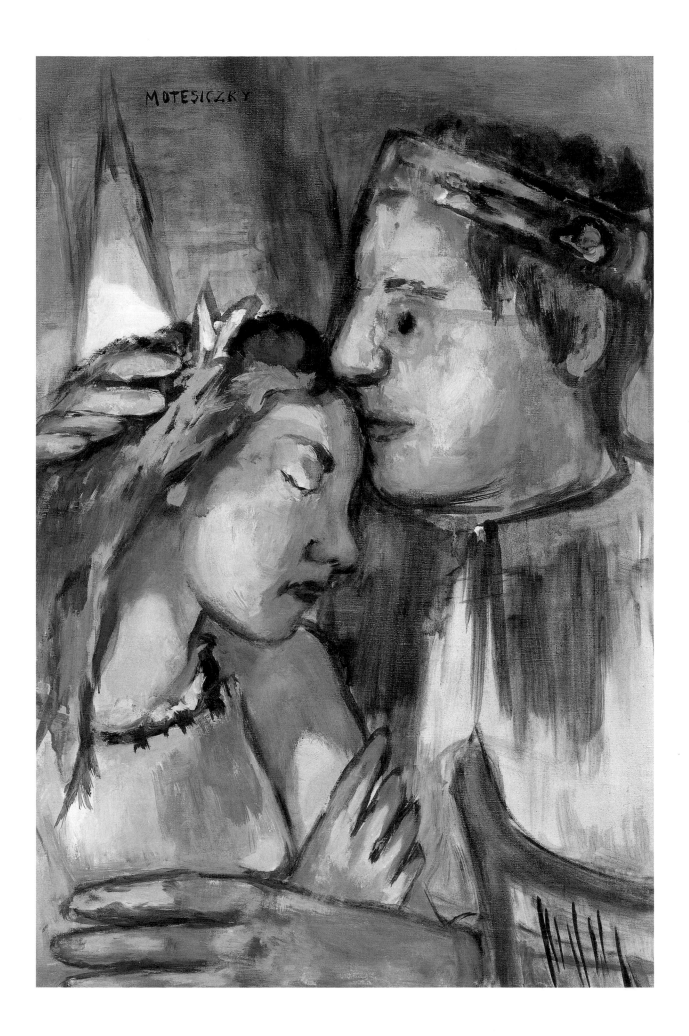

42 **Self-portrait (Selbstporträt)**

undated / nicht datiert
Watercolour on paper / Aquarell auf Papier
355 × 250 mm
Marie-Louise von Motesiczky Charitable Trust, London

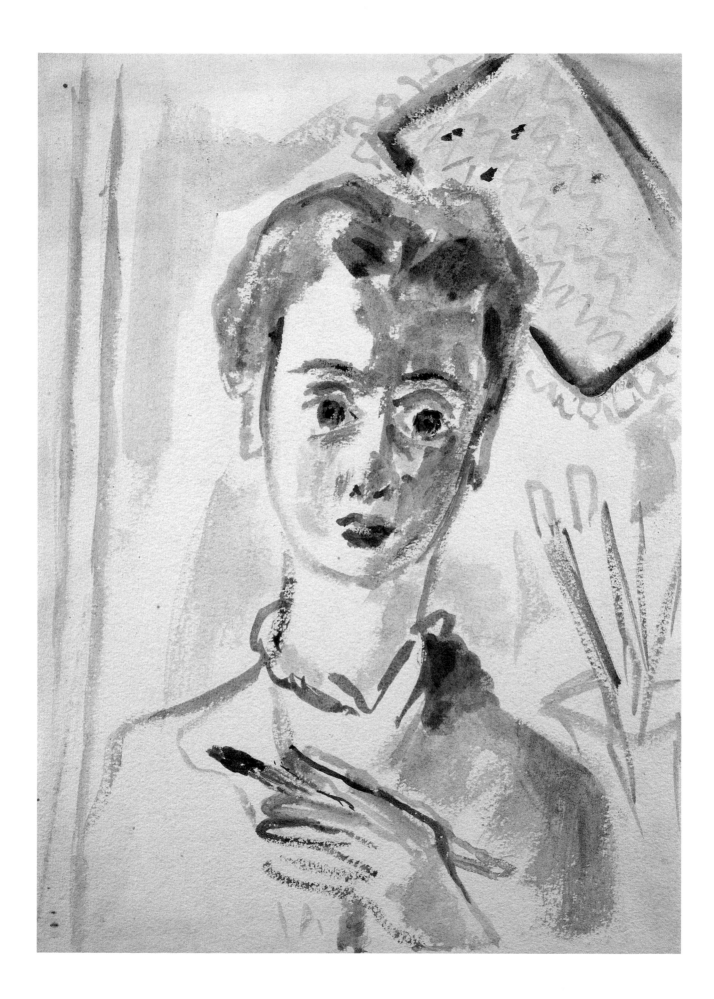

43 Conversation in the Library (Gespräch in der Bibliothek)
1950
Oil on canvas / Öl auf Leinwand
761 × 634 mm
Marie-Louise von Motesiczky Charitable Trust, London

This double-portrait shows the poet and scholar Franz Baermann Steiner and the writer and later Nobel Prize winner Elias Canetti involved in a vehement discussion. The two made friends in Vienna in 1937 and met up again in English exile. Steiner, a slight figure, seems to be defending his point of view, gesticulating emphatically, while Canetti, standing with his legs apart, pensively scratches his head. Steiner and Canetti were both enthusiastic book-lovers and Marie-Louise uses this fact to resolve the old problem of depicting a writer or poet at work. She places the two men in a room full of books, which represent the encyclopaedic knowledge they had both gathered over the years and which even their exile could not take away from them.

Dieses Doppelporträt zeigt den Dichter und Gelehrten Franz Baermann Steiner und den Schriftsteller und späteren Nobelpreisträger Elias Canetti in eine heftige Diskussion verwickelt. Die Freunde lernten sich 1937 in Wien kennen und fanden sich nun beide im englischen Exil wieder. Der schmächtige Steiner scheint heftig gestikulierend seinen Standpunkt zu verteidigen, während sich Canetti, breitbeinig dastehend, nachdenklich den Kopf kratzt. Steiner wie Canetti waren begeisterte Bücherfreunde und Motesiczky greift dies als Anregung auf, um dem alten Problem beizukommen, einen arbeitenden Dichter zu präsentieren. Sie platziert die beiden in einem Zimmer voller Bücher, die stellvertretend für das enzyklopädische Wissen stehen, das beide über die Jahre angehäuft hatten und das ihnen selbst das Exil nicht zu nehmen vermochte.

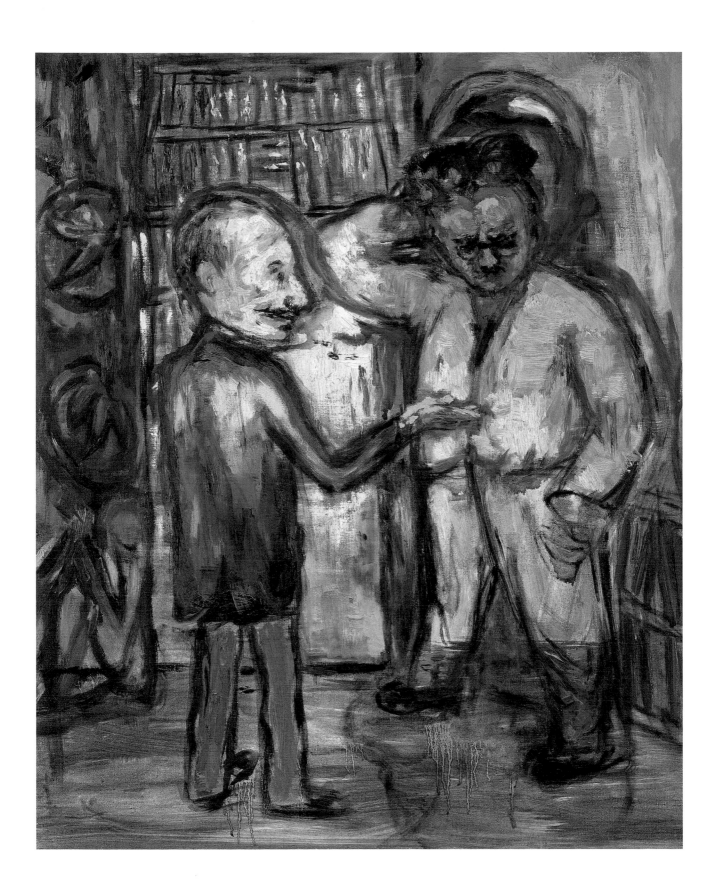

44 Hare (Hase)

c. 1950 / ca. 1950
Oil on canvas / Öl auf Leinwand
430 × 306 mm
Private collection / Privatbesitz

This study may have been partly inspired by Marie-Louise's nickname for her mother, whom she affectionately called "Has" or "Hasi", meaning "hare"—a common Austrian term of endearment. However, the title and painting allude above all to a figure in H. G. Adler's novel "Eine Reise" (A Journey) (1951–52). Adler, a close friend of Canetti, was deported to Auschwitz like Marie-Louise's brother, Karl, but survived the war and emigrated to England in 1947, spending the first night there in the Marie-Louise's apartment. His first wife, Gertrud Klepetar, who also bore the nickname "Hase", was murdered in Auschwitz in 1944. Adler's novel leaves a memorial to her in the story of a desperate "hare". Canetti was deeply moved when he read the manuscript shortly after the novel's completion, and the painter also knew the book. The frightened eyes of the hare in her painting, the fiery brushstrokes and the grey cloud are all marked by a reserved yet sombre symbolism.

Diese Studie wurde vielleicht durch Motesiczkys Kosenamen für ihre Mutter mitangeregt, die sie liebevoll »Has« oder »Hasi« nannte, doch spielen Titel und Darstellung vor allem auf eine Figur in H. G. Adlers Roman »Eine Reise« (1951/52) an. Adler, ein enger Freund Canettis, wurde wie Marie-Louises Bruder Karl nach Auschwitz deportiert, überlebte aber den Krieg und emigrierte 1947 nach England, wo er die erste Nacht in der Wohnung Motesiczkys verbrachte. Seine erste Frau, Gertrud Klepetar, die ebenfalls den Kosenamen »Hase« trug, wurde 1944 in Auschwitz ermordet. Ihr setzt Adlers Roman in der Geschichte eines verzweifelten »Hasen« ein Denkmal. Canetti las das Manuskript mit großer Bewegung bald nach der Fertigstellung, und auch die Malerin kannte das Buch. Die erschrockenen Augen des Hasen in Motesiczkys Bild, die feurigen Striche, die graue Wolke sind von einer verhaltenen, doch düsteren Symbolik geprägt.

45 **Two Women and a Shadow (Zwei Frauen und ein Schatten)**
1951
Oil on canvas / Öl auf Leinwand
758 × 1016 mm
Marie-Louise von Motesiczky Charitable Trust, London

The painter Oskar Kokoschka had been among the Motesiczkys' circle of friends in Vienna.
The contact was only briefly interrupted by their exile: before the end of 1938, the Motesiczkys
were to meet up again with Kokoschka in England, now accompanied by his future wife, Olda.
Kokoschka showed great interest in Marie-Louise's painting, and tried to direct her along
the right artistic path, alternating praise with criticism. In 1940 Kokoschka drew a portrait
of Marie-Louise in a straw hat (Fig. 46). Eleven years later she herself made her friendship
with the Kokoschkas—which was not without its problems—into the subject of a modern
conversation piece. The two women sit next to one another silently and expectantly on the
sofa in the foreground. The conversation does not really seem to get under way. The reason
for their reserve may be the presence of an unwanted listener, whose striking profile, very
recognisable as that of Oskar Kokoschka, appears clearly between them.

Der Maler Oskar Kokoschka gehörte zu den Wiener Freunden der Familie Motesiczky. Die
Verbindung wurde durch das Exil nur kurz unterbrochen. Schon 1938 trafen die Motesiczkys
Kokoschka, nun in Begleitung seiner zukünftigen Frau Olda, in England wieder. Kokoschka
zeigte großes Interesse an Motesiczkys Malerei und versuchte, ihr mit Lob oder Tadel den
richtigen künstlerischen Weg zu weisen. 1940 zeichnete Kokoschka ein Porträt Motesiczkys
mit Strohhut (Abb. 46). Elf Jahre später machte Motesiczky die Freundschaft mit den
Kokoschkas, die nicht ohne Probleme war, zum Gegenstand eines modernen Konversations-
stücks. Die Unterhaltung der beiden Frauen, die im Vordergrund stumm und erwartungs-
voll nebeneinander auf dem Sofa sitzen, scheint nicht recht in Gang zu kommen. Der Grund
für die Zurückhaltung mag in der Gegenwart eines unerwünschten Zuhörers liegen, dessen
markantes Profil, das eindeutig als das Oskar Kokoschkas zu erkennen ist, sich deutlich
zwischen ihnen abzeichnet.

46 Regent's Canal with Car (Regent's Park mit Auto)
1952
Oil on canvas / Öl auf Leinwand
761×508 mm
Marie-Louise von Motesiczky Charitable Trust, London

Regent's Park, situated not far from the Marie-Louise's residence, was one of the places in London that the artist most liked to visit. She made it the subject of several of her pictures. Here she presents the view from Macclesfield Bridge over Regent's Canal looking towards the zoo. This spring-like scene does not quite reflect reality, however, as Primrose Hill Bridge, which is in the background, cannot be seen from this vantage point. She has also placed the street lamp in the middle of the road. The idea of including a Volkswagen Beetle driving past may have been inspired by snapshots of this view that were spoiled by the sudden appearance of a car.

Der unweit ihrer Wohnung gelegene Regent's Park zählte zu jenen Orten Londons, an denen sich Motesiczky am liebsten aufhielt. Mehrfach machte sie ihn zum Motiv ihrer Bilder. Hier zeigt sie die Aussicht von der Macclesfield Bridge über den Regent's Canal hinweg in Richtung Zoo. Die frühlingshafte Szene entspricht jedoch nicht ganz der Wirklichkeit, da die Primrose Hill Bridge im Hintergrund von diesem Standpunkt aus nicht zu sehen ist. Ebenso platziert Motesiczky die Straßenlampe fälschlich mitten auf der Fahrspur. Der hübsche Einfall, einen vorbeifahrenden VW Käfer in die Komposition einzubeziehen, mag seine Inspiration in Schnappschüssen dieser Ansicht gefunden haben, die durch das plötzliche Auftauchen eines Autos verdorben wurden.

47 Frau Litwin

1952
Oil on canvas / Öl auf Leinwand
454 × 364 mm
Marie-Louise von Motesiczky Charitable Trust, London

Rachel Rebecca Litvin was born in 1890 into a family of Baltic Jews that fled to England ten
years later to escape the Tsarist pogroms. In the 1920s she rose to become a celebrated actress
under the name of Ray Litvin and regularly appeared on the stage of London's Old Vic Theatre.
In 1926 her career ended abruptly when she suddenly became almost completely deaf. Her
daughter, Natasha, made a name for herself as a concert pianist and married the well-known
poet, Stephen Spender. Frau Litwin, as she was always called by the Motesiczkys, was prob-
ably a friend of Henriette von Motesiczky. She died of cancer in 1977.

Rachel Rebecca Litvin wurde 1890 in eine Familie baltischer Juden geboren, die zehn Jahre
später vor den zaristischen Pogromen nach England floh. In den 1920er Jahren stieg sie unter
dem Namen Ray Litvin zur gefeierten Schauspielerin auf, die regelmäßig auf der Bühne des
Londoner Old Vic Theaters auftrat. 1926 nahm ihre Karriere durch eine plötzlich auftretende,
fast vollständige Taubheit ein jähes Ende. Ihre Tochter Natasha machte sich einen Namen
als Konzertpianistin und heiratete den bekannten Dichter Stephen Spender. Frau Litwin, wie
sie von den Motesiczkys immer genannt wurde, war vermutlich eine Freundin Henriette
von Motesiczkys und starb 1977 an Krebs.

48 **Still-life with Fishes (Stilleben mit Fischen)**

1953
Oil on canvas / Öl auf Leinwand
436 × 538 mm
Marie-Louise von Motesiczky Charitable Trust, London

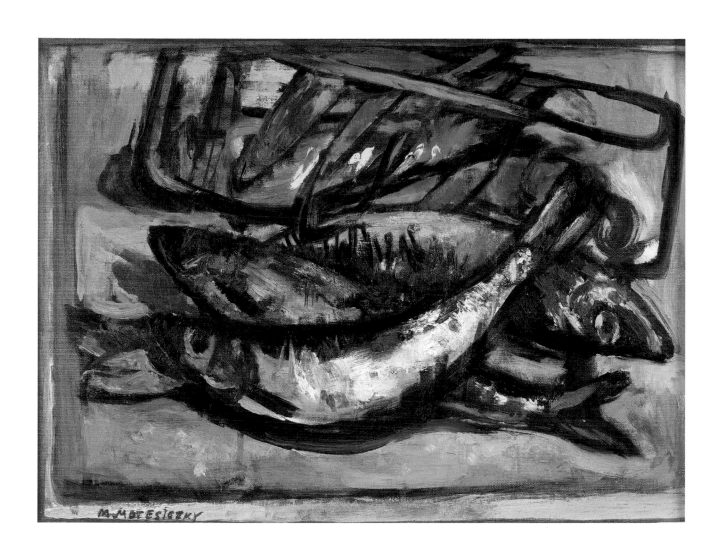

49 Water Melon (Wassermelone)

1954
Oil on canvas / Öl auf Leinwand
397 × 503 mm
Private collection / Privatbesitz

In this still-life, Marie-Louise created a daring composition of kitchen utensils and a big water melon that dominates the picture with its enticingly juicy, red flesh. As in most of Motesiczky's still-lifes, the objects appear to have been arranged almost at random. In fact they were carefully positioned to create this very effect. The extremely close-up view is also typical, and gives the objects an almost monumental appearance.

In diesem Stillleben schuf Motesiczky eine gewagte Komposition aus Küchenutensilien und einer das Bild dominierenden großen Wassermelone, die mit ihrem saftigen, roten Fleisch lockt. Wie in den meisten Stillleben Motesiczkys scheinen die Objekte eher zufällig arrangiert. In Wirklichkeit sind sie jedoch sorgfältig angeordnet, um gerade den Eindruck des Zufälligen zu erwecken. Typisch ist auch die extreme Nahsicht, die den Gegenständen eine gewisse Monumentalität verleiht.

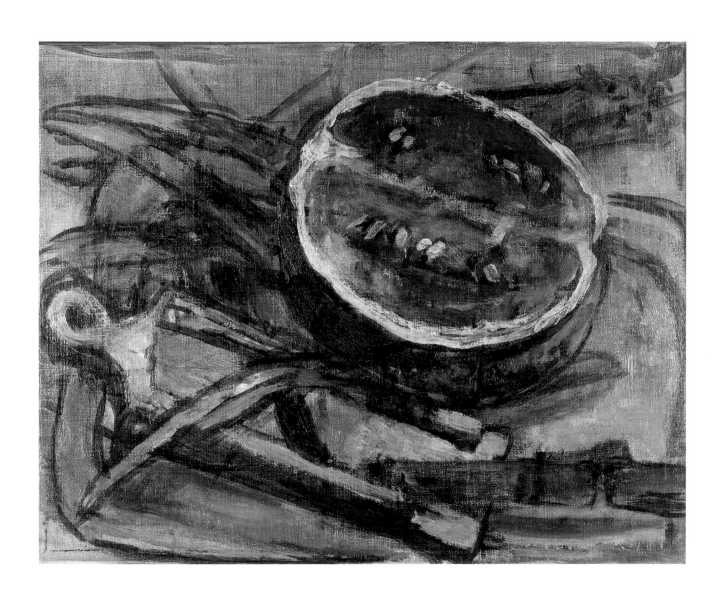

50 **Reclining Woman with Pipe (Liegende mit Pfeife)**

1954
Oil on canvas / Öl auf Leinwand
713 × 1017 mm
Marie-Louise von Motesiczky Charitable Trust, London

Henriette von Motesiczky, now already over 70 years of age, is presented here, as in other
pictures (cat. no. 17, 59, 74, 77, 78, 80), taking a rest in bed. Half sitting up, her sparse hair hidden
beneath a wig, and gesticulating animatedly, she does not seem to be interested in sleeping.
The pipe in her outstretched hand shows a masculine vice in which she indulged for several
decades.

Henriette von Motesiczky, nun schon über siebzig Jahre alt, wird hier wie auch in anderen
Bildern (Kat. Nr. 17, 59, 74, 77, 78, 80) ruhend im Bett dargestellt. Halb aufgerichtet, die spär-
lichen Haare unter einer Perücke versteckt und animiert gestikulierend, scheint sie jedoch
an Schlaf nicht zu denken. Die Pfeife in der ausgestreckten Hand zeugt von einem männlich
konnotierten Laster, dem sie einige Jahrzehnte frönte.

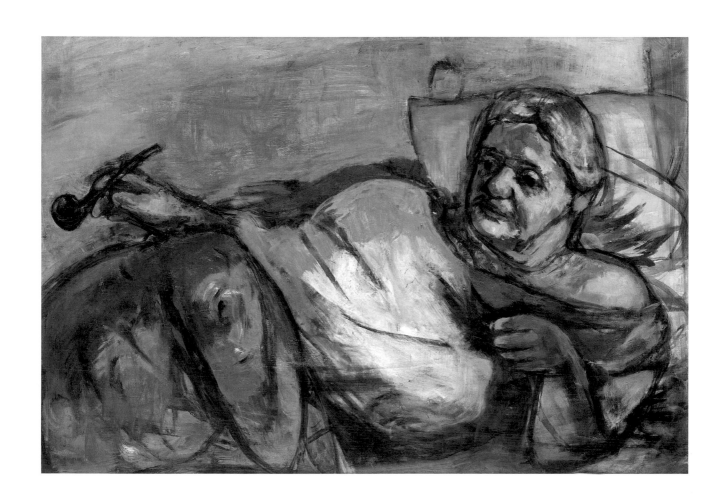

51 Apples from Hinterbrühl (Die letzten Äpfel aus der Hinterbrühl)

1955
Oil on canvas / Öl auf Leinwand
401 × 753 mm
Private collection / Privatbesitz

The inspiration for this still-life came from a sack of apples from Hinterbrühl that some friends brought Marie-Louise. Painted in just a few days, it is far more than just a colour study of slowly rotting fruit. It also has a profound personal meaning that explains its melancholy aura. After the painter and her mother had fled Austria in 1938, Karl von Motesiczky looked after the family estate in Hinterbrühl and planted an orchard there to carry the costs. However, shortly after this he was arrested by the Gestapo and deported to Auschwitz, where he died in 1943. In 1956 the Motesiczkys finally sold the property in Hinterbrühl to Hermann Gmeiner, who set up an SOS Children's Village there. In her still-life, Marie-Louise created a touching memorial for her brother and a world that had vanished, as she had done once before in *After the Ball,* 1949 (cat. no. 41).

Ein Sack voller Äpfel aus Hinterbrühl, den ihr Freunde mitgebracht hatten, regte Motesiczky zu diesem Stillleben an. In nur wenigen Tagen entstanden, ist es weit mehr als eine Farbstudie zu langsam faulendem Obst. Es besitzt eine tiefe persönliche Bedeutung, die seine melancholische Aura erklärt. Nachdem die Malerin und ihre Mutter 1938 aus Österreich geflohen waren, kümmerte sich Karl von Motesiczky um das Familienanwesen in Hinterbrühl und legte dort einen Obstgarten an, um damit die Kosten des Anwesens zu decken. Er wurde aber kurz darauf von der Gestapo verhaftet und nach Auschwitz deportiert, wo er 1943 starb. Im Jahr 1956 verkauften die Motesiczkys schließlich den Besitz in Hinterbrühl an Hermann Gmeiner, der dort ein SOS-Kinderdorf errichtete. Die hier abgebildeten Äpfel waren die letzten aus Karls Obstgarten. In ihrem stillen Gemälde schuf Motesiczky wie schon zuvor in *Nach dem Ball,* 1949 (Kat. Nr. 41), ein bewegendes Andenken an ihren Bruder und eine verlorene Welt.

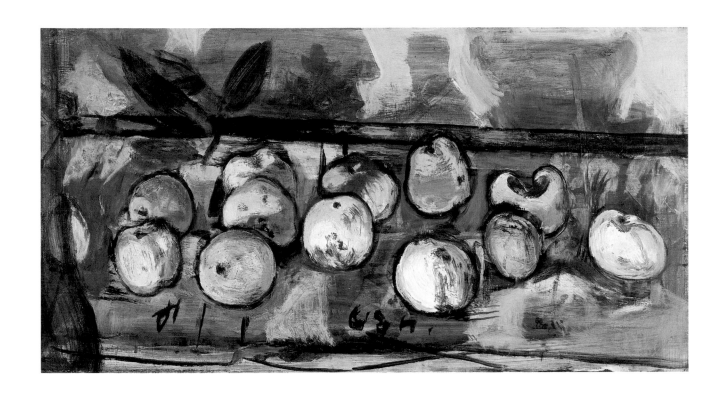

52 The Magic Fish (Zauberfisch)
1956
Oil on canvas / Öl auf Leinwand
765 × 1019 mm
Marie-Louise von Motesiczky Charitable Trust, London

The picture evokes a strange encounter that seems to have come directly from the mysterious world of fairy tales, but was probably really inspired by a dream. In a darkened room, a half-naked woman, similar in appearance to the painter, is wrestling with a huge, colourful, flying fish. It is unclear whether the fish represents an object of desire or a threat, whether she is trying to catch it or drive it away. The equipment, probably a fishing net, would seem inadequate in either case.

Motesiczky beschreibt hier eine rätselhafte Begegnung, die direkt der magischen Welt der Märchen zu entspringen scheint, in Wirklichkeit jedoch wohl eher von einem Traum inspiriert wurde. In einem abgedunkelten Zimmer ringt eine halb nackte Frau, die der Malerin ähnelt, mit einem riesigen, bunten, fliegenden Fisch. Es ist unklar, ob der Fisch ein Objekt der Begierde oder eine Bedrohung darstellt, ob sie den Fisch einzufangen sucht oder danach trachtet, ihn zu vertreiben. Das Werkzeug, vermutlich ein Fischnetz, scheint in jedem Fall ungeeignet.

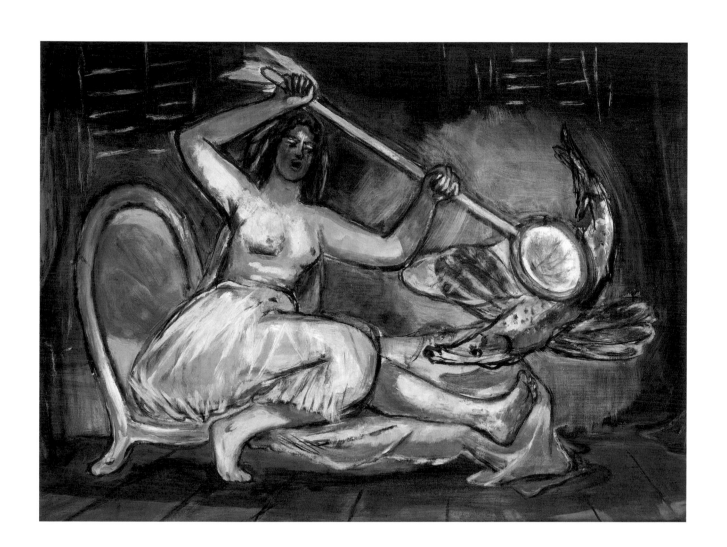

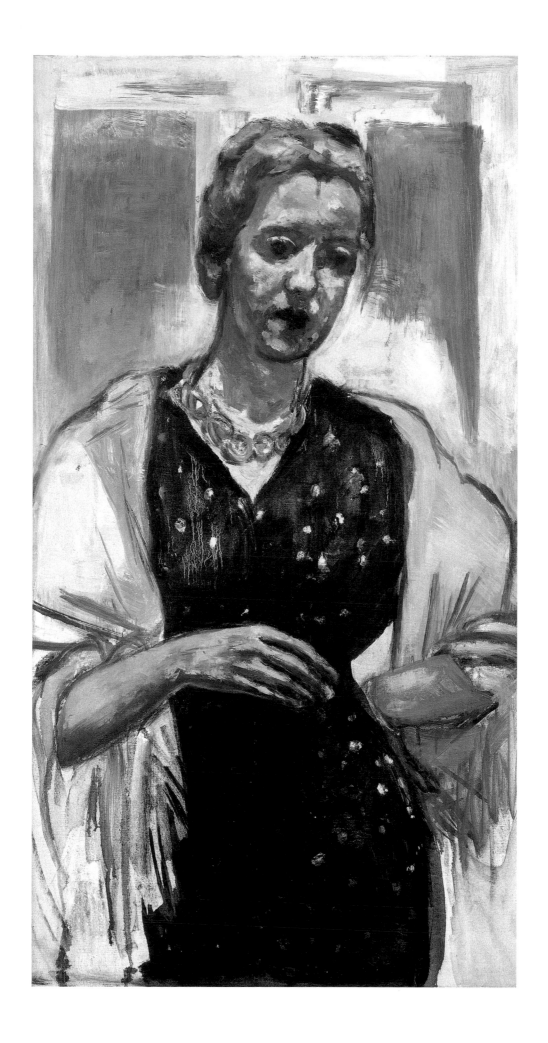

54 **Henriette von Motesiczky**

1959
Oil on canvas / Öl auf Leinwand
920 × 800 mm
Private collection / Privatbesitz

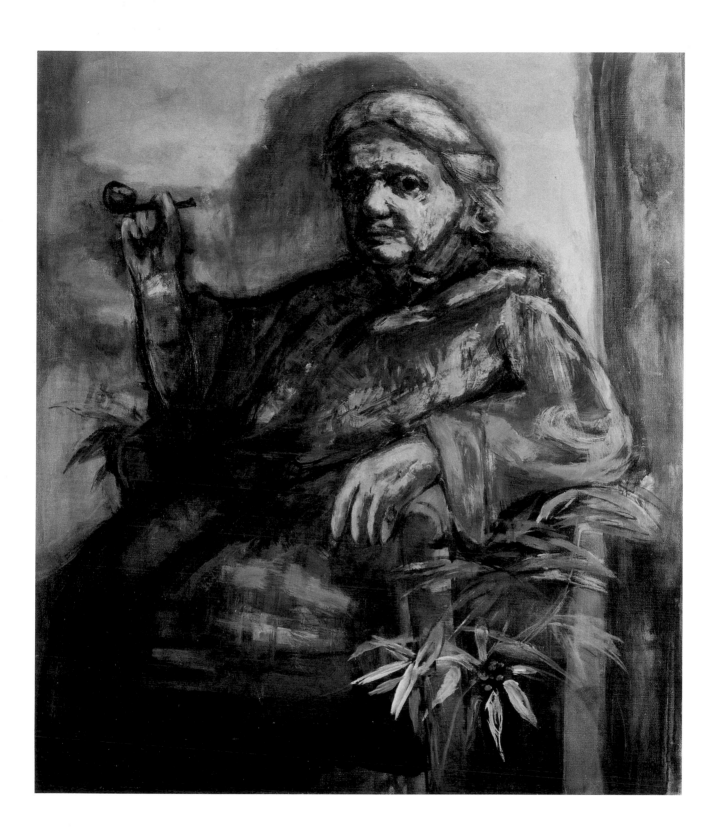

55 The Old Song (Das alte Lied)

1959
Oil on canvas / Öl auf Leinwand
1017 × 1526 mm
Marie-Louise von Motesiczky Charitable Trust, London

Marie-Louise's largest painting tells a story. An old woman, Henriette von Motesiczky, the painter's aged mother, is lying in bed. She has sat up against the pillows to be able to listen better to the harpist sitting at her feet. The musician is the German-born Liss Gray, a friend and neighbour of the Motesiczkys in Amersham, who was unhappily married to the composer Allan Gray. During her visits, she used to complain about her husband, probably represented in the picture by the bird that is disturbing the music. In *The Old Song*, Marie-Louise tried to capture an aspect of her mother's personality that seemed to her particularly important and that did not disappear even in old age: her joy in life, her longing for new things. Some iconographic allusions, such as the harpist's red cloak with ermine edging and the almost heraldic appearance of the bird, create another level in the picture, and allude to the vanished world of the aristocracy in which the Motesiczkys had moved before their exile. There is an almost mythical dimension here as well: the painter transforms the Biblical motif of David playing his harp for Saul into a female scene in which the phoenix-like bird and the Italian greyhound are to be seen as symbols of the spiritual and the earthly.

Motesiczkys größtes Bild erzählt eine Geschichte. Eine alte Frau, Henriette von Motesiczky, die betagte Mutter der Malerin, liegt im Bett. Sie hat sich neugierig in den Kissen aufgerichtet, um der zu ihren Füßen sitzenden Harfenspielerin besser zuhören zu können. Bei der Musikerin handelt es sich um Liss Gray, eine Freundin und Nachbarin der Motesiczkys in Amersham. Die gebürtige Deutsche war mit dem Komponisten Allan Gray in unglücklicher Ehe verheiratet. Bei ihren Besuchen pflegte sie sich über ihren Gatten zu beschweren, der im Bild vermutlich als Vogel dargestellt wird und die Musik stört. In *Das alte Lied* versuchte die Malerin einen Aspekt der Persönlichkeit ihrer Mutter einzufangen, der ihr besonders wichtig erschien und der selbst im Alter nicht verschwand: ihre Lebenslust und ihr Sehnen nach Neuem. Einige ikonographische Anspielungen, wie der rote, hermelinbesetzte Umhang der Harfenspielerin und der fast heraldisch anmutende Vogel, weisen auf eine weitere Ebene des Bildes hin, auf die untergegangene Welt der Aristokratie, in der sich die Motesiczkys vor ihrem Exil bewegten. Schließlich findet sich hier auch eine ans Mythische grenzende Dimension, verwandelt doch die Malerin die biblische Motivik des Harfenspielers David vor Saul in eine weibliche Szene, wobei der phönixhafte Vogel und das Windspiel als Sinnbild der Seele bzw. des Irdischen zu verstehen sind.

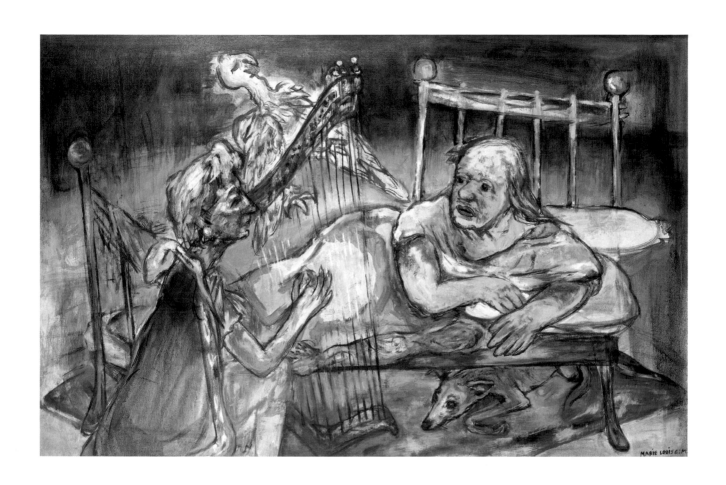

56 Elias Canetti

1960
Oil on canvas / Öl auf Leinwand
499 × 396 mm
Wien Museum, Inv. no. 133.725

The lifelong friendship between Marie-Louise von Motesiczky and the writer and later Nobel laureate Elias Canetti began shortly after they arrived in England in 1939. This portrait is one of the first in a series in which the painter captures Canetti's striking features. Work on this picture took several years, as Canetti did not like to sit. In the end, Marie-Louise had to make do with sketches, photographs and her memory. She painted a larger-than-life, majestic head surrounded by an atmosphere of profound concentration. At the time when this portrait was shown in Marie-Louise's solo exhibition at the Secession in Vienna, Canetti was awarded the Writer's Prize of the City of Vienna. The Culture Office of Vienna then purchased the picture and gave it to the Historisches Museum der Stadt Wien (now the Wien Museum).

Die lebenslange Freundschaft zwischen Marie-Louise von Motesiczky und dem Schriftsteller und späteren Nobelpreisträger Elias Canetti begann kurz nach beider Ankunft in England im Jahr 1939. Dieses Porträt ist eines der ersten in einer Reihe von Werken, in denen die Malerin die markanten Gesichtszüge Canettis einfängt. Die Arbeit an diesem Bild zog sich über mehrere Jahre hin, da Canetti ungern Modell saß. Motesiczky, die sich schließlich mit Skizzen, Fotografien und ihrem Gedächtnis behelfen musste, schuf einen überlebensgroßen, majestätischen Kopf, den eine Atmosphäre tiefster Konzentration umgibt. Genau zu dem Zeitpunkt, als das Porträt 1966 in Motesiczkys Einzelausstellung in der Wiener Secession zu sehen war, erhielt Canetti den Dichterpreis der Stadt Wien. Das Kulturamt der Stadt Wien erwarb daraufhin das Bild und übergab es dem Historischen Museum der Stadt Wien (heute Wien Museum).

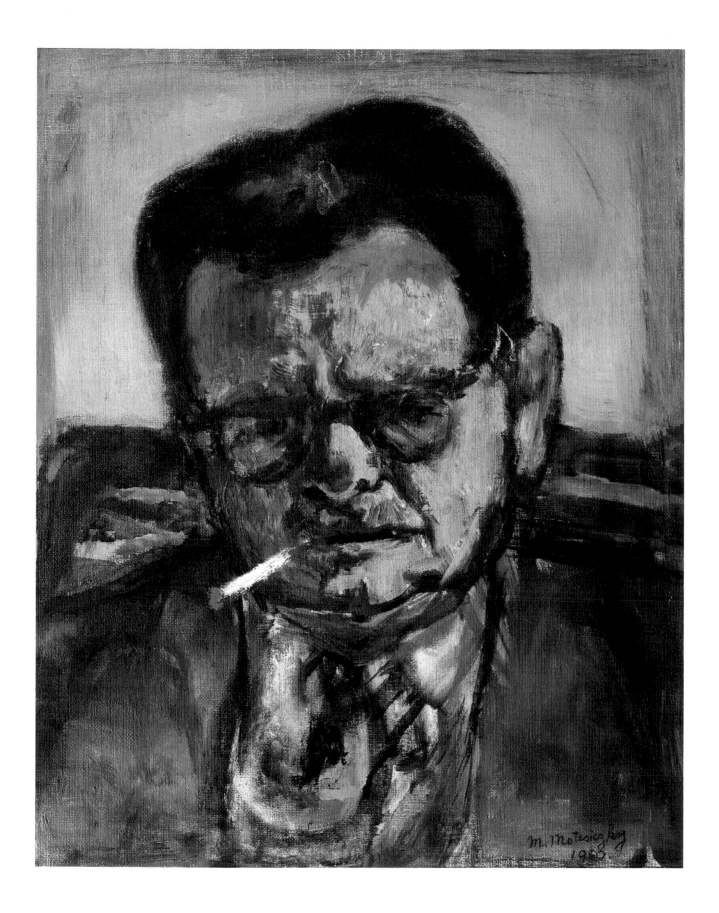

57 Head of Henriette (Kopf Henriette)

undated / nicht datiert
Black chalk on paper / Schwarze Kreide auf Papier
230 × 180 mm
Marie-Louise von Motesiczky Charitable Trust, London

58 Henriette M.

1961
Oil on canvas / Öl auf Leinwand
800 × 750 mm
Manchester Art Gallery, Inv. no. 1995.139

59 Mother with a Straw (Mutter mit Strohhalm)

1962
Oil on canvas / Öl auf Leinwand
509 × 613 mm
Marie-Louise von Motesiczky Charitable Trust, London

This portrait shows the now almost completely bald, eighty-year-old Henriette von Motesiczky lying in her bed, accompanied by her Italian greyhound. She seems to be drinking through a straw with difficulty. When this portrait was shown in the painter's first solo exhibition in Vienna in 1966, a critic classed it "among the most powerful portraits that could be seen in Austria in recent times". By then the painting already belonged to Elias Canetti, who regarded it as his favourite picture.

Dieses Porträt zeigt die nun fast vollständig kahlköpfige, 80-jährige Henriette von Motesiczky im Bett liegend mit ihrem Windspiel. Durch einen Strohhalm scheint sie mühsam etwas Flüssigkeit zu sich zu nehmen. Als dieses Bildnis 1966 in der ersten Einzelausstellung der Künstlerin in Wien gezeigt wurde, zählte ein Kritiker es »zu den stärksten Bildnissen, die man in der letzten Zeit in Österreich sehen konnte«. Zu diesem Zeitpunkt gehörte das Bild bereits Elias Canetti, der es als sein Lieblingsbild bezeichnete.

60 Uncle Ernst (Onkel Ernst)

1963
Oil and charcoal on canvas / Öl und Kohle auf Leinwand
408 × 510 mm
Marie-Louise von Motesiczky Charitable Trust, London

Ernst von Lieben, Henriette von Motesiczky's elder brother, was born in Vienna in 1875. In 1901 he received his doctorate in chemistry from Vienna University. From then on he worked in the family-owned bank, but was also active as an inventor. In the late 1930s he left Austria, spending the war years in Cuba. After the war he lived for some years in Portugal before returning for good to Vienna, where he died in 1970. When Ernst von Lieben visited his relatives in London in 1963, Marie-Louise tried to paint his portrait. The sittings proved to be unexpectedly difficult, however, as the model did not want to sit still. In her desperation, the artist resorted to a strategy that she often used later: she did a number of drawings that helped her with her work on the oil painting, which she would complete in the absence of the model. As if to signal a triumph over these difficulties, the portrait shows the uncle resting, perhaps even sleeping.

Ernst von Lieben, Henriette von Motesiczkys älterer Bruder, wurde 1875 in Wien geboren. Im Jahr 1901 promovierte er an der Wiener Universität in Chemie und arbeitete fortan in der familieneigenen Bank, betätigte sich aber außerdem als Erfinder. In den späten 1930er Jahren verließ er Österreich und verbrachte die Kriegsjahre in Kuba. Nach dem Krieg lebte er einige Jahre in Portugal, um dann endgültig nach Wien zurückzukehren, wo er 1970 starb. Als Ernst von Lieben 1963 seine Verwandten in London besuchte, versuchte sich Motesiczky an seinem Porträt. Die Sitzungen gestalteten sich jedoch unerwartet schwierig, da das Modell nicht stillsitzen wollte. In ihrer Verzweiflung nahm sie Zuflucht zu einer Strategie, die sie später immer wieder anwenden sollte: Sie fertigte eine Reihe von Zeichnungen, die ihr bei der Arbeit am Ölbild, oft in Abwesenheit des Modells, halfen. Wie als Zeichen des Triumphs über all die Widrigkeiten zeigt das Porträt den Onkel in Ruheposition, vielleicht sogar schlafend.

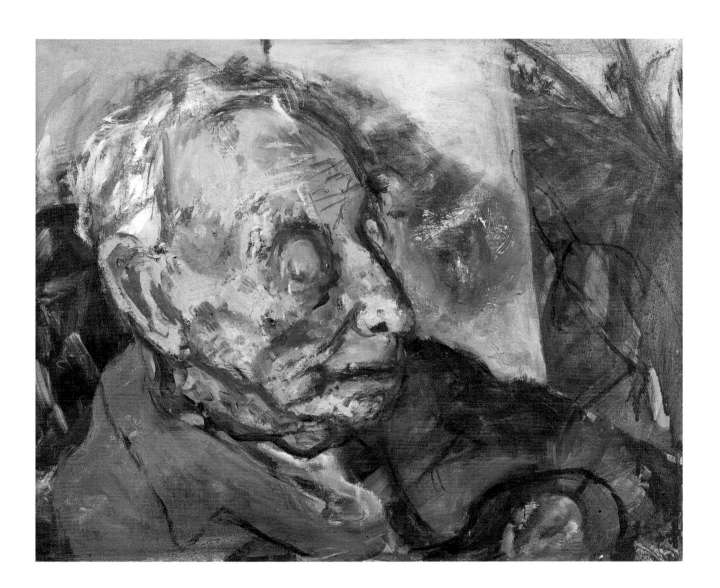

61 Iris Murdoch

1964
Oil on canvas / Öl auf Leinwand
751×498 mm
St Anne's College, Oxford

The writer and philosopher Iris Murdoch met Marie-Louise through Elias Canetti and Franz Baermann Steiner, who became unofficially engaged to her shortly before his death. When Iris Murdoch gave up her position as lecturer in philosophy at St Anne's College, Oxford, in 1963, so that she could devote herself to her novels, she wanted to give the College her portrait as a farewell present. She commissioned Marie-Louise to do the portrait, hoping to gain a wider audience for an artist whom she admired. The painting shows the writer, looking a little dishevelled and with an absent, dreamy expression, in front of a stormy sea, in which the bow of a ship can be seen. Marie-Louise uses the ship, the emblem of the college, to indicate the portrait's ultimate location. Murdoch first saw the portrait shortly before it was completed. She found it remarkably accurate, noting in her diary on 16 February 1964: "I think it is wonderful, terrible, so sad and frightening, me with the demons. How did she know?"

Die Schriftstellerin Iris Murdoch lernte Motesiczky über Elias Canetti und Franz Baermann Steiner kennen, der sich mit ihr kurz vor seinem Tode inoffiziell verlobte. Als Murdoch 1963 ihre Lehrtätigkeit als Dozent für Philosophie am St. Anne's College, Oxford, aufgab, um sich ihren Romanen zu widmen, wollte sie dem College als Abschiedsgeschenk ein Porträt von sich übergeben. Murdoch beauftragte Motesiczky mit der Ausführung des Bildnisses. Sie hoffte damit eine Künstlerin, die sie bewunderte, einem breiteren Publikum näher zu bringen. Das Gemälde zeigt die Schriftstellerin, die leicht zerzaust wirkt, mit einem abwesenden, träumenden Gesichtsausdruck vor einer stürmischen See, auf der der Bug eines Schiffes zu erkennen ist. Mit dem Schiff, dem Wahrzeichen des Colleges, verweist Motesiczky auf den Bestimmungsort des Porträts. Murdoch sah das Porträt zum ersten Mal kurz vor seiner Vollendung. Sie fand es verblüffend akkurat und notierte am 16. Februar 1964 in ihrem Tagebuch: »Ich finde es wunderbar, schrecklich, so traurig und Furcht erregend, ich mit den Dämonen. Woher wusste sie das?«

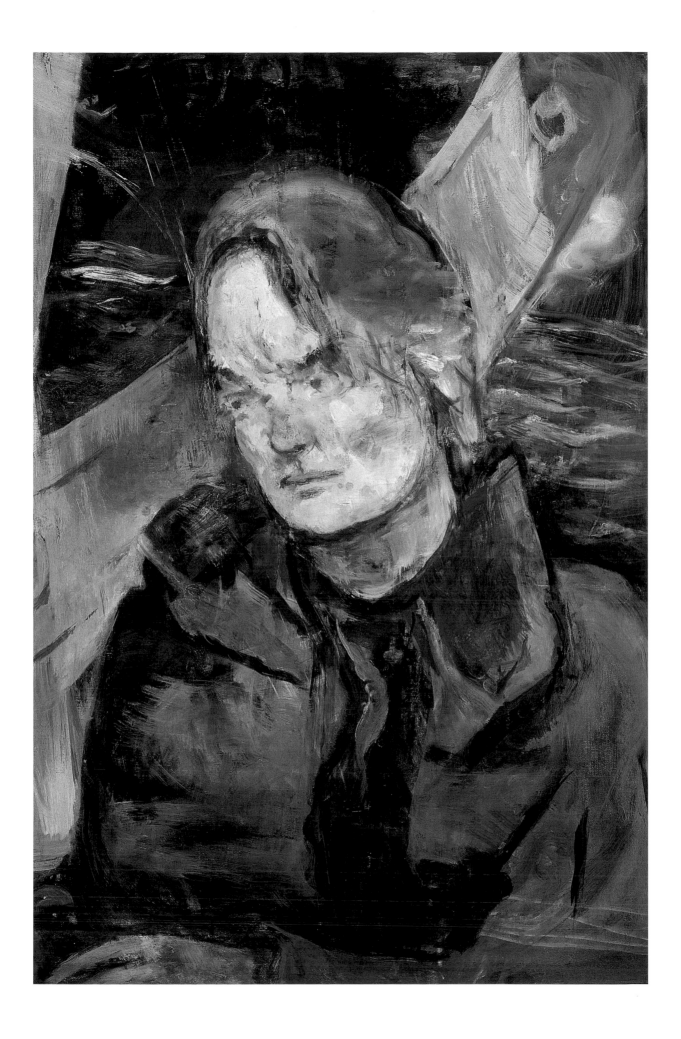

62 Chemist's Shop (Drogerie)

1964
Oil on canvas / Öl auf Leinwand
814 × 814 mm
Marie-Louise von Motesiczky Charitable Trust, London

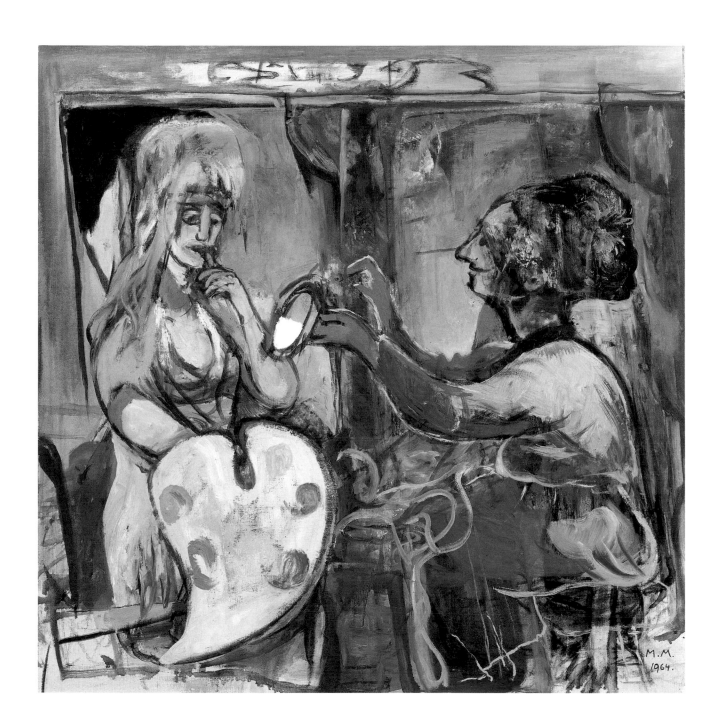

63 Canetti, London

1965
Oil on canvas / Öl auf Leinwand
253 × 304 mm
Marie-Louise von Motesiczky Charitable Trust, London

In the early 1960s, the relationship between Marie-Louise and Elias Canetti underwent a change. After the death of his first wife, the writer Veza Canetti, in 1963, the painter had hopes of marrying him. But a proposal was never forthcoming, although they continued to live together on close terms, often ate together and worked under the same roof. This portrait of Canetti, concentrated on reading the newspaper and smoking a cigarette, expresses the familiarity that had grown up over many years. It was probably painted while Canetti was staying in Brunswick in February 1965, where his "Komödie der Eitelkeit" (The Comedy of Vanity) was being given its premiere. In letters from Germany, he repeatedly requested a new picture for when he returned. Marie-Louise seems to have responded to his wish by painting this small quickly executed portrait, using a Polaroid photograph as an aid to her memory.

In den frühen sechziger Jahren änderte sich die Beziehung zwischen Marie-Louise von Motesiczky und Elias Canetti. Nach dem Tod der ersten Frau Canettis, der Schriftstellerin Veza Canetti, im Jahr 1963, hoffte die Malerin auf die Heirat mit dem Witwer. Ein Antrag erfolgte jedoch nie, obwohl sie weiterhin eng zusammenlebten, oft gemeinsam aßen und unter dem gleichen Dach arbeiteten. Dieses Porträt des konzentriert Zeitung lesenden, eine Zigarette rauchenden Canetti ist Ausdruck der über viele Jahre gewachsenen Vertrautheit. Es entstand vermutlich während Canettis Aufenthalt in Braunschweig im Februar 1965, wo seine »Komödie der Eitelkeit« uraufgeführt wurde. In Briefen aus Deutschland wünschte er sich wiederholt ein neues Bild zu seiner Rückkehr. Motesiczky scheint dem Wunsch mit diesem kleinformatigen, rasch entstandenen Porträt nachgekommen zu sein, zu dem sie als Gedächtnisstütze ein Polaroid benutzte.

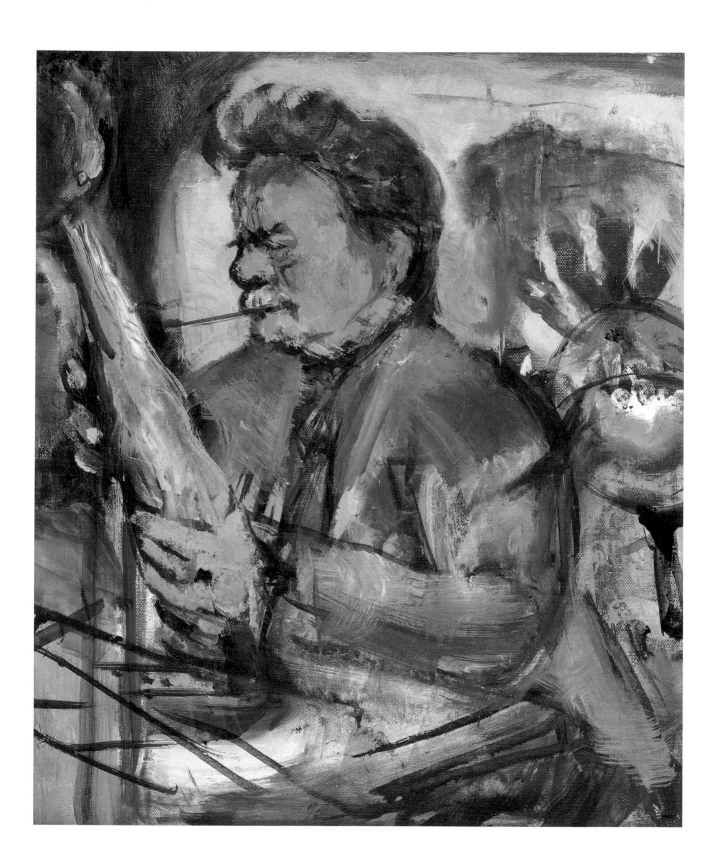

Ines Schlenker

"But an émigré ... not at all"[1]:
Marie-Louise von Motesiczky in England

When Marie-Louise von Motesiczky left Max Beckmann's master class in 1928, ending her years of apprenticeship, her prospects of a successful artistic career were extremely promising. The work of earlier generations of women artists had gone some way towards removing at least the chief reservations about women in the arts. As a pupil of one of the most celebrated representatives of the avant-garde, she could hope for the support of the public, collectors and critics. The following years, which she spent chiefly in Vienna, saw a phase of concentrated work during which the contours of her own characteristic style evolved. In 1933, she ventured into the public eye for the first time in an exhibition of the Vienna Hagenbund. The invasion of Austria by the National Socialists on March 12, 1938, however, put an abrupt end to her career before it could really begin. Marie-Louise instinctively sensed the danger posed by the National Socialists. Later, she told how the frightening calls of "Sieg Heil!" had upset her from the start. As was the case with so many assimilated Jews in Germany and Austria, it was the rise of the National Socialist party that for the first time made her take any notice of her origins. For Marie-Louise, who had been baptised a Protestant, the Jewish background of her family had never played any role before.

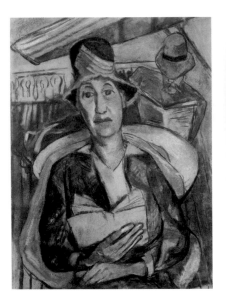

41 *Portrait Frau L. / Porträt Frau L.*, 1934, Pastel on paper / Pastellstift auf Papier, 600 × 480 mm, Private collection / Privatsammlung, Holland

Into Dutch exile

The very day after the "Anschluss", Marie-Louise precipitately left Vienna with her mother. Both of them travelled on Czech passports that they had been given at the end of the First World War. Uncertain of how long their enforced absence would be, they went first to Holland, where they could expect help from an aunt, Ilse Leembruggen (Fig. 41). Henriette von Motesiczky "felt very lost in the new Dutch surroundings",[2] while her daughter tried to keep up some semblance of normality in the makeshift world of hotels and pensions by continuing with her painting. She made pictures like *Self-portrait with Red Hat* (1938, cat. no. 29), one of her most striking self-portraits, and *Still-life with Sheep* (1938, cat. no. 30), which she arranged on an ironing board for lack of any other suitable surface. She also met up again with Max and Quappi Beckmann, who had emigrated to Amsterdam soon after the notorious Munich exhibition "Entartete Kunst" (Degenerate Art) of 1937. The Beckmanns were living in impoverished circumstances, and in the following years Marie-Louise arranged the sale of several of Max Beckmann's works to her Dutch relatives to provide him with financial relief. Her elder brother, Karl, who had returned to Vienna in the summer of 1937 from Norway, where he had worked with the psychoanalyst Wilhelm Reich for several years, could not bring himself to leave Austria. He decided to remain there to help his Jewish friends and look after the family's property. He sent Marie-Louise's paintings from the 1920s and 1930s to Holland. With a few exceptions, the paintings survived the war unscathed and were later shipped to England.

Any worries about the future were briefly pushed aside when Marie-Louise's first solo exhibition took place at Esher Surrey Art Galleries Ltd. in The Hague in January 1939. The exhibition, which was arranged by a lawyer and friend of the family, Rhein Bakker (Fig. 42), was very well received by the public. Art critics lauded the artist as "a fresh and fascinating talent",[3] but also stressed the sad fact that she was no longer in a position to exhibit her paintings in her native land owing to the "Anschluss".[4] For Marie-Louise herself, the preview at the gallery was overwhelming (Fig. 59). She only became a little less nervous when her dog relieved itself in the exhibition rooms; that seemed to her a good omen.[5]

The exhibition only briefly distracted her from her own, precarious situation. Before January was out, mother and daughter decided to emigrate to England. Marie Hauptmann,

Ines Schlenker

»Aber Emigrant ... überhaupt nicht«[1]: Marie-Louise von Motesiczky in England

Als Marie-Louise von Motesiczky im Sommer 1928 ihre Lehr- und Wanderjahre mit dem Ausscheiden aus Max Beckmanns Meisterklasse abschloss, waren ihre Aussichten auf eine erfolgreiche künstlerische Karriere durchaus viel versprechend. Vorbehalte gegen Frauen im Kunstbetrieb waren durch das Wirken früherer Generationen von Künstlerinnen zumindest teilweise abgebaut worden. Und als Schülerin eines der gefeiertsten Vertreter der Avantgarde konnte sie auf Sympathie bei Publikum, Sammlern und Kritikern hoffen. Die folgenden Jahre, die sie größtenteils in Wien verbrachte, sollten denn auch eine Phase konzentrierter Arbeit werden, in der sich die Konturen ihres eigenen charakteristischen Malstils herausbildeten. 1933 wagte sie sich in einer Ausstellung des Wiener Hagenbundes zum ersten Mal auch an die Öffentlichkeit. Der Einmarsch der Nationalsozialisten in Österreich am 12. März 1938 beendete ihre Karriere jedoch abrupt, ehe sie richtig beginnen konnte. Motesiczky erahnte instinktiv die Gefahr, die von den Nationalsozialisten ausging. Später berichtete sie, wie sie die unheimlichen »Sieg Heil«-Rufe von Anfang an verstört hatten. Wie im Falle so vieler assimilierter Juden in Deutschland und Österreich machte auch sie erst der Aufstieg der nationalsozialistischen Partei auf ihre jüdischen Wurzeln aufmerksam. Für Motesiczky, die evangelisch getauft war, hatte die jüdische Herkunft ihrer Familie vorher nie eine Rolle gespielt.

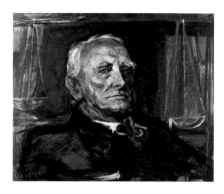

42 *Portrait Rhein Bakker / Porträt Rhein Bakker*, 1958, Oil on canvas / Öl auf Leinwand, Size and location unknown / Maße und Verbleib unbekannt

Ins holländische Exil

Bereits am Tag nach dem »Anschluss« verließ Motesiczky mit ihrer Mutter Hals über Kopf Wien. Beide reisten mit tschechischen Pässen, die sie Ende des Ersten Weltkriegs erhalten hatten. Ungewiss über die Dauer ihrer erzwungenen Abwesenheit, begaben sie sich zunächst nach Holland, wo sie auf die Hilfe einer Tante, Ilse Leembruggen, hoffen konnten (Abb. 41). Henriette von Motesiczky »fühlte sich sehr verloren in der neuen holländischen Umgebung«[2], während ihre Tochter sich bemühte, ein Mindestmaß an Normalität in der temporären Welt der Hotels und Pensionen aufrechtzuerhalten, indem sie malte. Es entstanden Bilder wie *Selbstporträt mit rotem Hut*, 1938 (Kat. Nr. 29), eines ihrer markantesten Selbstbildnisse, und *Stilleben mit Schafen*, 1938 (Kat. Nr. 30), das sie in Ermangelung einer geeigneten Oberfläche auf einem Bügelbrett arrangiert hatte. Es kam auch zu einem Wiedersehen mit Max und Quappi Beckmann, die bald nach der berüchtigten Münchner Ausstellung »Entartete Kunst« von 1937 nach Amsterdam emigriert waren. Um dem Ehepaar, das in ärmlichen Verhältnissen lebte, finanzielle Erleichterung zu verschaffen, vermittelte Motesiczky in den folgenden Jahren den Verkauf einiger Arbeiten Beckmanns an ihre holländischen Verwandten. Motesiczkys älterer Bruder Karl, der im Sommer 1937 aus Norwegen, wo er mehrere Jahre mit dem Psychoanalytiker Wilhelm Reich zusammengearbeitet hatte, nach Wien zurückgekehrt war, konnte sich dagegen nicht zum Verlassen Österreichs durchringen. Er beschloss zu bleiben, seinen jüdischen Freunden zu helfen und sich um das Familieneigentum zu kümmern. So schickte er Motesiczkys Bilder aus den zwanziger und dreißiger Jahren nach Holland. Mit wenigen Ausnahmen überstanden sie den Krieg wohlbehalten und wurden später nach England überführt.

Die Sorgen um die Zukunft wurden kurzzeitig verdrängt, als im Januar 1939 bei Esher Surrey Art Galleries Ltd. in Den Haag Motesiczkys erste Einzelausstellung stattfand. Vom Anwalt und Familienfreund Rhein Bakker initiiert (Abb. 42), fand die Ausstellung beim Publikum großen Anklang. Die Kunstkritik pries die Künstlerin als »ein frisches und faszinierendes Talent«[3], hob aber zugleich die traurige Tatsache hervor, dass sie durch den »Anschluss« nun

her former wet-nurse who had remained loyal to the family and whom Marie-Louise called a "second mother",[6] joined them from Vienna. The group travelled via Switzerland, arriving in London in February 1939. A painting, *The Travellers* (cat. no. 32), makes direct reference to the Channel crossing. Four defenceless passengers are crowded together in a wooden boat drifting helplessly on the stormy sea. They are only half dressed and almost without possessions, suggesting that they have made a hasty escape. As the picture would seem to be a product of Marie-Louise's own experience of her precipitate flight into exile, the passengers have often been interpreted as members of the Motesiczky household: her wet-nurse, her mother, her brother or uncle and the artist herself. The title depersonalises the four refugees, so that the picture evokes the universal feelings such as are suffered by so many exiles.

First years in England

Having arrived in London, the Motesiczkys at first lived in various hotel rooms and rented accommodation, also staying for a time with Marie Seidler, a Viennese opera singer who had emigrated to England. In 1940, Marie-Louise painted a portrait of her landlady (Fig. 43), whom she described as being one of those women "who really had everything taken from them".[7] Accordingly, she painted a sober portrait of a woman dressed in black who is resigned to her fate. The picture only hints at the losses that have been suffered.

Around this time came Motesiczky's fateful meeting with the writer Elias Canetti, who only a few years earlier had caused a literary furore with his novel *Die Blendung (Auto-da-Fé)*. He, too, had emigrated to England with his wife, Veza, in January 1939. The turbulent relationship between the painter and the author, which was to alternate between extreme closeness and violent disagreement—they were most intimate in the years 1941 to 1955—lasted for the rest of her life. In later years, Marie-Louise suffered some severe disappointments: for example, when she waited in vain for a marriage proposal from Canetti after Veza Canetti's death in 1963, or when friends told her about Canetti's subsequent marriage with Hera Buschor, and their daughter, Johanna, which had been kept secret from her. This latter revelation led her to break off contact with him for a while. The ambivalent character of the relationship becomes evident in two apparently contradictory statements by the artist: on the one hand, she called Canetti her "personal catastrophe",[8] whilst on the other she counted him among her "main gods", alongside Max Beckmann and her mother.[9] She saw herself confronted by an insoluble problem—"completely without C. a world without meaning—with C endless torment".[10] She suffered greatly because she was never allowed to play a more prominent role in Canetti's life.

In contrast with their private ups and downs, Marie-Louise and Canetti were unswerving in their mutual professional support. Absolutely convinced of each other's ability, they provided one another with the support they needed to create new works. For example, Canetti—who, along with her mother, was the person Motesiczky most often consulted on artistic questions—assured her as late as 1978: "You are a very great painter and, whether you want it or not, the world will learn of it. Every picture that you paint from now on will enter art history."[11] Moreover, Marie-Louise's financial support, particularly in the first years of Canetti's exile, was an important factor in the survival of the almost penniless author. The takeover by the Nazis meant that mother and daughter only possessed a fraction of their former fortune; however, although they were forced to live modestly, they still had much more than many émigrés, and Marie-Louise von Motesiczky was able to devote herself completely to painting, forced neither to work for a living nor to sell her pictures.

To escape the Blitz on London, in 1940 the Motesiczkys moved to the country, to Amersham, situated in the magnificent surroundings of the Chiltern Hills, only a short train ride from London. Canetti described the town, where many émigrés from the Continent took refuge, as "a sort of idyll",[12] despite the wartime conditions. Marie-Louise lived at first with the retired Anglican priest Gordon Milburn and his wife, Mary, where the Canettis later also found refuge. Father Milburn was later to inspire both the Canettis and Motesiczky. In *Party im*

nicht mehr in der Lage sei, ihre Bilder in der Heimat auszustellen.[4] Motesiczky selbst erlebte die Vernissage als überwältigendes Ereignis (Abb. 59). Ihre Nervosität ließ erst ein wenig nach, als sich ihr Hündchen in den Ausstellungsräumen erleichterte, was ihr als gutes Omen erschien.[5]

Die Ablenkung von der eigenen Notlage war jedoch nur von kurzer Dauer. Noch im Januar beschlossen Mutter und Tochter, nach England auszuwandern. Aus Wien stieß Marie Hauptmann, Motesiczkys ehemalige Amme, die der Familie treu geblieben war und von Motesiczky als »zweite Mutter«[6] bezeichnet wurde, zu ihnen. Die Gruppe reiste über die Schweiz und traf im Februar in London ein. Ein Gemälde, *Die Reisenden*, 1940 (Kat. Nr. 32), bezieht sich direkt auf die Überquerung des Ärmelkanals. Vier schutzlose Passagiere drängen sich in einem hölzernen Boot, das hilflos auf dem stürmischen Meer treibt. Nur halb bekleidet und weitgehend ohne Habseligkeiten, zeugen sie von einer überstürzten Flucht. Da das Bild Motesiczkys eigener Exilerfahrung zu entstammen scheint, wurden die Passagiere immer wieder als Angehörige des Motesiczky-Haushalts interpretiert: ihre Amme, ihre Mutter, ihr Bruder oder Onkel und die Künstlerin selbst. Der generalisierende Titel entpersonalisiert die vier Flüchtlinge jedoch und ermöglicht die Darstellung allgemeingültiger Gefühle, wie sie von so vielen Vertriebenen empfunden wurden.

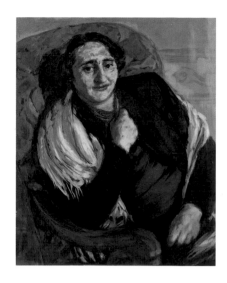

43 *Frau Seidler*, 1940, Oil on canvas / Öl auf Leinwand, 1005 x 807 mm, Marie-Louise von Motesiczky Charitable Trust, London

Erste Jahre in England

In London angekommen, lebten die Motesiczkys zunächst in raschem Wechsel in Hotelzimmern oder zur Untermiete; unter anderem bei Marie Seidler, einer Wiener Opernsängerin, die ebenfalls nach England emigriert war. 1940 malte Motesiczky das Porträt ihrer Vermieterin (Abb. 43), die sie zu den Frauen zählte, »denen wirklich alles genommen wurde«[7]. Dementsprechend schuf sie ein nüchternes Porträt einer schwarz gekleideten, in ihr Schicksal ergebenen Frau, das die erlittenen Verluste nur erahnen lässt.

Um diese Zeit kam es zur schicksalhaften Begegnung mit dem Schriftsteller Elias Canetti, der wenige Jahre zuvor mit seinem Roman »Die Blendung« für literarische Furore gesorgt hatte und im Januar 1939 mit seiner Frau Veza ebenfalls nach England ausgewandert war. Die turbulente Beziehung zwischen der Malerin und dem Schriftsteller, die sich zwischen enger Bindung und tiefem Zerwürfnis bewegen sollte, währte ein Leben lang und war wohl von 1941 bis 1955 intimer Natur. In späteren Jahren erlitt Motesiczky einige herbe Enttäuschungen, zum Beispiel als sie nach Vezas Tod 1963 vergeblich auf einen Heiratsantrag hoffte, oder als sie 1973 durch Freunde von Canettis bisher vor ihr geheim gehaltener Ehe mit Hera Buschor und der gemeinsamen Tochter Johanna erfuhr. Für eine Weile brach sie den Kontakt ab. Der ambivalente Charakter der Beziehung wird in zwei scheinbar widersprüchlichen Behauptungen Motesiczkys anschaulich. Einerseits nannte sie Canetti ihre »persönliche Katastrophe«[8], andererseits zählte sie ihn zu ihren »Hauptgöttern«, neben Max Beckmann und ihrer Mutter.[9] Sie sah sich mit dem unlösbaren Problem konfrontiert: »ganz ohne C. Welt ohne Sinn – mit C endlose Quälerei«[10], und litt unter der Tatsache, nie eine prominentere Rolle in Canettis Leben spielen zu dürfen.

Im Gegensatz zu dem privaten Auf und Ab gestaltete sich die wechselseitige berufliche Unterstützung stetig. Uneingeschränkt überzeugt vom Können des anderen, ließen sie sich die Hilfe zukommen, die zum Entstehen neuer Werke nötig war. Canetti, neben der Mutter der wichtigste Gesprächspartner in Kunstfragen, versicherte ihr noch 1978: »Du bist ein sehr grosser Maler und ob Du es willst oder nicht, die Welt wird es erfahren. Jedes Bild, das Du noch malst, wird in die Geschichte der Malerei eingehen.«[11] Motesiczkys finanzielle Zuwendungen waren außerdem für das Überleben des beinahe mittellosen Schriftstellers, vor allem in den ersten Jahren des Exils, entscheidend. Durch die Folgen der Naziherrschaft verfügten Mutter und Tochter zwar nur noch über einen Bruchteil ihres Vermögens. Sie waren zu einer bescheidenen Lebensführung gezwungen, besaßen aber weit mehr als viele andere Emigranten. Marie-Louise von Motesiczky konnte sich ganz der Malerei widmen und sah sich weder genötigt, einem Broterwerb nachzugehen noch ihre Bilder zu verkaufen.

Blitz (Party in the Blitz), the fourth part of Elias Canetti's autobiography, which covers the years in England, he devotes an entire chapter to the quirks of his landlord,[13] while Veza gives a satiric description of the Milburns in the short story, *"Toogoods oder das Licht".*[14] Motesiczky passed a milder judgement: her portrait *Father Milburn,* which was painted in 1958 (Fig. 44), shows the cleric, now an old man, as a reserved and serious figure of authority.

In 1941, the Motesiczkys bought their own house, "Cornerways", not far from their old place of residence. They planted vegetables in the large garden and kept hens, whose eggs sometimes went to improve the meagre rations of the Canettis as well. Karl von Motesiczky had meanwhile sent a large part of the household items from Vienna, including furniture and art works, in several containers, so that mother and daughter were able to set up the house comfortably. Marie-Louise used the spacious sitting room on the ground floor as her studio; Canetti's large library was also accommodated here. A number of photographs from the early 1940s (Fig. 45) show Marie-Louise, her mother, the Canettis and Marie Hauptmann in front of these books, surrounded by Marie-Louise's paintings. For her birthday in 1942, Canetti gave her a handwritten manuscript of his aphorisms. These pages, written in Canetti's best hand, contain his thoughts on war, God, his contemporaries, books, love and death.[15]

Marie-Louise was now also regularly meeting up with the painter Oskar Kokoschka, a friend of the family from Viennese days. He, too, had been forced to emigrate by the Nazis, and was living in England with his wife, Olda. In 1940, Kokoschka made a charming portrait of Marie-Louise wearing a straw hat (Fig. 46). He kept the original and gave Henriette a copy of the watercolour with a dedication. Although Kokoschka, unlike Beckmann, never gave her formal lessons, he has often been called a formative influence on Marie-Louise's later works. He doubtless provided an important stimulus for her work and was even allowed to look at her latest pictures on the easel while they were still being painted. Kokoschka did not conceal his opinion of them at all. Although some of his verdicts were hurtful, Marie-Louise, whom Kokoschka called "Florizl", seems mostly to have accepted and acted upon these comments. Praise was all the more gladly received. Once, when she was particularly angered by one of Kokoschka's negative remarks, she did the "drawing of Olda, K, me",[16] which is probably identical with *Kokoschka Fishing for Two Nudes* (Fig. 47). It shows Kokoschka standing amongst the reeds, trying to catch two naked bathers with a fishing rod. This humorous composition probably refers to a hidden side to their relationship: in the early 1940s, Kokoschka would seem to have been romantically interested in Marie-Louise. When his efforts proved unsuccessful, he tried to bring her together with Michael Croft, later Lord Croft and his first patron in England.[17] Croft is said to have proposed to Marie-Louise, but she rejected him, probably because of her increasing ties with Canetti.[18]

Despite her acquaintance with other émigré artists, in exile Marie-Louise lost the professional network that would have enabled her to make her art known to a wider audience. Revealingly, during the war her pictures were shown mostly in London exhibitions that had a political dimension and were directed more or less openly against the National Socialist regime, such as the "Exhibition of Contemporary Continental Art. Paintings, Water-Colours, Sculptures" in the Leger Gallery in 1941 or the "Exhibition of Allied Artists" in the R.B.A. Galleries the following year. In 1943 she became a member of the Artists' International Association, an organisation that fought against fascism; she took part in its exhibitions over several years.

At the end of 1944, an organisation of exiled émigrés, the Czechoslovak Institute in London, put on an "Exhibition of Painting and Sculpture by Marie Louise Motesiczky and Mary Duras". Among the exhibited works by the Czech sculptor Mary Duras, who also lived in Amersham, was a bust of Motesiczky (Fig. 62). During the exhibition, Kokoschka made an attempt to persuade the Tate Gallery to purchase some of Marie-Louise's pictures. He approached the director, John Rothenstein, who did not seem averse to the idea and selected five works,[19] but the offer was ultimately rejected by the trustees of the gallery. Over 40 years were to pass before three paintings by Marie-Louise found their way into the Tate Gallery.

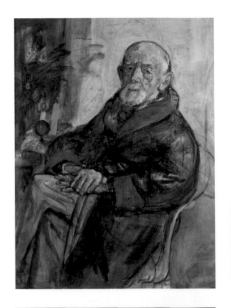

44 *Father Milburn / Vater Milburn,* **1958,**
Oil on canvas / Öl auf Leinwand, 1168 × 870 mm,
Marie-Louise von Motesiczky Charitable Trust,
London

45 Marie-Louise von Motesiczky, Veza
Canetti, Henriette von Motesiczky and Marie
Hauptmann in the artis's studio in Amersham /
Marie-Louise von Motesiczky, Veza Canetti,
Henriette von Motesiczky und Marie
Hauptmann in Marie-Louise von Motesiczkys
Atelier in Amersham, Photograph, early 1940s /
Fotografie, frühe 1940er Jahre

Um dem Bombenregen auf London zu entkommen, zogen die Motesiczkys 1940 aufs Land nach Amersham, nur eine kurze Zugfahrt von London entfernt und in der herrlichen Umgebung der Chiltern Hills gelegen. Canetti beschrieb den Ort, in dem damals viele Emigranten aus Kontinentaleuropa Zuflucht fanden, als »eine Art von Idylle«[12], wenn auch im Kriegszustand. Motesiczky wohnte zunächst bei dem pensionierten anglikanischen Pfarrer Gordon Milburn und seiner Frau Mary, wo später auch das Ehepaar Canetti Unterschlupf fand. Father Milburn sollte sowohl die Canettis als auch Motesiczky inspirieren. In *Party im Blitz*, dem vierten Teil seiner Autobiografie, der die Jahre in England abdeckt, widmet Canetti den Schrullen seines Vermieters ein ganzes Kapitel,[13] während Veza die Milburns in der Kurzgeschichte *Toogoods oder das Licht* satirisch überzeichnet.[14] Motesiczky fällte ein milderes Urteil. Ihr Porträt *Vater Milburn*, das 1958 entstand (Abb. 44), zeigt den inzwischen betagten Geistlichen als zurückhaltende, ernste Autorität.

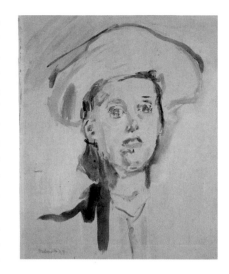

Im Jahr 1941 erwarben die Motesiczkys ein eigenes Haus, »Cornerways«, unweit ihres alten Domizils. In dem großen Garten bauten sie Gemüse an und hielten Hühner, deren Eier gelegentlich auch die mageren Rationen der Canettis aufbesserten. Da Karl von Motesiczky inzwischen einen Großteil des Wiener Haushalts, inklusive Möbel und Kunstwerke, in mehreren großen Kisten nach England geschickt hatte, konnte das Haus behaglich eingerichtet werden. Motesiczky benutzte das geräumige Wohnzimmer im Erdgeschoss als Atelier. Dort fand auch Canettis große Bibliothek Platz. Eine Reihe von Fotografien aus den frühen vierziger Jahren (Abb. 45) zeigt Motesiczky, ihre Mutter, die Canettis und Marie Hauptmann vor diesen Büchern, umgeben von Motesiczkys Gemälden. Zu ihrem Geburtstag im Jahr 1942 schenkte Canetti der Malerin ein Manuskript seiner Aufzeichnungen. Diese Seiten in Schönschrift enthalten Canettis Gedanken über den Krieg, Gott, seine Zeitgenossen, Bücher, Liebe und den Tod.[15]

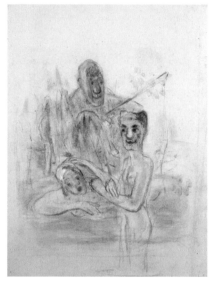

Regelmäßig traf Motesiczky nun auch den Maler Oskar Kokoschka, einen Freund der Familie aus Wiener Tagen, der von den Nationalsozialisten ebenfalls zur Emigration gezwungen worden war und mit seiner Frau Olda in England lebte. Im Jahr 1940 fertigte Kokoschka ein charmantes Porträt Motesiczkys mit Strohhut an (Abb. 46). Er behielt das Original und schenkte Henriette eine Kopie des Aquarells mit Widmung. Obwohl Kokoschka Motesiczky – im Gegensatz zu Beckmann – nie formell unterrichtete, wird seine Person immer wieder als prägend für ihr späteres Werk genannt. Er war zweifellos ein wichtiger Anreger ihrer Arbeiten, dem es sogar erlaubt war, die neuesten Bilder während ihrer Entstehung auf der Staffelei zu begutachten. Kokoschka machte dabei aus seiner Meinung keinen Hehl. Obwohl einige Urteile verletzend waren, scheint sich Motesiczky, von Kokoschka »Florizl« genannt, diese Kommentare meist zu eigen gemacht zu haben. Lob wurde umso dankbarer aufgenommen. Als Motesiczky einmal besonders wütend über eine von Kokoschkas abweisenden Bemerkungen war, schuf sie die »Zeichnung Olda, K, ich«[16], die wohl mit *Kokoschka fischt nach zwei Nackten* (Abb. 47) identisch ist. Sie zeigt den zwischen Schilfrohren stehenden Maler, der mit einer Angel versucht, die beiden nackten Badenden zu fangen. Diese humorvolle Komposition bezieht sich vermutlich auch auf eine verborgene Dimension ihrer Beziehung. In den frühen vierziger Jahren scheint Kokoschka ein Auge auf Motesiczky geworfen zu haben. Als seine Bemühungen nicht von Erfolg gekrönt waren, versuchte er, sie mit Michael Croft, dem späteren Lord Croft und seinem ersten Mäzen in England, zusammenzuführen.[17] Angeblich machte Croft Motesiczky einen Heiratsantrag, den diese aber – wahrscheinlich mit Blick auf ihre immer enger werdende Beziehung zu Canetti – ablehnte.[18]

Trotz ihrer Bekanntschaft mit anderen emigrierten Künstlern hatte Motesiczky im Exil das professionelle Netzwerk verloren, das ihre Kunst einem breiteren Publikum hätte näher bringen können. Bezeichnenderweise wurden ihre Bilder während des Kriegs vornehmlich in Londoner Ausstellungen gezeigt, die eine politische Dimension hatten und sich mehr oder weniger offen gegen das nationalsozialistische Regime wandten, wie zum Beispiel die »Exhibition of Contemporary Continental Art. Paintings, Water-Colours, Sculptures« in der Leger Gallery 1941 oder, im folgenden Jahr, die »Exhibition of Allied Artists« in den R. B. A. Galleries. 1943 wurde sie Mitglied der Artists' International Association, einer Künstlerorganisation, die gegen Faschismus kämpfte und an deren Ausstellungen sie für einige Jahre teilnahm.

46 Oskar Kokoschka: *Marie-Louise*, 1940, Watercolour on paper / Aquarell auf Papier, 630 × 475 mm, Foundation Oskar Kokoschka, Vevey

47 *Kokoschka Fishing for Two Nudes / Kokoschka fischt nach zwei Nackten*, 1945, Charcoal and pastel on paper / Kohle und Pastellkreide auf Papier, 510 × 380 mm, Marie-Louise von Motesiczky Charitable Trust, London

As the war went on, Marie-Louise found it more and more difficult to remain in contact with her brother. In the autumn of 1939, Karl had started up a resistance group that helped two Jewish couples from Poland escape to Switzerland in the summer of 1942. The group was, however, betrayed, and on October 13, 1942, Karl von Motesiczky was arrested by the Gestapo. Four months later he was deported to Auschwitz, where he soon became ill, and he died in the sick bay on June 25, 1943. Although the Motesiczkys learnt of his fate in October, 1943, through a letter from a Swiss relative, they were later under the misapprehension that he died only a few weeks before the end of the war. The thought of a death at this late stage probably made the loss seem even more senseless and terrible. For the rest of her life, Marie-Louise felt guilty for not having been able to save her brother.[20] She created a moving farewell picture of him in the painting *After the Ball* (1949, cat. no. 41), showing Karl with his Norwegian girlfriend, Aagot, returning from a masked ball in Vienna. They are exhausted from the evening's entertainment but embrace each other tenderly and warmly in a brief moment of happiness. In 1980, Karl was awarded the Israeli title of "Righteous Among the Nations", which honours people who risked their lives to save Jews from the Nazis.

After the end of the war, Marie-Louise returned to London, where she moved into an apartment in West Hampstead, in the north of the city, in 1948. From 1951 to 1957, Canetti had his own room there, in which he often worked. Here he wrote both a large number of the aphorisms and major parts of his magnum opus *Masse und Macht* (*Crowds and Power*). Over the next decades, Marie-Louise did several portraits of Elias Canetti that give insights into the state of this never easy relationship, portraits that were often made at the wish of, and sometimes even commissioned by, the portraitee, for example, the double portrait *Conversation in the Library* (1950, cat. no. 43), which shows Canetti talking to his friend, the poet and anthropologist Franz Baermann Steiner, who was the only other writer in exile with whom Canetti kept up any form of close contact during the war. This painting is a homage to the vanished world of the Central European Jewish intellectuals: there is no other double portrait of German writers from the 20th century to compare with it. *Self-portrait with Canetti* (cat. no. 71) from the 1960s, on the other hand, captures the almost tangible estrangement of the two people portrayed, contrasting Marie-Louise's expectant devotion with the obvious indifference of the writer, who is engrossed in his reading. She painted her last portrait of the author in 1992 (cat. no. 88), but although Canetti himself commissioned this picture, he did not accept it because he did not like the photograph upon which it was based. Today it hangs in the National Portrait Gallery in London.

Marie-Louise enjoyed some personal successes, but she also experienced painful rejections and disregard of her art. The breakthrough she had hoped for at the end of the war never came: the triumph of abstract art in London after 1945 made her paintings seem old-fashioned; the few successful exhibitions she took part in cannot hide this fact. In 1952, the Dutch galleries Kunstzaal Van Lier in Amsterdam and Kunstzaal Plaats in The Hague gave her the chance of a solo exhibition that culminated in the purchase of *Finchley Road at Night*, 1952 (Fig. 48), by the Stedelijk Museum of Modern Art in Amsterdam. This nocturnal urban landscape shows one of London's main arterial roads, which runs through the area in which Motesiczky had found her new home. In 1954, the Städtische Galerie in Munich organised an exhibition of works by Marie-Louise von Motesiczky and Erna Dinklage. In Great Britain, however, even small successes were long in coming. The only picture—*Lobster*, 1953 (Fig. 49)—that Motesiczky showed in the exhibition "The Renaissance of the Fish. Paintings from the 17th to the 20th Century" in the famous gallery Roland, Browse and Delbanco in Cork Street in London in 1953, remained unsold.

Despite the difficulties in gaining artistic recognition in her new homeland, Marie-Louise became a British citizen in 1948 and decided in the mid–1950s to remain in London for good. Although she had paid regular visits to Vienna after the war (and was to continue doing this until her old age), she broke off the last official tie to the land of her birth in 1956 when she sold the family property in Hinterbrühl to Hermann Gmeiner, who built an SOS Children's Village there. In memory of her brother, "who loved children and justice",[21] the Motesiczkys were prepared to accept a price far below market value. Gmeiner called the

Eine Organisation von Exilanten, das Czechoslovak Institute in London, veranstaltete Ende 1944 auch die »Exhibition of Painting and Sculpture by Marie Louise Motesiczky and Mary Duras«. Unter den ausgestellten Werken der tschechischen Bildhauerin Mary Duras, die ebenfalls in Amersham lebte, befand sich auch eine Porträtbüste Motesiczkys (Abb. 62). Während der Ausstellung unternahm Kokoschka einen Versuch, die Tate Gallery zum Erwerb einiger ihrer Bilder zu bewegen. Er wandte sich an den Direktor John Rothenstein, welcher der Idee nicht abgeneigt schien und fünf Werke auswählte.[19] Das Angebot wurde jedoch letztlich von den Trustees des Museums abgelehnt. Es sollten über vierzig Jahre vergehen, bis drei Gemälde Motesiczkys in die Tate Gallery Einzug hielten.

Im Laufe des Kriegs wurde es für Motesiczky immer schwieriger, Kontakt mit ihrem Bruder zu halten. Im Herbst 1939 hatte Karl mit Freunden eine Widerstandsgruppe gegründet, die im Sommer 1942 zwei jüdischen Ehepaaren aus Polen bei ihrer Flucht in die Schweiz half. Die Gruppe wurde jedoch verraten. Am 13. Oktober 1942 wurde Karl von Motesiczky von der Gestapo verhaftet. Vier Monate später kam er nach Auschwitz, wo er bald erkrankte und am 25. Juni 1943 im Krankenbau starb. Obwohl die Motesiczkys bereits im Oktober 1943 durch den Brief einer Schweizer Verwandten von seinem Schicksal erfuhren, dachten sie später fälschlich, er sei erst ein paar Wochen vor Ende des Kriegs gestorben. Ein so später Tod ließ den Verlust wohl noch sinnloser, noch furchtbarer erscheinen. Für den Rest ihres Lebens fühlte sich Motesiczky schuldig, da sie ihren Bruder nicht hatte retten können.[20] Mit dem Gemälde *Nach dem Ball*, 1949 (Kat. Nr. 41), schuf sie ein ergreifendes Abschiedsbild. Es zeigt Karl mit seiner norwegischen Freundin Aagot bei der Rückkehr von einem Maskenball in Wien. Beide sind erschöpft von der abendlichen Unterhaltung, umarmen sich aber zärtlich und beschützend in einem kurzem Moment des Glücks. 1980 bekam Karl die israelische Auszeichnung »Gerechter unter den Völkern« verliehen, welche Menschen ehrt, die ihr Leben für die Rettung von Juden aufs Spiel setzten.

Nach Kriegsende kehrte Motesiczky nach London zurück, wo sie ab 1948 eine Wohnung im Norden der Stadt, in West Hampstead, bezog. Von 1951 bis 1957 besaß auch Canetti dort ein eigenes Zimmer, in dem er oft arbeitete und neben seinen Aufzeichnungen wesentliche Teile seines Hauptwerks »Masse und Macht« schrieb. Über den Zustand dieser nie einfachen Beziehung geben im Laufe der nächsten Jahrzehnte mehrere Porträts von Elias Canetti Auskunft, die Motesiczky oft auf Wunsch, manchmal sogar im Auftrag des Porträtierten anfertigte. So entstand 1950 das Doppelporträt *Gespräch in der Bibliothek* (Kat. Nr. 43), das Canetti im Gespräch mit seinem Freund, dem ebenfalls exilierten Dichter und Anthropologen Franz Baermann Steiner, zeigt und eine Hommage an die untergegangene Welt der mitteleuropäischen jüdischen Intellektuellen darstellt. Steiner war der einzige Exildichter, mit dem Canetti im Krieg engeren Kontakt pflegte. Es gibt kaum ein vergleichbares Doppelporträt von deutschen Dichtern im 20. Jahrhundert. *Selbstporträt mit Canetti* aus den sechziger Jahren (Kat. Nr. 71) fängt dagegen die beinahe spürbare Entfremdung der beiden Dargestellten ein und setzt Motesiczkys erwartungsvolle Ergebenheit der offensichtlichen Indifferenz des lesenden Canetti entgegen. Ihr letztes Porträt des Schriftstellers malte Motesiczky 1992 (Kat. Nr. 88). Obwohl von Canetti in Auftrag gegeben, lehnte er die Annahme des Bildes ab, weil ihm die zugrunde liegende Fotografie missfiel. Es befindet sich heute in der National Portrait Gallery in London.

Mit Zurückweisung und Missachtung ihrer Kunst hatte Motesiczky freilich schon früher leidvoll Erfahrung gemacht. Der mit dem Ende des Kriegs erhoffte Durchbruch blieb aus. Der Siegeszug abstrakter Kunst nach 1945 ließ ihre Gemälde unzeitgemäß erscheinen. Darüber können auch vereinzelte Ausstellungserfolge nicht hinwegtäuschen. Die holländischen Galerien Kunstzaal Van Lier in Amsterdam und Kunstzaal Plaats in Den Haag boten Motesiczky etwa 1952 die Gelegenheit zu einer Einzelausstellung, die durch den Ankauf von *Finchley Road bei Nacht*, 1952 (Abb. 48), durch das Stedelijk Museum of Modern Art in Amsterdam gekrönt wurde. Die nächtliche Stadtlandschaft zeigt eine der Londoner Hauptausfallstraßen, die sich mitten durch Motesiczkys Wahlheimat zieht. 1954 veranstaltete die Städtische Galerie in München eine Einzelausstellung für Motesiczky und Erna Dinklage. In Großbritannien dagegen ließen selbst kleine Erfolge auf sich warten. Das einzige Bild, *Hummer*, 1953 (Abb. 49),

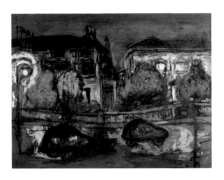

48 *Finchley Road at Night / Finchley Road bei Nacht*, 1952, Oil on canvas / Öl auf Leinwand, 710 × 910 mm, Stedelijk Museum, Amsterdam

completed complex in Hinterbrühl the "largest and most beautiful European SOS Children's Village".[22] In 1961, the Motesiczkys had a memorial stone set up for Karl. Its inscription reads: "He suffered death for the selfless aid that he gave innocent, persecuted people."

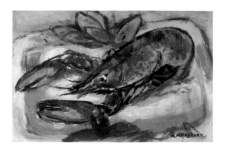

49 *Lobster / Hummer*, 1953, Oil on canvas / Öl auf Leinwand, 410 × 610 mm, Marie-Louise von Motesiczky Charitable Trust, London

A house in Hampstead

In 1960, Marie-Louise and her mother moved into a large, three-storied house in Chesterford Gardens in the lovely London district of Hampstead. Her studio faced the street on the first floor, her mother had the room next to it. Canetti was also given a room. He loved this house and its garden, which he called "a little paradise".[23] He particularly enjoyed "the fantastic Biedermeier peace"[24] of life there, which allowed him to hide from the world and to work undisturbed. Visitors must have felt the house to be a relic from a lost world, with its old Viennese furniture, its art works, its Austrian cuisine—the apple strudel was particularly famous—and, of course, its inhabitants, who had retained both their native dialect and their traditional way of life. The artist's joy in her new home is expressed in the picture *Garden in the Summer,* 1960 (Fig. 50), which shows her doing the gardening and her cheeky Italian greyhound hiding amid the brilliant display of flowers.

Hampstead had long provided many émigrés from Central Europe with a new home. Marie-Louise now became part of this lively intellectual and artistic community. The artist Milein Cosman, born in Düsseldorf in 1921, became a close friend; Marie-Louise held discussions about abstract art with her husband, the musicologist Hans Keller. In *Studio with Nude Model,* 1970 (Fig. 51), she portrays the couple working at their respective professions. Marie-Louise also knew several other fellow émigré artists, such as the painters Jacob Bauernfreund and Hilde Goldschmidt, and the sculptors Siegfried Charoux and Georg Ehrlich, but she seldom met up with them, preferring to live a more retired life in her own circle of friends and family.

As an outsider in a country that did not discover the art of the German and Austrian exiled artists until late, however, Marie-Louise had a long struggle for recognition. For a few years it looked as if she had achieved a new beginning when the influential London art dealer Helen Lessore—who exhibited the works of a number of the most important artists of the time, including Francis Bacon, Frank Auerbach and Leon Kossoff—took up her case and organised a solo exhibition in the Beaux Arts Gallery in 1960. This was probably Motesiczky's first big chance in England. But the collaboration did not last for long, as five years later the gallery was forced to close, for financial reasons. This disappointment caused Motesiczky to ask herself whether "[I] can ever be involved in the art scene again".[25]

Contrary to expectations, however, she achieved an artistic breakthrough in Austria in 1966 with a solo exhibition in the Vienna Secession. Critics called her a "riveting surprise",[26] and said that Marie-Louise von Motesiczky "would long ago have been appreciated as one of our most important painters, if things were always done as they should be".[27] The exhibition, which then went on to the Neue Galerie in Linz, the Galerie Günther Franke in Munich and the Kunsthalle Bremen, also led to some major works being purchased by public collections. The Österreichische Galerie in the Belvedere bought *Frau Ziegler* (1938), the Neue Galerie in Linz bought *Self-portrait with Pears* (1965, cat. no. 64), and the Culture Office of Vienna bought *Elias Canetti* (1960, cat. no. 56).

These first indications of success were, however, overshadowed by concern over the health of her mother. In the 1960s and 1970s, Marie-Louise selflessly devoted herself to the care of Henriette. In order to paint while still fulfilling her duties, Marie-Louise frequently used her aged mother as a model. She did a large number of portraits, including countless sketches and drawings and many oil paintings. These dominate her later work and are among the most expressive pictures in her *œuvre.* The series of portraits of her mother, all imbued with easy intimacy and moving frankness, is probably unique in the history of art. It reflects the profound relationship between the painter and her model, and vividly chronicles the inexorable nature of her mother's gradual decline. While *Henriette von Motesiczky* (1959,

das Motesiczky in der Ausstellung »The Renaissance of the Fish. Paintings from the 17th to the 20th Century« in der berühmten Galerie Roland, Browse and Delbanco in der Londoner Cork Street 1953 zeigte, wurde nicht verkauft.

Trotz der Schwierigkeiten, künstlerische Anerkennung in ihrer neuen Heimat zu erringen, entschied sich Motesiczky, die 1948 britische Staatsbürgerin geworden war, Mitte der fünfziger Jahre endgültig dafür, in London zu bleiben. Sie hatte Wien zwar nach dem Krieg regelmäßig besucht (und sollte diese Gewohnheit auch weiterhin aufrechterhalten), brach jedoch die letzte offizielle Verbindung mit ihrer Heimat ab, als sie 1956 den Familienbesitz in Hinterbrühl an Hermann Gmeiner verkaufte, der dort ein SOS-Kinderdorf baute. In Erinnerung an ihren Bruder, »der Kinder und Gerechtigkeit liebte«[21], waren die Motesiczkys bereit, einen Preis weit unter dem Marktwert zu akzeptieren. Die vollendete Anlage in Hinterbrühl bezeichnete Gmeiner als »größtes und schönstes europäisches SOS-Kinderdorf«[22]. 1961 ließen die Motesiczkys auf dem Gelände einen Gedenkstein für Karl errichten. Seine Inschrift lautet: »Für die selbstlose Hilfe, die er schuldlos Verfolgten gewährte, erlitt er den Tod.«

Ein Haus in Hampstead

Im Jahr 1960 zog Motesiczky mit ihrer Mutter in ein großes, dreistöckiges Haus in Chesterford Gardens im schönen Londoner Stadtteil Hampstead. Motesiczkys Atelier lag zur Straße im ersten Stock, ihre Mutter bewohnte das Zimmer gleich nebenan. Canetti erhielt ein Dachzimmer. Er liebte das Haus und den Garten, die er »ein kleines Paradies«[23] nannte. Besonders schätzte er »die phantastische Biedermeier-Ruhe«[24] des Lebens dort, die es ihm ermöglichte, sich vor der Welt zu verstecken und ungestört zu arbeiten. Besuchern musste das Haus mit seinen alten Wiener Möbeln, seinen Kunstwerken, seiner österreichischen Küche, aus der sich besonders der Apfelstrudel hervortat, und natürlich seinen Bewohnern, die sowohl ihren heimatlichen Dialekt als auch die traditionelle Lebensweise bewahrten, wie ein Relikt aus einer verlorenen Welt erscheinen. Motesiczkys Freude an ihrem neuen Zuhause kommt in dem Bild *Garten im Sommer*, 1960 (Abb. 50), zum Ausdruck, das die gärtnernde Künstlerin und ihr keckes, sich versteckendes Windspiel inmitten der reichen Blumenpracht ihres Gartens zeigt.

In der Vergangenheit hatte Hampstead schon vielen Emigranten aus Europa eine neue Heimat geboten. So wurde Motesiczky nun Teil dieser lebendigen intellektuellen und künstlerischen Gemeinschaft. Eine enge Freundin war die 1921 in Düsseldorf geborene Künstlerin Milein Cosman. Mit deren Mann, dem Musikologen Hans Keller, führte Motesiczky Gespräche über abstrakte Kunst. In *Atelier mit Aktmodell*, 1970 (Abb. 51), stellt Motesiczky das Ehepaar beim Ausüben ihres jeweiligen Berufs dar. Motesiczky kannte überdies einige andere ihrer ebenfalls emigrierten Künstlerkollegen, wie zum Beispiel die Maler Jacob Bauernfreund und Hilde Goldschmidt und die Bildhauer Siegfried Charoux und Georg Ehrlich. Diese traf sie jedoch nur selten, da sie ein zurückgezogenes Leben im Kreis ihrer Familie und Freunde bevorzugte.

Als Außenseiterin in einem Land, das die Kunst der deutschen und österreichischen Exilanten erst spät entdeckte, musste Motesiczky freilich weiterhin um Aufmerksamkeit kämpfen. Als sich die einflussreiche Londoner Kunsthändlerin Helen Lessore ihrer annahm und 1960 in der Beaux Arts Gallery eine Einzelausstellung ausrichtete, sah es ein paar Jahre lang so aus, als hätte sie einen Neuanfang geschafft. Helen Lessore stellte einige der bedeutendsten Maler jener Zeit, unter ihnen Francis Bacon, Frank Auerbach und Leon Kossoff, aus. Dies war wohl Motesiczkys erste große Chance in England. Die erfolgreiche Zusammenarbeit währte jedoch nicht lange, da die Galerie fünf Jahre später aus finanziellen Gründen schließen musste. Angesichts dieser Enttäuschung fragte sich Motesiczky, ob »[ich] nie mehr mitspielen kann im Kunstbetrieb«.[25]

Wider Erwarten gelang ihr jedoch 1966 der künstlerische Durchbruch in Österreich mit einer Einzelausstellung in der Wiener Secession. Kritiker nannten sie »eine fesselnde Überraschung«[26] und meinten, Motesiczky »hätte längst, ginge es immer mit rechten Dingen zu,

50 *Garden in the Summer / Garten im Sommer*, 1960, Oil on canvas / Öl auf Leinwand, 763 × 636 mm, Marie-Louise von Motesiczky Charitable Trust, London

51 *Studio with Nude Model / Atelier mit Aktmodell*, 1970, Oil on canvas / Öl auf Leinwand, 512 × 512 mm, Marie-Louise von Motesiczky Charitable Trust, London

showing 50 works from her career, which by now spanned seven decades. Critics unanimously expressed their joy at her long-overdue return to her native town. By now, Marie-Louise enjoyed universal recognition. Because the honour of a solo exhibition in the Belvedere is only very seldom accorded to a living artist, this show was interpreted as an act of atonement, a way of making good the crimes committed in the past.[31] During the exhibition, the Österreichische Galerie purchased its second painting, *Self-portrait with Comb* (1926, cat. no. 5), and planned to obtain some other pictures for its collection to fill a Motesiczky Room. But the artist could not make up her mind, and so this fine plan came to nothing. Marie-Louise received several congratulatory letters emphasising the importance of this purchase: "Paintings ... need a physical home to survive; yours have got it now—and what a one, one of the best in the world. So, you too, dear Marie-Louise, will never die."[32]

With this exhibition, Motesiczky was finally established as one of the most important Austrian painters of the 20th century. In recognition of her achievements, she was awarded the Austrian Cross of Honour for Sciences and the Arts, First Class, on September 19, 1994. When Marie-Louise von Motesiczky died in London on June 10, 1996, the painting on which she was working, *Still-life, Vase of Flowers* (Fig. 3), was still standing on the easel next to the flower arrangement that was serving as the model (Fig. 52). Her urn was installed in its resting place in the family vault in the Döblingen cemetery in Vienna.

Translated from German by Timothy Jones

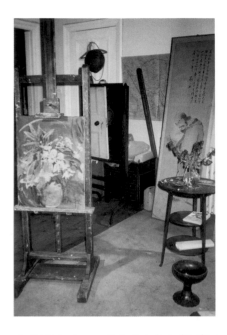

52 Marie-Louise von Motesiczky's studio after her death with her last painting, *Still-life, Vase of Flowers*, still on the easel / Marie-Louise von Motesiczkys Atelier nach ihrem Tod; auf der Staffelei ihr letztes Gemälde *Stilleben, Blumenvase*, Photograph, 1996 / Fotografie, 1996, Marie-Louise von Motesiczky Charitable Trust, London

teil, die zunächst in Berlin, dann in Wien, Oberhausen und London gezeigt wurde. Besonders in Deutschland und Österreich, wo die Kunst der Emigranten lange Zeit ignoriert worden war, fand die Ausstellung große Aufmerksamkeit. Zur gleichen Zeit als sie endgültig in den Kanon der Exilkünstler aufgenommen wurde, fand Motesiczky auch in England gleichsam als einheimische Malerin Anerkennung. Inzwischen feierte die figürliche Malerei eine Renaissance. Die deutsche Kunst, zumal der Expressionismus, wurde sehr verspätet rezipiert, und dies ermöglichte ein neues Verständnis von Motesiczkys Kunst. In der Ausstellung »Hampstead Artists 1946–1986« würdigte das unweit von Chesterford Gardens gelegene Camden Arts Centre 1986 ihren Beitrag zur florierenden Londoner Kunstszene der vergangenen Jahrzehnte. Nur wenige Jahre vor ihrem Tod sollte Motesiczkys Malerei dann auch öffentlich mit dem Judentum in Verbindung gebracht werden: 1992 wurde eines ihrer Werke, *Gespräch in der Bibliothek*, 1950 (Kat. Nr. 43), in der Ausstellung »Jüdische Lebenswelten. Jüdisches Denken und Glauben, Leben und Arbeiten in den Kulturen der Welt« in Berlin gezeigt. Es steht stellvertretend für die untergehende Welt der Exilanten, die in England der Kultur Mitteleuropas treu blieben.

Angesichts ihrer wachsenden Bekanntheit als Künstlerin machte sich Motesiczky nun ernsthaft Gedanken über die Zukunft ihres Œuvres. Sie begann mit ihrer Privatsekretärin einen Œuvrekatalog zu erarbeiten und machte Pläne für den Marie-Louise von Motesiczky Charitable Trust, der sich um ihre persönliche und künstlerische Hinterlassenschaft kümmern und sie einem breiteren Publikum nahe bringen sollte.

Zwei Jahre vor ihrem Tod erfreute sich Motesiczky eines letzten Triumphes in ihrem Heimatland, als die Österreichische Galerie im Belvedere in Wien eine Retrospektive mit 50 Werken aus ihrer sieben Jahrzehnte umfassenden Karriere zeigte. Kritiker drückten einmütig ihre Erleichterung über die längst überfällige Rückkehr und verdiente Anerkennung aus. Da die Ehre einer Einzelausstellung im Belvedere nur höchst selten einem noch lebenden Künstler zuteil wird, wurde die Schau als ein Akt der Wiedergutmachung gewertet.[31] Im Zuge der Ausstellung erwarb die Österreichische Galerie ihr zweites Motesiczky-Gemälde, *Selbstbildnis mit Kamm*, 1926 (Kat. Nr. 5), und wollte noch einige weitere Bilder in ihre Sammlung aufnehmen, um einen Motesiczky-Saal zu füllen. Die Malerin konnte sich aber nicht entschließen, und so wurde nichts aus diesem schönen Plan. Motesiczky erhielt einige Glückwunschbriefe, die die Bedeutung dieses Ankaufs betonten: »Bilder ... brauchen ein physisches Heim, um überleben zu können; Deine haben es nun – und was für eines, eines der besten der Welt. So wirst auch Du, liebe Marie-Louise, niemals sterben.«[32]

Mit dieser Ausstellung war es Motesiczky endgültig gelungen, sich als eine der wichtigsten österreichischen Malerinnen des 20. Jahrhunderts zu etablieren. Als Anerkennung ihrer Verdienste wurde ihr am 19. September 1994 das Österreichische Ehrenkreuz für Wissenschaft und Kunst I. Klasse überreicht. Als Motesiczky am 10. Juni 1996 in London starb, stand das Bild, an dem sie gerade arbeitete, *Stilleben, Blumenvase* (Abb. 3), noch auf der Staffelei neben dem Blumenstrauß, der zur Vorlage diente (Abb. 52). Ihre Urne wurde im Familiengrab auf dem Döblinger Friedhof in Wien beigesetzt.

1 Marie-Louise von Motesiczky in a radio interview on February 23, 1986: "Menschenbilder", ORF 1.
2 Marie-Louise von Motesiczky in "About myself", in: *Marie-Louise von Motesiczky. Paintings Vienna 1925–London 1985*, exh. cat., Goethe Institut, London, 1985, p. 13.
3 Cornelis Veth, "Cechische schilderes. Een frisch en boeiend talent", in: *De Telegraaf*, January 15, 1939.
4 A. d. B.: "Marie Louise Motesiczky. Huize Esher Surrey", in: *Avondpost*, January 17, 1939.
5 Marie-Louise von Motesiczky: handwritten note on the exhibition review by Cornelis Veth (Note 3), archive of the Marie-Louise von Motesiczky Charitable Trust, London.
6 Radio interview on February 23, 1986 (Note 1).
7 Marie-Louise von Motesiczky: entry in the "book of complaints", c. 1943, archive of the Marie-Louise von Motesiczky Charitable Trust, London.
8 Marie-Louise von Motesiczky to Sophie Brentano, November 8, 1974, archive of the Marie-Louise von Motesiczky Charitable Trust, London.
9 Hubert Gaisbauer, Heinz Janisch (eds.), *Menschenbilder*, Vienna, 1992, p. 173.
10 Marie-Louise von Motesiczky: diary entry, summer 1977, archive of the Marie-Louise von Motesiczky Charitable Trust, London.
11 Canetti to Marie-Louise, July 20, 1978, archive of the Marie-Louise von Motesiczky Charitable Trust, London.
12 Elias Canetti, *Party in the Blitz. The English Years,* translated by Michael Hofmann with an introduction by Jeremy Adler, London, 2005, p. 70.
13 Ibid., pp. 78–93.
14 Veza Canetti: *Der Fund*, Munich/Vienna, 2001, pp. 197–204.
15 Elias Canetti: *Aufzeichnungen für Marie-Louise*, ed. by Jeremy Adler, Munich/Vienna, 2005.
16 Marie-Louise: diary entry, June 25, 1945, archive of the Marie-Louise von Motesiczky Charitable Trust, London.
17 Marie-Louise in an undated letter to Canetti (1940s), archive of the Marie-Louise von Motesiczky Charitable Trust, London.
18 Interview of the author with Georgette Lewinson, May 15, 2000.
19 John Rothenstein to Oskar Kokoschka, October 16, 1944, archive of the Marie-Louise von Motesiczky Charitable Trust, London.
20 Marie-Louise to Canetti, November 1, 1960, archive of the Marie-Louise von Motesiczky Charitable Trust, London.
21 Marie-Louise in an undated letter to Sophie Brentano, archive of the Marie-Louise von Motesiczky Charitable Trust, London.
22 Hermann Gmeiner to Marie-Louise on June 27, 1978, archive of the Marie-Louise von Motesiczky Charitable Trust, London.
23 Canetti to Marie-Louise, July 27, 1963, archive of the Marie-Louise von Motesiczky Charitable Trust, London.
24 Canetti to Marie-Louise, February 24, 1965, archive of the Marie-Louise von Motesiczky Charitable Trust, London.
25 Marie-Louise to Canetti, June 25, 1964, archive of the Marie-Louise von Motesiczky Charitable Trust, London.
26 "Eine fesselnde Überraschung. Die Malerin Marie-Louise Motesicky stellt in der Secession aus", in: *Wiener Zeitung*, May 7, 1966.
27 Hilde Spiel, "Die Malerin Marie-Louise Motesiczky. Eine Ausstellung in der Wiener Secession", in: *Frankfurter Allgemeine Zeitung*, May 19, 1966.
28 Ernst H. Gombrich, "Marie-Louise von Motesiczky", exh. cat., London, 1985 (Note 2), p. 6.
29 John Russell Taylor, "Painting unparalleled for love and tender precision", in: *The Times*, December 10, 1985.
30 Larry Berryman, "Marie-Louise von Motesiczky", in: *Arts Review*, December 6, 1985.
31 Paul Kruntorad, "Die Wiederentdeckung einer Wiener Malerin", in: *Welt am Sonntag*, March 13, 1994.
32 Carole Angier to Marie-Louise on August 22, 1994, archive of the Marie-Louise von Motesiczky Charitable Trust, London.

"But an émigré ... not at all": Marie-Louise von Motesiczky in England

1 Motesiczky in einem Radiointerview »Menschenbilder«, ORF 1, 23.2.1986.
2 Marie-Louise von Motesiczky in: »About myself«, in: *Marie-Louise von Motesiczky. Paintings Vienna 1925–London 1985,* Ausst.-Kat. Goethe Institut, London 1985, S. 13.
3 Cornelis Veth, »Cechische schilderes. Een frisch en boeiend talent«, in: *De Telegraaf,* 15.1.1939.
4 A.d.B.: »Marie Louise Motesiczky. Huize Esher Surrey«, in: *Avondpost,* 17.1.1939.
5 Marie-Louise von Motesiczky, handschriftliche Notiz auf der Ausstellungs-kritik von Cornelis Veth (Anm. 3), Archiv des Marie-Louise von Motesiczky Charitable Trust, London.
6 Radiointerview vom 23.2.1986 (Anm. 1).
7 Motesiczky, Eintragung im »book of complaints«, ca. 1943, Archiv des Marie-Louise von Motesiczky Charitable Trust, London.
8 Marie-Louise von Motesiczky am 8.11.1974 an Sophie Brentano, Archiv des Marie-Louise von Motesiczky Charitable Trust, London.
9 Hubert Gaisbauer/Heinz Janisch (Hrsg.), *Menschenbilder,* Wien 1992, S. 173.
10 Motesiczky: Tagebucheintragung vom Sommer 1977, Archiv des Marie-Louise von Motesiczky Charitable Trust, London.
11 Canetti am 20.7.1978 an Motesiczky, Archiv des Marie-Louise von Motesiczky Charitable Trust, London.
12 Elias Canetti, *Party im Blitz. Die englischen Jahre,* München/Wien 2003, S. 33.
13 Ebd., S. 43–60.
14 Veza Canetti, *Der Fund,* München/Wien 2001, S. 197–204.
15 Elias Canetti, *Aufzeichnungen für Marie-Louise,* hrsg. von Jeremy Adler, München/Wien 2005.
16 Motesiczky, Tagebucheintragung vom 25.6.1945, Archiv des Marie-Louise von Motesiczky Charitable Trust, London.
17 Motesiczky in einem undatierten Brief an Canetti, (1940er Jahre), Archiv des Marie-Louise von Motesiczky Charitable Trust, London.
18 Interview der Verfasserin mit Georgette Lewinson, 15.5.2000.
19 John Rothenstein am 16.10.1944 an Oskar Kokoschka, Archiv des Marie-Louise von Motesiczky Charitable Trust, London.
20 Motesiczky am 1.11.1960 an Canetti, Archiv des Marie-Louise von Motesiczky Charitable Trust, London.
21 Motesiczky in einem undatierten Brief an Sophie Brentano, Archiv des Marie-Louise von Motesiczky Charitable Trust, London.
22 Hermann Gmeiner am 27.6.1978 an Motesiczky, Archiv des Marie-Louise von Motesiczky Charitable Trust, London.
23 Canetti am 27.7.1963 an Motesiczky, Archiv des Marie-Louise von Motesiczky Charitable Trust, London.
24 Canetti am 24.2.1965 an Motesiczky, Archiv des Marie-Louise von Motesiczky Charitable Trust, London.
25 Motesiczky am 25.6.1964 an Canetti, Archiv des Marie-Louise von Motesiczky Charitable Trust, London.
26 »Eine fesselnde Überraschung. Die Malerin Marie-Louise Motesicky stellt in der Secession aus«, in: *Wiener Zeitung,* 7.5.1966.
27 Hilde Spiel, »Die Malerin Marie-Louise Motesiczky. Eine Ausstellung in der Wiener Secession«, *Frankfurter Allgemeine Zeitung,* 19. Mai 1966.
28 Ernst H. Gombrich, »Marie-Louise von Motesiczky«, in: Ausst.-Kat., London 1985 (Anm. 2), S. 6.
29 John Russell Taylor, »Painting unparalleled for love and tender precision«, in: *The Times,* 10.12.1985.
30 Larry Berryman, »Marie-Louise von Motesiczky« in: *Arts Review,* 6.12.1985.
31 Paul Kruntorad, »Die Wiederentdeckung einer Wiener Malerin« in: *Welt am Sonntag,* 13.3.1994.
32 Carole Angier am 22.8.1994 an Motesiczky, Archiv des Marie-Louise von Motesiczky Charitable Trust, London.

64 **Self-portrait with Pears (Selbstporträt mit Birnen)**
1965
Oil on canvas / Öl auf Leinwand
615 × 465 mm
Lentos Kunstmuseum, Linz, Inv. no. 298

The small hand mirror on the table is the key to this painting. It shows the reflection of the painter with her head resting on her hand, creating the impression of a framed photograph. This rather melancholy self-portrait, in which Marie-Louise sadly tries to come to terms with ageing, is thus filled with the calmness of a still-life.

Der kleine Handspiegel auf dem Tisch ist der Schlüssel zu diesem Gemälde. Im Spiegelbild sieht man den auf die Hand gestützten Kopf der Malerin und bekommt den Eindruck einer gerahmten Fotografie. So ist dieses Selbstporträt, in dem sich Motesiczky melancholisch mit dem Altern auseinander setzt, erfüllt von der Ruhe eines Stilllebens.

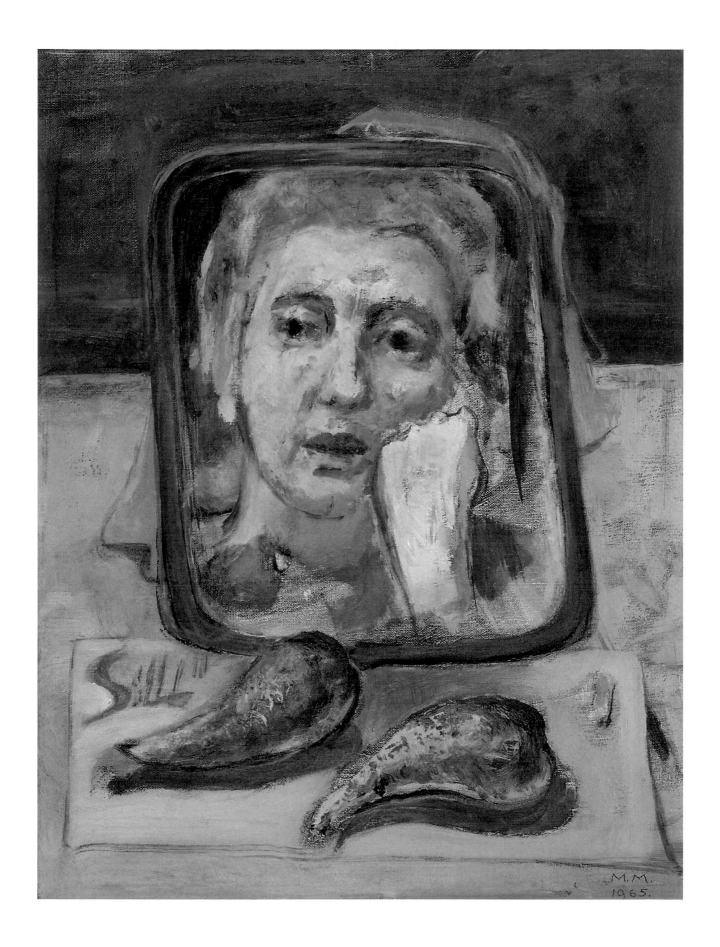

65 The Short Trip (Die kurze Fahrt)

1965
Oil on canvas / Öl auf Leinwand
882 × 1271 mm
Marie-Louise von Motesiczky Charitable Trust, London

When Henriette started to become frail with age, she bought small, electrically-driven vehicles to retain at least a little mobility. She turned out to be a daring driver whose disregard for traffic laws made people fear for her safety. In this painting, Marie-Louise created a dream scene set in her garden in Hampstead. This is indicated by the small sculpture of a cello-playing dwarf that she had set up on the garden wall in memory of her father and brother, both of whom played the instrument well. Henriette is driving a short distance over the lawn in her small electric scooter, while a ghostlike apparition, probably the painter herself, seems to be waving her on protectively. She is being met at the other end of the garden by a person dressed in an artist's smock. In all likelihood, this is Irma Simon, a relative of the Motesiczkys and the widow of Heinrich Simon, the former editor-in-chief of the "Frankfurter Zeitung". It was through Irma Simon, that Marie-Louise had met the young Max Beckmann in 1920. She emigrated to the USA and in 1965 visited the Motesiczkys in Hampstead. Henriette's lapdog, a small Italian greyhound called Bubi, almost flies over the lawn as he races with his mistress.

Als Henriette von Motesiczky im Alter gebrechlich wurde, legte sie sich kleine, elektrisch betriebene Gefährte zu, um sich wenigstens ein Stück weit ihre Mobilität und Unabhängigkeit zu bewahren. Sie entpuppte sich als wagemutige Fahrerin, und ihre Missachtung der Verkehrsvorschriften gab zur Sorge einigen Anlass. In diesem Bild schuf Motesiczky eine Traumszene, die in ihrem Garten in Hampstead spielt. Hierauf weist die kleine Plastik eines cellospielenden Zwergs hin, den sie in Erinnerung an Vater und Bruder, die beide das Instrument beherrschten, auf der Gartenmauer platzierte. In ihrem kleinen Wagen fährt Henriette ein kurzes Stück über den Rasen, wobei eine geisterhafte Erscheinung, wohl die Malerin selbst, sie beschützend zu verabschieden scheint. In Empfang nimmt sie eine mit einem Malerkittel bekleidete Person am anderen Ende des Gartens, wohl Irma Simon, eine Verwandte der Motesiczkys und Witwe Heinrich Simons, des ehemaligen Redaktionsleiters der »Frankfurter Zeitung«. Durch Irma Simon hatte Marie-Louise im Jahr 1920 den jungen Max Beckmann kennen gelernt. Irma Simon war in die USA emigriert und weilte 1965 zu Besuch in Hampstead. Henriette von Motesiczkys Schoßhund, ein kleines Windspiel namens Bubi, fliegt im Wettlauf mit seinem Frauchen geradezu über den Rasen.

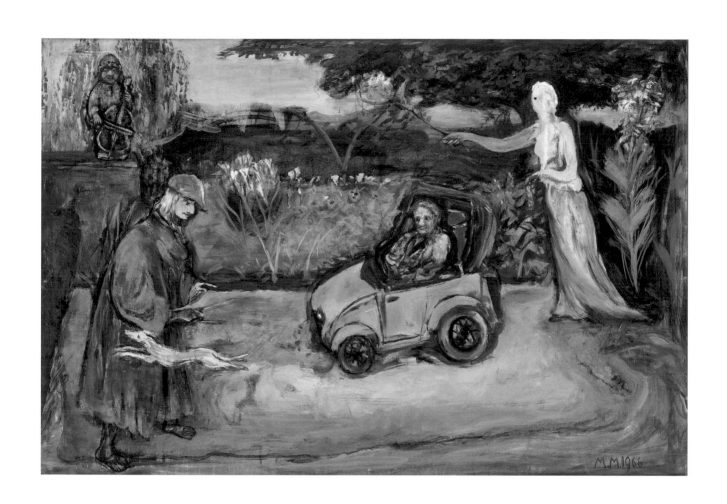

66 **Henriette von Motesiczky with Dog and Flowers**
(Henriette von Motesiczky mit Hund und Blumen)

1967
Oil, pastel and charcoal on canvas / Öl, Pastellkreide und Kohle auf Leinwand
613 × 763 mm
Marie-Louise von Motesiczky Charitable Trust, London

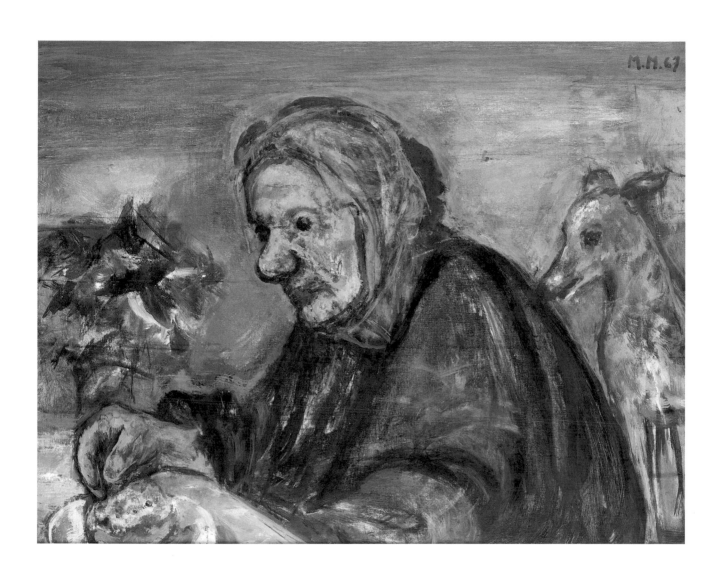

67 **Study for The Way (Studie zu »Der Weg«)**

c. 1967 / ca. 1967
Black ink, charcoal and pastel on paper / Schwarze Tinte, Kohle und Pastellkreide auf Papier
230 × 290 mm
Marie-Louise von Motesiczky Charitable Trust, London

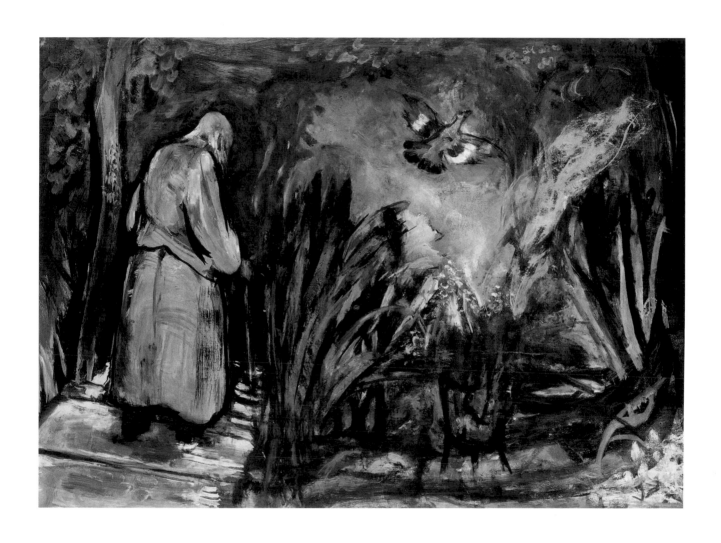

68 The Way (Der Weg)

1967
Oil on canvas / Öl auf Leinwand
490 × 660 mm
Private collection / Privatbesitz

69 **Swimming Pool (Schwimmbad vor dem Meer)**
1967
Oil on canvas / Öl auf Leinwand
767 × 1271 mm
Marie-Louise von Motesiczky Charitable Trust, London

On a trip to Spain in the summer of 1966, Marie-Louise photographed a swimming pool
that became the inspiration for this picture the following year. In contrast with the photo-
graph, which shows an untouched expanse of water, she enlivens the pool with numerous
humorous figures. Naked or only scantily clad, they swim, dive or splash in the water. The
young woman in the blue bathing costume sitting on the edge of the pool and watching the
activities in the water over her shoulder, is probably a self-portrait. Despite the amusing
undertones and its worldly character, this painting calls to mind pictures of the *Fountain of
Youth*, especially that by Lucas Cranach, particularly through its depiction of the child play-
ing in the grass and the small fountain at the left-hand end of the pool.

Auf einer Reise nach Spanien im Sommer 1966 fotografierte Motesiczky ein Schwimmbad,
das im folgenden Jahr als Inspiration zu diesem Bild diente. Im Gegensatz zur Vorlage, die
eine unberührte Wasserfläche zeigt, belebt Motesiczky das Becken mit einer Fülle humor-
voller Figuren. Nackt oder nur leicht bekleidet, schwimmen, tauchen oder plantschen sie
im Wasser. Die junge Frau im blauen Badeanzug, die am Rande des Beckens sitzt und, über
ihre Schulter blickend, dem nassen Treiben zusieht, stellt vermutlich ein Selbstporträt dar.
Trotz der amüsant-komischen Untertöne und seines weltlichen Charakters erinnert das
Gemälde an den Bildtypus des »Jungbrunnens« in der Bildformulierung Lucas Cranachs,
worauf das im Gras spielende Kind und der kleine Springbrunnen am linken Ende des
Beckens hinweisen.

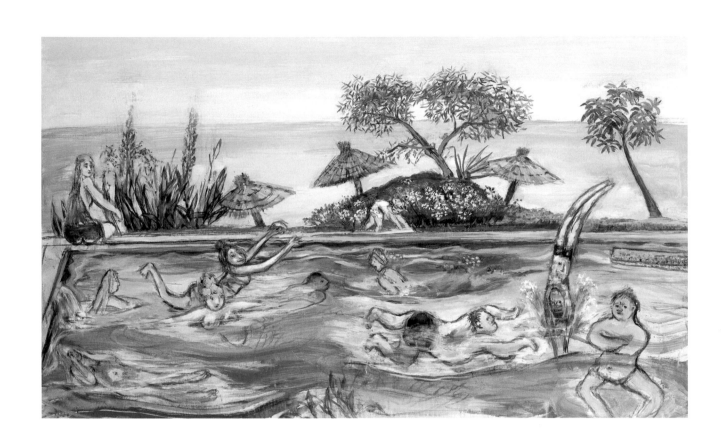

70 **Benno Reifenberg**
1968
Oil on canvas / Öl auf Leinwand
695 × 895 mm
Städelsches Kunstinstitut, Frankfurt am Main, Inv. no. 2113

The artist met Benno Reifenberg (1882–1970), art historian, publicist and co-editor of the
"Frankfurter Zeitung", in Frankfurt in the 1920s. During their long acquaintanceship, they
had many friends in common, including Beckmann and Kokoschka. In the early 1960s,
Reifenberg was involved in negotiations with Kokoschka for a portrait. However, the picture
had still not been started in 1966, when Reifenberg wrote an introduction for Marie-Louise's
Vienna exhibition catalogue. This gave her the idea of trying her hand at the portrait herself.
Reifenberg liked the proposal and when, shortly afterwards, he received a gift from the city
of Frankfurt in honour of his 75th birthday, he gave the commission to the painter. In the
summer of 1968 she travelled to Kronberg in the Taunus region to work with her model.
The resulting portrait pays tribute both to the public figure and the private friendship, and
was very highly regarded by Reifenberg himself.

Benno Reifenberg (1882–1970), Kunsthistoriker, Journalist, Publizist und Mitherausgeber der
»Frankfurter Zeitung«, lernte die junge Motesiczky in den 1920er Jahren in Frankfurt kennen.
Während ihrer langen Bekanntschaft hatten sie viele gemeinsame Freunde, unter ihnen
Beckmann und Kokoschka. In den frühen 1960er Jahren stand Reifenberg mit Kokoschka in
Verhandlungen über ein Porträt. Das Bild war jedoch im Jahr 1966, als Reifenberg eine Einlei-
tung für Motesiczkys Wiener Ausstellungskatalog schrieb, noch immer nicht begonnen, was
Motesiczky auf die Idee brachte, sich selbst an dem Bildnis zu versuchen. Reifenberg gefiel
der Vorschlag, und als er kurz darauf von der Stadt Frankfurt zu Ehren seines 75. Geburts-
tags eine Schenkung erhielt, beauftragte er die Malerin mit dem Porträt. Im Sommer 1968
fuhr sie für einige Wochen nach Kronberg im Taunus, um am Modell zu arbeiten. Es entstand
ein Porträt, das sowohl der öffentlichen Figur als auch der privaten Freundschaft Tribut zollt
und von Reifenberg selbst sehr geschätzt wurde.

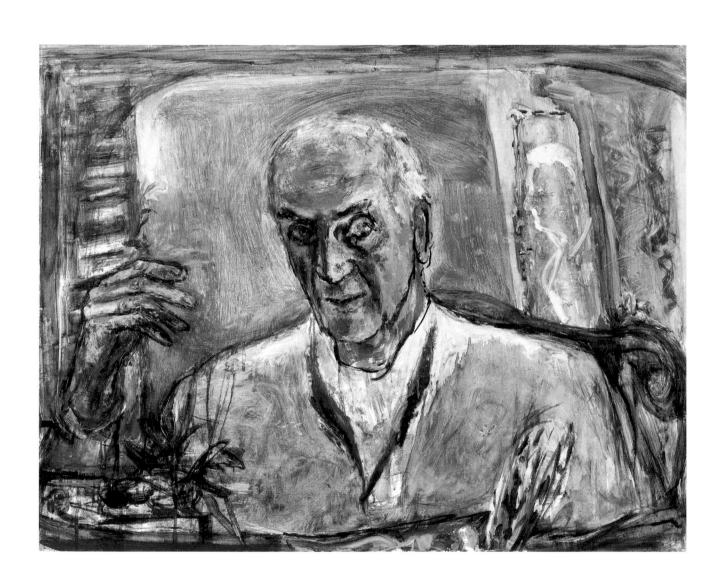

71 Self-portrait with Canetti (Selbstporträt mit Canetti)

1960s / 1960er Jahre
Oil on canvas / Öl auf Leinwand
509 × 818 mm
Marie-Louise von Motesiczky Charitable Trust, London

This double portrait reflects the tensions confronting Marie-Louise von Motesiczky and Elias Canetti after a deep but tempestuous relationship that lasted over twenty years, in which their roles had gradually become fixed. While Marie-Louise, who has ended her work and put away her painting utensils, is obviously waiting for some attention, Canetti, engrossed in his newspaper, does not even seem to notice her, let alone pay her any attention. The lack of communication and the seemingly separate halves of the painting suggest the difficulties that the writer and painter had with one another in their daily lives.

Dieses Doppelbildnis spiegelt die Spannungen wider, mit denen sich Marie-Louise von Motesiczky und Elias Canetti nach über zwanzig Jahren einer tiefen, aber stürmischen Beziehung, in der sich die Rollen allmählich verfestigt hatten, konfrontiert sahen. Während Motesiczky, die ihre Arbeit beendet und die Malutensilien verstaut hat, offenbar darauf wartet, Beachtung zu finden, scheint sie Canetti, in seine Zeitung vertieft, nicht einmal zu bemerken, geschweige denn Anstalten zu machen, sich um sie zu kümmern. Die fehlende Kommunikation sowie die separat anmutenden Bildhälften deuten die Schwierigkeiten an, welche Dichter und Malerin im täglichen Umgang miteinander hatten.

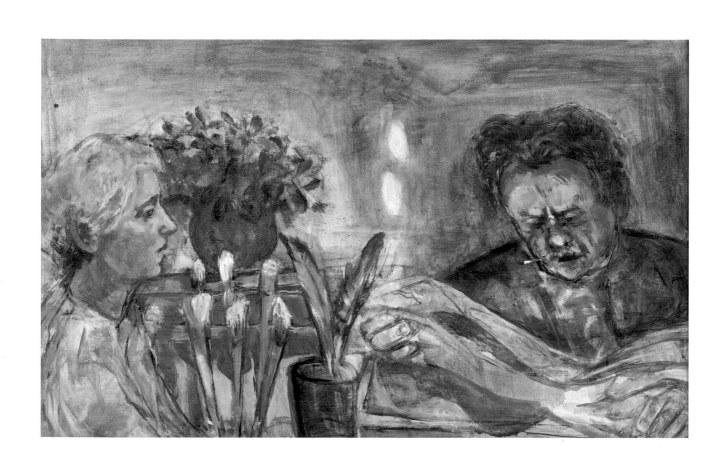

72 **Canetti—Head (Canetti – Kopf)**
undated / nicht datiert
Black chalk on paper / Schwarze Kreide auf Papier
245 × 175 mm
Marie-Louise von Motesiczky Charitable Trust, London

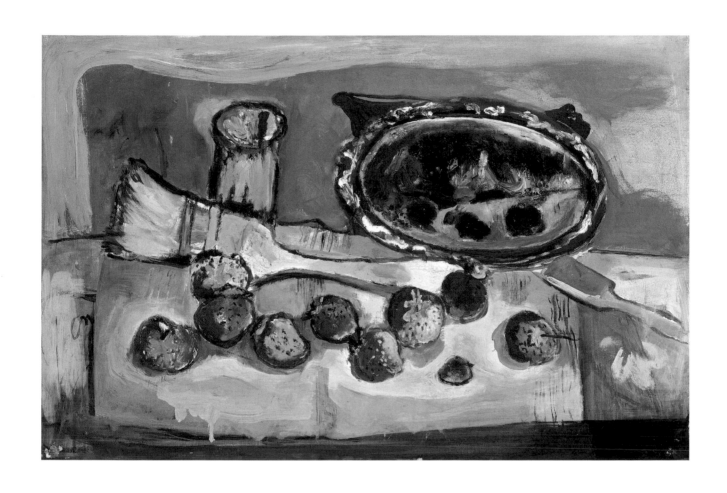

73 Still-life with Brush and Strawberries (Stilleben mit Pinsel und Erdbeeren)
1960s / 1960er Jahre
Oil on canvas / Öl auf Leinwand
507 × 761 mm
Marie-Louise von Motesiczky Charitable Trust, London

74 From Night into Day (Von der Nacht in den Tag)

1975
Oil on canvas / Öl auf Leinwand
838 × 1166 mm
Tate Gallery, London, Inv. no. T 04851

This portrait of Henriette von Motesiczky was painted in the artist's studio. Marie-Louise paid frequent visits to her bedridden model, who was in the room next door, to refresh her memory and make sure of details. In this way, she painted a picture that combines her lifelong memory of her mother's features with fresh observations. The title alludes to the difficulties her mother had in sleeping; she often lay awake at night waiting for morning to come. But at the same time it also reverses the conventional imagery of day and night as emblems of life or death to find a positive meaning in old age.

Dieses Bildnis Henriette von Motesiczkys entstand im Atelier der Malerin. Motesiczky stattete ihrem bettlägrigen Modell, das sich im Zimmer nebenan befand, immer wieder Besuche ab, um ihr Gedächtnis aufzufrischen und sich Details einzuprägen. Auf diese Weise entstand ein Porträt, das Motesiczkys lebenslange Erinnerung an die Gesichtszüge ihrer Mutter mit frischen Beobachtungen vereint. Der Titel spielt auf die Schlafprobleme der Mutter an, die nachts oft wach lag und auf den Morgen wartete, verwechselt aber gleichzeitig die konventionelle Bildersprache von Tag und Nacht als Embleme des Lebens bzw. des Todes, um dem Alter einen positiven Sinn abzugewinnen.

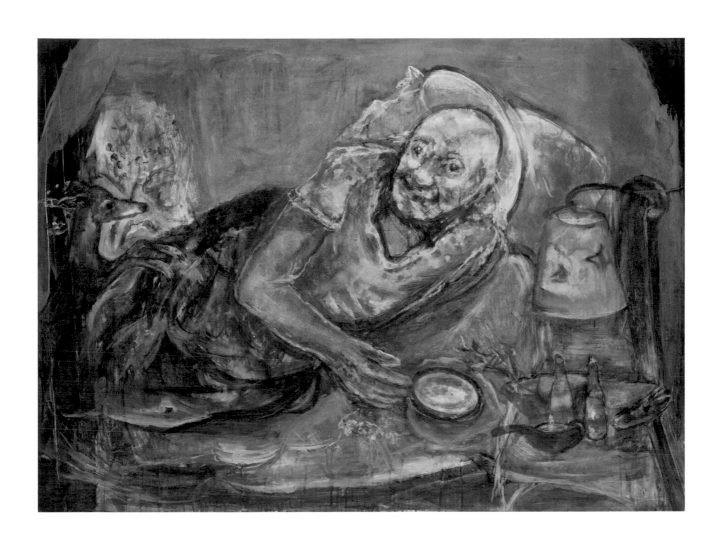

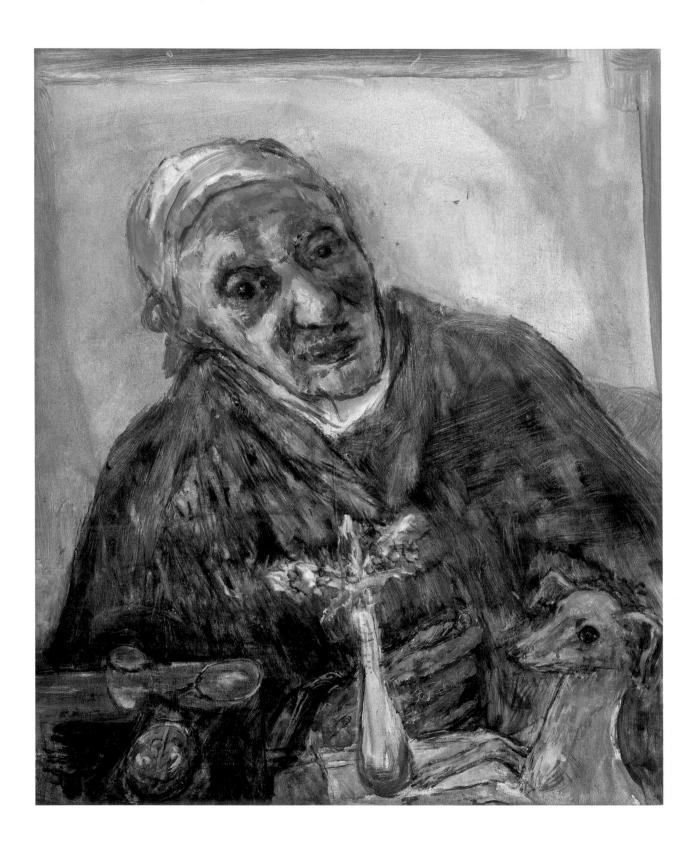

75 **Mother in Green Dressing Gown**
(Mutter im grünen Morgenrock)

1975
Oil on canvas / Öl auf Leinwand
661 × 560 mm
Marie-Louise von Motesiczky Charitable Trust, London

76 **Mother in the Garden (Mutter im Garten)**

1975
Oil, pastel and charcoal on canvas /
Öl, Pastellkreide und Kohle auf Leinwand
814 × 509 mm
Marie-Louise von Motesiczky Charitable Trust, London

228

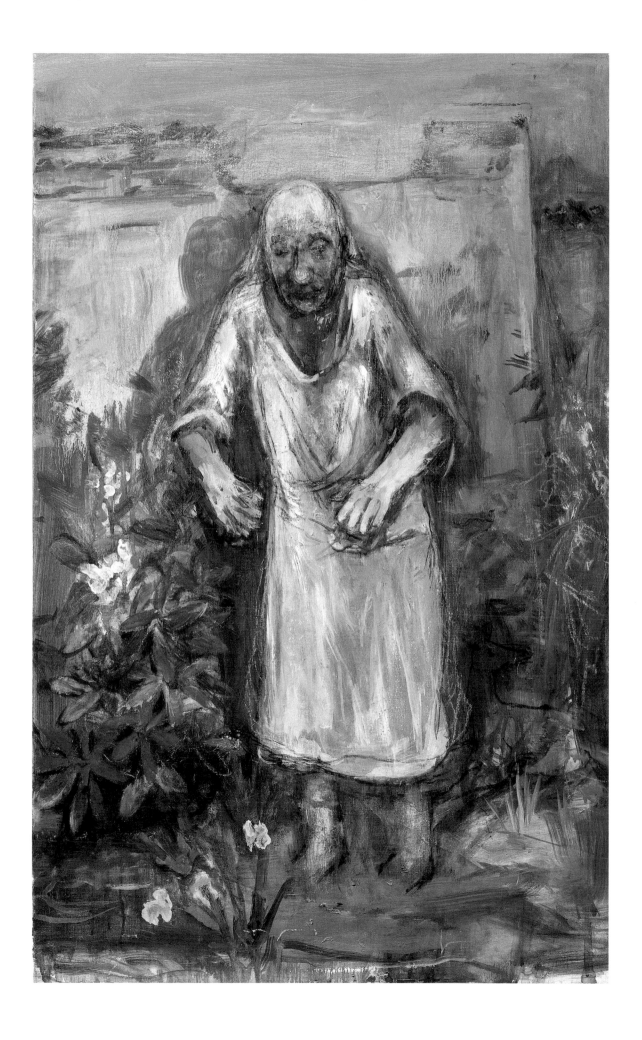

77 Mother with Baton (Mutter mit Stab)

1977
Oil on canvas / Öl auf Leinwand
764 × 607 mm
Arts Council, London

The artist's mother, advanced in years and almost bald, sits upright in bed. Despite her age, her eyes are bright and alert. She is holding a sort of baton—in other words, she still has her surroundings well in hand and not least the life of her daughter as a painter. She is surrounded by light as if from a halo, which cannot be coming from her small lamp but seems to symbolize joy and zest for life.

Die hochbetagte, fast kahlköpfige Mutter sitzt aufrecht im Bett, und trotz ihres Alters sind ihre Augen hell und wach. Sie hält einen Stab und hat so die Umwelt noch in der Hand – nicht zuletzt auch die Existenz der Tochter als Malerin. Sie ist von einem Licht umgeben wie von einer Gloriole, das nicht von der kleinen Lampe herrühren kann, sondern Lebenslust und Freude zu symbolisieren scheint.

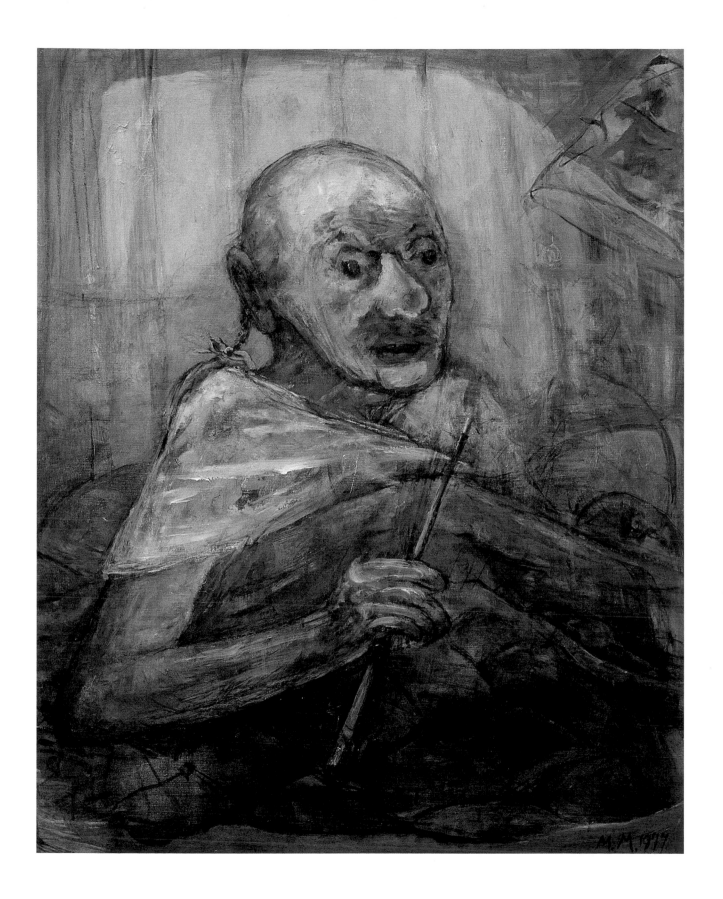

78 **Mother in Bed (Mutter im Bett)**
c. 1977/78 / ca. 1977/78
Oil and charcoal on canvas / Öl und Kohle auf Leinwand
453×357 mm
Marie-Louise von Motesiczky Charitable Trust, London

This portrait was painted in the mother's last year. It is extremely objective, indeed almost harsh, but at the same time deeply compassionate. Henriette von Motesiczky, now too feeble to leave her bed, seems close to death. The painter concentrates on the depiction of the familiar face of her old mother, perhaps fearing that she is sitting for her for the last time.

Entstanden im letzten Lebensjahr der Mutter, ist dieses Porträt besonders objektiv, ja geradezu schonungslos. Es ist zugleich aber auch zutiefst mitfühlend. Henriette von Motesiczky, nun zu schwach, um das Bett zu verlassen, scheint dem Tod nahe. Die Malerin konzentriert sich auf die Darstellung des vertrauten Gesichts ihrer alten Mutter, vielleicht befürchtend, dass diese ein letztes Mal für sie Porträt sitzt.

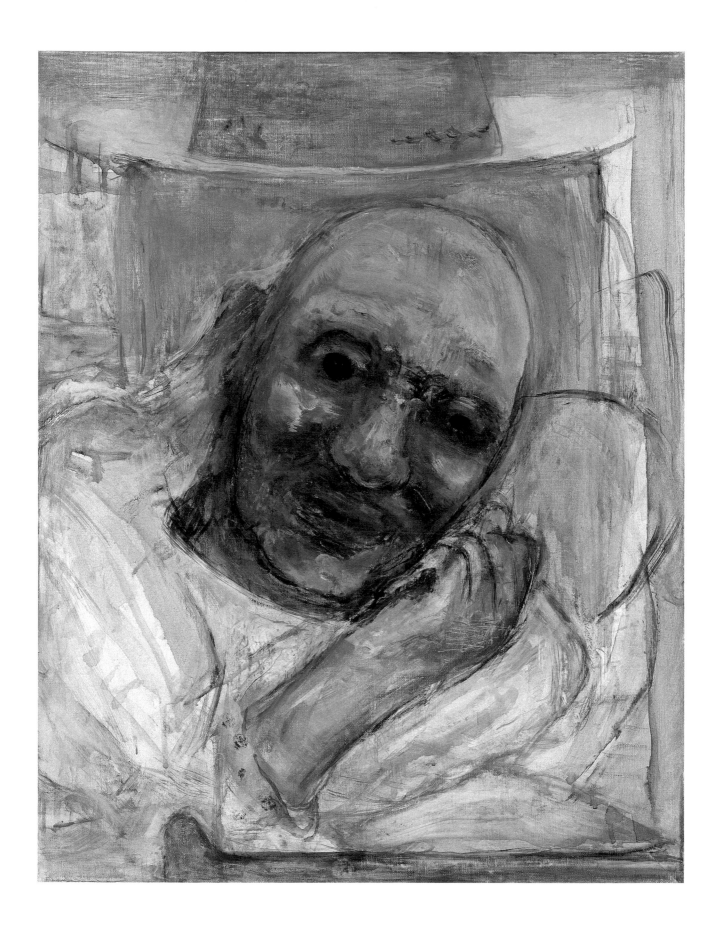

79 **The Greenhouse (Das Glashaus)**
1979
Oil and charcoal on canvas / Öl und Kohle auf Leinwand
557 × 815 mm
Marie-Louise von Motesiczky Charitable Trust, London

In this peaceful, dreamlike scene, the Motesiczkys' garden in Hampstead is transformed into an enchanted wilderness. The setting sun, reflected in the greenhouse, bathes the garden in a magical light. Amidst the luxuriant flora, a stooping, frail Henriette von Motesiczky is raking up leaves, accompanied by two Italian greyhounds leaping about. Marie-Louise painted this picture in memory of her mother, who had died in 1978. She had originally intended to paint all three of the greyhounds that her mother had possessed during the course of her life, but in the end only two were completed. The outlines of the smaller third dog, watched by the other two, can be seen faintly in front of the greenhouse.

Bei dieser friedlichen, traumhaften Szene wird Motesiczkys Garten in Hampstead in eine verzauberte Wildnis verwandelt. Die untergehende Sonne, die sich im Glashaus spiegelt, taucht den Garten in magisches Licht. Inmitten der üppigen Flora harkt eine gebückte, gebrechliche Henriette von Motesiczky Laub zusammen, begleitet von zwei herumspringenden Windspielen. Motesiczky malte dieses Bild im Andenken an ihre Mutter, die 1978 gestorben war. Ursprünglich hatte sie beabsichtigt, alle drei Windspiele, die ihre Mutter im Laufe ihres Lebens besaß, ins Bild zu nehmen. Es gelangten schließlich jedoch nur zwei zur vollen Ausführung. Der kleinere dritte, von den anderen beiden beobachtet, lässt sich in schwachen Umrissen vor dem Glashaus erkennen.

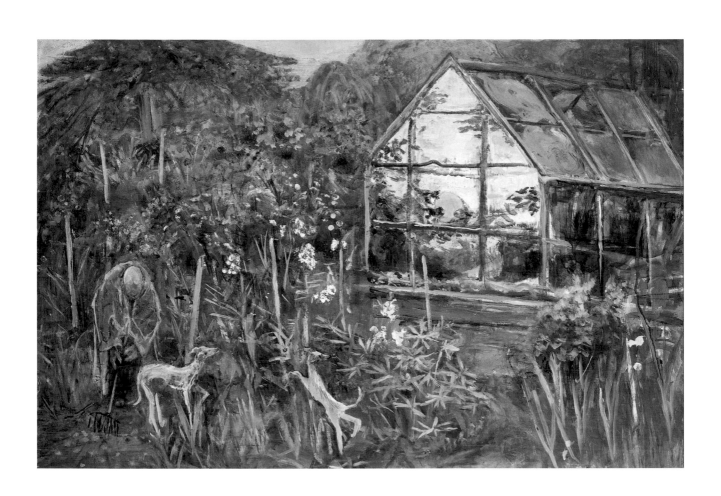

80 Henriette in Bed, Asleep with a Dog (Henriette im Bett, schlafend mit Hund)
undated / nicht datiert
Graphite on paper / Graphitstift auf Papier
180 × 265 mm
Marie-Louise von Motesiczky Charitable Trust, London

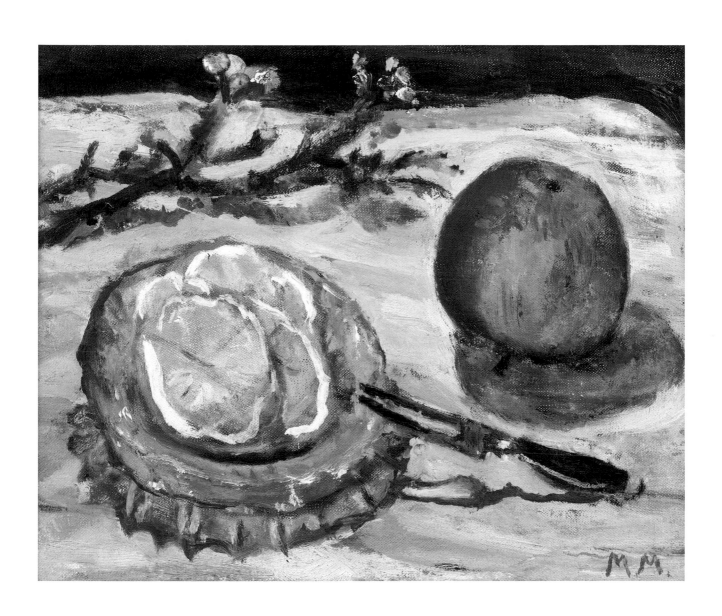

81 **Still-life with Lemon (Stilleben mit Zitronenscheiben)**
1980
Oil on canvas / Öl auf Leinwand
207 × 255 mm
Marie-Louise von Motesiczky Charitable Trust, London

82 Golders Hill Park

1981
Oil, pastel and charcoal on canvas / Öl, Pastellkreide und Kohle auf Leinwand
557 × 773 mm
Marie-Louise von Motesiczky Charitable Trust, London

Golders Hill Park, situated not far from Marie-Louise's house in Hampstead, is a popular London destination for outings. In her composition, the painter has brought together the characteristic elements of the park that she liked best: the fountain surmounted by a putto, a magnolia in full blossom and the flamingos from the nearby animal enclosure.

Golders Hill Park, unweit von Motesiczkys Haus in Hampstead gelegen, ist ein beliebtes Londoner Ausflugsziel. Die Malerin vereinigt in ihrer Komposition jene charakterischen Elemente des Parks, die ihr am besten gefielen: den von einem Putto gekrönten Springbrunnen, eine Magnolie in voller Blüte und die Flamingos aus dem nahe gelegenen Tiergehege.

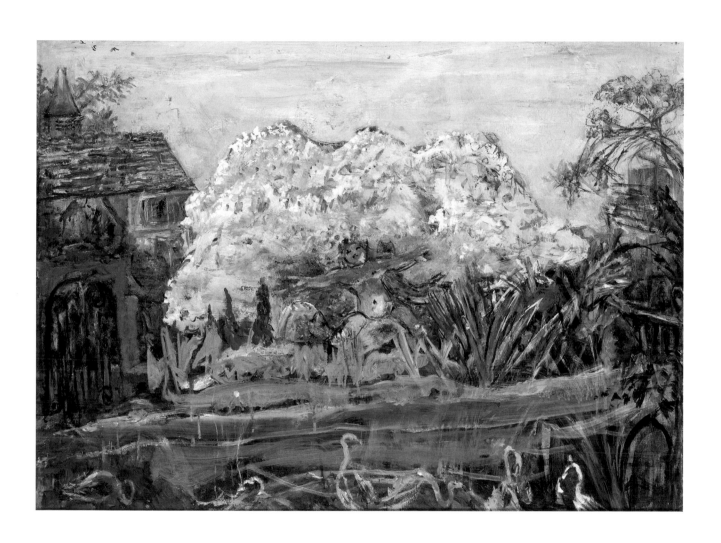

83 **Still-life with Fish (Stilleben mit Fisch)**
1982
Oil on canvas / Öl auf Leinwand
304 × 408 mm
Marie-Louise von Motesiczky Charitable Trust, London

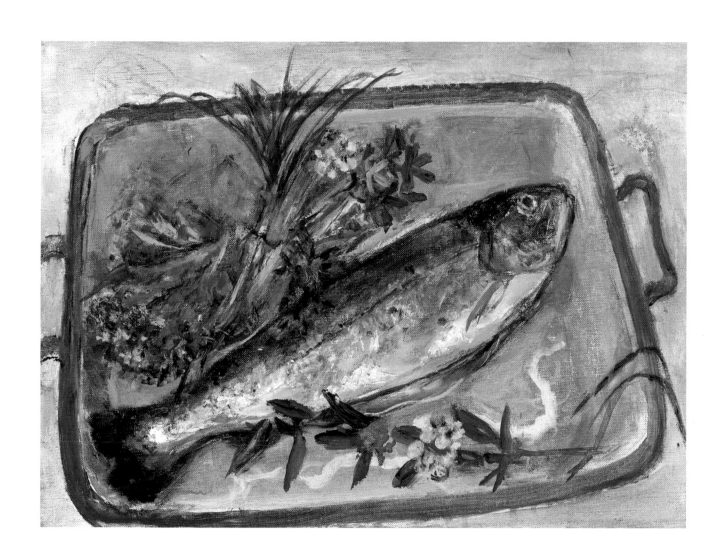

84 **Portrait Philippe de Rothschild (Porträt Philippe de Rothschild)**
1986
Oil on canvas, touches of charcoal / Öl und Kohle auf Leinwand
873 × 726 mm
Fitzwilliam Museum, Cambridge, Inv. no. PD 56-1993

Baron Philippe de Rothschild (1902–1988), a scion of the famous family, made an international
name for himself as a wine-grower, a poet and a scholar. He commissioned the artist to paint
his portrait in 1985. The following spring, she spent some weeks at his chateau in Bordeaux to
do sketches that she then used to complete the portrait in her studio. As an aid to memory
she also used photographs—as so often in her portraits—, whose spots of paint indicate
they were consulted frequently. The newly completed portrait was shown in Marie-Louise
von Motesiczky's very successful solo exhibition at the Fitzwilliam Museum in Cambridge.
As Rothschild was not prepared to accept the portrait, even after lengthy negotiations,
Marie-Louise made a gift of it to the museum.

Baron Philippe de Rothschild (1902–1988), ein Spross der berühmten Familie, der sich als
Besitzer eines Weinguts, Dichter und Gelehrter einen internationalen Namen machte, be-
auftragte Motesiczky 1985 mit der Ausführung seines Porträts. Im folgenden Frühjahr weilte
die Malerin einige Wochen auf seinem Schloss in Frankreich, um Skizzen anzufertigen, die sie
anschließend in ihrem Atelier zu einem Porträt ausarbeitete. Als Gedächtnisstütze verwen-
dete sie außerdem – wie so oft in ihren Porträts – Fotografien, deren Farbflecke vom häufigen
Gebrauch zeugen. Das gerade fertig gestellte Bildnis wurde in Motesiczkys überaus erfolg-
reicher Einzelausstellung im Fitzwilliam Museum in Cambridge gezeigt. Da der Auftraggeber
selbst nach langwierigen Verhandlungen nicht bereit war, das Bild anzunehmen, schenkte
es Motesiczky dem Museum.

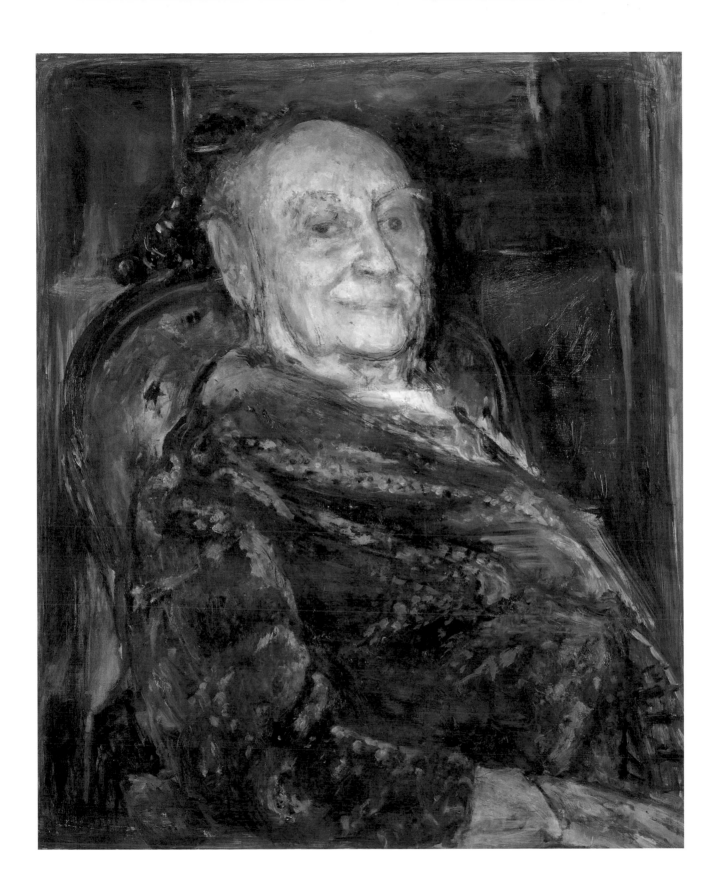

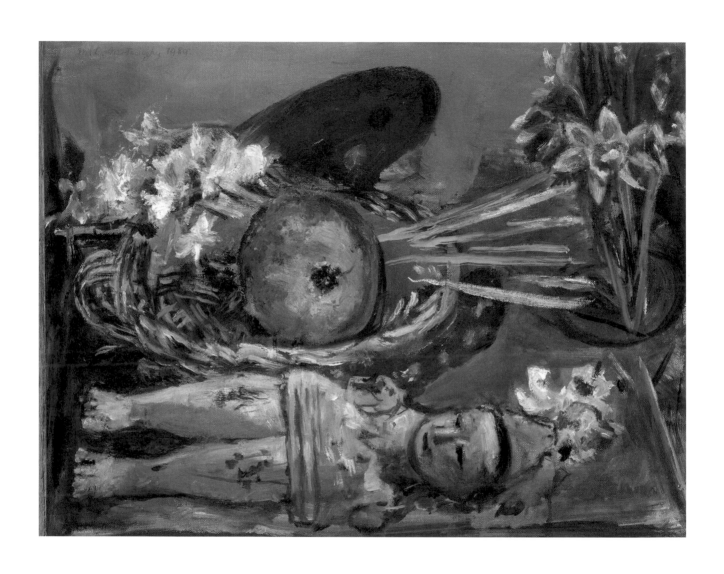

85 **Still-life with African Doll (Stilleben mit Puppe und Apfel)**

1989
Oil on canvas / Öl auf Leinwand
409 × 505 mm
Marie-Louise von Motesiczky Charitable Trust, London

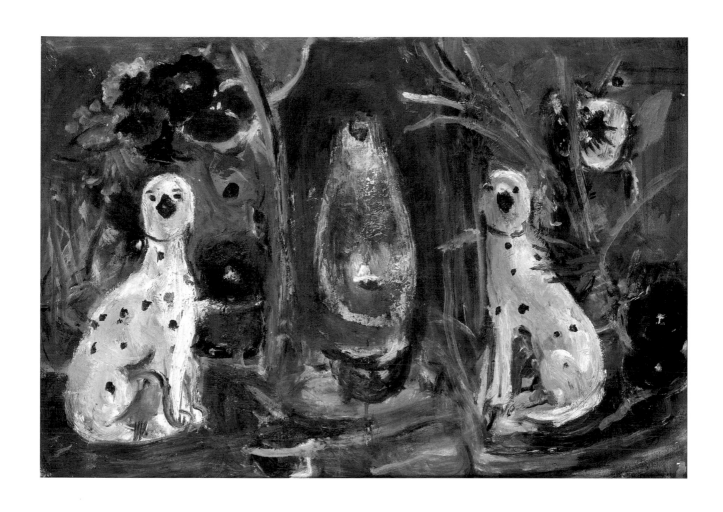

86 **Still-life with Two Porcelain Dogs (Stilleben mit zwei Porzellanhunden)**
1980s/1980er Jahre
Oil on canvas / Öl auf Leinwand
356 × 510 mm
Private collection / Privatbesitz

87 Child with a Candle, Birthday Cake and Dog (Kind mit Kerze, Geburtstagskuchen und Hund)
1990
Oil, charcoal and pastel on canvas / Öl, Kohle und Pastellkreide auf Leinwand
509 × 610 mm
Marie-Louise von Motesiczky Charitable Trust, London

The child in this painting is Louise Black, the daughter of one of Marie-Louise's Dutch relatives, Jantien Black née Salomonson, and the art historian Peter Black, who lived in the painter's house in the eighties. The Black family visited Marie-Louise in Hampstead in July 1990, when their daughter Louise was celebrating her first birthday.

Das kleine Kind auf diesem Bild ist Louise Black, die Tochter einer holländischen Verwandten Motesiczkys, Jantien Black, geborene Salomonson, und des Kunsthistorikers Peter Black, der in den 1980er Jahren im Haus der Malerin wohnte. Die Familie Black besuchte Motesiczky im Juli 1990, als Louise ihren ersten Geburtstag feierte, in Hampstead.

88 **Portrait Elias Canetti (Porträt Elias Canetti)**

1992
Oil on canvas / Öl auf Leinwand
914 × 710 mm
National Portrait Gallery, London, Inv. no. NPG 6190

In a letter dated 25 February 1990, Elias Canetti comissioned this, his last portrait from Marie-Louise: "I am often asked to sit for portraits, even by some artists who aren't all that bad. I always refuse for two reasons, first, because I think of the best portraitist of all, who knows me as well as no other, but also because I can't sit. So I am giving you the commission to paint a portrait of E. C. from memory. I think it could turn out particularly well". The painter used a press photo from "The Sunday Times" to create a portrait that shows Canetti, now well past eighty, as a powerful, seemingly ageless figure. Canetti did not much like the finished painting, and so she offered it to the National Portrait Gallery in London. As she wrote to the Director, John Hayes, on 28 July 1992, she gave the painting in thanks "to Great Britain for giving a home to my mother and me". Under the misapprehension that Canetti was already dead, however, the museum refused to accept the gift, saying that only portraits painted during the subject's lifetime could be accepted. The misunderstanding was only cleared up by a detailed letter from Canetti's publisher at André Deutsch, after which the National Portrait Gallery gratefully agreed to take the painting.

In einem Brief vom 25. Februar 1990 bestellte Elias Canetti sein letztes Bildnis bei Marie-Louise von Motesiczky: »Ich werde immer wieder um ein Porträt gebeten, auch von nicht ganz schlechten Künstlern. Ich lehne immer ab, aus zwei Gründen, einmal weil ich an den allerbesten Porträtisten denke, der mich so gut kennt wie niemand anderer, aber dann auch, weil ich nicht sitzen kann. Ich gebe Ihnen also den Auftrag, aus der Erinnerung ein Porträt von E. C. zu malen. Ich glaube, das könnte besonders gut werden.« Unter Verwendung eines Pressefotos aus »The Sunday Times« schuf die Malerin ein Bildnis, das den nun weit über 80-Jährigen als gewaltige, scheinbar alterslose Erscheinung zeigt. Als das fertige Gemälde bei seinem Auftraggeber wenig Gefallen fand, bot sie es der National Portrait Gallery in London an, als Ausdruck des Dankes »an Großbritannien, das meiner Mutter und mir ein Heim gegeben hat«, wie es in ihrem Brief an den Direktor, John Hayes, vom 28. Juli 1992 heißt (»to Britain for giving a home to my mother and me«: Archiv der National Portrait Gallery, London). In der falschen Annahme, dass Canetti bereits gestorben sei, lehnte das Museum das Geschenk jedoch ab, denn es würden nur Porträts angenommen, die zu Lebzeiten des Dargestellten entstanden seien. Erst ein ausführlicher Brief von Canettis Verlegerin bei André Deutsch klärte das Missverständnis auf, so dass sich das Bild nun doch in der National Portrait Gallery befindet.

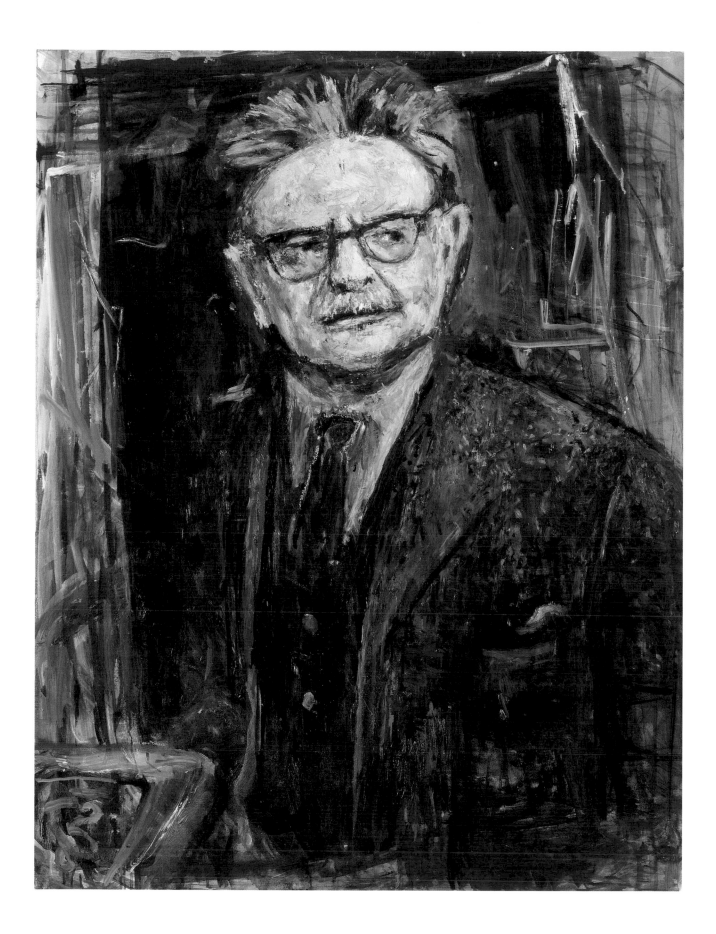

89 **Last Self-portrait (Letztes Selbstporträt)**

1993
Oil and charcoal on canvas / Öl und Kohle auf Leinwand
762 × 662 mm
Marie-Louise von Motesiczky Charitable Trust, London

In this last self-portrait, the artist reflects on her origins and depicts herself as an elegantly dressed woman of the world. Although large parts of this canvas remain unfinished—or perhaps precisely because of that fact—, this is a particularly moving work: created on the basis of profound self-examination, it surrounds the painter with an aura of mystery.

In diesem letzten Selbstbildnis besinnt sich Motesiczky auf ihre Herkunft und stellt sich als elegant gekleidete Dame von Welt dar. Obwohl, ja vielleicht gerade weil große Teile der Leinwand unvollendet blieben, ist dies ein besonders bewegendes Werk: Entstanden aus tiefer Selbstprüfung, umgibt es die Malerin mit einer Aura des Geheimnisvollen.

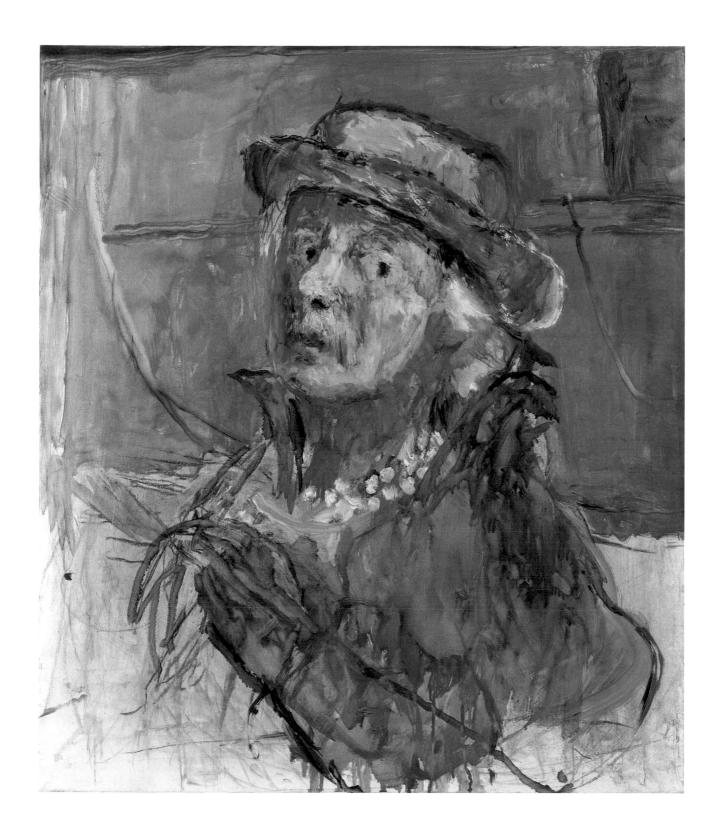

Chronology

Zeittafel

Ines Schlenker



1906

Marie-Louise Josefine Alice von Motesiczky is born in Vienna on 24 October to Henriette von Motesiczky (née von Lieben, born in 1882) and Edmund Franz von Motesiczky Kesseleökeö (born in 1866). Her mother is a talented amateur painter and poet; her father a gifted musician. She has one older brother, Karl Wolfgang Franz (born in 1904). Marie Hauptmann joins the family as Marie-Louise's nurse. The family divides its time between an apartment at Brahmsplatz 7, in the 4th district of Vienna, in winter, and the Villa Todesco at Kröpfelsteig 42, in the village of Hinterbrühl in the Wienerwald, south-west of Vienna, in the summer. During the hunting season they live at the Hungarian estate of Vázsony. The wider family is among the most prominent in Vienna and played a leading role in the city's cultural life, having interests in science, music, literature, painting and philosophy, and counting among its circle the composers Johann Strauß and Johannes Brahms, the writers Franz Grillparzer and Hugo von Hofmannsthal as well as Sigmund Freud.

1909

Edmund von Motesiczky falls ill with a twisted intestine on a hunting trip. He dies on 12 December. Henceforth Marie-Louise is educated by a succession of private tutors and governesses.

1916

Enters school, the Öffentliches Mariahilfer Mädchenlyzeum, in the 6th district of Vienna. A tall girl, she becomes known as "Piz" within the family because of her height, with reference to the Swiss mountain Piz Buin. Family friends in this period include the modernist architect, Otto Wagner (1841–1918), and the dramatist, Arthur Schnitzler.

1920

Leaves school at the age of thirteen, which she later greatly regretted. She begins to draw and for several months takes private art lessons in the Viennese studio of the artist, David Kohn. In the summer, the painter Max Beckmann (1884–1950) is introduced to the Motesiczkys by a relative, Irma Simon, the wife of Heinrich Simon, editor in chief of the "Frankfurter Zeitung". Beckmann becomes a close family friend and a key artistic influence on Marie-Louise. She often visits the Kunsthistorisches Museum in Vienna where the curator, Ludwig Baldass, introduces her to art history.





1906

Marie-Louise Josefine Alice von Motesiczky kommt am 24. Oktober als Kind von Henriette von Motesiczky (Geburtsname: von Lieben, geboren 1882) und Edmund Franz von Motesiczky Kesseleökeö (geboren 1866) in Wien zur Welt. Ihre Mutter war eine talentierte Freizeit-Malerin und Dichterin, ihr Vater ein begabter Musiker. Sie hat einen älteren Bruder, Karl Wolfgang Franz (geboren 1904). Marie-Louises Amme, Marie Hauptmann, wird in die Familie aufgenommen. Die Motesiczkys verbringen die Wintermonate in einer Wohnung am Brahmsplatz 7, im IV. Wiener Bezirk, und den Sommer in der Villa Todesco am Kröpfelsteig 42, im Dorf Hinterbrühl im Wienerwald, südwestlich von Wien. Während der Jagdsaison halten sie sich auf ihrem ungarischen Gut in Vázsony auf. Der ganze Kreis der Familie gehört zur Wiener Prominenz und spielt mit seinen Interessen in den Bereichen Wissenschaft, Musik, Literatur, Malerei und Philosophie eine herausragende Rolle im kulturellen Leben der Stadt. Zum engeren Kreis der Familie zählen Musiker wie Johann Strauß und Johannes Brahms, Dichter wie Franz Grillparzer und Hugo von Hofmannsthal sowie Sigmund Freud.

1909

Während eines Jagdausflugs erkrankt Edmund von Motesiczky an einer Darmverschlingung und stirbt am 12. Dezember. Von da an wird Marie-Louise von mehreren Gouvernanten erzogen und von verschiedenen Privatlehrern unterrichtet.

1916

Marie-Louise besucht das Öffentliche Mariahilfer Mädchenlyzeum im VI. Wiener Bezirk. Da sie hochgewachsen ist, wird sie im Familienkreis in Anspielung auf den Schweizer Berg Piz Buin »Piz« genannt. Zu den Freunden der Familie zählen zu dieser Zeit der moderne Architekt Otto Wagner (1841–1918) und der Dramatiker Arthur Schnitzler.

1920

Mit 13 Jahren geht Marie-Louise von der Schule ab, was sie später sehr bedauern wird, beginnt zu zeichnen und nimmt über mehrere Monate Privatstunden im Wiener Atelier des Malers David Kohn. Im Sommer lernen die Motesiczkys den Maler Max Beckmann (1884–1950) kennen, der ihnen von einer Verwandten, Irma Simon, der Frau des Mitherausgebers und Verlegers der »Frankfurter Zeitung«, Heinrich Simon, vorgestellt wird. Beckmann wird ein enger Freund der Familie und übt als Künstler entscheidenden Einfluss auf Marie-Louise aus. Sie stattet dem Kunsthistorischen Museum in Wien häufige Besuche ab; hier führt sie der Kurator Ludwig Baldass in die Kunstgeschichte ein.



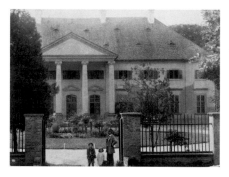

53 The Motesiczky estate at Vázsony. Karl, Marie-Louise and Edmund von Motesiczky are in the foreground, Photograph, before 1910 / Das Gut der Motesiczkys in Vázsony; im Vordergund erkennt man Karl, Marie-Louise und Edmund von Motesiczky, Fotografie, vor 1910

54 Henriette and Edmund von Motesiczky posing with two stags, Photograph, before 1910 / Henriette und Edmund von Motesiczky mit zwei Jagdtrophäen, Fotografie, vor 1910

1922

Falls in love with her cousin, Witold Schey. Her mother sends her to stay with her aunt, Ilse Leembruggen, in Holland to help her to recover from the infatuation. Marie-Louise spends four months in The Hague. She discovers the paintings of the Dutch school, notably Rembrandt, and of Vincent van Gogh, who becomes a decisive influence. She attends the private art school of the Czech painter, Carola Machotka, and also meets Mathilde von Kaulbach (1904–1996), daughter of the Munich painter Friedrich August von Kaulbach.

1923

Mathilde von Kaulbach stays with the Motesiczkys at their flat on Brahmsplatz, Vienna. She meets Beckmann and subsequently marries him in 1925. Marie-Louise's mother's nickname for her, "Quappi", is adopted by all her friends, including Beckmann.

1924

Attends the Städelschule in Frankfurt am Main for about three months where she studies with Professors Johann Vincenz Cissarz (1873–1942) and Franz Karl Delavilla (1884–1967). She stays with Heinrich and Irma Simon and attends their Friday lunches. The guests include the conductor Wilhelm Furtwängler, the ballerina Anna Pavlova, and the writers Benno Reifenberg and Fritz von Unruh. She regularly meets Max Beckmann, sees his work in the Simons' house, and visits his studio for the first time, where he shows her his latest oil paintings. On returning to Hinterbrühl, Marie-Louise takes up oil painting herself. She enrols at the School of Applied Arts, the Kunstgewerbeschule am Ring, Vienna, for one semester in the autumn, studying with Professors Adolf Boehm (1861–1927) and Erich Mallina (1873–1954).

1925–1927

Spends long periods in Paris, often in the winter. Studies at the Académie de la Grande Chaumière, Montparnasse. Discovers the French Impressionists. In Vienna, she has a romance with the exiled Hungarian writer, Baron Lajos Hatvany (1880–1961).

1925

Paints *Street in Hinterbrühl* (cat. no. 2).

1926

Paints *Workman, Paris* (cat. no. 8) and her first self-portrait, *Self-Portrait with Comb* (cat. no. 5).

1927–28

Beckmann invites Marie-Louise to attend his master class at the Städelschule in Frankfurt am Main. She later recorded her experiences in her essay "Max Beckmann as teacher".

1928

Paints *Bullfight* (cat. no. 12) and *Spanish Girl* (Fig. 17) after visiting Spain. The writer Heimito von Doderer (1896–1966) dedicates a poem to her, "Lebhafte Erinnerung" (Lively Memory).

1922

Marie-Louise verliebt sich in ihren Vetter Witold Schey. Damit sie über die Geschichte hinwegkommt, schickt ihre Mutter sie zu ihrer Tante, Ilse Leembruggen, nach Holland. Während ihres viermonatigen Aufenthalts in Den Haag entdeckt sie die Werke der niederländischen Schule, insbesondere die Rembrandts, sowie die Bilder Vincent van Goghs, der ihre künstlerische Entwicklung maßgeblich beeinflußt. Sie besucht die private Kunstschule der tschechischen Malerin Carola Machotka und lernt Mathilde von Kaulbach (1904–1996), die Tochter des Münchner Malers Friedrich August von Kaulbach, kennen.

1923

Mathilde von Kaulbach wohnt bei den Motesiczkys in deren Wiener Wohnung am Brahmsplatz. Sie lernt dort Max Beckmann kennen, den sie 1925 heiratet. Der Spitzname »Quappi«, den ihr Marie-Louises Mutter verleiht, wird von all ihren Freunden, einschließlich Beckmann, übernommen.

1924

Marie-Louise besucht ungefähr drei Monate die Städelschule in Frankfurt, wo sie bei den Professoren Johann Vincenz Cissarz (1873–1942) und Franz Karl Delavilla (1884–1967) studiert. Sie wohnt bei Heinrich und Irma Simon und nimmt an deren Freitagstisch teil. Zu den Gästen gehören u. a. der Dirigent Wilhelm Furtwängler, die Tänzerin Anna Pawlowa und die Schriftsteller Benno Reifenberg und Fritz von Unruh. Sie trifft regelmäßig Beckmann, der ihr zum ersten Mal seine Ölgemälde zeigt. Nach ihrer Rückkehr nach Hinterbrühl beginnt Marie-Louise selbst, Bilder in Öl zu malen. Im Herbst studiert sie ein Semester an der Kunstgewerbeschule am Ring in Wien, bei den Professoren Adolf Boehm (1861–1927) und Erich Mallina (1873–1954).

1925–1927

Längere Aufenthalte in Paris, zumeist während der Wintermonate. Marie-Louise studiert an der Académie de la Grande Chaumière, Montparnasse, und entdeckt die französischen Impressionisten. In Wien hat sie eine Liebesaffäre mit dem im Exil lebenden ungarischen Schriftsteller Baron Lajos Hatvany (1880–1961).

1925

Marie-Louise malt *Straße, Hinterbrühl* (Kat. Nr. 2).

1926

Sie malt *Arbeiter, Paris* (Kat. Nr. 8) und ihr erstes Selbstporträt, *Selbstporträt mit Kamm* (Kat. Nr. 5).

1927–1928

Beckmann lädt Marie-Louise ein, seine Meisterklasse an der Städelschule in Frankfurt am Main zu besuchen. Ihre Erfahrungen verarbeitet sie später in ihrem Aufsatz »Max Beckmann as Teacher« (Max Beckmann als Lehrer).

1928

Nach einer Spanienreise malt sie *Stierkampf* (Kat. Nr. 12) und *Spanisches Mädchen* (Abb. 17). Der österreichische Schriftsteller Heimito von Doderer (1896–1966) widmet ihr das Gedicht »Lebhafte Erinnerung«.

55 Max Beckmann with / mit Marie-Louise and / und Mathilde von Kaulbach, Photograph / Fotografie, 1924

56 Marie-Louise von Motesiczky as "Mondblüte" (Moonblossom) in the play "Der verwechselte Bräutigam" (The Mistaken Bridegroom), Frankfurt am Main, Photograph, 1927 / Marie-Louise von Motesiczky als »Mondblüte« in dem Theaterstück »Der verwechselte Bräutigam«, Frankfurt am Main, Fotografie, 1927

1928–1930

Moves to Berlin and studies life drawing ("Abend-akt") at the Studien-Atelier für Malerei und Plastik Robert Erdmann in Charlottenburg. Visits Alfred Flechtheim's Berlin gallery, which shows Beckmann, Picasso and Willi Baumeister. She makes friends with the painter Wolfgang Paalen (1907–1959) and forms a relationship with the artist Siegfried Sebba (1897–1975), which lasts several years. Her mother prevents their marriage.

1929

Paints *Henriette von Motesiczky—Portrait No. 1* (cat. no. 17), the first in the sequence of pictures of her mother that culminated some fifty years later.

1930

Paints *At the Dressmaker's* (cat. no. 20).

1933

First exhibits in public at the "Frühjahrsausstellung des Hagenbundes" in Vienna, showing two works, including *The Balcony* (1929, cat. no. 18). In the winter of 1933/34 the composers Gian Carlo Menotti (born 1911) and Samuel Barber (1910–1981) rent a flat in the Motesiczkys' house and soon become friends. Marie-Louise paints a portrait of each of them (both now lost).

1934

Travels to the United States and enquires about the possibilities of emigrating there with Sebba.

1937

Romantic attachment with Herbert Schey, the twin brother of Witold, which lasts until her flight from Austria in the following year.

1938

Flees Vienna for Holland with her mother on 13 March, the day after the "Anschluss". They live in several boarding houses and hotels, occasionally meeting Max and Quappi Beckmann. Paints *Self-Portrait with Red Hat* (cat. no. 29). Karl remains in Austria and sends out Marie-Louise's early paintings from the 1920s and 1930s. He subsequently joins a resistance group with Ella Lingens and others that helps Jews to escape from Austria.

1928–1930

Marie-Louise zieht nach Berlin und studiert Akt-zeichnung am Studien-Atelier für Malerei und Plastik Robert Erdmann in Charlottenburg. Sie besucht Alfred Flechtheims Berliner Galerie, die Bilder von Max Beckmann, Pablo Picasso und Willi Baumeister ausstellt. Sie freundet sich mit dem Maler Wolfgang Paalen (1907–1959) an und beginnt ein mehrjähriges Verhältnis mit dem Künstler Siegfried Sebba (1897–1975). Ihre Mutter verhindert eine Heirat.

1929

Sie malt *Henriette von Motesiczky – Porträt Nr. 1* (Kat. Nr. 17), das erste in einer Reihe von Bildnissen ihrer Mutter, die fast fünfzig Jahre später ihren künstlerischen Höhepunkt erreichen sollte.

1930

Marie-Louise malt *Bei der Schneiderin* (Kat. Nr. 20).

1933

Erste öffentliche Bilderschau auf der »Frühjahrs-ausstellung des Hagenbundes« in Wien. Es werden zwei ihrer Werke gezeigt, darunter *Akt auf dem Balkon* (1929, Kat. Nr. 18). Im Winter 1933/34 mieten die Komponisten Gian Carlo Menotti (geb. 1911) und Samuel Barber (1910–1981) eine Wohnung im Haus der Motesiczkys und freunden sich mit der Familie an. Marie-Louise porträtiert beide; die Bilder sind heute verschollen.

1934

Reise in die Vereinigten Staaten. Sie erkundigt sich nach Möglichkeiten, mit Sebba in die USA auszuwandern.

1937

Liebesaffäre mit Herbert Schey, Witolds Zwil-lingsbruder, die bis zu ihrer Flucht aus Österreich im folgenden Jahr andauert.

1938

Am 13. März, dem Tag nach dem »Anschluss«, flüchtet sie mit ihrer Mutter nach Holland. Sie wohnen in verschiedenen Pensionen und Hotels und kommen gelegentlich mit Max und Quappi Beckmann zusammen. Marie-Louise malt *Selbstporträt mit rotem Hut* (Kat. Nr. 29). Ihr Bruder Karl bleibt in Österreich und schafft Marie-Louises frühe Gemälde aus den 1920er und 1930er Jahren außer Landes. Später schließt er sich zusammen mit Ella Lingens und anderen einer Widerstandsgruppe an, die Juden zur Flucht aus Österreich verhilft.

57 Marie-Louise with her fellow pupils Karl Tratt (left) and Theo Garve (right) on a bench on the bank of the Main River in front of the Städel in Frankfurt am Main, Photograph, 1927/28 / Marie-Louise mit ihren Mitschülern Karl Tratt (links) und Theo Garve (rechts) auf einer Bank am Frankfurter Mainufer vor dem Städel, Fotografie, 1927/28

58 Siegfried Sebba, Photograph / Fotografie, c. 1930 / um 1930

1939

Has her first solo exhibition at Esher Surrey Art Galleries Ltd. in The Hague in January, which was well received by the critics. She and her mother decide to emigrate to England, travelling with Marie Hauptmann via Switzerland to London, where they arrive in February. They live in a hotel in Sloane Square, then in a flat in Marble Arch, and later rent rooms at 76, Adelaide Road, North London. Karl von Motesiczky sends out a substantial part of the Viennese household, including furniture and artworks. The Motesiczkys renew their acquaintance with the painter Oskar Kokoschka (1886–1980), a family friend from Vienna. Marie-Louise meets the writer Elias Canetti (1905–1994), who had fled to England with his wife, Veza, in February 1939. They embark on a turbulent relationship that lasts for the rest of their lives and is marked by unfailing support for each other's work. Marie-Louise also meets Canetti's friend, Gustav Mahler's daughter, the sculptress Anna Mahler (1904–1988), who makes a portrait bust of her (now lost).

1940

Escapes the dangers of the Blitz with her mother and Marie Hauptmann by moving to Amersham in Buckinghamshire, a village to the west of London. They first live with the priest, Gordon Milburn and his wife Mary at "Durris" in Stubbs Wood, where Canetti and his wife, Veza, live later on. After the war Marie-Louise paints the portrait, *Father Milburn* (1958, Fig. 44), and Canetti describes the couple in his English memoirs, "Party in the Blitz" (2005). Kokoschka paints a portrait of Marie-Louise (Fig. 46).

1941

The Motesiczkys acquire "Cornerways", a three-bedroom house at 86, Chestnut Lane, Amersham. The house affords space for a studio and for Canetti's substantial library. Marie-Louise participates in the "Exhibition of Contemporary Continental Art. Paintings, Water-Colours, Sculptures" at the Leger Gallery, London. She helps Max Beckmann to survive in exile during the war by mediating sales of his works to her relatives in Holland.

1942

Participates in the "Exhibition of Allied Artists" at the R.B.A. Galleries, London. Canetti dedicates a manuscript to her, "Aufzeichnungen für Marie-Louise" (Aphorisms for Marie-Louise), published in 2005. Her brother is arrested by the Gestapo on 13 October after helping two Jewish couples from Poland escape to Switzerland. He is deported to Auschwitz.

1939

Im Januar erste Einzelausstellung in den Esher-Surrey Art Galleries Ltd. in Den Haag, die von der Kritik sehr positiv aufgenommen wird. Sie und ihre Mutter beschließen, nach England zu emigrieren, und reisen mit Marie Hauptmann über die Schweiz nach London, wo sie im Februar eintreffen. Sie wohnen in einem Hotel am Sloane Square, beziehen dann eine Wohnung am Marble Arch und mieten später einige Zimmer im Haus Nr. 76, Adelaide Road, im Norden Londons, an. Karl von Motesiczky schickt ihnen einen beträchtlichen Teil des Wiener Haushalts nach, darunter Möbel und Kunstwerke. Die Motesiczkys erneuern ihre Bekanntschaft mit dem Maler Oskar Kokoschka (1886–1980), einem Freund der Familie aus Wiener Tagen. Marie-Louise begegnet dem Schriftsteller Elias Canetti (1905–1994), der im Februar 1939 mit seiner Frau Veza nach England geflohen war. Sie beginnen eine stürmische Liaison, die bis zum Ende ihres Lebens andauert und von unerschütterlicher gegenseitiger Unterstützung in ihrer Arbeit gekennzeichnet ist. Marie-Louise lernt auch Canettis Freundin, Gustav Mahlers Tochter, die Bildhauerin Anna Mahler (1904–1988) kennen, die eine (heute verschollene) Büste von ihr anfertigt.

1940

Um den Gefahren der Bombenangriffe auf London zu entgehen, zieht Marie-Louise mit ihrer Mutter und Marie Hauptmann nach Amersham in Buckinghamshire, einem Dorf westlich von London. Sie wohnen zunächst bei Pfarrer Gordon Milburn und seiner Frau Mary in »Durris«, Stubbs Wood, wo später Canetti und seine Frau Veza einziehen werden. Nach dem Krieg malt sie das Porträt *Vater Milburn* (1958, Abb. 44), und Canetti beschreibt das Paar in seinen englischen Erinnerungen »Party im Blitz« (Hanser Verlag, München 2003). Kokoschka malt ein Porträt von Marie-Louise (Abb. 46).

1941

Die Motesiczkys erwerben in Amersham das Haus Nr. 86 in der Chestnut Lane, das »Cornerways« genannt wird und über drei Schlafzimmer verfügt. Es bietet genügend Platz für ein Atelier und für Canettis umfangreiche Bibliothek. Marie-Louise beteiligt sich an der »Exhibition of Contemporary Continental Art. Paintings, Water-Colours, Sculptures« in der Londoner Leger Gallery. Sie hilft Max Beckmann, während des Kriegs das Exil zu überleben, indem sie den Verkauf seiner Werke an holländische Familienmitglieder vermittelt.

1942

Marie-Louise von Motesiczky beteiligt sich an der »Exhibition of Allied Artists« in den R.B.A. Galleries, London. Canetti widmet ihr ein Manuskript, die »Aufzeichnungen für Marie-Louise«, die erst 2005 veröffentlicht werden. Ihr Bruder Karl von Motesiczky wird am 13. Oktober von der Gestapo verhaftet, nachdem er zwei jüdischen Paaren aus Polen zur Flucht in die Schweiz verholfen hatte. Er wird nach Auschwitz deportiert.

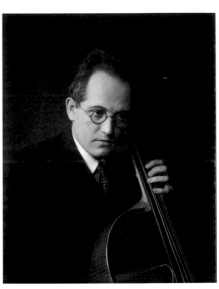

59 Group photograph at the opening of the exhibition "Tentoonstelling van werken door Marie Louise Motesiczky" at Esher Surrey Art Galleries Ltd., The Hague, January 1939 / Gruppenaufnahme bei der Eröffnung der Ausstellung »Tentoonstelling van werken door Marie Louise Motesiczky« in der Esher Surrey Art Galleries Ltd., Den Haag, im Januar 1939

60 Elias Canetti and Marie-Louise von Motesiczky in her studio at "Cornerways", Amersham, Photograph, early 1940s / Elias Canetti und Marie-Louise von Motesiczky in ihrem Atelier »Cornerways« in Amersham, Fotografie, frühe 1940er Jahre

61 Karl von Motesiczky with his cello / Karl von Motesiczky mit seinem Cello, Photograph / Fotografie, c. 1940 / um 1940

1943

Paints *Morning in the Garden* (cat. no. 36). Joins the Artists' International Association. Karl dies in the prisoners' infirmary at Auschwitz on 25 June.

1944

Shows 28 paintings at the "Exhibition of Painting and Sculpture by Marie-Louise Motesiczky and Mary Duras" at the Czechoslovak Institute, London. She shows a painting in "AIA 1944. Artists' International Association Members' Exhibition" at the R.B.A. Galleries in London.

1945

After the war Marie-Louise moves to London, staying at 139 Maida Vale. She takes part in "This Extraordinary Year. Annual Exhibition by the members of the Artists' International Association" at the Whitechapel Art Gallery in London.

1946

First trip to Vienna after the war. She returns regularly.

1948

She and her mother are naturalised as British citizens. She moves to a flat at 14, Compayne Gardens, West Hampstead. Canetti has a room here from 1951 to 1957, where he often works.

1950

Paints *Conversation in the Library* (cat. no. 43). Around this time she forms lasting friendships with the art critic and writer Edith Yapou the leading modernist architect and son of the former Liberal Party leader, Godfrey Samuel, the émigré artist, Milein Cosman and her husband, the music critic Hans Keller.

1952

Paints *Finchley Road at Night* (Fig. 48). Solo exhibitions at the Kunstzaal Van Lier, Amsterdam, and the Kunstzaal Plaats, The Hague. The Stedelijk Museum, Amsterdam, buys *Finchley Road at Night*.

1953

Participates in the exhibition "The Renaissance of the Fish. Paintings from the 17th to the 20th Century" at Roland, Browse and Delbanco, Cork Street, London.

1954

Paints *Reclining Woman with Pipe* (cat. no. 50). Her nurse Marie Hauptmann, who has been a second mother to her ever since her childhood, dies in March, aged 69. The Städtische Galerie, Munich, mounts an exhibition of works by Erna Dinklage and Marie-Louise featuring 34 of her works, chiefly recent paintings. Friendship with the composer, Ralph Vaughan Williams, and his wife, the poetess Ursula, whose portrait she paints.

1943

Marie-Louise malt *Morgen im Garten* (Kat. Nr. 36) und wird Mitglied in der »Artists' International Association«. Karl stirbt am 25. Juni im Krankenbau des KZ Auschwitz.

1944

Die Malerin zeigt 28 ihrer Bilder in der »Exhibition of Painting and Sculpture by Marie-Louise Motesiczky and Mary Duras« im Czechoslovak Institute, London. Ein Bild stellt sie in der »AIA 1944. Artists' International Association Members' Exhibition« in den R.B.A. Galleries aus.

1945

Nach Kriegsende zieht Marie-Louise wieder nach London, und zwar in das Haus Nr. 139, Maida Vale. Sie beteiligt sich an »This Extraordinary Year. Annual Exhibition by the members of the Artists' International Association«, einer Ausstellung, die in der Whitechapel Art Gallery stattfindet.

1946

Erste Wien-Reise nach dem Krieg. Sie kehrt regelmäßig dorthin zurück.

1948

Marie-Louise und ihre Mutter erhalten die britische Staatsangehörigkeit. Sie bezieht eine Wohnung im Haus Nr. 14, Compayne Gardens, West Hampstead. Dort hat Canetti von 1951 bis 1957 ein Zimmer, in dem er oft arbeitet.

1950

Sie malt *Gespräch in der Bibliothek* (Kat. Nr. 43). Etwa in diese Zeit fällt der Beginn ihrer lange währenden Freundschaft mit der Kunstkritikerin und Schriftstellerin Edith Yapou, dem führenden modernen Architekten und Sohn des ehemaligen Vorsitzenden der Liberalen Partei, Godfrey Samuel, der emigrierten Künstlerin Milein Cosman und deren Mann, dem Musikkritiker Hans Keller.

1952

Sie malt *Finchley Road bei Nacht* (Abb. 48). Einzelausstellungen im Kunstzaal Van Lier, Amsterdam, und im Kunstzaal Plaats, Den Haag. Das Stedelijk Museum, Amsterdam, kauft *Finchley Road bei Nacht*.

1953

Marie-Louise von Motesiczky beteiligt sich an der Ausstellung »The Renaissance of the Fish. Paintings from the 17th to the 20th Century« bei Roland, Browse and Delbanco, Cork Street, London.

1954

Sie malt *Liegende mit Pfeife* (Kat. Nr. 50). Ihr ehemaliges Kindermädchen und lebenslange »zweite Mutter«, Marie Hauptmann, stirbt im März im Alter von 69 Jahren. Die Städtische Galerie München veranstaltet eine Ausstellung mit Werken von Erna Dinklage und Marie-Louise von Motesiczky. Gezeigt werden 34 ihrer Werke, hauptsächlich neueren Datums. Freundschaft mit dem Komponisten Ralph Vaughan Williams und seiner Frau, der Dichterin Ursula, von der sie ein Porträt malt.

62 Mary Duras, *Marie Louise*, no date / undatiert, painted Plaster / bemalter Gips, Private collection / Privatsammlung, Glasgow

63 Milein Cosman and Marie-Louise on the steps of the Tate Gallery in London, Photograph, 1953 / Milein Cosman und Marie-Louise auf den Stufen der Tate Gallery in London, Fotografie, 1953

64 Marie Hauptmann in the kitchen, Amersham / Marie Hauptmann in der Küche des Hauses in Amersham, Photograph / Fotografie, 1940s / 1940er Jahre

1955

Together with Heinz May, Curt Beckmann and Hans van Breek Marie-Louise exhibits at the Kunstverein für die Rheinlande und Westfalen, Düsseldorf.

1956

Makes an extended trip to the United States and to Mexico. Here she meets Wolfgang Paalen again. The family estate in Hinterbrühl is sold to Hermann Gmeiner for the construction of an SOS Kinderdorf (a charitable children's village). Five years later, Henriette and Marie-Louise erect a monument to Karl on the site.

1958

Engages Maria Pauzenberger ("Bauzen") who cares for her mother for the rest of her life. Marie-Louise and her mother purchase a substantial three-storey Edwardian house in Chesterford Gardens, Hampstead.

1959

Paints *The Old Song* (cat. no. 55).

1960

Paints *Elias Canetti* (cat. no. 56), now in the Wien Museum. Moves with her mother to Chesterford Gardens. Her studio and bedroom are on the first floor. Canetti has a room on the top floor, which he uses for writing. "Cornerways" is rented out, then sold in the 1970s. Helen Lessore, who also showed Francis Bacon, Frank Auerbach and Leon Kossoff, mounts a solo exhibition for Marie-Louise at the Beaux Arts Gallery, London.

1961

Holidays with Gretel and Theodor Wiesengrund Adorno at Sils Maria, Switzerland. The art historian Josef Paul Hodin publishes an appreciation of her work in "The Painter & the Sculptor" and another in "Alte und moderne Kunst" (1966).

1962

Paints *Mother with a Straw* (cat. no. 59).

1963

Veza Canetti dies. Marie-Louise expects to become Canetti's second wife. A portrait of Iris Murdoch is commissioned by St Anne's College, Oxford, on the occasion of the writer's retirement from teaching (cat. no. 61).

1964

Paints *Chemist's Shop* (cat. no. 62). Travels to Tunisia. Shows two paintings in the "Last Anthology" exhibition at the Beaux Arts Gallery, London.

1965

Travels to Italy.

1955

Zusammen mit Heinz May, Curt Beckmann und Hans van Breek beteiligt sich Marie-Louise an einer Ausstellung im Kunstverein für die Rheinlande und Westfalen, Düsseldorf.

1956

Ausgedehnte Reisen durch die Vereinigten Staaten und Mexiko. Hier begegnet sie Wolfgang Paalen wieder. Das Anwesen der Familie in Hinterbrühl wird an Hermann Gmeiner verkauft, der auf dem Grundstück ein SOS-Kinderdorf baut. Fünf Jahre später errichten Henriette und Marie-Louise dort ein Denkmal für Karl.

1958

Marie-Louise stellt Maria Pauzenberger (»Bauzen«) ein, die sich bis zu ihrem Lebensende um ihre Mutter Henriette kümmert. Sie und ihre Mutter erwerben ein stattliches, dreistöckiges, im edwardianischen Stil erbautes Haus in Chesterford Gardens, Hampstead.

1959

Sie malt das Bild *Das alte Lied* (Kat. Nr. 55).

1960

Marie-Louise malt das Porträt von *Elias Canetti* (Kat. Nr. 56), das sich jetzt im Wien Museum befindet. Sie bezieht mit ihrer Mutter das Haus in Chesterford Gardens. Ihr Atelier und Schlafzimmer befinden sich in der ersten Etage. Canetti hat ein Zimmer im obersten Stockwerk, das er als Schreibzimmer nutzt. »Cornerways« wird vermietet und in den 1970er Jahren verkauft. Helen Lessore, die auch Francis Bacon, Frank Auerbach und Leon Kossoff ausgestellt hat, organisiert eine Einzelausstellung für Marie-Louise in der Londoner Beaux Arts Gallery.

1961

Urlaub mit Gretel und Theodor Wiesengrund Adorno in Sils Maria, Schweiz. Der Kunsthistoriker Josef Paul Hodin veröffentlicht einen anerkennenden Artikel über ihr Werk in »The Painter & the Sculptor« und später einen weiteren in »Alte und moderne Kunst« (1966).

1962

Sie malt *Mutter mit Strohhalm* (Kat. Nr. 59).

1963

Veza Canetti stirbt. Marie-Louise erwartet, dass Canetti sie heiratet. Ein Porträt von Iris Murdoch wird vom St Anne's College, Oxford, anlässlich ihres Eintritts in den Ruhestand in Auftrag gegeben (Kat. Nr. 61).

1964

Marie-Louise von Motesiczky malt *Drogerie* (Kat. Nr. 62). Reise nach Tunesien. Zwei ihrer Gemälde werden in der Ausstellung »Last Anthology« der Beaux Arts Gallery, London, gezeigt.

1965

Reise nach Italien.

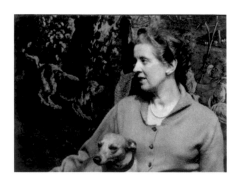

Theodor W. Adorno
Moments musicaux
Neu gedruckte Aufsätze 1928–1962

Suhrkamp Verlag

65 Marie-Louise with Franzi. In the background a tapestry with a hunting scene from the family property in Vienna, Photograph, c. 1955 / Marie-Louise mit Hund »Franzi«, im Hintergrund erkennt man einen Wandteppich mit Jagdszenen aus dem Wiener Familienbesitz, Fotografie, um 1955

66 Handwritten dedication from Theodor Wiesengrund Adorno to Marie-Louise / Handschriftliche Widmung Theodor Wiesengrund Adornos für Marie-Louise

67 Marie-Louise photographing her reflection in a window, Photograph, 1963 / Marie-Louise fotografiert ihr Spiegelbild in einem Fenster, Fotografie, 1963

1966

Major solo exhibition at the Wiener Secession, for which Canetti writes an essay on her work. The show travels to the Neue Galerie der Stadt Linz, the Galerie Günther Franke in Munich (1967) and the Kunsthalle in Bremen (1968). Paintings are bought by the Österreichische Galerie in the Belvedere (*Frau Ziegler*, 1938), the Neue Galerie der Stadt Linz (*Self-portrait with Pears*, 1965, cat. no. 64) and the Culture Office of Vienna (*Elias Canetti*, 1960, cat. no. 56).

1967

Paints *The Way* (cat. no. 68).

1968

Commissioned to paint the portrait of the biologist, Miriam Rothschild, and the portrait *Benno Reifenberg* (cat. no. 70) now in the Städelsches Kunstinstitut, Frankfurt am Main.

1969

First visit to Israel, where she returns several times.

1973

Suffers a bitter disappointment on learning that Canetti has entered a marriage with the art restorer, Hera Buschor (in 1971), and that they have a child. Marie-Louise temporarily breaks off all contact with him.

1974

Participates in the exhibition "Hampstead in the Thirties. A Committed Decade" at the Camden Arts Centre, London.

1975

Paints *Mother in Green Dressing Gown* (cat. no. 75) and *From Night into Day* (cat. no. 74). Participates in "Portraits Today", an exhibition of The Contemporary Portrait Society, at The Qantas Gallery, London.

1977

Paints *Mother with Baton* (cat. no. 77). Submits a painting for the "Summer Exhibition" at the Royal Academy of Arts, London. It is not accepted. She tries again with two paintings in 1981 and is again rejected.

1978

Henriette dies on 8 June at the age of ninety-six, having been nursed to the end by Marie-Louise. The house is altered to accommodate lodgers. Marie-Louise moves downstairs, but keeps her studio on the first floor.

1979

Paints *The Greenhouse* (cat. no. 79) and *The Very Reverend Victor de Waal, Dean of Canterbury*.

1966

Große Einzelausstellung in der Wiener Secession, für die Canetti einen Aufsatz über ihr Werk schreibt. Die Bilderschau wandert dann nach Linz (Neue Galerie der Stadt Linz), nach München (1967, Galerie Günther Franke) und zuletzt nach Bremen (1968, Kunsthalle). Bilder werden erworben von der Österreichischen Galerie im Belvedere (*Frau Ziegler*, 1938), der Neuen Galerie der Stadt Linz (*Selbstporträt mit Birnen*, 1965, Kat. Nr. 64) und vom Kulturamt der Stadt Wien (*Elias Canetti*, 1960, Kat. Nr. 56).

1967

Marie-Louise malt *Der Weg* (Kat. Nr. 68).

1968

Sie erhält den Auftrag, das Porträt der Biologin Miriam Rothschild und das Porträt *Benno Reifenberg* (Kat. Nr. 70) zu malen, das sich jetzt im Städelschen Kunstinstitut in Frankfurt am Main befindet.

1969

Erste Reise nach Israel, das sie danach noch mehrmals besucht.

1973

Als sie erfährt, dass Canetti 1971 die Restauratorin Hera Buschor geheiratet und ein Kind mit ihr hat, ist sie bitter enttäuscht und bricht vorübergehend jeden Kontakt mit ihm ab.

1974

Beteiligung an der Ausstellung »Hampstead in the Thirties. A Committed Decade« im Camden Arts Centre, London.

1975

Marie-Louise malt *Mutter im grünen Morgenrock* (Kat. Nr. 75) und *Von der Nacht in den Tag* (Kat. Nr. 74). Teilnahme an »Portraits Today«, einer Ausstellung der Contemporary Portrait Society, in der Qantas Gallery, London.

1977

Sie malt *Mutter mit Stab* (Kat. Nr. 77). Ein Bild, das sie für die »Summer Exhibition« der Royal Academy of Arts, London, einreicht, wird nicht angenommen. 1981 unternimmt sie einen erneuten Versuch mit zwei Bildern, die aber ebenfalls abgelehnt werden.

1978

Henriette stirbt am 8. Juni im Alter von 96 Jahren. Das Haus wird so verändert, dass Untermieter aufgenommen werden können. Marie-Louise zieht ins Parterre, behält aber ihr Atelier im ersten Stock.

1979

Sie malt *Das Glashaus* (Kat. Nr. 79). Ferner entsteht *The Very Reverend Victor de Waal, Dean of Canterbury*.

68 Marie-Louise in front of *Self-portrait with Red Hat*, 1938, in the exhibition "Hampstead in the Thirties. A Committed Decade", Camden Arts Centre, London. The gallery is a few minutes walk from Marie-Louise's home. Photograph, 1974 / Marie-Louise vor ihrem Bild *Selbstporträt mit rotem Hut* aus dem Jahr 1938 in der Ausstellung »Hampstead in the Thirties. A Committed Decade« im Camden Arts Centre, London. Die Galerie lag nur wenige Gehminuten von der Wohnung der Künstlerin entfernt. Fotografie, 1974

69 Marie-Louise in her garden, Chesterford Gardens. Photograph, 1975 / Marie-Louise im Garten ihres Anwesens Chesterford Gardens, Fotografie, 1975

70 Henriette von Motesiczky with her greyhound, Photograph, 1973 / Henriette von Motesiczky mit ihrem Windspiel, Fotografie, 1973

1980

Karl von Motesiczky is honoured as "Righteous Among the Nations". She shows 14 paintings in the exhibition "Max Beckmanns Frankfurter Schüler 1925–1933" at the Kommunale Galerie im Refektorium des Karmeliterklosters, Frankfurt am Main.

1981

Paints *Golders Hill Park* (cat. no. 82).

1982

Paints *Still-life with Fish* (cat. no. 83). Compiles a memorial book for her mother, which includes reproductions of paintings and poems by her mother Henriette as well as of some of her own paintings.

1985

Has her first retrospective, "Marie-Louise von Motesiczky. Paintings Vienna 1925–London 1985" at the Goethe Institut, London. The show brings together 73 paintings from public and private collections as well as from the artist's own collection. The catalogue contains essays by Ernst Gombrich, Günter Busch, Richard Calvocoressi and Marie-Louise herself. The exhibition is a huge success. It is widely reviewed in the British press as well as in the "Frankfurter Allgemeine Zeitung" and the "Süddeutsche Zeitung". The Tate Gallery, London, acquires three paintings, *View from the Window, Vienna*, 1925 (cat. no. 3), *Still-life with Sheep*, 1938 (cat. no. 30) and *From Night into Day*, 1975 (cat. no. 74). Travels to see the Manet exhibition at the Grand Palais, Paris, and in subsequent years to the Grand Palais exhibitions of Watteau and Seurat.

1986

Paints the portrait of Baron Philipp de Rothschild (cat. no. 84). The retrospective "Marie-Louise von Motesiczky. Paintings Vienna 1925–London 1985" travels to the Fitzwilliam Museum, Cambridge. She participates in the show of "Hampstead Artists 1946–1986", Camden Arts Centre, London. Takes part in the exhibition "Kunst im Exil in Großbritannien", at the Orangerie des Schlosses Charlottenburg, Berlin. This subsequently travels to the Historisches Museum der Stadt Wien, the Städtische Galerie in Oberhausen (1987) and the Camden Arts Centre in London (1987) under the name "Art in Exile in Great Britain 1933–1945".

1987

Participates in the exhibition "Emigré Artists" at the John Denham Gallery, London.

1988

The exhibition "Marie Louise von Motesiczky with 'Figurative Image'" at the Royal Hospital Kilmainham in Dublin shows 16 paintings by Marie-Louise.

1980

Karl von Motesiczky wird als »Gerechter unter den Völkern« geehrt. Sie zeigt 14 Gemälde in der Ausstellung »Max Beckmanns Frankfurter Schüler 1925–1933« in der Kommunalen Galerie im Karmeliterkloster, Frankfurt am Main.

1981

Sie malt *Golders Hill Park* (Kat. Nr. 82).

1982

Stilleben mit Fisch (Kat. Nr. 83) entsteht. Sie produziert ein Gedenkbuch für ihre Mutter Henriette mit Gedichten und Bildern von ihr sowie mit eigenen Bildern.

1985

Im Londoner Goethe Institut erlebt sie ihre erste Retrospektive, »Marie-Louise von Motesiczky. Paintings Vienna 1925–London 1985«. Die Ausstellung zeigt 73 Bilder aus privaten und öffentlichen Sammlungen sowie aus der persönlichen Sammlung der Künstlerin. Der Katalog enthält Aufsätze von Ernst Gombrich, Günter Busch, Richard Calvocoressi und von Marie-Louise selbst. Die Retrospektive ist ein durchschlagender Erfolg. Sie stößt auf großen Widerhall in der britischen Presse und wird auch in der »Frankfurter Allgemeinen Zeitung« und in der »Süddeutschen Zeitung« besprochen. Die Londoner Tate Gallery erwirbt drei Gemälde, *Blick aus dem Fenster, Wien*, 1925 (Kat. Nr. 3), *Stilleben mit Schafen*, 1938 (Kat. Nr. 30) und *Von der Nacht in den Tag*, 1975 (Kat. Nr. 74). Die Malerin reist nach Paris, um sich die Manet-Ausstellung im Grand Palais anzusehen, und besucht in den darauf folgenden Jahren eine Watteau- und eine Seurat-Ausstellung, ebenfalls im Grand Palais.

1986

Sie malt das Porträt Baron Philipp de Rothschilds (Kat. Nr. 84). Die Retrospektive »Marie-Louise von Motesiczky. Paintings Vienna 1925–London 1985« wird im Fitzwilliam Museum, Cambridge, gezeigt. Die Malerin beteiligt sich an der Ausstellung von »Hampstead Artists 1946–1986« im Camden Arts Centre, London, sowie an der Bilderschau »Kunst im Exil in Großbritannien« in der Orangerie des Schlosses Charlottenburg, Berlin. Diese wandert weiter ins Historische Museum der Stadt Wien und in die Städtische Galerie in Oberhausen (1978) und wird anschließend unter dem Titel »Art in Exile in Great Britain 1933–1945« im Camden Arts Centre, London, gezeigt.

1987

Marie-Louise beteiligt sich an der Ausstellung »Emigré Artists« in der John Denham Gallery, London.

1988

In der Ausstellung »Marie-Louise von Motesiczky with ›Figurative Image‹« im Royal Hospital Kilmainham in Dublin werden 16 Bilder der Malerin gezeigt.

71 Änne Meyer (widow of the Beckmann pupil Friedrich Wilhelm Meyer), Marie-Louise von Motesiczky, the art historian Günter Vogt and the former Beckmann pupils Theo Garve, Inge Dinand and Alfred Nungesser during a panel discussion at the Kommunale Galerie im Karmeliterkloster / Änne Meyer (Witwe des Beckmann-Schülers Friedrich Wilhelm Meyer), Marie-Louise von Motesiczky, der Kunsthistoriker Günter Vogt sowie die ehemaligen Beckmann-Schüler Theo Garve, Inge Dinand und Alfred Nungesser während einer Podiumsdiskussion in der Kommunalen Galerie im Karmeliterkloster, Frankfurt am Main, Photograph / Fotografie, 1980

72 Marie-Louise in her lounge / Marie-Louise in ihrem Wohnzimmer, Photograph / Fotografie, 1980

1989
With Milein Cosman, and others, shows two paintings in Peter Black's "Modern and Contemporary Works of Art", Highbury, North London.

1990
Travels to Egypt. Around this time begins to compile an *oeuvre* catalogue with her personal secretary, Barbara Price. Canetti commissions a portrait, which Marie-Louise completes in 1992; he rejects it, and it is accepted by the National Portrait Gallery, London (cat. no. 88).

1992
Exhibits *Conversation in the Library*, the double-portrait of Franz Baermann Steiner and Elias Canetti (cat. no. 43), in the major exhibition on Jewish life, "Jüdische Lebenswelten. Jüdisches Denken und Glauben, Leben und Arbeiten in den Kulturen der Welt" at the Martin-Gropius-Bau, Berlin. She devotes herself to assuring the future of her work and establishes the "Marie-Louise von Motesickzy Charitable Trust" to preserve her legacy.

1993
Following her interest in Sheela Bonarjee's charitable work at Wormwood Scrubs Prison, London, she spends her 87th birthday with the prisoners. In her last years, she continues to visit the major art exhibitions in London and elsewhere, sometimes attending in a wheel-chair for comfort with Richard Karplus, her American cousin.

1994
A retrospective comprising 50 works from seven decades is held at the Österreichische Galerie im Belvedere, Vienna. This later travels to Manchester City Art Galleries. The Österreichische Galerie acquires *Self-Portrait with Comb*, 1926 (cat. no. 5), and expresses interest in further works. She is awarded the Austrian Cross of Honour for Sciences and the Arts, First Class. Participates in the exhibition "Helen Lessore. Artist & Art Dealer" at Theo Waddington Fine Art Ltd., London. Makes her final trip to Israel to see the retrospective by Siegfried Sebba.

1995
Six paintings are included in the exhibition "Neue Sachlichkeit. Österreich 1918–1938" at the Kunstforum Bank Austria, Vienna.

1996
Marie-Louise von Motesiczy dies in London on 10 June. The Tate Gallery, London, arranges a commemorative exhibition and a memorial meeting, introduced by Nicholas Serota and addressed by Ernst Gombrich. Her ashes are consigned to the family grave at the Döblinger Friedhof in Vienna.

1989
Mit Milein Cosman und anderen stellt sie in Peter Blacks »Modern and Contemporary Works of Art« in Highbury, im Norden Londons, zwei ihrer Bilder aus.

1990
Reise nach Ägypten. Etwa in dieser Zeit beginnt sie mit Hilfe ihrer Privatsekretärin Barbara Price, ein Werkverzeichnis zusammenzustellen. Canetti gibt ein Porträt in Auftrag, das Marie-Louise 1992 vollendet; er lehnt es ab, und es wird von der National Portrait Gallery, London akzeptiert (Kat. Nr. 88).

1992
Zu der großen Ausstellung über jüdisches Leben mit dem Titel »Jüdische Lebenswelten. Jüdisches Denken und Glauben, Leben und Arbeiten in den Kulturen der Welt« im Martin-Gropius-Bau, Berlin, wird Marie-Louise von Motesiczkys Doppelporträt von Elias Canetti und Franz Baermann Steiner, *Gespräch in der Bibliothek* (Kat. Nr. 43), gezeigt. Aus Sorge um die Zukunft ihrer Werke richtet sie den »Marie-Louise von Motesiczky Charitable Trust« ein, der ihr Erbe bewahren soll.

1993
Da sie sich für Sheela Bonarjees soziales Engagement im Wormwood Scrubs Prison, London, interessiert, verbringt sie ihren 87. Geburtstag bei den Gefangenen. In ihren letzten Jahren besucht sie die großen Kunstausstellungen in London und anderswo, manchmal im Rollstuhl und in Begleitung ihres amerikanischen Vetters Richard Karplus.

1994
Eine Retrospektive, die 50 ihrer Werke aus sieben Jahrzehnten umfasst, wird in der Österreichischen Galerie im Belvedere, Wien, gezeigt. Sie wandert später weiter in die Manchester City Art Galleries. Die Österreichische Galerie erwirbt *Selbstporträt mit Kamm*, 1926 (Kat. Nr. 5) und zeigt Interesse an weiteren Werken. Sie erhält das Österreichische Ehrenkreuz für Wissenschaft und Kunst I. Klasse. Teilnahme an der Ausstellung »Helen Lessore. Artist & Art Dealer« bei Theo Waddington Fine Art Ltd., London. Letzte Reise nach Israel, wo sie sich die Siegfried-Sebba-Retrospektive ansieht.

1995
Sechs Bilder von ihr werden in der Ausstellung »Neue Sachlichkeit. Österreich 1918–1938« im Kunstforum Bank Austria, Wien, gezeigt.

1996
Marie-Louise von Motesiczky stirbt am 10. Juni in London. Die Tate Gallery, London, veranstaltet eine Gedenkausstellung und ein Memorial Meeting mit einer Einführung von Nicholas Serota und einer Ansprache von Ernst Gombrich. Ihre Asche wird in der Familiengruft im Döblinger Friedhof in Wien beigesetzt.

Übersetzung aus dem Englischen: Sylvia Höfer

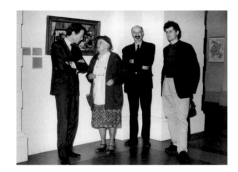

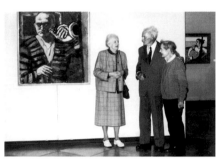

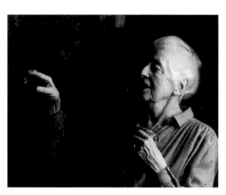

73 The Director of the Tate Gallery, Nicholas Serota, Marie-Louise, Richard Morphet and Sean Rainbird, Curator, in front of *Still-life with Sheep*, 1938, in the recent acquisitions display at the Tate Gallery / Der Direktor der Tate Gallery, Nicholas Serota, Marie-Louise, Richard Morphet und der Kurator Sean Rainbird vor Marie-Louises Gemälde *Stilleben mit Schafen* von 1938 während einer Ausstellung der Neuerwerbungen der Londoner Tate Gallery, Photograph / Fotografie, 1986

74 Marie-Louise with Stephan Lackner, the noted collector and patron of Max Beckmann, and Lackner's wife. They are standing in front of Max Beckmann's *Self-portrait with horn*, 1938, in the exhibition "Max Beckmann. Gemälde 1905–1950" at the Städel in Frankfurt am Main / Marie-Louise mit Stephan Lackner, dem bekannten Sammler und Förderer Max Beckmanns, sowie der Frau Lackners vor Max Beckmanns *Selbstbildnis mit Horn* aus dem Jahr 1938 in der Ausstellung »Max Beckmann. Gemälde 1905–1950« im Städel in Frankfurt am Main, Photograph / Fotografie, 1990

75 Marie-Louise von Motesiczky, Photograph / Fotografie, early 1990s / frühe 1990er Jahre

Select Bibliography / Auswahl-Bibliografie

Catalogues / Kataloge

London 1944
Exhibition of Painting and Sculpture by
Marie Louise Motesiczky and Mary Duras,
exhib. cat. / Ausst.-Kat. The Czechoslovak
Institute, London 1944

London 1953
The Renaissance of the Fish. Paintings from
the 17th to the 20th Century, exhib. cat. /
Ausst.-Kat. Roland, Browse and Delbanco,
London 1953

München 1954
Erna Dinklage. Marie Louise Motesiczky,
exhib. cat. / Ausst.-Kat. Städtische Galerie
München 1954

London 1960
Marie-Louise Motesiczky, exhib. cat. /
Ausst.-Kat. Beaux Arts Gallery, London 1960

London 1964
Last Anthology, exhib. cat. / Ausst.-Kat.
Beaux Arts Gallery, London 1964

Wien 1966
Marie-Louise von Motesiczky, exhib. cat. /
Ausst.-Kat. Wiener Secession, Wien 1966

Linz 1966
Marie-Louise von Motesiczky, exhib. cat. /
Ausst.-Kat. Neue Galerie der Stadt Linz 1966

München 1967
Marie-Louise von Motesiczky, exhib. cat. /
Ausst.-Kat. Galerie Günter Franke, München
1967

Bremen 1968
Marie-Louise von Motesiczky, exhib. cat. /
Ausst.-Kat. Kunsthalle Bremen 1968

London 1974
Hampstead in the Thirties. A Committed
Decade, exhib. cat. / Ausst.-Kat. Camden Arts
Centre, London 1974

Frankfurt 1980
Max Beckmanns Frankfurter Schüler
1925–1933, exhib. cat. / Ausst.-Kat. Karmeliter-
kloster, Frankfurt am Main 1980

Frankfurt 1983/84
Max Beckmann in Frankfurt 1915–1933,
exhib. cat. / Ausst.-Kat. Städtische Galerie
im Städelschen Kunstinstitut, Frankfurt
am Main 1983/84

London 1985
Marie-Louise von Motesiczky. Paintings
Vienna 1925–London 1985, exhib. cat. /
Ausst.-Kat. Goethe Institut, London 1985

London 1986
Hampstead Artists 1946–1986, exhib. cat. /
Ausst.-Kat. Camden Arts Centre, London
1986

Berlin 1986
Kunst im Exil in Großbritannien 1933–1945,
exhib. cat. / Ausst.-Kat. Orangerie des
Schlosses Charlottenburg, Berlin 1986

Berlin 1992
Jüdische Lebenswelten. Jüdisches Denken
und Glauben, Leben und Arbeiten in den
Kulturen der Welt, exhib. cat. / Ausst.-Kat.
Martin-Gropius-Bau, Berlin 1992

Wien 1994
Marie-Louise von Motesiczky, exhib. cat. /
Ausst.-Kat. Österreichische Galerie Oberes
Belvedere, Wien 1994

Wien 1995
Neue Sachlichkeit – Österreich 1918 bis 1938,
exhib. cat. / Ausst.-Kat. Kunstforum Bank
Austria, Wien 1995

Marbach 1998
»Ortlose Botschaft«. Der Freundeskreis
H. G. Adler, Elias Canetti und Franz Baermann
Steiner im englischen Exil, exhib. cat. /
Ausst.-Kat. Schiller-Nationalmuseum,
Marbach 1998

Wien 1999a
Neuerwerbungen. Meister von Heiligen-
kreuz bis Elke Krystufek. Österreichische
Galerie Belvedere 1992–1999, exhib. cat. /
Ausst.-Kat. Österreichische Galerie Belvedere,
Wien 1999

Wien 1999b
Blickwechsel und Einblick. Künstlerinnen
in Österreich. Aus der Sammlung des Histo-
rischen Museums der Stadt Wien, exhib. cat. /
Ausst.-Kat. Historisches Museum der Stadt
Wien 1999

Wien 1999c
Jahrhundert der Frauen: vom Impressionismus
zur Gegenwart. Österreich 1870 bis heute,
exhib. cat. / Ausst.-Kat. Kunstforum Wien,
Salzburg 1999

London 2000
Painting the Century. 101 Portrait Master-
pieces 1900–2000, exhib. cat. / Ausst.-Kat.
National Portrait Gallery, London 2000

Frankfurt 2000/01
Aus der Meisterklasse Max Beckmanns.
Karl Tratt, Friedrich Wilhelm Meyer und
ihre Kommilitonen, ed. / hrsg. v. Hans-Jür-
gen Fittkau, exhib. cat. / Ausst.-Kat. 1822-Stif-
tung der Frankfurter Sparkasse, Frankfurt
am Main 2000/01

London 2001
Mirror Mirror. Women's Self-Portraits,
exhib. cat. / Ausst.-Kat. National Portrait
Gallery, London 2001

Wien 2004
Die Liebens. 150 Jahre Geschichte einer
Wiener Familie, exhib. cat. / Ausst.-Kat.
Jüdisches Museum, Wien 2004

Books, essays and articles / Bücher, Aufsätze und Artikel

Adler 1994
Adler, Jeremy, »Kunst als Feier«, in: Marie-
Louise von Motesiczky, exhib. cat. / Ausst.-
Kat. Österreichische Galerie Oberes Belvede-
re, Wien 1994, 17–18

Baldass 1955
Baldass, Ludwig, »Die Malerin Marie-Louise
Motesiczky«, in: Die Kunst und das schöne
Heim, 55. Jg., Heft 6, März 1955, 218–219

Black 1996
Black, Peter, »Marie-Louise von Motesiczky«,
in: The Independent, June 15, 1996

Black 1997
Black, Peter, »Marie-Louise von Motesiczky«,
in: Dictionary of Women Artists, ed. Delia
Gaze, London/Chicago 1997, 991–994

Busch 1985
Busch, Günter, »Some comments on the art
of Marie-Louise von Motesiczky«, in: Marie-
Louise von Motesiczky. Paintings Vienna
1925–London 1985, exhib. cat. / Ausst.-Kat.
Goethe Institut, London 1985, 8–10

Calvocoressi 1985
Calvocoressi, Richard, »Introduction«, in:
Marie-Louise von Motesiczky. Paintings
Vienna 1925–London 1985, exhib. cat. / Ausst.-
Kat. Goethe Institut, London 1985, 59–63

Canetti 2005
Canetti, Elias, Aufzeichnungen für Marie-
Louise, hrsg. v. Jeremy Adler, München/
Wien 2005

Cohen 1994
Cohen, David, »Marie-Louise von Motesiczky«,
in: Modern Painters, 1994, vol. 7, no. 2, summer
1994, 93–95

Cohen 1996
Cohen, David, »Marie-Louise von Motesiczky.
Survivor from a vanished world«, in: The
Guardian, June 13, 1996

Dollen 1997
von der Dollen, Ingrid, »Marie-Louise von
Motesiczky. Malerei des Expressiven Realis-
mus«, Folge XIX, in: Weltkunst, Heft 15/16,
15. August 1997, 1594–1595

Dollen 2000
von der Dollen, Ingrid, Malerinnen im
20. Jahrhundert – Bildkunst der »verschol-
lenen Generation« – Geburtsjahrgänge
1890–1910, München 2000

Feaver 1985
Feaver, William, »Paintings by Marie-Louise
von Motesiczky«, in: Observer, December 7,
1985

Gaisbauer 1986
Gaisbauer, Hubert, »Wenigstens mit einem Bild ›bleiben zu dürfen‹. Marie-Luise von Motesiczky ist erst zu entdecken«, in: *Die Presse*, 22./23. Februar 1986

Gaisbauer 1992
Gaisbauer, Hubert und Heinz Janisch (Hrsg.), Menschenbilder, Wien 1992

Gallwitz 1984
Gallwitz, Klaus (ed. / Hrsg.), Max Beckmann in Frankfurt, Frankfurt 1984

Gombrich 1985
Gombrich, E. H., »Marie-Louise von Motesiczky«, in: *Marie-Louise von Motesiczky. Paintings Vienna 1925–London 1985*, exhib. cat. / Ausst.-Kat. Goethe Institut, London 1985, 6–7

Helmolt 1980
Helmolt, Christa, »Malerische Kraft und Seelenkenntnis. Eine Schülerin von Max Beckmann: Marie-Louise von Motesiczky«, in: *Frankfurter Allgemeine Zeitung*, 22. November 1980

Hodin 1961/62
Hodin, J. P., »The Poetic Realism of Marie-Louise Motesiczky«, in: *The Painter and Sculptor*, vol. 4, no. 3, London 1961/62, 19–23

Hodin 1966
Hodin, J. P., »Die Malerin Marie Louise von Motesiczky«, in: *Alte und moderne Kunst*, 11. Jg., Nr. 89, Wien 1966, 47–49

Kruntorad 1994
Kruntorad, Paul, »Die Wiederentdeckung einer Wiener Malerin«, in: *Welt am Sonntag*, 13. März 1994

Lloyd 2004
Lloyd, Jill, »Marie-Louise von Motesiczky – Eine Malerin der Erinnerung«, in: *Die Liebens. 150 Jahre Geschichte einer Wiener Familie*, exhib. cat. / Ausst.-Kat. Jüdisches Museum, Wien 2004, 205–225

López Calatayud 2005
López Calatayud, Elena, Marie Louise von Motesiczky. Technique and Materials, Courtauld Institute of Art, London, diploma thesis 2005

Michel 2003
Michel, Eva, Marie-Louise von Motesiczky 1906–1996: Eine österreichische Schülerin von Max Beckmann, Universität Wien, Diplomarbeit 2003

Motesiczky 1964
von Motesiczky, Marie-Louise, »Max Beckmann als Lehrer. Erinnerungen einer Schülerin des Malers«, in: *Frankfurter Allgemeine Zeitung*, 11. Januar 1964

Motesiczky 1984
von Motesiczky, Marie-Louise, »Max Beckmann as Teacher«, in: *Artscribe*, no. 47, July/August 1984, 50–53

Motesiczky 1985
von Motesiczky, Marie-Louise, »About myself«, in: *Marie-Louise von Motesiczky. Paintings Vienna 1925–London 1985*, exhib. cat. / Ausst.-Kat. Goethe Institut, London 1985, 11–14

Packer 1994
Packer, William, »Beautiful in isolation«, in: *Financial Times*, May 21/22, 1994

Plakolm-Forsthuber 1994
Plakolm-Forsthuber, Sabine, Künstlerinnen in Österreich 1897–1938, Wien 1994

Reifenberg 1966
Reifenberg, Benno, »Marie-Louise Motesiczky«, in: *Marie-Louise Motesiczky*, exhib. cat. / Ausst.-Kat. Wiener Secession, Wien 1966, n. p. / o. S.

Rothländer 2004a
Rothländer, Christiane, Karl Motesiczky. Biografie und Kontext, Universität Wien, Dissertation 2004

Rothländer 2004b
Rothländer, Christiane, »Karl Motesiczky. Biographische Annäherung an einen ›Gerechten unter den Völkern‹«, in: *Die Liebens. 150 Jahre Geschichte einer Wiener Familie*, exhib. cat. / Ausst.-Kat. Jüdisches Museum Wien 2004, 183–203

Schlenker 2003
Schlenker, Ines, »Painting Authors. The Portraits of Elias Canetti, Iris Murdoch and Franz Baermann Steiner by Marie-Louise von Motesiczky«, in: *From Prague Poet to Oxford Anthropologist: Franz Baermann Steiner Celebrated*, Jeremy Adler/Richard Fardon/Carol Tully (eds.), München 2003, 105–121

Schlenker 2005
Schlenker, Ines, »›So grüss ich von Herzen meinen Hofmaler Mulo und küss ihn auf die Palette.‹ Die Freundschaft zwischen Elias Canetti und Marie-Louise von Motesiczky«, in: *Text + Kritik*, Heft 28 (Elias Canetti), 4. Aufl., Neufassung, Juli 2005, 126–139

Schmidt 1994
Schmidt, Regine, »Marie-Louise von Motesiczky. Malerin zwischen den Zeiten«, in: *Vernissage. Magazin für aktuelles Ausstellungsgeschehen*, Heft 1, Februar 1994, 4–7

Spiel 1966
Spiel, Hilde, »Die Malerin Marie-Louise Motesiczky. Eine Ausstellung in der Wiener Secession«, in: *Frankfurter Allgemeine Zeitung*, 19. Mai 1966

Spiel 1986
Spiel, Hilde, »Unbeirrt auf ihrem eigenen Weg«, in: *Frankfurter Allgemeine Zeitung*, 2. Januar 1986

Vaizey 1985
Vaizey, Marina, »The revelation of a dazzling talent«, in: *Sunday Times*, November 24, 1985

Zimmermann 1994
Zimmermann, Rainer, *Expressiver Realismus. Malerei der verschollenen Generation*, München 1994

Photo credits / Fotonachweis

Fig./Abb. 1: Chris Warde-Jones, Rom. – Fig./Abb. 2 , 3: Matthew Hollow, London. – Fig./Abb. 4–6: Marie-Louise von Motesiczky Charitable Trust, London. – Fig./Abb. 7: Karl Skowronnek, Zur Entwicklung der Elektronenverstärkerröhre, Berlin 1931. – Fig./Abb. 8–9: Marie-Louise von Motesiczky Charitable Trust, London. – Fig./Abb. 10: Mathew Hollow, London. – Fig./Abb. 11: Marie-Louise von Motesiczky Charitable Trust, London. – Fig./Abb. 12–16: Matthew Hollow, London. – Fig./Abb. 17: Privatbesitz. – Fig./Abb. 18: Matthew Hollow, London. – Fig./Abb. 19: Max Beckmann Frankfurt 1915–1933, Ausst. Kat. Städtische Galerie im Städelschen Kunstinstitut Frankfurt a. M. 1983/84, 343. – Fig./Abb. 20: Sammlung Karin und Rüdiger Volhard. – Fig./Abb. 21: accent studios – Carsten Clüsserath, Saarbrücken. – Fig./Abb. 22–24: Matthew Hollow, London. – Fig./Abb. 25, 26: Institut für Stadtgeschichte, Frankfurt a. M. – Fig./Abb. 27, 28: Marie-Louise von Motesiczky Charitable Trust, London. – Fig./Abb. 29: Karlheinz Gabler, Siegfried Shalom Sebba. Maler und Werkmann mit Œuvre-Verzeichnis der Druckgrafik, Kassel 1981, 91. – Fig./Abb. 30: Historisches Museum, Frankfurt a. M., Foto Horst Ziegenfusz. – Fig./Abb. 31: Max Beckmann Frankfurt 1915–1933, Ausst. Kat. Städtische Galerie im Städelschen Kunstinstitut Frankfurt a. M. 1983/84, 91. – Fig./Abb. 32: Max Beckmann Frankfurt 1915–1933, Ausst. Kat. Städtische Galerie im Städelschen Kunstinstitut Frankfurt a. M. 1983/84, 133. – Fig./Abb. 33: Max Beckmann, Retrospektive, Ausst. Kat. Haus der Kunst München/ Nationalgalerie Berlin 1984, 315. – Fig./Abb. 34: Max Beckmann Frankfurt 1915–1933, Ausst. Kat. Städtische Galerie im Städelschen Kunstinstitut Frankfurt a. M. 1983/84, 125. – Fig./Abb. 35: Matthew Hollow, London. – Fig./Abb. 36: Max Beckmann Retrospektive, Ausst. Kat. Haus der Kunst München/ Nationalgalerie Berlin 1984, 40. – Fig./Abb. 37: Max Beckmann Frankfurt 1915–1933, Ausst. Kat. Städtische Galerie im Städelschen Kunstinstitut Frankfurt a. M. 1983/84, 127. – Fig./Abb. 38: Max Beckmann Retrospektive, Ausst. Kat. Haus der Kunst München/ Nationalgalerie Berlin 1984, 125. – Fig./Abb. 39: Max Beckmann Frankfurt 1915–1933, Ausst. Kat. Städtische Galerie im Städelschen Kunstinstitut Frankfurt a. M. 1983/84, 109. – Fig./Abb. 40: Max Beckmann Frankfurt 1915–1933, Ausst. Kat. Städtische Galerie im Städelschen Kunstinstitut Frankfurt a. M. 1983/84, 144. – Fig./Abb. 41: Jeannine Hovaers, Amsterdam. – Fig./Abb. 42: Marie-Louise von Motesiczky Charitable Trust, London. – Fig./Abb. 43, 44: Matthew Hollow, London. – Fig./Abb. 45: Marie-Louise von Motesiczky Charitable Trust, London. – Fig./Abb. 46: Foundation Oskar Kokoschka, Museum Jenisch, Vevey. – Fig./Abb. 47: Matthew Hollow, London – Fig./Abb. 48: Stedelijk Museum, Amsterdam. – Fig./Abb. 49–51: Matthew Hollow, London. – Fig./Abb. 55–61, 63–74: Marie-Louise von Motesiczky Charitable Trust, London. – Fig./Abb. 62: Alaisdair Smith, Glasgow. – Fig./Abb. 75: Peter Rauter, London.

Amsterdam, Jeannine Hovaers: 15, 23, 31, 35, 49. – Cambridge, Fitzwilliam Museum: 20, 84. – Frankfurt a. M., David Hall: 70. – Glasgow, Alaisdair Smith: 51. – Linz, Lentos Museum: 64. – London, Arts Council: 77. – London, Matthew Hollow: 1, 2, 4, 6–14, 16–18, 21, 22, 24, 26–29, 32–34, 36–48, 50, 52, 53, 55, 57, 59, 60, 62, 63, 65–67, 69, 71–73, 75, 76, 78–83, 85–87, 89. – London, National Portrait Gallery: 88. – London, Tate Gallery: 3, 30, 74. – Manchester, City Art Gallery: 58. – Oxford, St Anne's College: 61. – Privatbesitz: 25, 54, 68. – Wien, Österreichische Galerie Belvedere: 5. – Wien, Fotostudio Otto: 19. – Wien, Wien Museum: 56.